Deep Classics

Also available from Bloomsbury

Ancient Magic and the Supernatural in the Modern Visual and Performing Arts, edited by Filippo Carlà and Irene Berti

Greek and Roman Classics in the British Struggle for Social Change, edited by Henry Stead and Edith Hall

Imagining Xerxes, Emma Bridges

Ovid's Myth of Pygmalion on Screen, Paula James

Seduction and Power: Antiquity in the Visual and Performing Arts, edited by Silke Knippschild and Marta García Morcillo

Victorian Classical Burlesques: A Critical Anthology, Laura Monros-Gaspar

War as Spectacle: Ancient and Modern Perspectives on the Display of Armed Conflict, edited by Anastasia Bakogianni and Valerie M. Hope

Deep Classics

Rethinking Classical Reception

Edited by Shane Butler

Bloomsbury Academic
An imprint of Bloomsbury Publishing Plc

B L O O M S B U R Y
LONDON · OXFORD · NEW YORK · NEW DELHI · SYDNEY

Bloomsbury Academic

An imprint of Bloomsbury Publishing Plc

50 Bedford Square	1385 Broadway
London	New York
WC1B 3DP	NY 10018
UK	USA

www.bloomsbury.com

BLOOMSBURY and the Diana logo are trademarks of Bloomsbury Publishing Plc

First published 2016

British Library Cataloguing-in-Publication Data

A catalogue record for this book is available from the British Library.

ISBN:	HB:	978-1-47426-052-7
	PB:	978-1-47426-051-0
	EPDF:	978-1-47426-054-1
	EPUB:	978-1-47426-053-4

Library of Congress Cataloging-in-Publication Data

A catalog record for this book is available from the Library of Congress.

Typeset by RefineCatch Limited, Bungay, Suffolk
Printed and bound in Great Britain

Contents

vi Contents

Acknowledgements

A conversation with Pantelis Michelakis gave 'Deep Classics' its initial impetus, and the original request for conference funding from the Institute of Greece, Rome and the Classical Tradition (IGRCT) at the University of Bristol was drafted with the help of Vanda Zajko. Robert Fowler, then director of the IGRCT, immediately became and has remained a champion of the project; so too has much encouragement and support come from Beth Williamson, Bristol's Deputy Head of Research for the School of Humanities. The original conference would never have been possible without the heroic efforts of IGRCT Co-ordinator Sam Barlow, as well as those of interns Rhiannon Easterbrook and Jessica Romney. Further help along the way was provided by Shelley Hales, Laura Jansen and Adam Lecznar. Warm thanks also to Nora Goldschmidt and Luke Richardson, whose stimulating papers at the conference belonged to other projects that will see publication elsewhere. Alice Wright of Bloomsbury attended the conference from start to finish (though an early train back to London deprived her of her dinner!) and deftly has guided this volume through publication. Image and other publication costs have partially been defrayed by additional support from the IGRCT. At Johns Hopkins, Michele Asuni has helped to bring bibligraphic and citational order to the ensemble, and Earl Havens and Paul Espinosa helped with images. Further adjustments and polish have been provided by the production team at Bloomsbury. The editor's deepest thanks go to this volume's contributors, who took up this topic with enthusiasm and imagination, and whose speedy revisions, in close contact with one another, have made the timely publication of this remarkable collaborative effort possible. Additional thanks by contributors can be found in the notes to their single chapters. The editor's own efforts are dedicated to Leonardo Proietti.

List of Contributors

Joshua Billings is Assistant Professor of Classics at Princeton University and author of *Genealogy of the Tragic: Greek Tragedy and German Philosophy* (2014).

Shane Butler held the Chair of Latin at the University of Bristol and is now Professor of Classics at Johns Hopkins University. His most recent book is *The Ancient Phonograph* (2015).

Stephanie Ann Frampton is Assistant Professor of Classical Literature at the Massachussetts Institute of Technology. Her first book, *Alphabetic Order: Writing in Roman Literature and Thought*, will appear soon.

Brooke Holmes is Professor of Classics at Princeton University. Her books include *The Symptom and the Subject: The Emergence of the Physical Body in Ancient Greece* (2010) and *Gender: Antiquity and Its Legacy* (2012).

Laura Jansen is Lecturer in Latin Language and Literature at the University of Bristol and editor of *The Roman Paratext: Frames, Texts, Readers* (2014). She currently is working on a book titled *Borges' Classics*.

Joshua T. Katz is Professor of Classics and member of the Program in Linguistics at Princeton University. He is the author of numerous articles on the languages, literatures and cultures of the ancient world, broadly conceived.

Adam Lecznar is the A.G. Leventis Fellow in Greek Studies at the University of Bristol. He is working currently on a book on the understanding of Dionysus and Greek tragedy in the wake of Nietzsche.

Sebastian Matzner is Lecturer in Comparative Literature at King's College London. His first book, *Rethinking Metonymy: Literary Theory and Poetic Practice from Pindar to Jakobson*, will appear soon.

Sarah Nooter is Associate Professor of Classics at the University of Chicago and author of *When Heroes Sing: Sophocles and the Shifting Soundscape of Tragedy* (2012).

Mark Payne is Professor of Classics and in the John U. Nef Committee on Social Thought at the University of Chicago. His most recent book is *The Animal Part: Human and Other Animals in the Poetic Imagination* (2010).

Alex Purves is Associate Professor of Classics at UCLA and author of *Space and Time in Ancient Greek Narrative* (2010).

Edmund Richardson is Lecturer in Classics at Durham University and author of *Classical Victorians: Scholars, Scoundrels and Generals in Pursuit of Antiquity.* He is currently working on the afterlives of Alexander the Great and his cities.

Giulia Sissa is Professor of Political Science and of Classics at UCLA. Her most recent book is *La jalousie: Une passion inavouable* (2015).

Helen Slaney holds a British Academy Postdoctoral Fellowship in Classics at St Hilda's College, Oxford, and is the author of *The Senecan Aesthetic: A Performance History* (2015).

Davide Susanetti is Associate Professor in the Dipartimento di Studi Linguistici e Letterari at the University of Padova. His most recent book is *Atene post-occidentale: Spettri antichi per la democrazia contemporanea* (2014).

Introduction

On the Origin of 'Deep Classics'

Shane Butler

'No one owns Homer, not even the best of his readers. Each one of our readings is done through layers of previous ones that pile upon the page like seams in a rock until the original text (if there ever really was so pure a thing) is hardly visible.'[1] So writes Alberto Manguel, who in his youth was a reader to the blind Borges and who in recent decades, following in the master's footsteps, has penned lyrical meditations on the fine art of reading to and for oneself. Hardly one to botch a simile, Manguel nevertheless presents us, in the introduction to *Homer's 'The Iliad' and 'The Odyssey': A Biography*, with an image that does not make proper sense. If each reading of Homer is like a layer of rock over the 'original text', then surely just one was sufficient to shield entirely whatever lay below from any unaided view from above, plunging all subsequent readers into a blindness at once Borgesian and Homeric. Perhaps, in fact, Manguel partly means to remind us that reading and writing alike hardly depend on something as banal as ordinary vision: we are all blinded by the page, through which we see by some stronger sense. But it seems equally likely that Manguel is not really looking from above, and that his view is instead that of the geologist, who has stumbled upon, or perhaps quarried to find, a sidelong perspective on time's stacked strata. That this is in fact what Manguel has in mind is further suggested by the fact that the chapters of his 'biography' of the Homeric epics through the ages proceed mostly chronologically, through to the last century. Seen from the side, those chapters thus present a kind of reverse stratigraphy, from early to late, unless you flip the book over, where the jacket of one edition suggestively borrows the very quote with which I began. We may well judge books by their covers, but to read them we must eventually open them up *from the side*. Accordingly, Manguel's invitation to read takes us

into the thickly layered history of Homeric reading laterally. Though he may encourage us to explore each seam separately and for its own sake, his book's very existence suggests that these add up to a lesson more profound than that which any of them could offer singly.

Part of that lesson, to be sure, is a rather old-school one about the endless fecundity of the Homeric poems themselves. Pointedly aimed at a general readership, in a series titled 'Books That Shook the World', Manguel's book partly offers the kind of celebration of *Homer and His Influence* that has been a staple of generalist literature on the Classics at least since John A. Scott's booklet of that title in the popular series 'Our Debt to Greece and Rome', nearly a century ago. Nevertheless, Manguel also deploys many of the tools by which recent scholars of 'classical reception' have sought to distinguish their work from outmoded heroic accounts of 'the classical tradition', including an egalitarian emphasis on reader response ('no one owns Homer' – i.e., everyone potentially does), a globalization of the 'we' who read and respond to the Classics (Manguel considers, among others, Derek Walcott, Columbian villagers and the Islamic world), and a willingness to let intertextual connections defy chronology (so that Goethe, for example, can be seen to influence Augustine). In other words, Manguel's book offers something of a methodological hybrid, its attention divided between the Homer who endures and the Homer who is endlessly reinvented. And while most works of reception studies for, instead, the academic market have tended to prefer the latter perspective, the field as a whole continues to offer a similarly mixed message. On the one hand, 'meaning ... is always realized at the point of reception'; on the other, the author of those often quoted words, reception-studies pioneer Charles Martindale, in his landmark *Redeeming the Text: Latin Poetry and the Hermeneutics of Reception* (1993), properly frames them as a question, regards the points to which they refer as connected by a 'chain of receptions', and in his recent work has emphasized still other kinds of 'transhistorical' continuities.[2] Along different but not diametrically opposed lines, Michael Silk, Ingo Gildenhard and Rosemary Barrow have argued that the very term 'the classical tradition' was discarded too hastily and is ready to be redeployed, though with nuance that it lacked before.[3] *The Classical Tradition*, in fact, had already resurfaced as the title of a 2010 dictionary thereof, edited by Anthony Grafton, Glenn Most and Salvatore Settis, which, however, opens in invocation of the competing term,

treated as a synonym: 'This book aims to provide a reliable and wide-ranging guide to the reception of classical Graeco-Roman antiquity in all its dimensions in later cultures.'[4]

Between 'tradition' and 'reception', however, Manguel's geological simile hints at a third perspective irreducible to either. It will be the contention of the present book that this *tertium quid*, to which we have assigned the name of 'Deep Classics', offers us, if not an entirely new way forward, then at least a new way of contextualizing some of what we all seem to have been doing, all along. To better understand what this might be, and to explain the reason for the name, let us briefly consider a superficially similar point of view, directed at actual layers of real rock. In the following, John Playfair, an associate of John Hutton, frequently called 'the founder of modern geology',[5] describes their 1788 excursion to the base of a soaring cliff on the Scottish coast, where Hutton's theories of the complex interaction between igneous and sedimentary rock met with dramatic visual confirmation:

> What clearer evidence could we have had of the different formation of these rocks, and of the long interval which separated their formation, had we actually seen them emerging from the very bosom of the deep? We felt ourselves necessarily carried back to the time when the schistus on which we stood was yet at the bottom of the sea, and when the sandstone before us was only beginning to be deposited, in the shape of sand or mud, from the waters of a superincumbent ocean. An epocha still more remote presented itself, when even the most ancient of these rocks, instead of standing upright in vertical beds, lay in horizontal planes at the bottom of the sea, and was not yet disturbed by that immeasurable force which has burst asunder the solid pavement of the globe. Revolutions still more remote appeared in the distance of this extraordinary perspective. The mind seemed to grow giddy by looking so far into the abyss of time; and while we listened with earnestness and admiration to the philosopher who was now unfolding to us the order and series of these wonderful events, we became sensible how much farther reason may sometimes go than imagination can venture to follow.[6]

Originally offered as a biographical vignette of the late Hutton to the Royal Society of Edinburgh, Playfair's remembrance of that day at Siccar Point has become a classic of scientific literature and, more recently, an emblematic scene of the modern encounter with what has been called 'Deep Time'. Deep

Time places us, on the one hand, face-to-face with almost unthinkable timespans: Playfair's 'abyss of time', which leaves him and the others 'giddy' and awestruck, outstripping even the limits of 'imagination' itself. But in a second moment, Deep Time confronts us with the no less awe-inspiring *presence* of the distant past, right before Playfair's eyes and, indeed, just beneath his feet, in 'the schistus on which we stood', once upon a time 'at the bottom of the sea'. ('We found that we actually trode on the primeval rock,' he has already remarked, a paragraph before.)[7] Other kinds of Deep Time manifest themselves as similarly jarring juxtapositions of distant past and immediate presence, such as evolutionary time, which leaves pieces of the genetic code for our pre-human ancestors embedded in the DNA in our own bodies, or cosmic time, more dizzying than any earthly abyss but still connecting everything in and around us to the matter with which the universe burst into being.

Hutton's perspective was, in part, that of a new science, as would be those of Darwin and subsequent thinkers in and of Deep Time. But evidence that his perspective was, simultaneously, a familiar one is there in Playfair's description of him as a 'philosopher' and epic storyteller or even historian, 'unfolding to us the order and series of these wonderful events'. Indeed, his pose resembles nothing so much as that of an archaeologist, standing at the bottom of an excavated trench or, perhaps, atop Rome's Campidoglio, gesturing at the Roman Forum below, ruined long ago, but still there. No less than geologists, evolutionary biologists and astrophysicists do, archaeologists and other classicists also stare into abysses of time, and these are not necessarily less moving or meaningful for being chronologically shallower; it is all a question of scale. Scale, to be sure, has been taken to be part of Deep Time's provocation to history itself:

> Consider the Earth's history as the old measure of the English yard, the distance from the King's nose to the tip of his outstretched hand. One stroke of a nail file on his middle finger erases human history.[8]

But even that fingernail shaving looms massive over the only trembling timespan we know first-hand: that of our own lives. Time, in other words, has never needed much of itself in order to dwarf us.

A basic aim of 'Deep Classics', therefore, is to re-propose Classics as an early species, and partial origin, of Deep Time thinking itself. For what is 'antiquity'

– the thing classicists say they work on, via things they call 'antiquities' – if not precisely a word for a depth of time? Claiming Classics as one of Hutton's antecedents, however, should not lead us to underestimate its transformation in his wake. Dramatic evidence of this can be found in Figure 1, which reproduces the diagram added to the beginning of the English edition of Heinrich Schliemann's *Troy and its Remains* (1875), which translates, supplements and illustrates (in part from the separate German publication of an illustrated catalogue of artifacts) his *Trojanische Alterthümer: Bericht über die Ausgrabungen in Troja*, published the year before. 'A chief key to the significance of the discoveries is found in the *depths* of the successive *strata* of remains, which are exhibited in the form of a diagram on page 10,' explains the editor in the preface to this English edition, addressing a readership well used to stratigraphic charts.[9] These had proliferated in the nineteenth century, as British geologists eagerly sought to reveal and explain what lay beneath British feet, mapping strata that correlated (and were in turn correlated by) the objects trapped in them, though these were not human artefacts, as would be found at Troy, but the fossilized remains of the planet's other inhabitants, many of them extinct long before there were humans, much less Trojans and Greeks. That the diagram of Schliemann's Troy has been shaped by its geological counterparts is already clear from the fact that the city here is perched on 'native rock', which, we might add, the successive urban layers only seem to dominate, since that rock simultaneously is the lurking source of the earthquakes responsible, as Schliemann himself confirmed, for some of the destruction above. More important, however, is the diagram's foregrounding of stratigraphy itself, which by that name is a concept native to geology and its rocks, consciously or unconsciously echoed here in the alternating striations used to distinguish each stratum along the left (where the sideways numbering indicates the number of subsidiary strata within strata). Finally, we can say that geology and other modern sciences of Deep Time are implicitly present in Schliemann's whole endeavour (and so in this diagram that represents it), for they helped to fuel the very confidence with which nineteenth-century archaeology went looking for the *prehistoric* past, including any real events lying behind the already prehistoric, orally transmitted poetry of the *Iliad*. If geology over the course of the nineteenth century had been drafting accounts of whole eras situated hundreds of millions of years in the past, like the 'Cambrian' and the

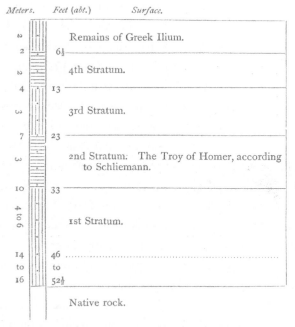

DIAGRAM

SHEWING THE SUCCESSIVE *STRATA* OF REMAINS ON THE
HILL OF HISSARLIK.

Figure 1 From the 1875 English edition of Heinrich Schliemann, *Troy and Its Remains*. Image courtesy of the Johns Hopkins University Libraries.

'Devonian', named for their chief British find spots, then surely Classics, that same century increasingly confirmed, had nothing to fear from the relatively recent Bronze Age.

Among modes of inquiry into the classical past, it was not just archaeology that found itself graphically and conceptually aligned with the Deep Time of new science. Vivid demonstration of the symmetry between nineteenth-century philology, for example, and evolutionary biology is provided by Figure 2, reproducing one of the first diagrams that would come to be known as textual *stemmata* or 'family trees', from Friedrich Ritschl's 1838 critical edition of the proem to Dionysius of Halicarnassus's *Roman Antiquities*,[10] and Figure 3, the sole illustration in Charles Darwin's *On the Origin of Species*, first

published in 1859.[11] Between Darwinism and textual criticism, the direction of influence, if it ever was direct, is hard to work out: Darwin's earliest known sketch of the 'tree of life' is found in a notebook contemporary with Ritschl's edition;[12] both men, however, were adapting the metaphors and graphic conventions of predecessors in their own and related fields. One way or another, the similarities are striking, and not just at first glance: both diagram a past that, though it may no longer exist in its own right (vanished archetypes, extinct species), nonetheless has structured what survives. There is, of course, one very conspicuous graphic difference, namely, the inversion of their triangular shapes, reflecting diametrically opposed teleologies. Darwin, on the one hand, despite his title's promise of 'origins', is ultimately concerned with accounting for the present diversity of life forms on the planet, including, of course, our own. The endpoint of Ritschl's efforts, by contrast, is the reconstruction of the archetype, that is, the common ancestor of all known manuscripts of the work in question, to which he suggestively assigns not the first letter of the Greek alphabet, but the last. The present, from above, triumphs over the past in Darwin's diagram; Ritschl seems to invert this, though in another sense, his work restores to the present the supreme authority of the past. One way or another, in their attempts to uncover the relationship between past and present, both propose pictures of the work of time itself – corrupting of texts, but ennobling of the species that had made them and that now was learning to undo time's harm.

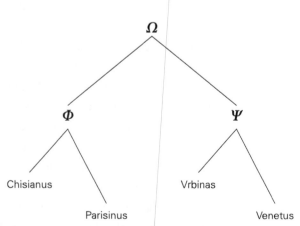

Figure 2 Redrawn from Friedrich Ritschl, ed., *Dionysii Halicarnassensis Prooemium Antiquitatum Romanarum* (1838).

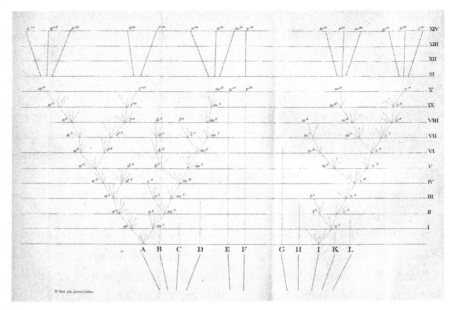

Figure 3 From Charles Darwin, *On the Origin of Species* (1859). Image courtesy of the Johns Hopkins University Libraries.

Recent scholarship has several times observed that it was only in the nineteenth century that the use of phrase 'classical tradition' to designate the continuing influence of Greco-Roman antiquity acquired currency.[13] That same scholarship has tended to link the diffusion of the phrase to debates about the value of the Classics and, especially, of an education based upon them: 'tradition' in this sense is that which, for better or worse, is 'traditional', i.e., customary, established, and authoritative – an inheritance, or even a birthright, that would not be easy (or wise?) for its putative heirs to renounce. But as anyone with a nineteenth-century classical education knew well, *traditio*, in Latin, is literally a 'handing over' of something, such as that of a conquered city to its new masters, or of knowledge to each new generation.[14] Like the new diagrams of archaeology and philology, 'tradition', in this sense, is a spatial representation of something that has happened in and over time. Indeed, the term itself was shared with the newly scientific methods of philology, concerned with what came to be known as a text's 'tradition' (or 'transmission'), i.e., its *movement*

over time, through copying, from one book to another. If tradition, as a term of value, makes explicit or implicit appeal to something like timelessness, then the same word, in its more literal sense, proposes yet another picture of time as it has unfolded.

From all of these perspectives – archaeological, philological and that of the so-called classical tradition – nineteenth-century Classics was directing its attention not just towards 'the ancient past' as some static entity but, equally, towards the time between then and now, the time that made that past 'ancient'. To be sure, thinking about Greece and Rome in a post-classical world had often entailed thinking deeply about time itself, as we shortly shall remind ourselves. But the nineteenth century lent that meditation new purpose, as well as metaphors that would endure into the century to come. Consider, in fact, one of the twentieth century's most remarkable uses of an ancient site as itself a metaphor: Freud's comparison, in *Civilization and its Discontents* (1930), of the human psychic apparatus to the Eternal City of Rome.

Now let us, by a flight of imagination, suppose that Rome is not a human habitation but a psychical entity with a similarly long and copious past – an entity, that is to say, in which nothing that has once come into existence will have passed away and all the earlier phases of development continue to exist alongside the latest one. This would mean that in Rome the palaces of the Caesars and the Septizonium of Septimius Severus would still be rising to their old height on the Palatine and that the castle of S. Angelo would still be carrying on its battlements the beautiful statues which graced it until the siege by the Goths, and so on. But more than this. In the place occupied by the Palazzo Caffarelli would once more stand – without the palazzo having to be removed – the Temple of Jupiter Capitolinus; and this not only in its latest shape, as the Romans of the Empire saw it, but also in its earliest one, when it still showed Etruscan forms and was ornamented with terra-cotta antefixes. Where the Coliseum now stands we could at the same time admire Nero's vanished Golden House. On the Piazza of the Pantheon we should find not only the Pantheon of today, as it was bequeathed to us by Hadrian, but, on the same site, the original edifice erected by Agrippa; indeed, the same piece of ground would be supporting the church of Santa Maria sopra Minerva and the ancient temple over which it was built. And the observer would perhaps only have to change the direction of his glance or his position in order to call up the one view or the other.[15]

Riffing fantastically on the archaeological cross-section, Freud joins the city's classical and post-classical architecture into a seamless tradition. As with the unconscious, nothing is ever finally, fully lost here.

Freud's simile depends on a venerable tradition of seeing Rome's ruins as graphic figures for time, but it does so in deliberate breach of that tradition's usual lessons: where he gives us a scenario of potentially total recall (the return of the forgotten or repressed), the Romantic imagination had instead surveyed, with melancholic desire, a scene of irremediable destruction. Compare Freud to the deliberately disconsolate Byron, looking out at the same city in the final canto of *Childe Harold's Pilgrimage*, finished in 1818 and characterized by anything but the forward-looking optimism of new science:

> Tully was not so eloquent as thou,
> Thou nameless column with the buried base!
> What are the laurels of the Caesar's brow?
> Crown me with ivy from his dwelling-place.
> Whose arch or pillar meets me in the face,
> Titus or Trajan's? No – 'tis that of Time:
> Triumph, arch, pillar, all he doth displace
> Scoffing; and apostolic statues climb
> To crush the imperial urn, whose ashes slept sublime.[16]

Such meditations are, in fact, as old as the very fall of Rome: 'No survivor can forget you', is the backward cry of the poet Rutilius Claudius Namatianus to Rome, as he makes his way from the city to Gaul through the ravaged Italian peninsula, in 416.[17] Technically speaking, Rutilius calls for Rome's triumphant resurgence, but the tone had been set: the Rome the world had known was gone, forever. Even the era celebrated for its efforts to promote the 'rebirth' of classical culture knew this. It was the nineteenth century, once again, that gave the Renaissance that name, and perhaps this act of naming can partly be attributed to the later age's search for precedents for its own increasingly confident dominion over the past, its increasingly miraculous ability to make that past present. But such miracles would not fully dispel from Classics its Byronic gloom and forgetfulness. Even Freud's unconscious does not really resemble his fantastic vision of a ruinless Rome as much as it does the real, ruined, buried city: not a gleaming reconstruction, but the dark shading of Piranesi's *Views* (Figure 4), or the even darker vision of the same artist's

Prisons. One needs antiquity's shadows as well as its light to represent what Marguerite Yourcenar memorably calls 'the dark brain of Piranesi' – or any brain, for that matter.[18] Freud's easy perspicuity ('the observer would perhaps only have to change the direction of his glance or his position in order to call up the one view or the other') is really that of modern science, like Hutton's on the Scottish shore; it will not always correspond to the workings of memory (hence Freud's 'perhaps') or, indeed, to the steady labour of analysis, all of which may require rather substantial heavy lifting. And, of course, even the full exhumation of a memory will not restore the dead to the land of the living. *Quidquid aetatis retro est mors tenet,* 'any time behind us is in the grip of death', proclaims Seneca, speaking not of the fully dead, but of the slow slide into oblivion of our own mortal lives.[19]

By the end of Freud's century, few classicists had time for the kind of poetic philosophizing just sampled. In Classics and throughout the humanities, under the double banners of 'new historicism' and, more broadly, of 'theory' (a word suggestively derived from the Greek verb for vision), the study of art and

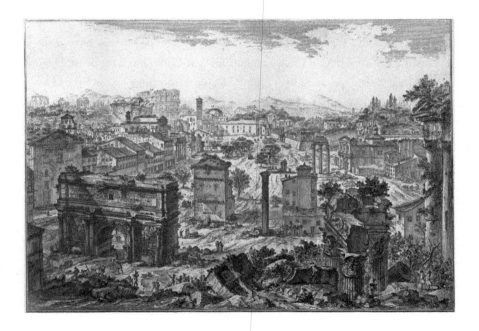

Figure 4 Giovanni Battista Piranesi, *Veduta di Campo Vaccino* (etching), from the *Vedute di Roma* (1748–74).

literature was driven by questions about the root causes of observable phenomena, including the questions of Freud, as well as those of history and the rest of the social sciences. The goal, it everywhere seemed, was *to get to the bottom of things*, genealogically, archaeologically (to use the two metaphors favoured by one of that era's defining thinkers, Michel Foucault). One might even go so far as to say that Classics was never *deeper* than it was then. But the trouble with excavation, even on its own terms, can be seen already in the diagram of Schliemann's Troy. To get fully to the bottom of this place would be to destroy (again) the very place you are looking for. In effect, that is precisely what Schliemann did: having located 'Homer's Troy' in the 'second stratum', he bored through the layers most scholars now think most likely to be those of the city of the *Iliad* – assuming, of course, that the Trojan War has any factual basis at all. Needless to say, not all archaeologies, real or metaphorical, are this invasive or produce, when they do go wrong, such irreversible damage. Nor would even a Byron be ungrateful for all that we have come to know about antiquity in the two centuries since *Childe Harold's Pilgrimage* came to an end (not in Rome, by the way, but 'by the deep Sea', which is more or less where it had begun). But suppose, for a moment, that we had access to a *perfect* archaeology, along the lines of that imagined by Freud, capable of revealing, with nothing more violent than a glance, all that Rome has ever been. Having learned everything we could ever want to know about this place, where exactly would we be, and what would we then discover we had lost?

Since the Renaissance, Classics has repeatedly constituted itself as a science, or at least, as one of the 'human sciences'. But if 'knowledge' (*scientia*) is the purported object of any science so called, then Classics poses something of a puzzle. The aggregate object of its attention, 'antiquity', like the single 'antiquities' that comprise antiquity's remains, can be extraordinarily resistant to our efforts to know it. Can we really say, for example, that we know more about the prehistory of Rome and the Romans than we do about the Big Bang, or the birth of our planet, or the origin of our or any other species? No sooner does new science tell us that the past is ours to rediscover than more recent 'antiquity' steps in to say, 'Not so fast'. Yes, *rerum natura sacra sua non semel tradit*, 'the universe does not hand over its mysteries just once', as Seneca observes, this time in a confidently scientific mood; thus did modern physics learn all it cared to know about atomic particles, for example, long before running out of

atoms to split. But these are not the luxuries of the classicist, who may never even know, for example, whether the Lucilius to whom Seneca addresses his *Epistles* was their real recipient or a literary invention. And what of antiquity's countless smaller fragments, most of which will never hand over their secrets? 'We but feel our way to err', notes Byron, who continues,

> The ocean hath his chart, the stars their map,
> And Knowledge spreads them on her ample lap;
> But Rome is as the desert, where we steer
> Stumbling o'er recollections . . .[20]

In such a 'desert', even the excavation of our own shallow shadows will not be easy, as Byron's whole autobiographical poem has made plain. Why then have so many deep thinkers dedicated themselves to surveying such impossible terrain? Byron has just given us one answer, in that his Grand Tour was driven by one very specific 'scientific' imperative, the same one once inscribed on the Temple of Apollo at Delphi: *gnōthi seauton*, 'know thyself'. But the work of time has not been limited to the making of a better mirror. Speaking through and as one another, time and antiquity have something to say for *themselves*. Deep Classics looks and listens for these lessons, which often have less to do with 'knowing' than with other modes of affect and experience. *Khalepa ta kala* went a Greek proverb, 'beautiful things are difficult', quoted by that earlier heeder of Apollo's call, Socrates, at the conclusion of an early dialogue on beauty, the *Hippias Major*. Socrates mostly means that it is difficult to know what beauty is. But scientists of all sorts would readily agree with this converse: sometimes, the things that are hardest to know are the most beautiful.

Indeed, whatever its scientific trajectories, the cliff-side giddiness of Hutton and his associates looks very much like an experience of the sublime, that ancient category of extreme beauty which Hutton's exact contemporary, Edmund Burke, had resuscitated, distinguishing it from beauty proper and seeking scientific laws for both. Burke was influenced by the writings of Grand Tourists awed by the Alps en route to Italy. Here Anthony Ashley Cooper, Earl of Shaftesbury, has a character in a fictitious dialogue of 1709 describe the grandeur of nature with a 'giddy' vertigo that strikingly anticipates that of Hutton and friends:

> But behold! thro a vast Tract of Sky before us, the mighty ATLAS rears his
> lofty Head, cover'd with Snow, above the Clouds. Beneath the *Mountain's*

foot, the rocky Country rises into Hills, a proper Basis of the ponderous Mass above: where huge embody'd Rocks lie pil'd on one another, and seem to prop the high Arch of Heaven.—See! with what trembling Steps poor Mankind tread the narrow Brink of the deep Precipices! From whence with giddy Horrour they look down, mistrusting even the Ground which bears 'em; whilst they hear the hollow Sound of Torrents underneath, and see the Ruin of the impending Rock; with falling Trees which hang with their Roots upwards, and seem to draw more Ruin after 'em. Here thoughtless Men, seiz'd with the Newness of such Objects, become thoughtful, and willingly contemplate the incessant Changes of this Earth's Surface. They see, as in one instant, the Revolutions of past Ages, the fleeting Forms of Things, and the Decay even of this our Globe; whose Youth and first Formation they consider, whilst the apparent Spoil and irreparable Breaches of the wasted Mountain shew them the World it self only as a noble Ruin, and make them think of its approaching Period.[21]

In this Alpine setting, geology, philosophy and theology are placed face to face with an object of 'contemplation' thrice described by a word normally applied, not to nature, but to the storied human landscapes of points farther south: 'ruin'. The pose of the student of antiquity, in other words, is here borrowed as paradigmatic of all human questioning about time and its work(s), in and as the world. One can object that this is still the pose of Narcissus, bending forward (*pronus*) before his pond, as he is described by Ovid. But this is only to complain that all of our attempts to know the world are fundamentally narcissistic. What would be the alternative? We surely cannot claim to be disinterested. And in any case, though such scenes are framed as quests to know, they again and again place at their centre things that, deep down, we know we cannot fully know. Classics may now constitute itself as a science in the very form in which science is increasingly (and reductively) celebrated, i.e., as an engine of knowledge, and so of economies, etc. But Classics long ago lent its sister arts of knowledge the animating conviction of true science: build a better microscope (vel sim.), and it will finally reveal, not answers, but even deeper questions.

This volume, therefore, like the conference that has inspired it, poses questions about what the original call for papers described as 'the very pose by which the human present turns its attention to the distant human past', a phrase several times echoed in what follows.[22] Emblematically, that pose,

'sitting in a library, standing in a gallery, moving through a ruin' (another phrase from the call, invoked and supplemented by contributors), is directed towards time, as an obstacle to knowing that is forever on the verge of becoming itself the object of inquiry and contemplation. Time, to be sure, is hardly the only abyss into which the deep classicist stares, as will be clear in the chapters to come. But it is time, as already has been noted, that gives 'antiquity' its name. And that name should remind us that spatiotemporal 'tradition' is not just what happens to the past after the past, but an extension of the question of why the past, qua past, continues to compel our attention.

<p align="center">* * *</p>

A word or two on the specific origins and resulting shape of this volume. The name 'Deep Classics' first emerged, as not much more than a joking provocation, over lunch between the volume editor and his Bristol colleague, Pantelis Michelakis. Unexpectedly, the formulation proved to have legs, leading to a conference under that banner, with the generous sponsorship of the Institute of Greece, Rome and the Classical Tradition at the University of Bristol. With a couple of exceptions, preliminary versions of the essays collected here first saw light of day (or, at least, a cold, gray English sky, through the windows of the Orangery of Goldney Hall in Clifton) at that conference, held over two days in November 2014. If, however, 'the deep' provided this project's opening motif (to the extent that we soon adopted the expedient of abbreviating the rubric as DeepC, pronounced 'deep sea'), then, in our resulting writing, complex surfaces have so often emerged in relationship to the theme of depth that one must conclude that 'Surface Classics' would have been no less apt a moniker. In this volume's third chapter, Alex Purves puts under her lens – and more to the point, beneath her fingers – that titular metaphor of 'depth', finding compelling connections between what we are proposing here and what some other scholars have instead been calling 'surface reading'. A similar surface/depth counterpoint emerges with particular intensity in the chapters by Helen Slaney, Joshua Katz (who further asks us to consider the relationship between depth and height), Stephanie Ann Frampton and Davide Susanetti.

As our subtitle, 'Rethinking Classical Reception', makes plain, Deep Classics is intended foremost as an intervention in the field of Classical Reception Studies, especially as practised over the last few decades in the United Kingdom,

which has provided especially fertile terrain. Inevitably, we make that intervention against the backdrop of often polarizing debates about how reception studies should be conducted, emblematized by a celebrated exchange between Charles Martindale, largely responsible for putting 'reception', so called, on the intellectual map of Classics, and Simon Goldhill, who, among other contributions, has helped to train a brilliant generation of scholars of reception.[23] However, the reader expecting this volume to take sides or otherwise to resolve the dispute may be disappointed. To be sure, there will be in what follows no shortage of qualities rightly called 'aesthetic', the rubric increasingly embraced by Martindale, as well as a range of efforts to move beyond the term generally opposed thereto, 'historicism'. Nevertheless, moving beyond historicism – or rather, beyond certain kinds of well-ordered historicist chronologies – sometimes winds up taking us not away from history but, profitably, more deeply into it, especially in relation to historical subjects 'on the margins' of ordinary history, as contributions by Shane Butler, Sebastian Matzner and Sarah Nooter endeavour to show. (In a different vein, Giulia Sissa reveals how a modern word for a deep passion still embodies an ancient struggle.) In any case, the 'rethinking' here proposed is not so much a rethink – i.e., a forward-looking, programmatic manifesto along the lines of Martindale's groundbreaking *Redeeming the Text* – as it is a thinking-back-over, looking for things that students and scholars of antiquity have been doing perennially, though sometimes without noticing. Deep Classics, in other words, is not opposed to some putatively 'shallow' other; rather, it makes the claim that Classics is almost always 'deep', since, more or less constitutionally (we shall argue), it cannot easily be otherwise. Nor is our shift here from 'Classical Reception Studies' to 'Classics' *tout court* inadvertent, for like many others (including Goldhill and Martindale alike), we regard reception studies not as a detachable postscript to Classics but, rather, as a deep exploration – and, when needed, close interrogation – of our whole discipline's raison d'être. Among our contributors, in fact, are several who have been pursuing this perspective to powerful effect elsewhere, most notably Joshua Billings, whose recent exploration of the 'erotics' of reception has many resonances here,[24] and Brooke Holmes, whose piece for this volume is part of her broader investigation of the 'open field' of Classics and the kinds of world-making (or 'cosmopoiesis') that it invites,

an investigation that is itself part of a larger ongoing collaborative project called 'postclassicisms'.[25]

Some of the most surprising and exciting things to emerge from the shared but shifting 'deep sea' to which this volume's contributors have turned have been connections between Classics and other modes of inquiry. The latter include even more than the scientific disciplines briefly reviewed in this introduction and several times revisited in what is to come. For instance, the fact that meditating on antiquity has helped to model the search for self provides another important leitmotif – one that emerges with special urgency in Adam Lecznar's examination of Modernist self-expression. Laura Jansen instead explores connections to the virtuosic thought and writing of Jorge Luis Borges, who lends the end of the volume a moving *envoi*. Intriguingly, Classics' connections to the ghostly and otherwise nonhuman supernatural are the subjects of no fewer than three separate contributions, by Mark Payne, Edmund Richardson and Davide Susanetti. The last of these offers something of a scholarly call to action, as do other contributors, along various lines. Nevertheless, it will be up to our readers to decide whether this volume's studies collect, across their disparate subject matters, a set of practices worth (re)embracing, going forward, or, more retrospectively, a new, clarifying way to understand and value the creative and intellectual past to which Classics belongs. The two options, of course, are not mutually exclusive.

Presenters at the original conference had responded to its open call for papers and were selected on the basis of the independent merit of their proposals. No effort, then or now, has been made to offer representative coverage either of classical antiquity itself or of the longue durée of its tradition(s). Regarding the former, literary texts predominate, though Slaney's meditation, via the eighteenth century, on antiquity's material remains provides a profoundly evocative exception, and Frampton's exploration of real and imagined epigraphic texts that seem fully aware of their material existence offers something of a hybrid case. Greek topics outnumber Roman ones, not so much because Greece is older than Rome and therefore 'deeper' to think with as because Greece has been paradigmatically central to most (though not all) classicisms of the past three centuries. Those same centuries provide most of the moments of reception pondered here, in part because that period, as this introduction has already begun to reveal, saw fruitful contamination between

the humanistic contemplation of antiquity and the scientific contemplation of Deep Time. As a part-time scholar of the Renaissance himself, however, the editor has no doubt that the kinds of questions asked here about the 'pose' of the student of antiquity could be applied to earlier periods with profit; indeed, certain aspects of that pose have been important to Renaissance Studies for a while now.[26] In that regard, and others besides, we hope this volume provides not just the culmination of a conversation begun in Bristol, but a useful contribution towards an ever widening one, not just with classicists, but among all who look back in time, regardless of the particular species of the past to which they devote their deepest thought and care.

Notes

1 Manguel (2007: 3).

2 Martindale (1993: 3); Martindale (2013a).

3 Silk, Gildenhard and Barrow (2014).

4 Grafton, Most and Settis (2010: vii).

5 For example, by Bailey (1967).

6 Playfair and Ferguson (1997: 72–3).

7 Playfair and Ferguson (1997: 71).

8 Gould (1987: 3).

9 Schliemann (1875: xi), italics original. Among modifications to the diagram for its reuse in the sequel Schliemann (1881: vii) was this expansion: 'Native rock – Its present height above the sea is 109½ feet. Its present height above the plain at the foot of the hill is consequently 59½ feet, but it may probably have been 16 or 20 feet more at the time of the Trojan war, the plain having increased in height by the alluvia of the rivers and the detritus of vegetable and animal matter.'

10 Ritschl (1838: 26).

11 Darwin (1859: folding plate following 115).

12 Viewable at http://darwin-online.org.uk/content/frameset?viewtype=side&itemID =CUL-DAR121.-&pageseq=38

13 The matter receives the first footnote to Silk, Gildenhard and Barrow (2014: 3), pointing to an 1877 use by John Addington Symonds. More in Richardson (2013: 166–7), whose earlier doctoral dissertation is cited on the same point by Goldhill (2010: 58).

14 In terms of both meanings, it is tempting to find a buried link to the old concept of *translatio imperii et studii*, by which imperial Britain, e.g., was claimed as the legitimate heir to the classical culture and power.

15 Sigmund Freud, 'Civilization and its Discontents', in *The Standard Edition of the Complete Psychological Works of Sigmund Freud*, trans. James Strachey, vol. 21 (London, 1961), p. 70.

16 Byron, *Childe Harold's Pilgirimage* 4.110 in Byron (1854: 238).

17 Rutilius Namatianus, *De reditu suo* 61, *sospes* (emended from *hospes*) *nemo potest immemor esse tui*, perhaps meaning 'no one can be safe if forgetful of you'; the wording seems to play on the two possibilities.

18 'Le Cerveau noir de Piranèse', the essay that lends its title to the English translation of her collection *Sous bénéfice d'inventaire*: Yourcenar (1984).

19 Seneca, *Epistles* 1.2.

20 Byron, *Childe Harold's Pilgrimage* 4.81, in Byron (1854: 228).

21 Cooper (1709: 200–1).

22 A preliminary version of the announcement had only the first 'human', though the second was present in all subsequent versions. Joshua Katz was the first to notice the change. Just where – and whether – the human needs to be in this formulation now strikes me as a very worthwhile question (one tackled regarding nonhumans by Payne, this volume). Already in light of the disciplinary comparanda reviewed in this introduction, for example, the repeated word seems partly to insist on the distinctiveness of the humanities – a rather dubious claim to make precisely while contemplating 'the very pose' that scientists and humanists share!

23 Martindale (2010b); Goldhill (2010a).

24 Billings (2010).

25 On 'postclassicisms', developed by Holmes with Constanze Güthenke, see www.postclassicisms.org.

26 This has been true at least since Barkan (1999). On the sometimes spectacular resistance of Renaissance objects to ordinary temporality, see Nagel and Wood (2010).

1

Homer's Deep[*]

Shane Butler

*When we speak of "the wine-dark sea," we think of Homer and of the thirty
centuries that lie between us and him.*

Borges, 'The Riddle of Poetry'[1]

Achilles, on the beach, stares out at a word. What does he see, in the sea? This
turns out to be hard to say. His eyes choked with tears, perhaps he does not
really 'see' anything at all, like the blind poet who has put him there. Of course,
Homer himself may never have been seen except in the mind's eye of those
who, in some distant age, felt moved to invent him, as the author of poems that,
for them, were already ancient. Nevertheless, someone was there as the *Iliad*
came into being, however long that took, and he or she or they must have
found a soul mate in the passionate hero who is as much a lover of words as he
is of deeds. For after storming away from the Greek camp in disgust, Achilles
has whiled away much of the poem on this very beach, 'gladdening his heart'[2]
by singing and strumming the lyre he learned to play, as a boy, from a centaur.
There is no gladness now, but if, in the grief-stricken silence that he is about to
break, he could hear the poet who has crafted him, or the readers who still
conjure him, we can be sure that his musical ear would know that what he is
made to look at is not just a sight, but a sound. It is, in fact, a familiar sound, as

[*] Though not read at the Deep Classics conference, this paper was circulated beforehand to
participants. Oral versions have been presented in Cambridge, Leiden and Bristol (twice: once as
the author's inaugural address in the Chair of Latin and again as a plenary address at the annual
meeting of the Classical Association). The author would like to thank his hosts and audience on
each of these occasions.

familiar as the waves that strike the shore, a phrase repeated over and over in
the *Iliad*, and again in the *Odyssey*, always at the end of the line, crashing into
the margin (before our eyes recede towards the start of the next verse), forever
churning away at the same vowels and consonants: *oinopa ponton, oinopa
ponton, oinopa ponton.*

'And sore troubled spake he, looking forth across *the wine-dark sea*'
(ὀχθήσας δ' ἄρα εἶπεν ἰδὼν ἐπὶ οἴνοπα πόντον).³ As his lips part, however, all
that Achilles can really see and hear is the one thing he can no longer see or
hear – except in haunting dreams, where, to his despair, the more important
sense of touch has eluded him. For all his thoughts are on Patroclus, whose
lifeless body still awaits reluctant flames nearby. And it is of Patroclus that,
upon the dying syllables of the narrator's *oinopa ponton*, Achilles himself is
about to speak. Or rather, of Patroclus he is about to sing, for all of Homer's
poem was originally meant for the music we now mostly hear only in the
dactyls and spondees of its meter, long short short, long long, *oinopa ponton*,
the same metrical pattern out of which Beethoven crafts the entire second
movement of his haunting seventh symphony. The meaning of this sweetly
sonorous phrase, however, confronts us with a puzzle. There is nothing
mysterious about the second word, the accusative case of *pontos*, 'sea'. It is
instead the first that gives us pause. What does *oinopa* mean? In ancient word
lists and modern dictionaries of Ancient Greek, we find it under *oinops*, though
such a form appears nowhere else, for it is now and probably was then no more
than a reconstruction of the nominative form of a word that Homer never uses
in that case, a reconstruction that partly depends on the word's evident
derivation from *oinos*, 'wine', and *ops*, a root designating vision that, as a
standalone word, can mean 'face'. What presumably is the same word also
appears as a proper name, not only in Homer but in tablets written in Linear B,
meaning that it is as old as the oldest known form of Greek, spoken centuries
before Homer – indeed, at the notional time of the Trojan War itself.⁴ In other
words, *oinops* fell out of common use after stable shape was given to the
Homeric epics, which thus preserved a word destined for extinction while the
living language continued to evolve.

Regarding this spectacular fossil, far more ancient than what we normally
mean when we say 'Ancient Greek', the dictionary offers 'wine-dark' as the
'conventional' English equivalent,⁵ though the hyphenated adjective is no older

than 1882, when it first appeared in the English translation of the *Iliad* quoted above. The rendering has been remarkably influential, so much so that 'wine-dark' may well now be the most famous 'word' in Homeric English. Nevertheless, the trio of translators who coined it, two Englishmen and a Scot, were used to vistas very different from those of the eastern Mediterranean, and their solution can hardly be said to have settled the matter. Long before them, and still today, the fraught question of how the sea, to Greek eyes, might have looked like wine has exercised the imaginations of philologists, poets, and even a prime minister, William Gladstone.[6] These have sought to explain the word in terms of hue (possibly under a crimson sunset), saturation (a sea as blue as wine is red), or surface (the froth and foam of fermenting wine, or else, as Ezra Pound stops to suggest in a couple of *Cantos*, the 'gloss' of wine in the cup[7]) – or perhaps even as evidence that the Ancient Greeks had not yet evolved a capacity to see colors. (This last theory was the prime minister's.) Recent investigations of Greek color words observe instead that they often function in complex networks of synesthetic reference; accordingly it has been suggested that *oinops* does not mean that the sea looks like wine but, rather, that looking at the sea, alluring but dangerous, is like tasting wine and drinking deeply.[8] One can expand this suggestion by noting that, whatever the actual etymology of *oinops*, a Greek listener would also have heard in its last letters, *ops*, not just a word for 'face' but a homonym meaning 'voice' and might therefore have brought to mind the inebriating *sounds* of the sea.[9] But just when this seems to make good sense of things, we face a vexing complication: Homer uses the same adjective of cattle, looking at or listening to which can perhaps be soothing – but intoxicating? How now, wine-dark cow? And so we are back more or less where we started, really none the wiser. What is *oinops*? It is what Homer calls the sea. And it is not entirely impossible that not even he or his singers, for whom *oinopa ponton* may well have been an inherited formula, i.e., a ready-made building block for epic songs, could have told us clearly and consistently what its thoroughly ancient adjective meant. Want to know exactly what Achilles saw? You would have to ask Achilles. And as Odysseus learns when he interrogates the hero's shade in the *Iliad*'s sequel, all Achilles is likely to tell us is that to survey eternally, even as a king, the vast, dark realm of the dead is something he would gladly trade for the chance to look once more upon the land of the living:

> Though absent long,
> These forms of beauty have not been to me,
> As is a landscape to a blind man's eye . . .

What he never again will see, we ourselves still struggle to remember. Short-sighted readers of a blind poet, dwarves who stand not so much on the shoulders of giant Achilles as in his shadow, we seem condemned to remain forever in the dark, because we never have been anywhere else.

There is, however, another way to look at things. The indecipherability of *oinopa ponton* may indeed seem a serious defect to the literally minded. But let us consider the point of view of a more sensitive reader, perhaps one romantic (and Romantic) enough to recognize that the lines I have just foisted on Achilles come not from Homer, but from Wordsworth, from a poem in which a ruin embodies the enduring truth of time itself.[10] In the eyes of such a reader, the lexical mystery about what face of the sea confronts Achilles and his unspeakable grief cannot but perfect the scene, like a veil thrown over a mirror as Jewish mourners sit shiva, or better, like the one with which the ancient painter Timanthes concealed the unrepresentable face of Agamemnon at the sacrifice of his daughter Iphigenia, demanded before the Greeks could launch the thousand ships that brought them to the Trojan shore.[11] Such a reader stands not in Achilles' shadow, but side-by-side with him, staring at what neither can really fathom. In fact, Achilles and his reader have been here before, in book 1, after Agamemnon has taken from him the slave-girl Briseis, prompting the 'wrath' that already has provided the poem's very first word. Then too Achilles turns his eyes towards the *oinopa ponton*.[12] Or so one usually reads, though the ancient Alexandrian critic Aristarchus, followed on this point by a few modern editors, thought that the first word there should be the accusative of *apeiron*, allowing Achilles to stare out at a sea as 'boundless' as his fury.[13] The substitution is a prosaic one, but it has the merit of suggesting that *oinopa* occupies the very space of infinitude itself, as if Aristarchus were seeking to literalize the way in which the word had perhaps already begun to resist 'definition'. In other words, *oinops* would come not merely to name that which cannot be defined (like *apeiron*) but actually to enact the condition of indefinability, as a kind of mimetic super-signifier of what defies words, a name for the unnamable. And it is precisely as a ruin, like the 'steep and lofty cliffs' of Wordsworth's Tintern Abbey, that it is able to do so, at least for the

Romantic reader, reconnecting human forms and words to a seemingly limitless world. One can explain the basic mechanism here simply as the opening up of the text to the reader's imagination; alternatively, we can here diagnose an illusion of conscious contact with what Lacan calls the real, that fantastical realm before and beyond language from which each of us already had been banished by the time we learned to speak – which we might find suggestively echoed, in our opening example, by the fact that Achilles is on the verge of words, and facing the watery habitat of his mother, the sea-goddess Thetis. But however explained, what remains key is the fact that this mechanism has been set in motion not so much by the hand of the poet as by the poetic hand of time itself, synchronizing a horizon of knowledge in the text (the limitless grief of Achilles, which not even he can fully grasp) with the reader's horizon of knowledge of the text (beyond which lies any sure definition of *oinops*): the reader's struggle to make sense of things aligns with that of the hero.

Thus, for such readers, has Homer's 'wine-dark' improved with age, growing more complex, striking notes not easy to put into words. But there is more to be had from time's work on Homer than the deepening pleasures of his metaphors. The invitation to gaze with Achilles, through a glass, darkly, upon an enigmatic sea, attractive though it has been, has paled beside the prospect of peering directly into his heart – and, more pruriently, into the tent he shared with Patroclus. While he stares at the deep, Achilles sheers the hair he had sworn not to cut until he brought Patroclus safely home; into the latter's lifeless hand he will press a lock of this.[14] Instructed by Patroclus's ghost in a dream, Achilles asks the faithful Myrmidons, when his time too comes, to bury them both in a single tomb, their ashes mixed in a single urn, a request that tragically reprises and reverses his startling prayer, earlier in the poem, that only he and Patroclus, of all the Greeks and Trojans alike, might survive the war.[15] Such spectacular expressions of love are difficult to match anywhere in literature. Nevertheless, for skeptical readers, the question of whether the two were lovers in a sexual sense often hinges on a single sentence, delivered *en passant* in the speech with which Thetis appears to her son to urge him to set aside his grief and move on:

τέκνον ἐμόν, τέο μέχρις ὀδυρόμενος καὶ ἀχεύων
σὴν ἔδεαι κραδίην, μεμνημένος οὔτε τι σίτου

οὔτ' εὐνῆς; ἀγαθὸν δὲ γυναικί περ ἐν φιλότητι
μισγεσθ'· οὐ γάρ μοι δηρὸν βέῃ, ἀλλά τοι ἤδη
ἄγχι παρέστηκεν θάνατος καὶ μοῖρα κραταιή.

My child, how long will you devour your heart with weeping and sorrowing,
and take no thought of food or of the bed? *Good is it for you even to sleep
with a woman in love.* For, I tell you, you will not yourself be long in life, but
even now does death stand hard by you and resistless fate.[16]

The ever meddlesome Aristarchus, convinced that Achilles and Patroclus were
not lovers, marked the lines containing these words of sexual advice as an
interpolation, i.e., as a late addition to the text that should be ignored. Much
more recently, classicist Marco Fantuzzi, in what aims to be a definitive study
of the subject, accepts the lines but insists that the proper reading of the particle
per (here translated as 'even') sets up a contrast between sex with women and
moping, not sex with women and sex with Patroclus.[17] In fact, Fantuzzi argues,
there is no evidence anywhere in the poem that the latter was ever what Homer
had in mind:

[A]n objective reading of the *Iliad* offers no explicit evidence that Achilles
and Patroclus were bound by an erotic bond, or were anything more than
exemplary good friends ...

Instead of forcing Homer's Achilles and Patroclus to wear the strait-jacket of
the classical idea of pederastic love, we might rather consider the *Iliad* not so
much an implicit beginning of the pederastic narrative, but rather take it as
the final attestation of the traditional epic motif of intense male 'comradeship'
that is found in at least two Middle Eastern poems whose latest versions
precede or are contemporary with the (likely) time of the *Iliad*'s written
fixation[: t]he Assyrian epic *Gilgamesh* and the later Books of Samuel in the
Old Testament ... [I]nnuendo, in these two poems as well as in the *Iliad*,
seems to concern more the reader-response than the explicit intentions of
the texts. And in any case the common intention of the texts, in all of the
three poems, seems to refrain from adopting clear-cut labels/definitions that
unequivocally point to homoerotic overtones ...

[Homer] could not care less ... about defining Achilles' erotic sentiments ...[18]

Striking is the way in which Fantuzzi's language of binding and limiting
('bound by an erotic bond', 'the strait-jacket of the classical idea of pederastic

love') shades into that of defining ('clear-cut labels/definitions', 'defining Achilles' erotic sentiments'). For one could argue that it is Fantuzzi who is imposing the 'strait-jacket' here, by the very act of looking for 'labels' as 'explicit' as those of 'classical' pederasty, viz., *erastēs* and *erōmenos* ('lover' and 'beloved'), terms which differentiated a couple in terms of sexual roles (on which more below), captioning an implied (but unambiguous) scene of sexual penetration. Fantuzzi does not expect to find these particular terms, because he believes that their use in this way, or at least 'the classical idea of pederastic love', is post-Homeric. But here his argument hits an unacknowledged impasse, for he does not (and cannot) tell us how Homer *could* have made a pre-pederastic male-male 'erotic bond' visible.[19] Outside the language and logic of pederasty and the condemnatory 'labels' of later morality and law, the kind of easy clarity Fantuzzi insists upon simply did not exist until the nineteenth and twentieth centuries; otherwise, 'explicit evidence' of such a 'bond' has generally taken the form of explicit references to sexual acts. It is true that Homer provides not even a glimpse of such a sex scene, but it is not entirely clear how much this should surprise us. Already in antiquity, the Athenian orator Aeschines argued that, for an educated audience, such explicitness would have been vulgar and, more to the point, superfluous.[20]

We shall turn in a moment to post-Homeric writers who instead did not hesitate to conjure Achilles and Patroclus explicitly in the act, but let us first take a step back. 'Every attempt at unveiling the supposedly untold in Homer ... stands on shaky ground', warns Fantuzzi.[21] Quietly underlying his whole argument is a basic assumption that Homer always means what he says and says what he means, a trait Erich Auerbach had already attributed to the Homeric heroes themselves, actors in a poem in which he famously (if controversially) found only surface, no depth.[22] What happens, however, if we instead imagine what Fantuzzi calls 'shaky ground' to be that of the Trojan plain itself? In other words, let us suppose for a moment that the Greeks who fought alongside Achilles and Patroclus, including even the faithful Myrmidons, did not fully know what their relationship was. Indeed, suppose that Achilles and Patroclus were not themselves entirely sure. To be clear, I am not suggesting that we imagine an impossibly anachronistic ambivalence about sexual 'identity', nor certainly a crisis about a 'Love that dare not speak its name' (though it seems worth noting that Fantuzzi never even entertains the

possibility that there could have been constraints on what Homer and his singers were *allowed* to say). Rather, I am suggesting something far more basic, namely, that *our* inability to 'define' the love between Achilles and Patroclus, whether or not Homer himself was indifferent to the task of doing so, is part of what makes that love believable *as* love. For if one were to draw only a single lesson from the long history of love, especially the literary history of love, including but not limited to same-sex love, it would surely be about love's Houdini-like ability to escape 'labels', to say nothing of 'strait-jackets'. Were Achilles and Patroclus friends, or battlefield comrades, or lovers? When it comes to true love, the best answer is always 'yes'. Forget the 'intention' that Fantuzzi remarkably claims to know not only for Homer but for the authors of *Gilgamesh* and the Books of Samuel.[23] Or rather, suppose that he is right, since, heaven (alone) knows, he may well be. In that case, time has given us the true-love stories that a single age perhaps could not: that is to say, stories of that kind of love that leaves questions about labels to those lovers of words who are really only lovers of dictionaries.

Before I am accused of being apolitical about love – or worse, merely sentimental – let us turn to the mirror image of the skeptical tradition to which Aristarchus and Fantuzzi belong. The alternative and, perhaps, more prevalent reading never stops to doubt that Achilles and Patroclus were lovers, but it has worried endlessly about who did what to whom. This, in the ordinary conventions of Greek pederasty, would have depended on their ages, which functioned both relatively (the penetrating partner, or *erastēs*, had to be older than the other) and absolutely (the younger one, or *erōmenos*, could not have reached the age at which bristly hair had begun to grow on his face and body), a distinction in roles that corresponded, in theory, to a radical distinction in sentiment that assigned sexual desire solely to the former. So established was this hierarchy that an author who indicates which member of a pair was older or had a beard is already telling us all we need to know. Sometimes, to be sure, we are told more: in a tiny fragment from Aeschylus' lost tragedy *Myrmidons*, Achilles in mourning recalls the pleasures of Patroclus' 'thighs'.[24] More irreverently, the Roman poet Martial reports that 'no matter how often Briseis flipped for him in bed, closer to Achilles was his smooth-skinned friend'.[25] And from the Renaissance, the notoriously pornographic *Hermaphroditus* of the Sicilian poet Antonio Beccadelli includes a poem in which Achilles delights

the ghost of his dead teacher, the centaur Chiron, by giving Patroclus a good pounding atop his tomb.[26] Plato, however, in the *Symposium*, has Phaedrus complain that Aeschylus gets everything backwards:

> Aeschylus talks nonsense when he says that Achilles was the the *erastēs* of Patroclus, since Achilles was more beautiful not only than Patroclus but than all the heroes, and was still beardless, being much younger than the other, as Homer says.[27]

Other writers too weigh in on this or that side of the controversy, but I have chosen these particular examples because they are those reviewed in a remarkable chapter of a landmark work of classical scholarship: Angelo Poliziano's *Miscellanea*, first published in Florence in 1489.[28] For good measure, Poliziano throws in a unique example of a compromise view, reporting that the Roman poet Statius, in his unfinished epic, the *Achilleid*, makes Achilles and Patroclus 'equals in age', though Poliziano curiously (and uncharacteristically) misparaphrases the relevant lines (which he then quotes), in which we are told that the two, as boys, simply acted the same age, though the latter 'fell far behind in strength'.[29] More curious still is the way in which Poliziano ends the chapter. Having first quoted at length from the relevant passage in the *Symposium*, including its appeal to the authority of Homer himself, he concludes with this:

> If anyone requires directions to Homer's own words (for Plato obviously does not provide these), one may read in the eleventh book of the *Iliad*, where Nestor is speaking, with what instructions Menoetius, father of Patroclus, sent his son off to war.

No one who knows Poliziano and the meticulous research that allowed his *Miscellanea* to offer lavish evidence not only of his erudition but of his access to the rich holdings of the library of his patron, Lorenzo de' Medici, can attribute his failure to quote the Homeric passage either to laziness or to the lack of a copy ready to hand. Nor can we suppose that Poliziano, who as a boy had begun a celebrated but unfinished translation of the *Iliad*, had any doubts about the meaning of Homer's Greek. Rather, his refusal reads like a deliberate tease, a final veil beneath which lies who knows what, though the eager reader who races to Homer finds nothing more titillating than confirmation that Patroclus was, in fact, older.[30] But perhaps we can say more. By not giving us (or really even paraphrasing) the actual words of Homer, the only author who

might, for some readers, have the authority to settle the question once and for all, Poliziano avoids a climax both scholarly and sexual, allowing his essay to capture and perpetuate, not a moment of philological resolution, but the moment that precedes that resolution. And I think we can go farther still. The erotic tradition that Poliziano is the first modern author to review (indeed, his essay is arguably the first work of modern scholarship on ancient same-sex love) can itself be said to embody the very quality that, strictly speaking, pederastic hierarchies made impossible: namely, in modern sexual parlance, 'versatility'. By following this source, or that one, or this one and then that one, we make the lovers change roles. And by avoiding the definitive intervention of Homeric authority, which Poliziano suggestively represents as a set of paternal 'instructions', we allow ourselves to go on playing this game endlessly.

This turns out to be a game with extraordinary stakes. In 1883, 400 years after Poliziano's *Miscellanea*, the Victorian writer and scholar John Addington Symonds privately printed, in a limited edition of just ten copies, an extended essay titled *A Problem in Greek Ethics* (henceforth referred to as *Greek Ethics*), which he apparently had drafted a decade earlier. A sequel, *A Problem in Modern Ethics*, followed in 1891 and included what seems to be the first occurrence in printed English of the word 'homosexual', earlier coined in German, whence it was imported by Symonds and others.[31] *Greek Ethics* was included in Havelock Ellis's *Sexual Inversion* (on the planning of which the two had collaborated closely before Symonds's death in 1893), which first appeared in German in 1896 (where the essay forms the book's third chapter) and in English the following year (where it instead appears as an appendix). The first English edition of *Sexual Inversion* was quickly suppressed, and its second edition eliminated Symonds's name; frequent reprintings, however, both as part of *Sexual Inversion* and on its own, with Symonds's name restored, in editions that often falsely claim to be limited, attest to its continuing influence. While originally composing *Greek Ethics*, Symonds had also completed cycles of lectures on Greek poetry and drama, assembled, along with other essays first published in periodicals, as *Studies in the Greek Poets* (henceforth cited as *Greek Poets*), which first appeared in two separate 'series', in 1873 and 1876. Accordingly, the reconstruction of Greek pederasty offered in *Greek Ethics* ranges widely over literary evidence that Symonds knew well. (Symonds also was well acquainted with the life and works of Poliziano, on whose own

sexuality he offers cryptic commentary in his seven-volume *Renaissance in Italy*, the work for which he was best known.[32]) Nevertheless, both *Greek Ethics* and *Greek Poets* devote particular attention to Achilles and Patroclus. Remarkably, Symonds's position in *Greek Ethics* is almost identical to that of Fantuzzi (who, by the way, seems unaware of his predecessor): namely, he argues that the Homeric poems pre-date the emergence of Greek pederasty, and the relationship between Achilles and Patroclus in the *Iliad* is best understood as a kind of battlefield friendship, which Symonds assimilates to the much later traditions of medieval chivalry. In part, such a reading serves the apologetic project that, for better or for worse, Symonds has in common with other gay writers of his period, i.e., he seeks at least partly to decouple the history of homosexuality, including post-Homeric pederasty, as well as (re)-nascent 'homosexual' identity, from the history of sex. He thus observes 'two separate forms of masculine passion clearly marked in early Hellas – a noble and a base, a spiritual and a sensual'.[33] But although the former form, which he also calls 'heroic' (as opposed to 'vulgar'),[34] is exemplified by pre-pederastic Achilles and Patroclus, their Homeric example ultimately serves to set up a contrast and synthesis internal to pederasty itself:

> The immediate subject of the ensuing inquiry will therefore be that mixed form of παιδεραστία [*paiderastia*] upon which the Greeks prided themselves, which had for its heroic ideal the friendship of Achilles and Patroclus, but which in historic times exhibited a sensuality unknown to Homer. In treating of this unique product of their civilisation I shall use the term *Greek Love*, understanding thereby a passionate and enthusiastic attachment subsisting between man and youth, recognised by society and protected by opinion, which, though it was not free from sensuality, did not degenerate into licentiousness.[35]

Symonds might seem here simply to be having his cake and, sanctimoniously, eating it too, desexualizing Achilles and Patroclus but having them very much on the minds, albeit as an 'ideal', of later embracers of 'Greek Love', whose 'sensuality' he quietly recharacterizes as accommodating rather than opposing the 'spiritual'. But he is aiming for something more besides, which paradoxically is clearer in the generally more guarded language of *Greek Poets*:

> Plato, discussing the *Myrmidones* of Aeschylus, remarks in the *Symposium* that the tragic poet was wrong to make Achilles the lover of Patroclus, seeing

that Patroclus was the elder of the two, and that Achilles was the youngest and most beautiful of all the Greeks. The fact, however, is that Homer himself raises no question in our minds about the relations of lover and beloved. Achilles and Patroclus are comrades. Their friendship is equal. It was only the reflective activity of the Greek mind, working upon the Homeric legend by the light of subsequent custom, which introduced these distinctions. The humanity of Homer was purer, larger, and more sane than that of his posterity among the Hellenes.[36]

The operative contrast here only seems to be that between love and friendship. Ever since Walt Whitman, with whom Symonds corresponded and to whom he would eventually dedicate a book-length study, had sung of the 'love of comrades', this last word had emerged as a kind of proto-gay code for something more than friends. (Indeed, 'comrade' is the ordinary word for 'lover' in the secret autobiography first published nearly a century after Symonds's death.) The real contrast lies instead in 'equal'. It has become easy for us to forget how astonishing it would have been, throughout most of Western history, to suggest that lovers of any gender were 'equals'. To be clear, Symonds does not mean that Achilles and Patroclus were of equal age. Indeed, for Symonds as for Whitman and others (including Oscar Wilde, to whom we shall turn in a moment), the relationship between an older man and a younger one had always been and was expected to remain paradigmatic of same-sex love. What Symonds does instead mean is that a difference in age, as well as any distinction in sexual roles hinted at thereby (a matter he leaves unclarified, regarding modernity), need not imply a difference in status or sentiment. And this is why Symonds's pursuit of an 'ethical' defense of same-sex love, though it partly excludes Homer from the key precedent of 'Greek Love', so pointedly continues to require the ancient bard's 'humanity'. Out of an alleged Homeric 'equality' of Achilles and Patroclus, Symonds crafts nothing less than what he sees as the defining feature of any future (or at least ideal) 'homosexual' existence.[37] Sexually speaking, even if he never says so in as many words, Symonds is postulating what had continued to elude thematics of Western desire, ancient and modern, homosexual and heterosexual: namely, non-hierarchical sexual 'positions'.

Under the ordinary principles by which the reception of classical antiquity has come to be studied, our investigation of Symonds has reached its 'aha!' moment: a thoroughly modern impulse has just been detected making of

antiquity what it wills. Indeed, this particular kind of (ab)use of the classical past has been well known to us at least since David Halperin's *One Hundred Years of Homosexuality, and Other Essays on Greek Love*, which argues that the proper study of Greek sexuality must begin by rejecting much of its nineteenth- and twentieth-century reception and recognizing that modern homosexuality and ancient pederasty are, fundamentally, false friends: historically speaking, they have nothing to do with one another. Indeed, in a still broader sense, no word in Symonds's formulation is more redolent of its historical context than 'equal'. Consider, just for starters, Britain's attempts to disentangle itself from the slave trade that had helped to build the eighteenth-century splendor of Symonds's boyhood surroundings in Clifton, or the Civil War battlefields where Whitman had worked as a nurse – and the trumpeting by both men of a kind of sentimental 'democracy'. Compare too the class-crossing desires and activism of another gay Victorian, the socialist Edward Carpenter, who knew Symonds and Whitman both.[38] One could accordingly argue that 'homosexual' emancipation could not have emerged in such a context without renouncing, or at least problematizing, inequality between 'comrades'. Alternatively, and complementarily, one can follow the lead of Jana Funke in attributing the growing attachment of Symonds and others to 'the equality model of male homosexuality' to the specific pressures of homophobic rhetoric and legislation, increasingly preoccupied with the corruption of youth, including in Britain's philhellenic schools and universities.[39] By the time of a late essay published in the year of his death, Funke observes, Symonds was driven to declare, 'Platonic love, in the true sense of that phrase, was the affection of a man for a man.'[40] One way or another, reception studies in its historicist mode would tend to conclude that Symonds found, in the enigma of a distant Homeric 'friendship', a relatively blank slate on which to inscribe a modern value that his ethical project needed in order to correct the (false) precedent of conspicuously unequal *paiderastia*.

But does this really settle things? Where, for example, does the localization of this 'equality' to the nineteenth century leave its partial anticipation, no fewer than four centuries earlier, by Poliziano, seemingly willfully misreading Statius in order to claim an 'equal age' (*par aetas*) for Achilles and Patroclus? What about the endless alternation of their sexual positions over the course of, even if not in single moments of, their long contribution to erotic literature?

And to turn finally to a Homeric question we have yet to consider, what of the interchangeability that has set in motion the very tragedy that sends Achilles to the Trojan shore to grieve? For Patroclus dies because he dons his comrade's armour and leads the Myrmidons into battle in his stead, reaching even the walls of the city, at first mistaken by the Trojans for Achilles himself. At the hands of Hector, with the help of the gods, this equivalence is finally made to fail, but not for any want of trying on the part of Patroclus. So too would Achilles seek to match the other in death. In a very real way, these two have been struggling to be 'equal', in a variety of senses, from the beginning; that they would continue to do so after the tradition explicitly makes them lovers comes, in this light, as no surprise. One could of course insist (as, indeed, does Fantuzzi) that their original mirroring confirms that Homer, at least, saw the two fundamentally as friends, in the very sense of friendship later theorized by Aristotle in the *Nicomachean Ethics*, where true friends function as one another's 'other self', a reciprocity the philosopher pointedly denies to pederastic lover and beloved.[41] But this only deepens our wonder that, among others, Aristotle's teacher Plato, from whom he largely borrows this formulation of friendship, was so ready to see lovers precisely in such exemplary friends.[42] In other words, Fantuzzi's anxious efforts to work out when Achilles and Patroclus began having sex misses the far more important question of when they began, as the phrase goes, to fall in love *with one another*. When we consider all the evidence, can we really suppose that this reciprocal love affair only begins in the egalitarian imagination of a lovelorn Victorian? How, in other words, should we describe the temporality of a process in which the past, even if in retrospect, seems so pointedly to anticipate the future? Are simple past tenses enough to capture what, deep down, we really believe is happening here?

Symonds died in 1893, two years before Oscar Wilde was tried and convicted for 'the Love that dare not speak its name'. Asked by the prosecutor to explain that phrase, which had concluded 'Two Loves', a poem by Wilde's lover Alfred Douglas published the year before, Wilde replied,

> The 'Love that dare not speak its name' in this century is such a great affection of an elder for a younger man as there was between David and Jonathan, such as Plato made the very basis of his philosophy, and such as you find in the sonnets of Michelangelo and Shakespeare.... It is in this

century misunderstood, so much misunderstood that it may be described as the 'Love that dare not speak its name,' and on account of it I am placed where I am now.[43]

At the heart of this reply, often quoted but not always fully understood, there seems to lie a typically Wildean paradox: he laments the censorship, now but not always before, of a word that actually never existed. For Wilde does not mean 'pederasty', nor certainly 'sodomy', 'buggery', or 'unnatural vice' (the terms used against him), nor any of his century's attempts at new terms and typologies, including 'inversion', 'Uranianism' and, thanks in part to Symonds, whose treatise Wilde had almost certainly read, 'homosexuality'.[44] The only serious candidate for the suppressed name lies instead in Douglas's own riddling poem, in which the 'Two Loves' of the title are rival personifications, the second of which is asked his name by the narrator:

'... I pray thee speak me sooth
What is thy name' He said, 'My name is Love.'
Then straight the first did turn himself to me
And cried, 'He lieth, for his name is Shame,
But I am Love, and I was wont to be
Alone in this fair garden, till he came
Unasked by night; I am true Love, I fill
The hearts of boy and girl with mutual flame.'
Then sighing, said the other, 'Have thy will.
I am the Love that dare not speak its name.'[45]

Strictly speaking, therefore, 'the Love that dare not speak its name' is simply a love not permitted to use the name 'Love', though it has no *other* proper name. Hindsight has connected the phrase, and Wilde's courageous self-defence, forward to countless acts of coming out, which usually have taken precisely the form of naming oneself and one's love in ways unknown before the nineteenth century: 'I am (a) homosexual,' etc. But for Douglas and Wilde, the more pressing task was instead that of demonstrating that love was able to exist even when, 'in this century', it went unnamed *as such*. Hence Wilde's examples, which offer not merely precedents of same-sex love but precedents for calling such love 'love': e.g., 'And it came to pass, when he had made an end of speaking unto Saul, that the soul of Jonathan was knit with the soul of David, and Jonathan loved him as his own soul.'[46]

Descriptions of the love of David and Jonathan (to whom Symonds would dedicate a poem) pervade the just-quoted Books of Samuel, which along with *Gilgamesh*, my reader may recall, are compared to the *Iliad* by Fantuzzi, arguing that the proper name for all these loves is 'comradeship', apparently unaware that he thereby reprises the erotic code of Whitman and Symonds. 'And in any case,' he proceeds, 'the common intention of the texts, in all of the three poems [*sic*], seems to refrain from adopting clear-cut labels/definitions that unequivocally point to homoerotic overtones . . .' Let us reply, with Douglas's Love, 'Have thy will'. Where Fantuzzi goes wrong is his assumption that those who have read heroic 'comradeship' as love have merely been inventing 'innuendo' in which they could then falsely find (g)ratification of sexual desire. Wilde pursues instead something rather different. His prosecution gleefully sought his degradation, entering into evidence, *inter alia*, reports that sheets from a hotel bed he had shared with a young man were stained with faecal matter, which Wilde was forced to attribute to diarrhoea.[47] Against the luridness of this close scrutiny, Wilde offers an expansive redefinition of the illicit desire of which he is accused. To be sure, his eclipsing of sex is again part of the apologetic project to which he, like Symonds, was constrained – here under the particular duress of an ordeal that would soon lead to his imprisonment, financial ruin and death. But this should not distract us from the fact that his central point is not so much that famous friends had been lovers as it is that lovers could be famous friends, i.e., that his relationship to Douglas could not be reduced to a question of sexual acts any more than David and Jonathan's could. In like fashion, Symonds hardly went looking for sexual 'innuendo' in the *Iliad*. That Achilles and Patroclus could be read as lovers had amply and explicitly been demonstrated by the post-Homeric tradition. Symonds instead embraces Homer's difference from that later tradition. And that is because he recognizes that the thing he is looking for, to which he gives no name clearer than the 'problem' of his title, has only ever been expressed as, in essence, an idea networked across time. In other words, this idea is neither the source of the Achilles/Patroclus tradition nor some intermediate or end product that can be distinguished from that beginning. It resides instead in the totality of the tradition itself, of which it is insufficient to say that Symonds provides a summation or synthesis. Rather, that tradition remained for him a place-holder for expression still not fully possible – indeed, for expression of something

that, as his long suppressed *Memoirs* repeatedly reveal, he himself was not entirely sure could exist in the real world.

As a result, Symonds's Achilles turns out to be a remarkably elusive figure, at once nowhere and everywhere. Indeed, Symonds first finds him for us not in Homer but in Dante, subject of his debut monograph, first published in 1872. 'Of all Dante's portraits,' he writes, 'those were perhaps the most admirable which are briefly sketched with the force of Velasquez, with the *sprezzatura* of Tintoretto, every line and deeply indented shadow telling.'[48] Jason of the Argonauts is the first example given, but then,

> Behold Achilles, with a commentary on the *Iliad* in a single line:
>
> > Il grande Achille
> > Che per amore al fine combatteo.

Four years later Symonds would repeat the quotation (dropping 'il grande', 'the great', and providing a translation) in his chapter on Achilles, which first appeared in the second volume of the first edition of *Greek Poets*:

> When Dante, in the *Inferno*, wished to describe Achilles, he wrote, with characteristic brevity:
>
> > Achille
> > Che per amore al fine combatteo.
> >
> > Achilles
> > Who at the last was brought to fight by love.
>
> In this pregnant sentence Dante sounded the whole depth of the *Iliad*.[49]

The reader used to Auerbach's thesis that Homer's characters lack unexpressed depth is astonished to hear the claim that they are instead depicted with 'deeply indented shadow' and that the poem itself has not just depths, but *a* depth – indeed, a 'whole depth'. That this depth can be 'sounded' suggests, moreover, that it is as deep as the wine-dark sea itself, though even more vertiginous thoughts of what lies below our terrestrial feet come from the fact that it is Dante, in Hell, doing the sounding. Most affecting of all is the depth of time framing this reportedly deep insight: centuries separate Symonds and us from Dante; millennia, Dante from Homer. What, however, is all of this insistent depth *doing*? That Homeric depth is introduced as a 'telling shadow' might

seem to make it the sign precisely of deep secrets; so too is its comparison to Castiglione's *sprezzatura*, the concealment of a practiced Renaissance courtier's private thoughts through an affectation of easy 'nonchalance', about which Symonds remarks in his *Memoirs*, 'What the Italians call *sprezzatura* sustained me.'[50] But as we have seen, Symonds himself denies that there are any secrets buried in Homer. Indeed, for Symonds, Achilles' love is there in the *Iliad*'s first word, *mēnis*, which he translates not as 'wrath' but, dubiously, as 'ardent energy', allowing it to embrace both the positive and the negative sides of 'the Passion of Achilles', which comprises the 'whole subject' of the poem, 'first as anger against Agamemnon, and afterwards as love for the lost Patroclus'.[51] We are left finally to conclude that what Dante sounds is simply a depth of feeling: love hardly lies buried deep in Achilles' heart, out of view; it is rather the case that he is deeply – and obviously – in love. In context, however, this sentimental message is anything but simple. For it is the vanishing point of the Tintoretto-like brush strokes by which Symonds, depicting Achilles, shades one kind of depth into another: from the secret depths of gay desire in Victorian England, to the depth of time that separates the present from the buried past, to the emotional depth of true love itself. Deep shame gives way to deep time which gives way to an almost impossibly deep falling-in-love; Symonds's heroic struggle against the first becomes a hero's surrender to the last. Symonds shares this plumb-line with other gay writers who looked back as a way to look forward, and his use of it helps us to see why it is insufficient to understand their retrospection only as a search for precedents and authorities (though it surely was that too). More than a viable alternative to heterosexual love, like 'the Love that dare not speak its name' in Douglas's 'Two Loves', Symonds gives us something that is potentially paradigmatic of love itself, with living roots in the earliest records of (Western) civilization. What love could be deeper than that?

But there is still more to say about Symonds's detour through Dante. In terms both broad and narrow, his reading of the quoted passage cannot be right. In the first place, he seemingly forgets that Dante did not have direct access to Homer, not even in translation. Indeed, these lines almost certainly refer not to Patroclus at all, but to a rich medieval tradition of chivalric literature that had crafted for Achilles a fatal love affair with the Trojan princess Polyxena. Dante, in fact, clearly wrote that Achilles fought *con amore*, 'with

love', playing on the sense of 'against love', not *per amore*, 'for love', the rare variant preferred by Symonds.[52] In a footnote, Symonds acknowledges the textual crux but does not defend his preference, which, surely not accidentally, though perhaps unconsciously, allows Dante's meaning to depend on the same three-letter sequence on which Homer's is said to depend, even though the words are of different languages and meanings, and their crucial position in the two traditions is itself entirely coincidental. Nevertheless, here too it would not be quite accurate to say that the depths detected by Symonds are only the shadows cast, consciously or unconsciously, by his own eager reading. Medieval commentators on the text had to defend the lines against homoerotic interpretation: not only is Polyxena meant here, one of these cheerfully explains, but had Dante believed that Achilles loved Patroclus 'dishonorably', he would have placed him elsewhere in Hell, among the sodomites.[53] Is it enough to say that such commentators, like Fantuzzi on Homer (and as I myself have just done, regarding Dante), are defending 'authorial intent' against the creative vagaries of 'reader response'? I would suggest that something rather more complex – and wonderful – is happening here. Those renegade readers, including Symonds, as we already have seen regarding the respective sexual 'roles' of Achilles and Patroclus, are hardly just making things up. Rather, they are insisting on reading the tradition as a whole (the 'whole depth' of the tradition itself). Their reading, however, is anything but traditional, for it does not use that tradition to assert the authority of Homer or Dante or anyone else. They read instead for a networked idea to which *even* Homer and Dante have contributed, if perhaps unconsciously, along with Aeschylus, Plato, Martial, Beccadelli, Poliziano, plus more peripheral contributors, including readers themselves, sometimes linked in ways that leave smaller textual traces, or even none at all. Depth, in this sense, is not depth at all, but depth of field, an ability to bring into focus what no single text has shown us but which is seen all the same as residing in the tradition itself. The conflicted will and multivalent desires of the totality of that tradition trump those of any single author: even Dante cannot save *il grande Achille* from this complexity, certainly not simply by establishing his place in Hell. Tradition has, or seems to have, a mind of its own: a mind, to be sure, sometimes in the gutter (think of Beccadelli's dirty poem), but one also capable of thoughts that soar beyond the horizons of a single will or age or language. Part of the history of homosexuality – if 'history'

is the right word, for we are doing battle here, *per amore*, with history as the idea that all thoughts belong neatly to single times and places – is its emergence from this collective, unsituated, restless mind.

I say 'part' because I mean not to minimize but, rather, to amplify the concurrent role of individual lovers and thinkers, most of them anonymous, in this grand thought, linked to one another through time. Here, too, time functions as depth of field: a space or span of time, connecting not vertically, genealogically, sequentially, but laterally, complicitly, collaboratively. Someone, somewhere, either in a copy they were reading or in a new one they were generating, changed Dante's *con* to *per*, probably with Patroclus on his or her own mind, and possibly fighting battles not just with but for love, at who knows what cost. And that tiny change reached Symonds (even as contemporary editors were laboring to purge Dante's text of such scribal interference); that he is willing to mistake it for a signal from Dante himself is, in the end, of secondary importance. Compare Symonds's own correction of *she* to *he*, etc., in his edition and translation of the sonnets of Michelangelo – though in this case, the change is right on its own terms, undoing the poems' bowdlerization by Michelangelo's own grand-nephew.[54] Contemplating the preposition governing Achilles' love in Dante, despite his stated effort to peer into the Italian poet peering into Homer, Symonds catches semi-conscious sight of a fellow dissident.

To be sure, this like-minded corrector is barely more visible than the 'passing stranger' to whom Symonds (like another distant, elusive soul-mate, Walt Whitman) devoted love poems. Let us borrow lines from one of these, if only in a sympathetic nod to Symonds's much maligned poetic efforts:

> . . . one fleeting glance
> Fraught with a tale too deep for utterance,
> Even as a pebble cast into the sea,
> Will on the deep waves of our spirit stir
> Ripples that run through all eternity.[55]

Here, the doubling of the key word 'deep' joins its relentless repetition across Symonds's whole vast body of work, like an echo lending sound to silence itself. Yet in the end, depth gives way to surface, offering up a medium for messages of almost impossible subtlety. These not only run along the surface tension of private glances, publicly exchanged, but flit, in infinite relay, across

the face of time itself. Perhaps they even radiate out to the farthest edge of the wine-dark deep, where a beloved heroic lover still waits, expectantly. 'It is well: for if we think of the infinity of the Universe in Space & in Time, what incalculable myriads of beautiful human beings must be forever unknown to us! – & to have just seen the phantom shape of one of these flit by a hand's breadth out of reach, is better at least than nothing,' as Symonds writes to his friend and confidant Henry George Dakyns, in a cryptic letter regarding not the past but frustrated desires in the present.[56] The whole stretch of time, in other words, becomes for Symonds the canvas of what he famously, and repeatedly, calls *l'amour de l'impossible*, 'love of the impossible', which is not, though the subtlety is often missed, itself an impossible love.

In a chapter of *Greek Poets* notionally about fragmentary comedy, Symonds abruptly turns to address tragedy, Greek heroes struck down at Troy, and the question of 'modernity'. This remarkable apostrophe bears quoting at length:

> The Chorus in the *Agamemnon* upon the beautiful dead warriors in the Trojan war is called modern because it comes home directly to our own experience. Not their special mode of sepulture, or the lamentation of captive women over their heaped-up mounds, or the slaughter of human victims, or the trophies raised upon their graves, are touched upon. Such circumstances would dissociate them, if only accidentally, from our sympathies. It is the grief of those who stay at home and mourn, the pathos of youth and beauty wasted, that Aeschylus has chosen for his threnos. This grief and this pathos are imperishable, and are therefore modern, inasmuch as they are not specifically ancient. Yet such use of the phrase is inaccurate. We come closer to the true meaning through the etymology of the word modern, derived perhaps from *modo*, or *just now*; so that what is modern, is, strictly speaking, that which belongs to the present moment. From this point of view modernism must continually be changing, for the moment now is in perpetual flux. Still, there is one characteristic of the now which comprehends the modern world, that which does not and cannot alter: we are never free from the consciousness of a long past.[57]

'We are never free from the consciousness of a long past': Gideon Nisbet borrows this sentence as the epigraph to his *Greek Epigram in Reception*, noting that it 'is underlined in the copy owned by [Symonds's] attentive contemporary reader, the young Oscar Wilde', the other bookend of Nisbet's subtitle, *J.A. Symonds, Oscar Wilde, and the Invention of Desire, 1805–1929*. The way that

Nisbet's soft-spoken title gives way to the splashier marquee of his subtitle anticipates the drama within, in which small things, including, of course, the epigrams themselves, open up onto vistas that are epic in scale, with results that are nothing short of breathtaking. Symonds, as his top billing suggests, has the starring role, outshining even Wilde. So too does he figure prominently in another remarkable recent work of reception studies, Daniel Orrells, *Classical Culture and Modern Masculinity*, which devotes a chapter to 'The Case of John Addington Symonds'. The reasons for Symonds's centrality to both these works are numerous and complex, but as Nisbet's epigraph and its original context suggest, a major theme is the complexity of Symonds's relationship to the past qua past, i.e., to the past as an artefact of time itself.

In light of what we have seen in this chapter, and encouraged by recent interest in the complexity of Symonds's classicism, let us now claim the author of *Greek Poets* and *Greek Ethics* as an exemplary 'deep classicist'. As he wrestled with questions about his own life and age, Symonds turned to the classical past; in this he was, of course, like countless other participants in the classical tradition. Symonds, however, neither embraced modernity's difference from the past nor longed for the rebirth of (or to have been born himself in) an ancient utopia. As Orrells puts it at the end of his chapter on Symonds, glossing the phrase he has earlier borrowed from Symonds's own *Memoirs* as his own epigraph, 'Symonds's self-characterization as "a stifled anachronism" suggests that both labels, "ancient" *and* "modern," are ultimately unhelpful for locating Symonds "within" the history of sexuality.'[58] We can extend that insight, for Symonds's sense of his own 'untimeliness' (to borrow not his term, but Nietzsche's, to whom Nisbet daringly compares him) must be part of what enabled him to read the past itself anachronistically, synchronically. Symonds reads the past *through* its tradition, finding in that tradition something that arguably really *is* there, just not in any single time and place. Naturally, one could object that this is simply an especially sophisticated kind of 'reader response' (and so of classical reception); indeed, we might even be inclined to characterize it in older, outmoded terms, as a heroic act of imagination. But is Symonds's imagination really the only one at work here? He certainly is not this story's only hero. As he himself puts it in a late essay on 'Ideals of Love', 'There are delusions, wandering fires of the imaginative reason, which, for a brief period of time, under special conditions, and in peculiarly constituted

natures, have become fruitful of real and excellent results. This was the case, I take it, with both Plato and Dante.'[59]

Anachronism, however, born of the past's synchronic presence to us, like that of the strata of rock in John Hutton's Scottish cliff, or of Rome's stacked ruins,[60] is only half of the portrait of Symonds's portrait as a deep classicist. What finally completes the picture is the fact that his gaze is directed towards something that is as fundamentally unknowable, in a fully epistemological sense, as the distant past itself: in this case, love. It may seem startlingly naïve to insist on the ineffability of love when we have spent the past several pages seeking better to recount love's history. But Greeks or no Greeks, that love is and must remain a mystery is something that Symonds himself never doubted. In other words, to go looking for love in the fragmented cyphers of the past is already to find something like love itself, for to know love in the sense of experiencing love almost definitionally requires knowing that one will never fully understand love. One can, of course, reject such sentimentalism, but without it, one cannot really understand what Symonds got from his Arcadian fantasies. He was, to the end, an incurable romantic.

If Symonds has emerged as exemplary of some of the modes claimed in this volume's introduction for Deep Classics, then let us close this chapter with something even more ambitious, by claiming Homer's Achilles as the *first* deep classicist. After all, his pose, as he stares out, 'sore troubled', at that still inscrutable Greek phrase, is in a very real sense a *philological* one. Perhaps someone – perhaps, indeed, Marco Fantuzzi – will object that philology is not really a 'love of words', but only 'friendship' (*philia*) with them. Perhaps others will insist that it is not Achilles who loves the words, but the words that love Achilles, line after line, book after book. But in friendship or in love, as lover or beloved, Achilles strikes me as the first character *in* the classical tradition to anticipate the pose of the deepest readers *of* that tradition, who stare with desire and despair at what they cannot fully understand, and who find in the work of time not the dimming or obscuring of classical eloquence, but its wine-dark efflorescence. 'I have been writing out of the heart's depth,' reports Symonds in a letter to Horatio Brown, who upon Symonds's death two years later would become his literary executor and, eventually, his biographer, in both of which roles he would work to suppress Symonds's work on the history of sexuality, to say nothing of that heart's

desires. Symonds continues, once more invoking his time-traveling soul mate: 'And as Achilles says in Shakespeare –

> My soul is troubled like a fountain stirred,
> And I myself see not the bottom of it.[61]

Notes

1 Borges (2000: 14).

2 Homer, *Iliad* 9.189.

3 Homer, *Iliad* 23.143. Translation from Lang, Leaf and Myers (1883: 454); italics added. The translation of book 23 fell to the last of these, 'but the whole has been revised by all three Translators, and the rendering of passages or phrases recurring in more than one portion has been determined after deliberation in common' (Lang, Leaf and Myers 1883: *v*).

4 Linear B *wo-no-qo-so*, the 'name of an ox': Ventris and Chadwick (1973). For an image, see Chadwick et al. (1986: 417, no. 1015).

5 Liddell and Scott (1996), s. v. *oinops*.

6 Gladstone (1877: 366–88).

7 *Cantos* 97 and 102, both linking *oinops* with *aithiops* (cf. *aithops*): Pound (1964: 706, 756).

8 Clarke (2004: 136); Bradley (2013: 132–3).

9 This possibility seems not to have been considered, but the Greeks heard an analogous ambiguity (one, by contrast, genuinely difficult to settle) in *euruopa*, a Homeric epithet for Zeus that they took to mean either 'wide-eyed' (or 'far-seeing'), or 'far-sounding', i.e., 'far-thundering' (Liddell and Scott 1996, s.v.).

10 'Lines Written a Few Miles Above Tintern Abbey, On Revisiting the Banks of the Wye During a Tour, July 13, 1798.' I have quoted the lines in their original form, later slightly modified by Wordsworth, from Coleridge and Wordsworth (1798: 202–3).

11 Pliny the Elder, *Natural History* 35.75.

12 Homer, *Iliad* 1.350.

13 I report Aristarchus, here and below, on the basis of the apparatus in West (1998–2000).

14 Homer, *Iliad* 23.150–3.

15 Homer, *Iliad* 23.83–4, 243–8; 16.97–100.

16 Homer, *Iliad* 24.128–32. Translation from Murray and Wyatt (1999: 573); italics added.

17 Fantuzzi (2012: 201–2). For earlier scholarship on the subject, see his notes and bibliography, supplemented by those of Halperin (1990: 75–87).

18 Fantuzzi (2012: 2–3, 190–1, 229).

19 Halperin (1990: 84–5), notes that even the language of intense male friendship was (and is) limited; accordingly, the Homeric pair's 'friendship is parasitic in its conceptualization on kinship relations and on sexual relations. That is, it must borrow terminology and imagery from these other spheres of human relations in order to identify and define itself'.

20 Aeschines, *Against Timarchus* 142, discussed by Fantuzzi (2012: 189).

21 Fantuzzi (2012: 190).

22 Auerbach (1953: 3–23), on 'Odysseus' Scar'.

23 Comparison of the three texts had already been central to other discussions of Achilles and Patroclus, including that of the chapter 'Heroes and their Pals' in Halperin (1990: 75–87), 'with whose results I substantially agree', notes Fantuzzi (1990: 190).

24 Aeschylus, *Myrmidons*, fr. 135 and 136, in Radt (1985: 250–1). On the play's depiction of Achilles and his story, see Michelakis (2002: 22–57), with discussion of these fragments in the context of the play's erotic theme and its reception (41–53).

25 Martial, *Epigrams* 11.43.

26 Antonio Beccadelli (il Panormita), *Hermaphroditus* 1.7, available in Beccadelli (2010: 12–13).

27 Plato, *Symposium* 180a.

28 Angelo Poliziano, *Miscellanea (I)* 45, consulted in Poliziano (1498).

29 Statius, *Achilleid* 1.174–7.

30 Homer, *Iliad* 11.787.

31 Symonds in Brady (2012: 151), translating from Richard von Krafft-Ebing's *Psychopathia Sexualis* (1889), with a footnote on the term in which he suggests, '*Unisexual* would perhaps be better'. First to call attention Symonds's priority (and the neglect thereof by the *Oxford English Dictionary*) was DeJean (1989: 169, n. 25), although, on the basis of the later version of *Greek Ethics*, she wrongly assumes the word first appeared in that essay, rather than in its 1891 companion. The first English appearance of 'homosexual' (in reference to ancient Greek toleration of 'homosexual passions') in *Greek Ethics* is instead in the first section of its revised version in Ellis and Symonds (1897: 165), repeating its appearance in the German version, Ellis and Symonds (1896: 37); properly speaking it could have been added by either Symonds or Ellis. I shall continue to cite *Greek Ethics* from Brady (2012: 41–121), which includes commentary on variants in later editions (some anticipated by autograph notes in Symonds's own copy, now in the British

Library), as well as a useful introduction. Further introductions to the essay in the context of Symonds's broader engagement with Greek sexuality and culture are provided by Blanshard (2001) and Holliday (2000).

32 On Symonds on Poliziano's sexuality, see Stewart (1997: 3–8, 37).

33 Brady (2012: 48).

34 Brady (2012: 48).

35 Brady (2012:49–50); in the revised version for Ellis's *Sexual Inversion*, Symonds transliterates παιδεραστία and adds 'mere' before 'licentiousness'. Symonds's conception of 'the mixed form of παιδεραστία called by me in this essay Greek love' (29), as he himself pointedly acknowledges (24), is deeply indebted to Karl Otfried Müller's formulation of the 'Dorian' pederasty of Ancient Sparta in *Die Dorier* (1824), probably consulted in its English translation as Müller (1839). By foregrounding Homer, however, Symonds predicates that 'mixed form' on a dual temporality, since even the Dorians (like the later Athenians, as well as Symonds himself) were 'inspired by the memory of Achilles'. Orrells (2011) examines Müller's work and its pervasive influence (77–88) and devotes a chapter (146–84) to Symonds, both as inspired by Müller (and by others inspired by him, like Walter Pater) and in his own right. The influence of Müller, Pater, and others on Symonds also receives extensive analysis by Nisbet (2013), passim.

36 Symonds (1920: 68).

37 Given his debt to Müller (see above), Symonds surely heard in 'homosexual' an echo of Sparta's warrior class of Homoioi, 'Equals'. To be sure, Symonds's emphasis on male 'equality' and 'comradeship' is fundamentally more sexual than social or democratic and is often driven by self-centered anxieties about the charge either of effeminacy or of paedophilia. Responding in his *Memoirs* to the work of German sexologist Karl Heinrich Ulrichs, he notes, 'With regard to Ulrichs, in his peculiar phraseology, I should certainly be tabulated as a *Mittel Urning*, holding a mean between the *Mannling* and the *Weibling*; that is to say, one whose emotions are directed to the male sex during the period of adolescence and early manhood; who is not marked either by an effeminate passion for robust adults or by a predilection for young boys; in other words, one whose comradely instincts are tinged with a distinct sexual partiality': Symonds (1984: 65).

38 Echoed by Symonds himself in his letters to Carpenter. See, e.g., Symonds (1967–69: 3.808 = Letter 2079), January 21, 1893: 'The blending of Social Strata in masculine love seems to me one of its most pronounced, & socially hopeful features. Where it appears, it abolishes class distinctions ... If it could be acknowledged & extended, it would do very much to further the advent of the

right sort of Socialism.' In a letter to Whitman enthusiast J.W. Wallace, Symonds credits Whitman with convincing him 'of the absolute equality of men' (Symonds 1967–9: 3.825 = Letter 2094).

39 Funke (2013: 141).

40 Symonds (1893: 61), quoted by Funke (2013: 146), who slightly misleads by presenting such assertions as visions of an 'age-equal' homosexuality (two 'men' can still be of different age), though she is quite correct to detect a marked shift from 'boy' or 'youth'. As Evangelista (2007: 213–14), observes, 'Symonds followed the Greek model in his own choice of sexual partners, being mostly attracted to men who were younger than himself, or, alternatively, to working-class men – thereby transferring the asymmetry in age constitutive of *paiderastia* into the terms of social difference.'

41 Aristotle, *Nicomachean Ethics* 9.4.1166a; 9.9.1169b, 1170b.

42 Plato, *Lysis* 214c–d.

43 Quoted from Ellmann (1987: 435).

44 There seems to be no direct evidence for Wilde's reading of *Greek Ethics*, but on his early engagement with other work by Symonds and the two men's eventual contact, see Rutherford (2014: 625).

45 Douglas (1894: 28).

46 1 Samuel 18:1 (King James Version).

47 Ellmann (1987: 432, 448).

48 Symonds (1872: 156).

49 Symonds (1920: 53). Dante, *Inferno* 5.65. In Symonds's own copy of the *Divina Commedia* (Dante 1863), now held in the Special Collections of the Library of the University of Bristol (Restricted A401a), with a note describing it as 'the annotated copy of Dante carried everywhere by Symonds', he has underlined the passage from *vidi* to *combatteo*.

50 Symonds (1984: 233), which continues, 'I enjoyed mental energy, but I held opinion, as Farinata [in Dante's *Inferno*] held hell, *in gran dispitto*'. These declarations appear in a chapter that begins, 'Since I have reached the point of my embarking on the great wide sea of literature' (215) and open a paragraph of that ends with an image of the author reading, 'in hours of inertia, face to face with Mediterranean seas or Alpine summits' (233). Symonds (1872: 155–6) discusses Farinata's 'great scorn' for Hell, immediately before turning to the *sprezzatura* of Dante's portraits of Jason and Achilles.

51 Symonds (1920: 53).

52 Symonds's preference is also that of the edition he owned (Dante 1863), though his awareness of the two variants makes it clear he consulted other texts.

53 Benvenuto da Imola (1887: 203): 'Dicunt etiam aliqui quod Achilles amavit
 Patroclum inhoneste, quod est falsum, quia tunc poneretur alibi, ubi punitur
 luxuria innaturalis inter flammas.'
54 Symonds (1878).
55 Symonds, 'The Passing Stranger (I)', in Symonds (1882: 13).
56 Symonds (1967–9: 2.342 = Letter 935).
57 Symonds (1920: 455).
58 Orrells (2011: 184).
59 Symonds (1893: 86).
60 See the introduction.
61 Symonds (1967–9: 3.589 = Letter 1899), to Horatio Brown, written from Davos,
 2 July 1891, quoting *Troilus and Cressida* 3.3.314–15, though Symonds changes
 Shakespeare's 'mind' to 'soul'. He repeats the quotation (this time correctly) in a
 letter a year later to his daughter Margaret (Symonds 1967–9: 3.707 = Letter 1995).

The Sigh of Philhellenism*

Joshua Billings

The paradigmatic scene of philhellenism takes place on or near a shore. The shore could be in the Crimea, or Egypt, or Naxos, or Troy, or Lemnos – any place, indeed, except Greece. There is a figure on the shore, usually alone, watching the sea, The figure can be a woman or a man. She or he can be sorrowful, in physical pain, or both. This description could characterize any number of scenes, but the opening of Goethe's *Iphigenie auf Tauris* (1787) is a particularly apt place to start. It locates us in a space between, defined by the grove into which Iphigenia enters on one hand, and the sea over which Iphigenia gazes on the other:

> Heraus in eure Schatten, rege Wipfel
> Des alten, heil'gen, dichtbelaubten Haines,
> Wie in der Göttin stilles Heiligtum,
> Tret' ich noch jetzt mit schauderndem Gefühl,
> Als wenn ich sie zum erstenmal beträte,
> Und es gewöhnt sich nicht mein Geist hierher.
> So manches Jahr bewahrt mich hier verborgen
> Ein hoher Wille, dem ich mich ergebe;
> Doch immer bin ich, wie im ersten, fremd. (*FA* 5.555, ll. 1–9)[1]

Out into your shadows, stirring treetops of the ancient, holy, thick-foliaged grove, as into the silent sanctuary of the goddess, I enter even now with trembling feeling just as when I first trod them, and my spirit does not grow accustomed to this place. For many years I am held here hidden by a higher will to which I yield myself, but always I am, just as at first, alien.

* This essay has benefited from the comments of the Deep Classics audience and from the sensitive readings of Shane Butler, Constanze Güthenke, Mark Payne and Helen Slaney.

Iphigenia addresses the permanence of the natural world as a transient herself, both spatially and temporally. Time collapses for her: she shudders 'just as when she first trod' into the grove, and remains 'always, just as at first, alien'. Ten years on from her arrival in Tauris, saved from sacrifice by the goddess Artemis and spirited to the Crimea, she has resigned herself to a sense of displacement and unanswered longing:

> Denn ach mich trennt das Meer von den Geliebten,
> Und an dem Ufer steh' ich lange Tage,
> Das Land der Griechen mit der Seele suchend;
> Und gegen meine Seufzer bringt die Welle
> Nur dumpfe Töne brausend mir herüber. (*FA* 5.555, ll. 10–14)

> For ah! the sea divides me from my loved ones, and on the shore I stand for long days, seeking the land of the Greeks with my soul. And in response to my sighs the waves bring to me only dull sounds roaring.

The sea appears as a contrast to the grove described in the first sentences: exposure instead of protection, sound instead of stillness, absence instead of presence. Both, though, serve as markers of displacement, a sense conveyed through a rich emotional vocabulary – *Gefühl, Geist, Seele* – that places both the language of affect and the desire for Greece at the heart of the play. Iphigenia's words are situated in the space between land and sea, Tauris and Argos, speaking and sighing.

It would be easy to read Iphigenia as a figure for the philhellene, who feels herself in a modern world alien to her natural atmosphere of ancient Greece. Indeed, E.M. Butler's *The Tyranny of Greece Over Germany* begins with an image of the nations of the world as children 'marooned on an island of hard facts', some of them seeking to swim away, some to build boats, but a certain group of them 'brooding' and 'strained', 'less fit for life on the island than those around them'.[2] These last are the Germans. Indifferent to the world around them, they throw themselves slavishly before ideals of all sorts, and in Greece, Butler argues, they had found their own greatest master. From the time of Winckelmann, she writes, 'Germany is the supreme example of her [Greece's] triumphant spiritual tyranny'.[3] The maladjusted children brooding on the shore might be imagining the lost world of antiquity and reflecting on the gap that separates their desolate island from the 'Greek sky' of Winckelmann's imagining. Goethe's Iphigenia, 'seeking the land of the Greeks with the soul', in

Butler's reading, might be the expression of an elegiac philhellenism that experiences its distance from antiquity as a permanent displacement, an exile from the sources of true meaning.

But one could equally – and this is where my intervention begins – read Iphigenia as a figure for ancient Greece itself, displaced into a modern world in which it is 'always, as at first, alien'. As much as there is a powerful sense of nostalgia for antiquity, there is also a feeling that it remains strange and incomprehensible to moderns. Butler describes this as 'rebellion' – and at times, the word is appropriate – but the more profound fear seems to be not that the power of Greece will overcome moderns, but that the tyranny of Greece is a figment of the modern imagination.[4] Iphigenia's sigh, I suggest, would then express a lingering doubt about the philhellenic project, a fear that the echo of antiquity might amount to no more than 'dull sounds roaring'. It is the sigh of an age as it confronts the simultaneous necessity and the impossibility of a relation to Greek antiquity, which finds itself displaced from its notional homeland of antiquity, but equally unable to remember or imagine what that home looked like.[5]

Sighs and cries are everywhere in the late eighteenth century. 'German poetry,' Friedrich Kittler writes, 'begins with a sigh.'[6] He is referring to the first words of Goethe's *Faust I*:

Habe nun, ach! Philosophie
Juristerei und Medizin,
Und leider auch Theologie!
Durchaus studiert, mit heißem Bemühn. (*FA* 7.33, ll. 354–7)

I have, ah!, studied philosophy, jurisprudence and medicine, and unfortunately theology too with heated effort.

The parallels between Faust's 'ach' and Iphigenia's sigh might be followed further with Kittler's analysis, which argues that *Faust* is concerned with reconciling a notion of learning that looks back to early modernity – a heaping up of books and knowledge – with a more intuitive, even soulful conception of knowledge. Goethe's play declares its effort to begin anew, but can only do so in the language of the old. Faust's sigh expresses the torment of proto-Romantic consciousness caught in the Enlightenment world. 'German Poetry,' Kittler writes 'thus begins with the Faustian experiment of trying to insert Man into the empty slots of an obsolete discourse network.'[7] Iphigenia's 'ach' – written

later, though published earlier than Faust's – could be a moment in the same question of inserting man into an alien time and discourse network. Faust is a modern caught in early modernity, Iphigenia an ancient caught in an alien modernity. Their sighs emanate from a sense of liminality, which is at once temporal and spatial: they are out of time and out of place.

The elegiac tone of Goethe's prologue to *Iphigenia* is wildly different from the ironizing opening speech of *Faust*, but both employ the device of a character alone on stage, explaining his or her dilemma. This typically Euripidean opening is not so common that it should be overlooked: none of Goethe's other 'classical' dramas opens in the same way.[8] The affective economy of Goethe's version can be discerned against the background of its predecessors – not just Euripides' version, but a host of other eighteenth-century adaptations. Euripides – true to the fashion he brags about in Aristophanes' *Frogs*[9] – opens the play with Iphigenia describing her genealogy and the background of the story:

> Pelops the son of Tantalus going to Pisa with his swift horses married the daughter of Oenomaus, from whom was born Atreus. The children of Atreus were Menelaus and Agamemnon. From the latter I was born, child of the daughter of Tyndareus, Iphigenia, whom my father slaughtered for Artemis by the eddies which the Euripus with its frequent breezes turns, rolling the dark sea, on account of Helen – so it seems – in the famous folds of Aulis.

We are located quickly in the mythical story, which of course would not prevent us from being surprised to find that Iphigenia – sacrified in Aulis – is the one speaking to us. A tradition of her rescue seems to have predated Euripides, but it would nevertheless have required some explanation.[10] Euripides is concerned mainly to fill in the story, and only secondarily (if at all) to fill in any of Iphigenia's internality. She tells a curiously sanitized version of her family's history, omitting Pelops' trick and Atreus' treachery. As the play goes on, to be sure, one sees much more of her emotions, and the affective register of Euripides' prologue seems rather different from the rest of Iphigenia's appearances. Goethe, on the other hand, concentrates affect in the opening speech, using philhellenic longing to position the work.

Iphigenia's description of herself on the shore of Tauris places her among a number of philhellenic sufferers on beaches, who seem to have appealed

particularly to the late eighteenth century. Longing women on beaches are a constant of late-eighteenth-century drama, and their sighs often take musical form. This is the case in Gluck's *Iphigénie en Tauride*, which was almost exactly contemporary with, and independent of, the prose version of Goethe's *Iphigenia*. While the earlier eighteenth century had been interested primarily in the idealized depiction of male friendship in the story, both Goethe and Gluck (along with his librettist Nicolas François Guillard) place female emotion at the centre of the work.[11] The operatic version opens with an agitated Iphigenia begging the gods for mercy in a storm, and continues with Iphigenia relating her dream and the lamenting aria, 'Ô toi qui prolongeas mes jours': 'Oh you who prolong my days, take back a gift that I hate. Diana, I beg you, end my life.'[12] The structuring function of emotion is evident in the way that Gluck/Guillard give Iphigenia a series of prominent arias – including a particularly prominent lament ending the second act, 'Ô malheureuse Iphigénie'. Likewise, Goethe gives Iphigenia a series of metrically irregular speeches, almost taking the function of choruses. There is some Euripidean precedent for this – Iphigenia does have a lamenting *kommos* (lyric exchange) later in her first appearance on stage – but the focus on internality and female emotion is remarkably strong in the late eighteenth century. Something about the longing of a displaced Greek for Greece at this moment concentrated currents of nostalgia and mourning into a particularly potent brew of emotion.

Female emotion has been central to operatic expression since Monteverdi's second opera, *L'Arianna*, now lost but for its striking aria 'Lasciatemi morire', another sea-side lamentation. Music was another language in which emotion could be expressed – and its mode of expression was often connected back to the notional origin of music-drama in ancient Greece.[13] Gluck's Paris operas of the 1770s all centred on a single female character: *Iphigénie en Tauride*, *Iphigénie en Aulide*, *Armide*. Gluck's works were often thought to open up a new dimension of affective expression, which reclaimed the power of ancient Greek tragedy.[14] Ariadne, likewise, is at the centre of a number of important late-eighteenth-century cantatas and melodramas, of which Haydn's *Arianna a Naxos* is only the most famous. The form of the melodrama – text spoken over orchestral accompaniment, which had a brief moment in the sun in the late eighteenth century following Rousseau's advocacy – might have been invented for such abandoned women: alongside Rousseau's *Pygmalion*, the most popular

works in the genre were Georg Benda's 1775 *Ariadne auf Naxos* and his 1778 *Medea*. Benda's *Ariadne* is loosely based on a 1767 cantata with a libretto by the *Stürmer und Dränger* Heinrich Wilhelm von Gerstenberg. Interestingly, none of these versions include a hint of the next scene in the story, when Bacchus descends to rescue Ariadne and deify her. In fact, the epiphany is so conspicuously absent from Benda's famous version that one contemporary parody gave Bacchus an epilogue complaining. This is a stark contrast to a tradition of operatic versions of the story going back to Monteverdi, the libretto of which concludes with Bacchus' apparition.[15] Monteverdi is followed by an important early German opera – Conradi's *Ariadne* of 1691 – and, most famously, by Richard Strauss and Hugo von Hofmansthal's (1916) *Ariadne auf Naxos*, in which the plot itself seems to epitomize a hackneyed melodramatic character, and is continually ironized by the intrusions of a troupe of *commedia dell' arte* players. The epiphany of Bacchus is a crucial part of all these operatic versions, but the late-eighteenth-century versions all conclude with Ariadne's lamentations – or, following one ancient tradition, her suicide. Though the eighteenth century by and large preferred reconciliatory endings in drama, Ariadne seems to have been most compelling as an abandoned woman on the beach, frozen in her suffering.

The inevitable reference point for all these Iphigenias and Ariadnes is the close of Winckelmann's *Geschichte der Kunst des Altertums* (1764), which associates the longing of a woman on a beach with a desire for the presence of ancient Greece:

> In the history of art, I have already gone over its limits, and even though in the observation of its downfall I am almost despairing, like one who in describing the history of his fatherland must touch on its destruction, which he himself lived through, I could not restrain myself from following the fates of the works of art as far my eye could go. As a beloved on the shore of the sea follows with teary eyes her departing lover, without hope ever to see him again, and even believes that she sees the image of her beloved in the distant sail (*in dem entfernten Segel das Bild des Geliebten zu sehen glaubt*), so we, like the beloved, have as it were only the shadowy outline of the object of our wishes left (*einen Schattenriß von dem Vorwurfe unsrer Wünsche übrig*); but this awakens an even greater longing for what is lost, and we observe the copies of the originals with greater attention than we would have done if we were in full possession of the originals.[16]

This famous description of the philhellene as a beloved watching her lover's ship disappear has usually been read in terms, on one hand, of gender, focusing on the identification of the modern viewer-historian as female, and the ancient object of desire as male;[17] and on the other hand, in terms of epistemology or historical method, focusing on the way that the passage figures research into antiquity as a response to 'desire for the lost'.[18] The reading of Goethe's Iphigenia pursued above suggests that both concerns might be productively thought in relation to one another, that the gendering of philhellenic affect may carry with it an epistemology of philhellenic knowing.[19] Seen in this way, the layering of gender roles in Winckelmann's description would itself be an expression of the conflict of different modes of knowledge of the past – the male historian associated with an accurate recounting of the past, the female beloved with a desiring relation to antiquity that issues in delusion. These roles would be reinforced by a layer of Virgilian allusions, to the Carthage books of the *Aeneid*, where Aeneas in book 2 takes the role of the historian recounting the downfall of his country, and Dido in book 4 watches from the beach as Aeneas' ships sail away.

Winckelmann could have called upon any number of mythical women on beaches. The crucial ones are surely Dido and Ariadne, but the scene evokes many more layers of classical characters: Penelope, Andromeda, maybe even the Sirens. Behind the image also lies a passage in Pliny which describes the daughter of a Corinthian potter who traced an image of her departing beloved, which her father moulded over with clay, creating the first sculpture. All of these resonances are in play, but they are also importantly complicated by a much less frequently noted element: the imagining of the face of the beloved in the sail of the departing ship. This is essential to the logic of the passage, as the point at which Winckelmann's description turns from individuals to a collective, the 'we' who now 'have as it were only the shadowy outline of the object of our wishes left'. This seems to have no parallel in any classical text. The focus on vision and belief could be suggested by Catullus 64, and its description of Ariadne awaking on Naxos to find herself deserted: *Necdum etiam sese quae visit visere credit, / utpote fallaci quae tum primum excita somno / desertam in sola miseram se cernat harena* (55–7: 'not yet can she believe she sees what she sees; since now, first awakened from treacherous sleep she sees herself, poor wretch, deserted on the lonely sand'). The description inspired

Ovid likewise to connect vision, belief, and emotion, in his letter from Ariadne to Theseus in *Heroides* 10: *Inde ego – nam ventis quoque sum crudelibus usa – / vidi praecipiti carbasa tenta Noto. / Ut vidi haut dignam quae me vidisse putarem, / frigidior glacie semianimisque fui.* (29–32: 'From there – for I was buffeted also by cruel winds – I saw your sails stretched full by the headlong southern wind. As I looked on a sight I thought I had not deserved to see, I grew colder than ice and half-alive'). Winckelmann layers these resonances on top of one another, but intervenes in the classical image to add the illusory consolation of the image in the sail, the moment at which the despairing, disbelieving Ariadne turns into the delusional philhellene.

There is another twist to Winckelmann's passage, as he goes on to suggest a third comparison for his own project. The male historian and the female beloved have received the bulk of critical attention, but the third image is crucial:

> We often act like people who want to meet ghosts, and believe they see them where there is nothing: the name 'antiquity' has become a prejudice, but even this prejudice is not without use. One always imagines that one will find much, so that one seeks much, in order to catch sight of something (*Man stelle sich allezeit vor, viel zu finden, damit man viel suche, um etwas zu erblicken*).[20]

Following directly on the above passage, Winckelmann expands on the desire to revive the figures of antiquity as ghosts. The three identities proposed for his project – male historian, female beloved, collective of necromancers – grow progressively more doubtful about the possibility of any kind of access to antiquity: the historian speaks from personal experience about the past, the beloved externalizes the memory of her lover as a hallucination, and the people who believe in ghosts are utterly deluded by their desires. This delusion, to be sure, is productive, but the image remains ambiguous as to whether what we find has any relation to what actually is or was. By the third image, we are no longer examining copies of the originals, but imagining ghosts 'where there is nothing'. Coming at the end of Winckelmann's investigation of the art of antiquity, this is a surprising and troubling admission. The core of the description, taken as a whole, is not longing for what we have experienced and lost, but concern that what we see of the past is only an illusion.

In Winckelmann's description of the beloved on the shore, as in the figures of Ariadne, Iphigenia and their sisters, expressions of affect carry the weight not only of a cultural longing, but of an epistemological anxiety. The fear is not only that the beloved will not return, but that the beloved never was. Behind this complex of philhellenic women on beaches there stands another complex of men on beaches, which similarly links questions of affect and knowing in the wake of Winckelmann's investigations of Greek art. The famous Laocoön debate was set off by Winckelmann's *Thoughts on the Imitation of Greek Works in Painting and Sculpture* (*Gedanken über die Nachahmung der Griechischen Werke in der Malerey und Bildhauerkunst,* 1755), which proved the single greatest impetus for philhellenism through the rest of the century. Though the issues of this debate are more familiar, they appear in a different light when read through the (largely later) depictions of female emotion discussed above. The Laocoön debate began as a conflict over the expression of emotion, and the normative quality of Greek artworks.[21] It concerned the portrayal of the Trojan priest Laocoön, who (in Virgil's epic version at least – the Greek tragic versions are lost) was killed by a pair of sea-serpents after warning his countrymen not to accept the Trojan horse into the city. Virgil's rich description of the serpents as they swim towards Troy and make for Laocoön placed the scene near a beach, while the graphic narrative of his struggle raised questions of the portrayal of suffering and the limits of language.[22] The Laocoön debate can be read, then, as an important moment of the discourse discussed above, which reflects not only problems of identity and the body, but questions of language, form, and knowledge that trouble the philhellenism of the later eighteenth century.

'The purest sources of art are open; happy is he who finds them and tastes,' declares Winckelmann's *Imitation* essay.[23] The essay introduces the famous Laocoön sculpture as 'a perfect rule of art', which establishes the norm for ancient as well as modern artists.[24] We today believe Winckelmann to be hundreds of years off in dating the sculpture, which is now thought to be a Hellenizing Roman work, but in Winckelmann's time, the group was considered one of the heights of the classical style of Greek artwork. It represents precisely the 'noble simplicity and quiet grandeur' of the best Greek works.[25] Winckelmann explains these characteristics by reference to the representation of affect, invoking the sea as a metaphor for the struggle of Laocoön on the beach:

Just as the depths of the sea remain always calm no matter how much the surface is disturbed, just so, the expression in the figures of the Greeks shows, in all passions, a great and resolute soul (*So wie die Tiefe des Meers allezeit ruhig bleibt, die Oberfläche mag noch so wüten, ebenso zeiget der Ausdruck in den Figuren der Griechen bei allen Leidenschaften eine große und gesetzte Seele*).

This soul shows itself in the face of Laocoon, and not only in the face, at the time of the greatest suffering. . . . He raises no terrible shout, as Virgil sings about his Laocoon. The opening of the mouth does not allow it; it is more a fearful and oppressed sigh, as Sadoleto describes. Pain of the body and greatness of the soul are distributed through the whole arrangement of the figure in equal measure. Laocoon suffers, but he suffers like the Philoctetes of Sophocles: his misery touches us in the soul, but we would wish to be able to bear the misery like this great man.[26]

A question of form – the rule of art constituted by the Laocoön group – is yoked to a question of emotion: the extent to which suffering is expressed in the sculpture. Greek artwork is a model for moderns because of the way it relates troubled surface and calm depth, suffering and its representation in language and the body.[27] The comparison with the sea, placid below while agitated above, suggests an undiscovered and perhaps inaccessible depth to the Greek spirit. It is a powerful metaphor for the same reason that Homer's Achilles looking out over the deep and Goethe's Iphigenia searching the sea are so haunting: it shows us coming to terms with an unfathomable greatness.[28] For Winckelmann, sighing (*Seufzen*) – as opposed to crying – seems to be gendered masculine, since it represents a greater mastery of self. The greatness of the Greeks, for Winckelmann, consists in their non-expression of suffering, in contrast to the more emotive – and apparently, weaker – Romans of Virgil, who cry out their pain. And the model for this self-mastered suffering is Sophocles' Philoctetes, whose cries, Winckelmann suggests, are not the screams of Virgil's Laocoön, but the subdued sighs of the statue group.

The normative language of internality in Winckelmann's description established the questions of Greek emotion and corporeality as central issues for the philhellenism of his time. With the mention of Philoctetes, another beach-bound sufferer, Winckelmann inscribes his work into an apparently independent tradition of reflection concerning the expression of emotion in

drama. Around the same time as Winckelmann's essay, Denis Diderot had employed the figure of Philoctetes in his *Entretiens sur 'Le fils naturel'* (1757). Here, the figure of Philoctetes seems to represent natural expression as opposed to the artifice of French theatre in Diderot's time – especially that of the recent, and quite popular, adaptation of the story, *Philoctète* by Jean-Baptiste Vivien Châteaubrun (1755). Where Winckelmann's Philoctetes represented the triumph of virtue over emotion, Diderot's Philoctetes is an emblem of immediacy and expression: 'I will not cease to cry to our French: truth! nature! the ancients! Sophocles! Philoctetes! The poet [Sophocles] shows him in the scene, lying at the entrance to his cave and covered with torn rags. He wraps himself up. He experiences an attack of sorrow. He cries out. He makes heard inarticulate utterances.'[29] Diderot's Philoctetes represents pure, animal expression rather than self-mastered suffering. Diderot focuses less on physical pain than on the squalor and emotional distress of Philoctetes, left to his own devices on the island of Lemnos and plagued by a diseased foot.

The question of how suffering can and should be represented in art was particularly urgent in the 1750s. Philoctetes seems to have been something of a problem for Adam Smith, who in his *Theory of Moral Sentiments* (1759) emphasizes, like Diderot, the emotional appeal of Philoctetes, but finds this to be potentially compromised by his physical pain. He invokes Philoctetes's isolation as the key to the appeal the figure makes to the imagination: 'It is not the sore foot, but the solitude, of Philoctetes which affects us, and diffuses over that charming tragedy, that romantic wildness, which is so agreeable to the imagination.'[30] But for Smith, Sophocles' depiction of such suffering on stage is 'among the greatest breaches of decorum of which the Greek theatre has set the example.'[31] Better than representing suffering, the following paragraph maintains, is to show us its suppression, which will lead to a feeling of admiration in the viewers. Philoctetes, Smith implies, fails to incite such a feeling of admiration, and instead incites only pity.[32] Though working from a stoical framework similar to Winckelmann's, Smith reads Philoctetes' cries in the opposite way: not as a model of suppressed suffering, but as a scandal of the expression of physical pain.

The cries of Philoctetes – 'ah!', 'papai!', 'pheu!' and all varieties of combinations – beggar translation. Though often expressed within regular tragic meters, they push the boundaries of meaning and the possibilities of language:[33]

ἀπόλωλα, τέκνον, κοὐ δυνήσομαι κακὸν
κρύψαι παρ' ὑμῖν, ἀτταταῖ· διέρχεται,
διέρχεται. δύστηνος, ὦ τάλας ἐγώ
ἀπόλωλα, τέκνον· βρύκομαι, τέκνον· παπαῖ,
ἀπαππαπαῖ, παπᾶ παπᾶ παπᾶ παπαῖ. (742–6)

I am destroyed, child, I will not be able to conceal my ill before you. Attatai!
It goes through me, it goes through me. Misery, oh, unhappy as I am! I am
destroyed, child, I am devoured, child! Papai! Apappapai! Papa! Papa! Papa!
Papai!

It is rather astonishing to find these cries read, in Winckelmann's *Imitation*
essay, as an example of suppressed suffering. They seem to most readers to be
anything but, and the reactions to them portrayed on stage suggest that they
are genuinely horrifying.[34] Lessing, though admitting Winckelmann's reading
of the Laocoön group as a portrayal of stoic resistance to suffering, takes issue
with the description of Philoctetes in his *Laokoon* (1766):

> 'Laocoon suffers like Sophocles' Philoctetes.' How does he suffer? It is
> surprising that his suffering left such different impressions in us. – The cries,
> the shout, the wild curses with which his pain filled the camp and disturbed
> all the sacrifices, all the holy actions, resound no less awfully through the
> barren island, and they were the thing that caused him to banished there.[35]

Like Diderot, Lessing sees Philoctetes as a model of immediacy and raw
emotion. From here, Lessing goes on to argue that the Greeks did not believe
expression of suffering to be incompatible with heroism, with the examples of
Homer's heroes, among others, to support the assertion. The central category
of Lessing's dramatic aesthetics is sympathy (*Mitleid*), which gives suffering a
privileged role as a means of creating an emotional connection between
character and audience. 'All that is Stoic in untheatrical', Lessing writes, 'and
our sympathy is always equal to the pain that the interesting object expresses'.[36]
The expression of strong affect – prohibited to works of visual art because it
would render them ugly – finds its home on stage, and in a culture that does
not judge emotion as unheroic.[37]

Lessing's exaltation of emotive suffering might be expected to have appealed
to the young Johann Gottfried Herder: like Lessing, Herder is a disciple of
Diderot's aesthetic of naturalness and directness, and like Lessing, he is broadly

an opponent of the tyranny of the eye that Winckelmann had initiated in German culture. Philoctetes crops up again and again in Herder's writings and seems particularly important for his expressions of emotion. And yet, Herder sides with Winckelmann over Lessing on the question of how Philoctetes expresses suffering:

> Let the Philoctetes of Sophocles decide: how does he suffer? It is strange that the impression this play has left on me from long ago is the same that Winckelmann believes it makes: namely, the impression of a hero who struggles against the pain that assails him, holds it back with hollow sighing for as long as he can, and finally, when the 'oh!' and the dreadful 'alas!' overwhelm him, still utters only solitary, stolen sounds of sorrow and conceals the rest within his great soul.[38]

To Herder, Philoctetes is important for his representation of a whole spectrum of responses to suffering. Where Lessing sees the cries in one dimension – expression vs. suppression of pain – Herder adds a temporal element, seeing the struggle with pain over time as the essential point of the scene. He also adds an emotional nuance, distinguishing the sensitivity to loss of Greek heroes from the sensitivity to physical suffering. We sympathize with Philoctetes, Herder argues (along lines similar to Smith), less because of his physical agony than because of his isolation and cruel betrayal at the hands of his countrymen. Herder admits that Greek heroes often cry, but, he argues, this is always in response to grief and loss, rather than physical pain. Though not advocating an emotional stoicism, Herder does advocate a physical one, and uses the example of Philoctetes to demonstrate the heroic struggle against pain. Herder places Philoctetes within a broader understanding of emotions in ancient Greece, and contextualizes Lessing's observation that heroism and expression of emotion were compatible for the Greeks. The divergent answers reached by Winckelmann, Lessing, and Herder all speak to the way that questions of knowledge and questions of affect were bound up in the eighteenth century.

Sighs and cries, to an even greater extent than articulate speech, demand interpretation. Their urgency creates a burden that is ethical as much as hermeneutic, which renews itself with every reading or hearing. They demand that we give them sense, redeeming their inarticulateness. This burden is felt particularly in contexts – like the philhellenic one – in which what demands

interpretation is already itself the object of intense emotional and intellectual cathexis. Philoctetes' cries (or sighs) make a claim on philhellenic discourse to translate the Greek letters on the page into our own language. We move between the poles of the ancient, suffering body, and modern, scientific speech. The specific form of this movement, I suggest, is in flux in the period sketched in this paper, as the ambiguities of Winckelmann's programme concerning both knowledge and the body played out in the thought and art of his contemporaries and epigones.[39] The sighs and cries of the late eighteenth century enact the many, often contradictory possibilities of interpretation that inhere in a philhellenism that recognizes the Greeks both as inimitable and as the only model for imitation.

Winckelmann's *Imitation* essay makes the Greek, suffering body a privileged space for the layering of philhellenic meaning. Expressions of affect carry with them expectations about the way that emotion is inscribed on the male and female body.[40] At the same time, philhellenism presents a notably fluid regime of gender and embodiment. One cannot always confidently assign stable identities to the subjects of philhellenism, and this may have been part of its appeal. The gendered discourse surrounding Iphigenia's sigh or Laocoön's cry may seem rather bald and straightforward, but it gains a greater brisance in the context of philhellenic thinking, where expressions of emotion have a tendency to exceed their subject and speak to broader questions of identity. Though there is undoubtedly a tendency within philhellenism towards abstraction and idealization – and this has been the main focus of historiography – one also finds an immersion in the individual, emotion, and the body. Which (if either) of the two is the primary impulse, and which the reaction, is by no means clear.

The sighs and cries of philhellenism take place on the border of meaning. They delimit the boundaries between sense and nonsense, human and animal, male and female.[41] This is not only because they bring up radical problems of semiotics and translation, but because they point to emotions that seem to exceed language. Sighs and cries express an affective depth that cannot come to the surface of meaning, and bespeak an internality that is fundamental to the Romantic view of expression. Their prevalence around 1800 is symptomatic of an age in which (returning to Kittler's analysis) 'discourse networks' are in transition, from a notion of speech as something defined and ulterior to the self to one that sees language as an opaque emanation of the self.[42] This suggests

a developmental narrative to the movement sketched here, as the debates of the age of Lessing as to what Philoctetes' cry mean are replaced in the age of Goethe by sighs, which demand but also frustrate attempts to comprehend. What had seemed knowable (if debatable) through antiquarian erudition came to be itself the unknown and unspeakable, the depth that produces language and meaning. This dumbness or untranslatability is at the heart of the new discipline of classical philology, which seeks to give voice to texts that have become silent, to make sense out of nonsense. What emerges is, by and large, what we know as interpretation or hermeneutics; but there is nevertheless a remainder, something uninterpreted and perhaps uninterpretable. Philhellenism, I suggest, gains its emotional and intellectual urgency from this remainder, which speaks itself out in Iphigenia's sighs simultaneously as a longing for the depths that remain unplumbed, and a fear that there is in fact nothing beneath the surface. The sigh of philhellenism looks out to a deep that is also an abyss.

Notes

1 Goethe citations refer to volumes in the edition (abbreviated *FA* for *Frankfurter Ausgabe*) *Sämtliche Werke: Briefe, Tagebücher und Gespräche*, 40 vols (Frankfurt 1985–99). All translations are my own.

2 Butler (1935: 3).

3 Butler (1935: 6).

4 Butler (1935: 6).

5 These questions are explored with depth and insight in Güthenke (2008) and Valdez (2014).

6 Kittler (1990: 3).

7 Kittler (1990: 4).

8 Though, unsurprisingly, the Helen act of *Faust II* does. I do not have space to discuss either Goethe's Helen or Euripides' *Helen*, but both are directly relevant to the material here. See Curran (2000). Though Euripides' two plays bear striking resemblances to each other, the *Iphigenia*'s more serious tone may have made it more palatable to eighteenth century norms of tragic decorum.

9 Aristophanes, *Frogs* 946–7: 'But in my plays the one entering very first immediately tells the origin of the drama.' Goethe was well aware of Aristophanes' text and had read widely in Euripides' works. See Petersen (1974).

10 Fragments of the Hesiodic Catalogue of Women and of Stesichorus suggest that Iphigenia had been saved by Artemis and deified, and Herodotus mentions that the Taurians worship Iphigenia (4.103).

11 Torrance (2007). This is one of the factors that make the piece the most Euripidean of the many eighteenth-century *Iphigenia* operas: Evans (2007: 37–53).

12 On parallels with Winckelmann's and Herder's aesthetics, see Richter (1996).

13 See Berger (2007: 19–42).

14 Goldhill (2010b: 216–17).

15 On Ariadne and her legacy in Italian opera, see Heller (2004: 82–135).

16 Winckelmann (1764: 430). Translation modified from Winckelmann (2006: 351).

17 Davis (1996).

18 Potts (1994: 48–50) and Harloe (2009).

19 I follow here Constanze Güthenke's lead in Güthenke (2010).

20 Winckelmann, *Geschichte*: 430–1. Translation modified from Winckelmann (2006: 351).

21 On the importance of Lessing for thought on art, see Wellbery (1984) and Mitchell (1986).

22 Vergil, *Aeneid* 2.199–227. On the Laocoön tradition in poetry and the arts, see Most (2010).

23 Winckelmann (1756: 2). Winckelmann's essay is usually quoted in the expanded second edition from 1756.

24 Winckelmann (1756: 3): 'eine vollkomene Regel der Kunst'.

25 Winckelmann (1756: 21): 'edle Einfalt . . . stille Grösse'.

26 Winckelmann (1756: 21–2).

27 Richter (1992: 43–8).

28 On Achilles and the deep, see Butler, 'Homer's Deep', this volume.

29 Diderot (1757: 205).

30 Smith (2002: 37).

31 Smith (2002: 37).

32 On the problem of pity, see Nussbaum (2008).

33 On Philoctetes' cries in Sophocles, see especially Nooter (2012: 134–9).

34 See Budelmann (2007).

35 Lessing (1990: 18).

36 Lessing (1990: 21).

37 This applies equally to Lessing's understanding of Ajax, another Greek sufferer on the shore: in painting, he must not be represented mad (since this would be ugly – as presumably would a painting of the suicide, which Sophocles places on stage), but after his madness, as he makes the decision to kill himself: Lessing (1990: 34).

38 Herder (1993: 69).
39 See Giuliani (2001).
40 See especially Potts (1994) and Richter (1992).
41 See further Weissberg (1989).
42 Kittler (1990: esp. 36–42).

Feeling on the Surface: Touch and Emotion in Fuseli and Homer*

Alex Purves

There are three hands on view in Henry Fuseli's 1778 drawing 'The Artist Despairing over the Grandeur of Ancient Ruins' (Figure 5). One, a giant fragment leftover from a colossal statue of Constantine the Great, points upwards, so that the index finger touches the edge of the drawing. Another, half obscured, covers the face of the weeping artist. The third reaches, at the end of a long outstretched arm, to feel the surface of the ancient stone. With this right hand, therefore, the artist 'connects' with antiquity, feeling its surface through his skin, even as the gesture enacted by his left expresses the futility of ever really connecting at all.

This red chalk and brown wash drawing has been called a textbook example of the eighteenth-century view of antiquity, insofar as it positions the artist below, after, beneath, literally at the feet of, the fragments of a once complete past.[1] For my purposes, I want to focus on the notion of feeling that this image evokes, and to try to think about how feeling may grant us a form of access to the past that is different from other modes of interpretation.

Three hands, and thus also three deictic gestures: up, across and back towards oneself. Three acts of touching that call into question the distance, or more accurately the depth, between antiquity and ourselves. For it is not just that the artist touches the statue and thereby connects with classics through

* I thank the audience at the Deep Classics conference for stimulating discussion and Shane Butler for his inspiration and ideas in helping me to formulate this topic. Joshua Katz, Cannon Schmitt and Mario Telò have also kindly read drafts of this essay at various stages of its conception – I am grateful for their comments and observations.

Figure 5 Henry Fuseli, *Der Künstler, verzweifelnd vor der Grösse der antiken Trümmer* ('The Artist Despairing over the Grandeur of Ancient Ruins') (1778–80). Photo by DeAgostini/Getty Images.

the haptic rather than the visual sense. It is that he touches it all the way along his arm, from his index finger to his chest, with the stretch of his reach draped across the marble foot. In an otherwise wholly static drawing, all the action is contained here, in this single line of tactile exchange between the underside of the forearm and the surface of the stone.

Foreclosing sight with one hand, and reaching out to feel a surface on the other, Fuseli repeats the same gesture five years later in an oil painting depicting

Polyphemus as he gropes the back of his ram (Figure 6).[2] Again, one hand moves up and back toward the face, registering deep but hidden emotion,[3] while the other reaches forwards, and – through the act of feeling – suggests intimacy. As with the earlier drawing, here the depth of feeling transmitted by the act of touching registers despair at what has been lost. In Homer's epic, that feeling is voiced at *Odyssey* 9.444–57:[4]

> Last of all the flock the ram went out of the doorway,
> loaded with his own fleece, and with me, and my close counsels.
> Then, feeling him, powerful Polyphemos spoke a word to him:
> 'My dear old ram, why are you thus leaving the cave last of
> the sheep? Never in the old days were you left behind by
> the flock, but long-striding, far ahead of the rest would pasture
> on the tender bloom of the grass, be first at running rivers,
> and be eager always to lead the way first back to the sheepfold
> at evening. Now you are last of all. Perhaps you are grieving (*potheeis*)
> for your master's eye, which a bad man with his wicked companions
> put out, after he had made my brain helpless with wine, this
> Nobody, who I think has not yet got clear of destruction.
> If only you could be one with me and only be given a voice,
> (εἰ δὴ ὁμοφρονέοις ποτιφωνήεις τε γένοιο)
> to tell me where he is skulking away from my anger . . .'[5]

As his words make clear, Polyphemus cannot, despite his fingers' massive span, grasp the knowledge of what lies beneath (in the painting, as in Homer, the legs of Odysseus are easily perceptible to us). Regardless of the familial way in which the giant pets his ram, Fuseli's painting stages an irreparable moment of rupture between two periods in time ('the old days' and 'now') as between the beings themselves. This is particularly obvious at the end of the speech, when the giant wishes that the ram were endowed with voice and laments the impossibility of *homophrosunē* (like-mindedness) between them: 'If only you could be one with me and be given a voice' (456). *Homophroneō* is used elsewhere in the *Odyssey* to express the like-mindedness of a husband and wife, but here the final aching syllables of *homophroneois* are full of frustration and desire (the optative form in *-ois* introduces an unattainable wish, as it also evokes the 'oi' of *oimoi*, the Greek words for 'alas', while the opening of the mouth around *e-oi*, is perhaps also captured in Polyphemus' 'extraordinary open mouth' on the canvas).[6] The

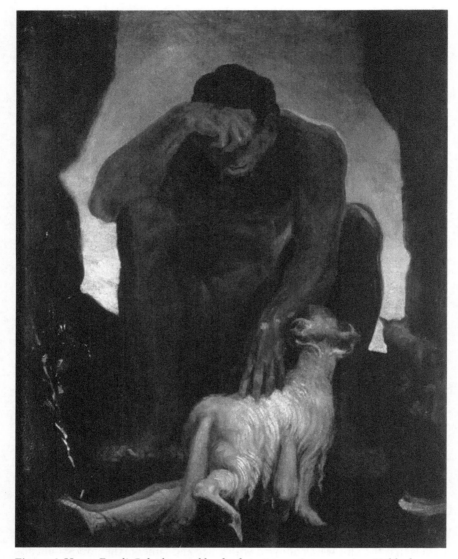

Figure 6 Henry Fuseli, *Polyphem, geblendet, betastet am Ausgang seiner Höhle den Widder, unter den Odysseus entweicht* ('Polyphemus, blinded, feels at the exit of his cave his ram, under whom Odysseus is escaping') (1803). Private collection. Image courtesy of the Schweizerisches Institut für Kunstwissenschaft.

yearning which generates the final omicrons and iotas of *homophroneois* and *genoio* emerges from the convergence of feeling and speaking (*epimassamenos prosephē*, 9.446) with which the passage began. It is only under the pressure of

the Cyclops' touch, in other words, that we are driven to understand the sense of loss that physically connects Polyphemus to his ram.[7]

As we look at these images side by side, it is easy – as with many of Fuseli's drawings – to spot similarities in structure and composition. The body of the sheep in the Polyphemus scene occupies approximately the same space within the frame as the body of the artist in the scene upon the ruin, and the legs that emerge from beneath the ram in the former are similar in composition to the legs of the artist in the latter.[8] The giant hand and foot of the colossus establish a discrepancy in scale that is similar to the discrepancy established by the giant Polyphemus, whose ram is about the same size, relative to him, as a cat would be to a normal man. In other ways, though, the terms of the comparison are crossed. For it is Polyphemus' ram which looks up in the second drawing, while the giant himself, like the despairing artist, bends his face forward in one hand and feels with the other. And instead of feeling a fragment, Polyphemus grasps for something that is overloaded, complete in itself but also superfluous, with extra limbs added on (cf. 9.445). When compared along these lines, we can now see that high and low, left and right, have been reversed to turn the meaning of Fuseli's earlier drawing into something slightly more complicated. For in the Polyphemus scene the emotive acts of feeling and touching no longer react to but are represented in the vast and damaged body of the past. In the Cyclops we see antiquity, the great ruin, itself despairing as it tries blindly to feel its way between the world as it was then and the world as it is now. This second image, most importantly, shows us antiquity touching back, with a grasp that is – like the modern artist's – despairing and insufficient.

I am interested in the Cyclops' touch because it provides a warm-blooded response to what is often classified as the 'feel of antiquity', or what we might usually describe as the cold feel of smooth marble beneath our own living hands. Of course, we cannot really feel the past, but that is not to say that we don't imaginatively do so. Using the haptic sense as a mode of 'reading' or 'connecting' to the past fuses with the idea that we can tap into some unique or special quality, some kind of essence, only through the fingers. As Eve Sedgwick writes in *Touching Feeling* (2003: 17), to touch or feel is to sense through both our interior selves (as in 'being touched') and our exterior ones (by ourselves touching) in a curious overlaying of surface and depth. Moreover, as she points out, 'a particular intimacy seems to subsist between textures and emotions'.

Figure 7 Leon A. Borensztein, photograph of Judith Scott (1999). Reprinted with permission.

Of central importance to *Touching Feeling* is a picture of the artist Judith Scott embracing one of her yarn sculptures, made from bits and pieces of fabric and found or stolen objects (Figure 7). This third image resonates quite intriguingly with the play between surface and depth of feeling that we have

seen already in Fuseli's work. The portrait of Scott evokes both the outstretched arm of Fuseli's artist (in each of the three images a single forearm plays a decisive role) and the intimacy and emotion of Polyphemus' touch.

Sedgwick chose the photograph for the cover of her book because, as she writes, 'it conveys an affective and aesthetic fullness that can attach even to experiences of cognitive frustration' (24). The artist Judith Scott, born deaf and with Down Syndrome, was mute throughout her life, and just as this photograph of her privileges touching over viewing, so does it also privilege the affective ties that connect us outside the realm of language. Everything about this picture calls out to be read as a kind of immersion in a deep surface,[9] even to the extent that Scott burrows her face into the object she embraces (the yarn, like the ram's back, suggests the quality of an 'overlaid' or 'deep' surface). For Sedgwick, the image is significant because it helps us to interpret using a different set of prepositions. Not 'beneath', 'behind' or 'beyond' – the usual terms in critical exegesis – but instead 'beside'.[10] Just as the introduction to this volume speaks of the importance of lateral thinking, so Sedgwick expresses an attempt in her book to 'explore some ways around the topos of depth or hiddenness, typically followed by a drama of exposure' which she associates with a hermeneutics of suspicion.[11] For both, I think, the ways in which words or ideas can 'resist definition' point towards a form of dispersal, texture, or depth of field.[12]

Polyphemus has already been exposed by Odysseus' 'No-man' trick as a creature ill-equipped to manage words. From one perspective therefore the passage from *Odyssey* 9 simply stages Polyphemus as a bad or 'surface' reader. Like a plodding textual critic, the Cyclops cannot perceive the true subtext of the scene before him – the secret beneath the ram's belly – but instead fumbles about on the surface, feeling for what is literally there. He laments the fact that his ram has no voice, yet the scene still suggests that he communicates something to him through his touch, and something is communicated from the ram back to him. We ourselves can feel it in this passage, as we can also feel it in Fuseli's painting.[13] There is something fuzzy at the edges of Homer's text; something woolly, brackeny, foamy, and difficult to make logical sense of.

The verb that denotes the Cyclops' touch, *epimaiomai*, might just refer to a kind of generalized feeling or groping, such as a creature who has been recently blinded might engage in. The verb occurs twice after the blinding, first at 9.441 when Polyphemus 'felt along the backs of all his sheep', and then again at 446,

in the passage we have been studying ('feeling [his ram] he spoke . . .'). It joins
a small set of haptic phrases that cluster around Polyphemus after the trauma
of being blinded (9.415–18):

> But the Cyclops, groaning aloud and in the pain of his agony,
> felt with his hands (χερσὶ ψηλαφόων), and took the boulder out of the
> doorway,
> and sat down in the entrance himself, spreading his arms wide (χεῖρε
> πετάσσας),
> to catch anyone who tried to get out with the sheep . . .

Epimaiomai, as others have observed, is also used at 19.468, during the
scene of the discovery of Odysseus' scar ('and she [Eurycleia] knew, by
feeling it') (γνῶ ῥ᾽ ἐπιμασσαμένη).[14] Its placement there suggests that, as a
mode of interpretation, Polyphemus' thick fingers on the tangled back of the
ram do count for something. Those fingers add something to how we read
the scene and suggest that surface reading – alongside what we have long
called deep or symptomatic reading – figures somehow in our approach to
ancient texts.

If my 'something' and 'somehow' in the previous paragraph sound vague,
this is because I have strayed into the territory of feelings. Although we have
long been instructed to ignore our feelings when approaching the past, James
Porter has described classicism as itself an elusive idea that is 'steeped in the
language of feeling and affect'.[15] The question, as he puts it, of 'what . . . it feel[s]
like to be classical, or to be in the presence of whatever is felt to be classical' is
not only raised by the first Fuseli image but accentuated by the textured
surfaces of the ram's back. The thick, pliant and especially deep possibilities of
both speak to the sense that surfaces have a grain that we might choose to read
'along' or 'with' instead of the more traditional 'against'.[16]

Homer's shallows

In Derek Walcott's *Omeros*, Homer's name emerges through the smooth
touch of the fingers upon a small marble bust of the poet, and from there is
transposed onto various forms of what we might call deep surface (*Omeros*
1.2.3 [Walcott 1990, 14]):

"O-meros," she laughed. "That's what we call him in Greek,"
stroking the small bust with its boxer's broken nose,
and I thought of Seven Seas sitting near the reek

of drying fishnets, listening to the shallows' noise.
I said: "Homer and Virg are New England farmers,
and the winged horse guards the gas-station, you're right."

I felt the foam head watching as I stroked an arm, as
cold as its marble, then the shoulders in winter light
in the studio attic. I said, "Omeros,"

and O was the conch-shell's invocation, mer was
both mother and sea in our Antillean patois,
os, a grey bone, and the white surf as it crashes

and spreads its sibilant collar on a lace shore.
Omeros was the crunch of dry leaves, and the washes
That echoed from a cove-mouth when the tide has ebbed.

The name stayed in my mouth.

Together, these thickly textured surfaces accumulate in the poet's mouth, filling out the rounded sound of 'O' or conch shell or recurring wave even as the imagery of the lines is drawn back again and again to the surface. The fishnets reek of the deep, yet their job is also to bring what is underneath to the top and leave it drying on the land. In his description of the water-filled cove, Walcott ends with shallows, at that moment when everything is washed away. Depth, to be sure, has a place in Homer's name; symbolized by the 'mother and sea' in the fourth stanza, or even in the subterranean origins of crops and petrol in the second, but it is what's on the surface that gives substance to the poet's words: the soft texture of foam riding on top of the wave's edge or breaking smoothly against the shore. Homer may have become a New England farmer, but the operative critical metaphor in Walcott's articulation of his name is not digging but feeling; even Virgil, nicknamed 'Virg', puns on 'verge', edge, or brink.

Like the ram's back, which transfers touching to a thicker medium, Walcott's act of 'feeling through' Homer's name moves from fingers on a cold marble bust to the rich, foamy, crunchy taste of one poet's name inside the mouth of another. But it is the sea, which – as both the *Omeros* passage and Shane Butler's

essay in this volume show – reflects perhaps best of all the ever-revolving question of surface and depth.

In the *Iliad*'s description of the destruction of the Achaean wall, Troy is famously obliterated when washed smooth by the force of several rivers and covered over with sand (12.30–1):[17]

λεῖα δ' ἐποίησεν παρ' ἀγάρροον Ἑλλήσποντον,
αὖτις δ' ἠιόνα μεγάλην ψαμάθοισι κάλυψε . . .

and made all smooth again by the hard-running passage of Helle
and once again piled the great beach under sand . . .

What is left behind, in Homer's configuration, is not the surface of a ruin or fragment but literally nothing. The past is washed away into smoothness, becoming a curious kind of aesthetic object whose absence and impossibility, as Porter has argued, paradoxically recalls its past.[18] But the temptation has also been strong among critics to see Homer as similarly flat – as all shiny surface without lacuna, shadow or depth.[19] This widespread practice has something to do with Homeric style: the paratactic nature of epic verse, its lack of suspense, the strung-along way in which it presents temporal events (aka Zieliński's Law), the apparent absence of interiority, or 'deep self', among the characters, the extensive use of description, and the supposed 'immediacy' of composing without writing.[20] This makes of Homer a curiously shallow and surface poet. In honor of the title of this volume, here is one of those critics explaining why Homer is not 'deep':[21]

> Homeric speech does not yet know this aspect of the word 'deep'. It is more than an ordinary metaphor; it is almost as if speech were by this means trying to break through its confines, to trespass on a forbidden field of adventure. Nor does Homer show himself conversant with the specifically spiritual facet of 'deep knowledge', 'deep thinking' and so forth. The words βαθύφρων and βαθυμήτης are, it is true, formed by analogy with Homeric expressions, but they are πολύφρων and πολύμητις, 'much-pondering' and 'much-thinking'. Just as lyric poetry specializes in compounds formed with βαθυ-, so Homer uses the prefix πολυ- to express an increase of knowledge or suffering: πολύιδρις, πολυμήχανος, πολυπένθης, etc., 'much-knowing, 'much-devising', 'much-suffering.' Quantity, not intensity, is Homer's standard of judgment.

According to his analysis, the word *bathu* (deep) is underutilized in epic and far subordinate to *polu* (many) compounds. Although Snell overstates his case, the distinction he raises between 'depth' and 'multiplicity', as well as between 'intensity' and 'quantity', is a fascinating one. What does it mean that depth, classified in the same sentence as 'more than an ordinary metaphor' and a 'forbidden field of adventure', is not admitted into our reception of Homer? We may think of the classical past as deep because so far away, yet we also insist on making the earliest parts of that past shallow, smooth, and transparent.[22]

For the remainder of this paper, I will suggest that we are mistaken in doing so, and I will argue that an important kind of depth lies on the surface in Homeric epic. I think it is important to point this out because it counters our practice of reading antiquity along the lines of either smooth, polished surface, as if a pristine ruin, or as archaeological site or archive which we dig through in our continued effort to reveal the long-buried secrets of the past. One might also say that reading Homer on the surface means stopping to pay attention to the trivial details, filler words, and various stylistic elements that we might otherwise skip over.[23] To read depth on the surface is to pay attention to affect over action, as scholars such as Sedgwick (2003) and Brinkema (2014) have suggested, and to rethink surfaces as unstable forces with their own intensities.

 Let's start with one seemingly innocuous word, the participle *dakruoessai* ('weeping') used to describe the Nereids as they emerge from the sea at the behest of Achilles at *Iliad* 18.65–7 (translation mine):

> ...αἱ δὲ σὺν αὐτῇ
> δακρυόεσσαι ἴσαν, περὶ δέ σφισι κῦμα θαλάσσης
> ῥήγνυτο·

> ...they went with [Thetis]
> weeping, and about them the wave of the water
> was broken.

At first glance, the detail that the Nereids are weeping seems somewhat irrelevant, especially because the section of the *Iliad* following the death of Patroclus is filled with tears. But the doubling of the wet, salty surface of the Nereids' face with the wet, salty surface of the broken wave as the women

emerge from the sea calls attention to a somewhat complex transition from interior to exterior and from depth to surface. As the exteriorization of one's interior self, tears attain a surface visibility once they have welled up within the eye and for the duration of their passage down the face, but in their near-immateriality, near-invisibility, and their one-word mention in the poem, they cry out to be ignored. No sooner have they materialized on the Nereids' cheeks than the seawater washes them off.[24]

Like Walcott's fishing nets, Homer surfaces the deep, bringing the thirty-four Nereids up from under the sea. But their tears can hardly be called deep: the goddesses carry their emotions on the surface of their faces, and even the tears themselves are in some sense false. How can anyone cry underwater, how can a tear appear on a wet face that breaks through the waves?[25] Even worse, here the Nereids are crying without really knowing why they are crying, for they have not yet, supposedly, learned of Patroclus' death. Their tears could then be seen as utterly stylized, as shallow as the surface of the water they emerge from. But the truth is that we don't really know what the Nereids know and how much they care:[26] their tears are, like the wave before it breaks, transitory and fragile – hard to read and hard to grasp. Indeed, their doubling with the water's surface makes clear what is always true about weeping: tears are hard to depict. Witness Fuseli's artist and Polyphemus, who both cover their faces as they weep.[27] In this scene, as I have mentioned, the tears are no sooner expressed than displaced, washed away by the wave's break into the sibilant θαλάσσης (18.66).

Why then does *dakruoessai* emerge at this precise point in the text, at the very moment of the face's contact with the water's surface? The breaking curve of the sea pulls into its swell the multiple tears of the nymphs (there are thirty-four of them in all, so how many individual drops of water are produced by each pair of eyes?), transforming *bathu* into *polu* as the sea rolls back and forth from a limitless horizon. It is a quick moment of transition, and quickly forgotten. But this twofold eruption of troubled surfaces leaves a small trace of feeling in the poem that is different from the heartfelt lament of Thetis from the depths for a son who will never return to her.[28]

In this sense Snell is right – it is not depth that gives the Homeric sea its intensity but the waves that roll across its surface and crash against beach and headland. The beach, hit repeatedly by the breaking wave of the sea, is *poluēxes*

('much-resounding'), not *bathuēxes,* and this ongoing rush of waves is a recurrent motif in the poem (4.422–6):[29]

> As when along the thundering beach (ἐν αἰγιαλῷ πολυηχέϊ) the surf of the
> sea strikes
> beat upon beat as the west wind drives it onward; far out
> cresting first on the open water, it drives thereafter
> to smash roaring along the dry land, and against the rock jut (ἄκρας)
> bending breaks itself into crests spewing back the salt wash . . .

I have discussed elsewhere the juxtaposition of sea and land in the *Iliad*'s description of the magical foals of Tros running along the edge of the shore (20.226–9).[30] There the word for surface (*akron*) registers two differently resistant planes – one not breaking ('they ran on the surface [*akron*] of the stalks of the wheat but did not break it') the other subsisting only as the form of a break stable enough to run along ('they would run along the surface [*akron*] of the break of the grey surf'). In both cases, as with the breaking wave of the sea around the Nereids' faces and Walcott's 'sibilant collar on a lace shore', Homer focuses attention on the transient surface.

As a form, therefore, the surface of the sea – like the tear on the face – is transient and contingent. In a famous simile from *Iliad* 16, the Myrmidons readying for battle are compared to wolves whose jaws are stained with blood after feeding on a stag. After their feast, having gathered around a dark-watered spring, the wolves drink from the water (16.159–62):

> . . .πᾶσιν δὲ παρήιον αἵματι φοινόν
> καί τ᾽ ἀγεληδὸν ἴασιν ἀπὸ κρήνης μελανύδρου
> λάψοντες γλώσσῃσιν ἀραιῇσιν μέλαν ὕδωρ
> ἄκρον, ἐρευγόμενοι φόνον αἵματος·

> . . .till the jowls of every wolf run blood, and then go
> all in a pack to drink from a spring of dark-running water,
> lapping with their lean tongues along the black edge of the surface
> and belching up the clotted blood.

As they lap the black edge of the surface (μέλαν ὕδωρ ἄκρον) with their narrow tongues, they belch up blood (literally 'spew'; ἐρευγόμενοι is elsewhere used of the sea sending forth a spray of foam), mixing the gore of blood (φόνον αἵματος) into the black water. In a chiastic act of regurgitation, from recto to

verso, interior to exterior (κρήνης μελανύδρου ... μέλαν ὕδωρ ἄκρον) the wolves bring back to the surface, in reverse order, the red blood (αἵματι φοινόν ... φόνον αἵματος) that stained their jaws two lines above. Like the affective, although practically invisible, overlaying of tears onto the water's break, or like the sand washed smooth in the Achaean wall's destruction, the blood that disappears into the dark spring's running surface leaves barely a trace of itself behind. But the streak of *phonos* – slaughter, gore, blood, hunger, desire – that slips into the water from the bellies of the wolves was first kindled in the eager spirits of the Myrmidons. The dark surface of the water, which first caught in its currents the flow of Patroclus' tears at the beginning of the book (16.2–4: 'standing by him [Patroclus] wept warm tears [δάκρυα θέρμα χέων] like a dark-watered spring [κρήνη μελάνυδρος] which drips dark water [δνοφερὸν χέει ὕδωρ] from a steep rock') now draws into its orbit the promise or threat of blood for Achilles and his men.[31]

The traces of affect in δακρυόεσσαι and φόνον αἵματος that linger briefly on the edges of Homer's world never make it to the depths. They offer no traction for the practice of deep reading.[32] Insistently buoyant, their special affinity is to the place of the surface, suggesting that certain structures of feeling survive only on the exterior. What is revealed through them is not hidden or repressed meaning but quite the opposite: something that momentarily breaks onto the surface, appearing as a form of 'seeming', an over-spilling of emotion and sensibility that rapidly disperses.

As we have already seen in the description of the weeping Nereids, the skin and the sea stand as two especially responsive modes for the notion of 'feeling on the surface'. In the last section of this paper, I will consider two of the *Iliad*'s passages where the skin is grazed by an arrow and flooded with blood: the wounding of Menelaus in book 4 and of Aphrodite in book 5. Both of these wounds turn out to be trivial and both privilege the superficial – *akron* – as a site of potential and desire. First, in *Iliad* 4 (130–47), Pandarus shoots an arrow at Menelaus that is not supposed to harm him, for we are told at the very opening of the passage that Athene brushes it away from his skin as she also directs it within (*en*), through (*dia*) and straight through (*diapro*) the multiple pieces and elaborate layers of Menelaus' armor until it scratches or inscribes (*epegrapse*) the topmost surface of his skin (*akrotaton chroa*, 4.130–40, 146–7):

She brushed it away from his skin (ἀπὸ χροός) as lightly as when a mother
brushes a fly away from her child who is lying in sweet sleep,
steering herself the arrow's course straight (ἴθυνεν) to where the golden
belt buckles joined and the halves of his corselet were fitted together.
The bitter arrow was driven against (ἐν) the joining of the war belt
and passed clean through (διά) the war belt elaborately woven:
into (διά) the elaborately wrought corselet the shaft was driven
and the guard which he wore to protect his skin and keep the spears off,
which guarded him best, yet the arrow plunged through (διὰπρό) even this
 also
and it grazed (ἐπέγραψε) the man's skin on its very surface (ἀκρότατον)
and straightaway from the cut there gushed a cloud of dark blood.
. . .
so, Menelaos, your shapely thighs were stained with the colour
of blood, and your legs also and the ankles beneath them.

As the arrow passes through and through, it seems both to reach and fail to
reach its target: certainly the interlacing of *dia* with *akrotaton* suggests both
interior and exterior, or depth before the edge. One might say that the arrow's
course plots a fantasy of reaching the surface, one that is superficially validated
by the immediate rush of Menelaus' blood.[33] But as this new blood flows over
the skin like a stain or dye, so does it also wash through and renew the surface,
beginning to reform the contours of the body, from its well-formed thighs all
the way down to its shins and ankles.

Aphrodite is similarly grazed at the very edge (*akrēn*) of her soft (*ablēchrēn*)
hand in *Iliad* 5. The desire of Diomedes, who reaches out and leaps after the
goddess, like the desire of the arrow as it passes through Menelaus' armor,
leaves its trace as a form of surface affect on the soft edge of her hand, a
temporary disequilibrium, discoloring, or change of texture that also reflects
on the mood of the poem (5.334–40):

Now as, following her through the thick crowd, he caught her,
lunging in his charge far forward the son of high-hearted
Tydeus made a thrust against the soft surface (ἄκρην) of the hand with the
 bronze spear,
and the spear tore the skin driven clean on through the immortal
robe that the very Graces had woven for her carefully,

over the palm's base; and blood immortal flowed from the goddess,
ichor, that which runs in the veins of the blessed divinities.

The editors of a recent collection on affect theory talk of affect as a kind of
'bloom-space', always full of potential, of never-quite-knowing, and of an
indeterminate stilling, or over-spilling, of the present.[34] The spread of blood
(or *ichor*) across the skin, tears across the sea's surface, or the fingers of
Polyphemus across the ram's back all leave only ineffable traces on the action
of their stories. What I have tried to do in the second half of this paper is not
just to come to terms with the alluring fantasy that we ourselves might touch
the surfaces of antiquity[35] (and if we could touch them what would they feel
like?), but also to try to work out how – in Homer at least – those surfaces
might react to the touch. Whether, in short, they can guide us towards reading,
experiencing, or even feeling the ancient world in a different way.

We have seen in these last Homeric examples some of the ways in which
akron breaks, resists, withholds, and transmits the flood of emotion and
expression between interior and exterior. By trying to read on the surface, in
some way or other, we end up perhaps no closer than Sappho's apple pickers,
for whom the fruit that 'turns red on a high branch / high on the highest branch'
(ἐρεύθεται ἄκρῳ ἐπ' ὕσδῳ / ἄκρον ἐπ' ἀκροτάτῳ) is always out of reach.[36] In
pointing so insistently to a reduplicating (*akrō . . . akron . . . akrotatō*) surface
that can never be touched, the fragment teases the reader with multiple
strategies: deixis, erasure, and then deflection ('. . . and the apple pickers forgot
– / well no, they didn't forget – were not able to reach').[37] Yet the apple pickers'
ambivalent desire still leaves its mark on the surface of the fruit, an apple that
is both sweet and – at the moment we turn our attention to it – reddening with
the blush of being felt for.[38]

In his essay for this volume, Shane Butler has spoken of how Homer's *oinopa
ponton* crashes into the margins of verse, 'forever churning away at the same
vowels and consonants', and how that same sea, through the sense of depth and
infinitude which it conveys, in some senses resists definition. I have tried in my
essay to focus on a different kind of depth; one which lies on the surface of
Homer's poem, both literally and litorally (borrowing from Billings' figure on
the shore).[39] I have suggested that what rests on that surface is neither stable
nor flat, but is, rather, responsive to, and responsible for, its own particular
depths of feeling and reading.

Notes

1 Myrone (2001: 6). See further Nochlin (1994: 7): 'Modernity, in this memorable red chalk and sepia wash drawing, is figured as irrevocable loss, poignant regret for lost totality, a vanished wholeness.' For recent modifications to this reading (based on the plausibility of its title, attributed by Gert Schiff) see Pop (2015: 70–2 & n. 3).

2 The painting served as a prototype for an engraving of the same subject used as an illustration for Francis Isaac du Roveray's 1806 lavish reissue of Alexander Pope's translation of the *Odyssey* (Pop 2015: 200–1).

3 The painting suggests emotion rather than pain, despite Polyphemus' recent blinding. Note the highlighting of his mouth and knuckles against the dark colouring of the picture. Pop reads pain, shame and 'irredeemable loss' (2015: 203–12) in the scene.

4 Fuseli's engraving of this scene (n. 2, above) illustrated Pope's translation of these lines, as quoted in Pop (2015: 204).

5 Translations of Homer are by Richmond Lattimore (occasionally modified) unless otherwise noted.

6 Pop (2015: 204).

7 See further Buchan (2004: 18–35). I discuss a different aspect of the Cyclops' touch in Purves (forthcoming).

8 For a further rendition of these legs – but in a sexual pose – see Fuseli's drawing 'Symplegma with a Man and Three Women', *c.* 1809–10 (Victoria and Albert Museum, London).

9 I borrow the notion of immersion in the surface from Schmitt (2012: esp. 14–15).

10 Sedgwick (2003: 8, 23). See also Apter and Freedgood (2009: 145).

11 Sedgwick (2003: 8).

12 Butler, this volume (39).

13 In the painting, as Pop notes, the lighting on the wool draws attention to the giant's sense of touch, 'amplified by affection' (2015: 207).

14 Montiglio (forthcoming 2016); Mueller (2016); Purves 2013b.

15 Porter (2006a: 308).

16 On which see Bewes (2010).

17 Cf. Homer, *Iliad* 7.462.

18 Porter (2011a); Porter (2016: 370–1). See also on the force of rivers, Holmes (2015).

19 See especially Auerbach 1953 (also discussed in Butler, 'Homer's Deep', this volume); Porter (2008b); Purves (2013b).

20 See especially Haubold (2007: 45), who discusses the last two stanzas from *Omeros* quoted above.

21 Snell (1953: 18). Snell has just been discussing the discovery of depth in intellectual and spiritual matters in the archaic poets. See also Stanford (1950).

22 The rhetoric of depth vs. surface has received renewed attention recently in the call for 'surface reading', on which, see Best and Marcus (2009); Love (2010), Love (2013); Schmitt (2012); Schmitt (forthcoming); Lesjack (2013); Freedgood and Schmitt (2014). In *Mimesis,* Auerbach claimed that Christian literature is marked by a struggle between 'sensory appearance and meaning', whereas 'Greco-Roman specimens of reality are . . . perfectly integrated in their sensory substance' (1953: 49, as partially quoted in de Man 1983: 23).

23 Schmitt (2012).

24 Brinkema (2014: 17): 'the tear demands interpretation, but that reading does not point inward toward the depths of the soul – it remains a surface reading always, a tracing of the bodily production of the sign that signifies only its refusal to reveal itself'.

25 Cf. Homer, *Iliad* 16.2–4, where Patroclus' crying resembles dark water flowing from a steep rock, as discussed further below.

26 In the parallel scene of Thetis' emergence from the sea in Homer, *Iliad* 1, she only pretends not to know why Achilles is crying (1.365). In this scene, however, Achilles tells her what has happened as if she did not already know.

27 Pop (2015: 200–5). Cf. Timanthes' unrepresentable grieving Agamemnon, as discussed by Fuseli in his 1801 Royal Academy Lectures. Fuseli asserts there (of Timanthes' gesture of having Agamemnon cover his eyes) 'neither height nor depth, *propriety* of expression was his aim' (Knowles 1831: 52). The quotation is discussed in Pop (2015: 204–5 and n. 161).

28 Homer, *Iliad* 18.52–64. On Thetis' lament, see Tsagalis (2004: 136–9), with bibliography.

29 On this passage, see Martin (1997: 154–6).

30 Purves (2015: 90–91).

31 See n. 25, above.

32 What is often referred to as 'deep' or 'symptomatic' reading is based on a psychoanalytical model of underlying meaning, often attributed to Marxist and psychoanalytic criticism. Jameson (1981) made the case for symptomatic reading explicitly: e.g., 'Interpretation proper . . . always presupposes, if not a conception of the unconscious itself, that at least some mechanism of mystification or repression in terms of which it would make sense to seek a latent meaning behind a manifest one, or to rewrite the surface categories of a text in the stronger language of a more fundamental interpretive code' (63).

33 See further, on both of these woundings and the visible significance of blood in the poem, Holmes (2007).

34 Gregg and Seigworth (2010: 9).

35 See Slaney, this volume.

36 Fr. 105a, trans. Carson (1986). For an astute reading of these lines, see Carson (1986: 26–9).

37 On the reduplication of *akro-,* compare Homer, *Iliad* 20.226–9, both in my reading above, and more extensively in Purves (2015: 90–91). For the importance of surface to deixis, see Schmitt (forthcoming).

38 Porter (2006a: 329) has discussed the idea of classicism, when the writer reaches the peak (ἄκρον) of perfection, having a certain blossom or 'bloom' (ἐπανθεῖν), such – as Longinus says – as one finds on the most beautiful statues (Longinus [attributed], *On the Sublime* 30.1). On *akron* and its cognates used by Longinus to represent the sublime, see Porter (2015: 367, 369, and ch. 1, n. 63).

39 Billings, this volume. On Homer as 'the Great Ocean', see Porter (2015: 360–82).

Perceiving (in) Depth: Landscape, Sculpture, Ruin

Helen Slaney

The eye glances off the surface of things. Much can be ascertained, of course, from exteriors, but in order to access the unseen, unseeable, hence inaccessible matter *beneath* or *behind* or *within*, some other form of sensory apprehension seems warranted. Among these inaccessible dimensions might be included the extent of the object's temporal existence, conceived in a metaphorical sense as trailing behind it 'back' in time, or building up silently like sediment inside.[1] Antiquity is a necessarily imaginary property invested in particular landscapes, in objects (such as sculpture), and in architecture (such as ruins) by an awareness on the part of the perceiving subject that these material phenomena possess a certain temporal density, an interiority predicated on occluded experience: a form of depth. Typically, Enlightenment philosophy of science privileged vision as the sense of discovery, lucidity, veracity.[2] Where vision could not penetrate, however – into the past, into stone – the faculty of the imagination could be deployed to broker a different type of epistemological transaction, one in which knowledge of antiquity was not something legible to the external gaze but rather a sympathetic intuition formed in the inaccessible recesses of the perceiving subjects themselves: Herder's *Liebhaber*, Beckford's dreamer, de Staël's prophetess.

Verbal description, like visible surfaces, can only take us so far. This essay can therefore be read in two ways. Superficially, we could say, it offers a reading of three roughly contemporary meditations on the contribution made by the haptic imagination to the perception of antiquity. Johann Gottfried Herder's essay *Plastik,* subtitled 'Some observations on shape and form from Pygmalion's creative dream' (1779) argues that touch is the sense most apposite for

apprehending material artefacts; William Beckford's semi-fictionalized Grand Tour journal, *Dreams, Waking Thoughts, and Incidents* (1783) presents a walk through the landscape as a journey back in time; and Germaine de Staël's semi-autobiographical novel, *Corinne, ou l'Italie* (1806) emphasizes the imaginative labour required if the world is to be perceived in four dimensions. Interwoven with the critical discourse, for those who would prefer to dig a little deeper, I have extrapolated from these authors their respective paradigms for stimulating in practice the imaginative responses they record, their methods for perceiving the invisible (but by no means intangible) *Innigkeit* (innerness) of antiquity.

'The sense that perceives things in depth'[3]

In *Plastik*, a reformulation of arguments originally laid out in an earlier essay (*Viertes Kritische Wäldchen*),[4] Herder makes the somewhat counter-intuitive proposal that sculpture is experienced not by the sense of vision but through the sense of touch. 'That statues can be seen, no-one doubts,' he explains, 'but ... the living, embodied truth of the three-dimensional space of angles, of form and volume, is not something we can learn through sight' (*Plastik* 1.3, 40).[5] Unlike painting, whose flat surfaces depict illusionistic images of objects and figures and scenes fascinating precisely because they represent or stand in for that which is absent, sculpture occupies the same physical space as its beholder and hence possesses *dargestellte, tastbare Wahrheit*, a present and tangible reality (*Plastik* 1.3, 40). Its tangibility is what leads Herder to define sculpture as 'the fine art for touch' (*Gefühl*), touch being 'the sense that perceives things in depth' (Moore's translation of *solide Körper*, 'solid bodies') (*KW4* 2.3, 216). Although touch can also provide information about surfaces, such as their texture and temperature, these properties are not, for Herder, intrinsic to the perception of sculpture as a solid, three-dimensional phenomenon; rather, he emphasises its depth and interiority (*Innigkeit*), its fullness and plenitude (*Fülle*), and its curvature or convexity (*Runde*). That sculpture possesses *Raum* and *Rundung* – volume, roundedness – does not, according to Herder, appeal to an ocularcentric assessment of qualities such as proportion, but rather stimulates a subconscious response to shape-in-proximate-space

which he refers to as a movement of the soul, but which we might alternatively term a haptic impression. While the haptic senses do include the skin-to-surface contact we might commonly think of as touch, they also include proprioception (feedback from your own body) and kinaesthesia (perception of movement), and it is these modalities that have most affinity with Herder's *Gefühl*.[6]

The canon of classical sculptures on which Herder chooses to exercise this sixth, haptic sense includes the 'Belvedere Apollo', the 'Belvedere Torso' (or 'Farnese Hercules'),[7] and the 'Borghese Hermaphrodite'. To perceive beauty (*Schönheit*) in depth, one should turn to these ideal examples of the art-form, pure Nature unimpeded by such irrelevancies as clothing or colouring.[8] It is ironic, then, that the peerless Greek antiques recommended by Herder as his ideal haptic apparatus were neither Greek nor antique. Having not yet visited the great collections of Italy when he published *Plastik*, the aesthetic principles it lays out were developed on the basis of copies and casts; moreover, the extant antiquities themselves are first- and second-century Roman artworks whose Greek antecedents are lost.[9] This caveat regarding authenticity does not, however, vitiate the principles and associated practices outlined in *Plastik*. The aesthetic properties of a sculpture may be felt regardless of the object's provenance, as they result from an interaction occurring in the present moment between material form and perceptual capacities.

The faculty of haptic awareness can be cultivated through exposure and experience. Herder represents this cultivation as a learning process in which we train ourselves to recover the bodily, tactile responses to three-dimensional (graspable, climbable) objects that in early childhood we acted upon, consolidating our embodied understanding of the world.[10] As adults, we rationalize and sublimate these sensations in a process termed 'abbreviation' (*Verkürzung*), deluding ourselves that we find sculpture aesthetically pleasing because it charms the eye by conforming to abstract criteria of beauty, not because its sensuous curves would *feel good* to imitate, stroke, embrace or slide along. It is not necessary to follow through on any of these impulses. What is important is recognizing them for what they are in order to appreciate sculpture fully via its appropriate sensory modality. We can form, if you like, the habit of sensuous cognition.[11]

Begin by approaching the artwork. This technique will work best for sculpture in the round, rather than reliefs or works displayed in niches, because it involves circling the piece slowly and repeatedly. Herder's rationale for this is that sculpture (in the round) is not oriented to a single point of view; unlike painting, it possesses an infinite multiplicity of angles from which it might be perceived, all of which offer a distinctive composition. 'Deep in contemplation' (*tiefgesenkt*), the beholder circles around the artwork in constant motion in an effort to encompass it from all possible directions (*Plastik* 1.3, 41). Because the sculpture itself is fixed, you are thrown back on using the movement of your own body to transform it, kaleidoscopically, from one configuration to another. In this way, a single piece of stone becomes polymorphous, and a figure whose motion is arrested appears to turn on the spot, its rotation mirroring the action of the beholder as if responding interactively to your manipulation of space. Again, while this interaction has a visual component, it functions in concert with motor activity, each sense informing the other.[12] This methodical circling not only liberates the sculpture from a fixity of perspective but also associates it with the palpable experience of motion.

But something more is needed, says Herder, to meld what would otherwise remain a disjointed sequence of images, a 'mesh of surfaces', into a unified totality. This synthesis is performed by the beholder's 'imagination' (*KW4* 2.3, 217), namely our haptic awareness of the properties of solid objects, a sense which adult beholders no longer need to test empirically but can activate through deliberate virtual application. Once you have gathered enough information for this synthesis to be felt, you can stop circling physically while continuing to explore the sculpture's contours in their three-dimensional capacity. To an external observer, Herder's beholder in this state would appear motionless, but would in fact be prolonging the sensation of movement deep within his own kinaesphere, re-running the recent motor memory of smooth lateral rotation in conjunction with a more ingrained awareness of solidity. As the beholder's gaze sweeps over the marble, it acts as haptic proxy: while remaining still, '*he gently glides* only around the contours of the body, *changes his position*, *moves* from one spot to another and then back again; *he follows the line* that unfolds and runs back on itself, the line that forms bodies and here, with its gentle declivities, forms the beauty of the body standing before him' (*KW4* 2.3, 218–19, emphasis added). Gaze and kinaesphere elided, the beholder

experiences the sculpture less in terms of its subject matter, its representational content, than of its materiality, its literal contents, solid stone. It stands in for nothing; instead, it co-exists.

This contrast between representational and material apprehension resembles what Marc Jeannerod terms the 'semantic' and 'pragmatic' modes of understanding objects in proximity to ourselves. Semantic recognition identifies an object, whereas pragmatic recognition involves running a neural simulation in the premotor cortex of what you might do with it, the actions it prompts: in other words, the 'affordances' which are implied by its configuration.[13] In a sense, we could say, the object is recognised as a verb rather than a noun; not as a static, separate entity but as something integral to the execution of a movement. Jeannerod goes on to argue that if one acts upon a potential affordance, the associated simulation remains subconscious, subsumed into actual performance; but if, on the other hand, the action remains 'covert' or unperformed, its simulation continues to loop until the beholder's perceptual attention is attracted or directed elsewhere.[14] What we might call kinaesthetic gratification, then, discharges the tension of an unrealized affordance. Alternatively – and this is the Herder method of deepening your engagement with sculpture – cultivating the simulation of movement while simultaneously withholding its execution can produce a pleasurable condition of unresolved anticipation, denial experienced neurologically as perpetual deferral.

When content as well as form becomes salient, two possible attitudes can be adopted towards anthropomorphic sculpture: objectification or identification. Objectification treats the figure as an other; this can have an erotic dimension, as the Pygmalion paradigm suggests, or may involve a more Platonic attachment which nonetheless casts the sculpture as recipient of devotional attention: 'A sculpture before which I kneel can embrace me, it can become my friend and companion; it is *present*, it is *there*,' writes Herder (*Plastik* 1.4), indulging Pygmalion's fantasy of the animated statue in order once again to underline the contrast with painting. Marble figures can neither embrace, nor (in a conventional gallery setting) can they be embraced, but they do appear to afford the physical possibility. A beholder attending to this affordance can run the simulation indefinitely. Kneeling, a significant shift in bodily orientation with overtones of worship, supplication or subjection, also contributes to the

beholder's attitude. Making the choice to adopt this posture reinforces your perception of the sculpted figure as desirable Other.

Alternatively, the sculpture can be approached as a version of the self; or rather, you morph your own body schema in response to its carriage and musculature.[15] When perceiving the figure of Hercules, for example, via what Herder calls 'the feeling imagination' (*die fühlende Einbildungskraft*), this faculty 'will always find Hercules in his whole body and this body in all its deeds ... is enraptured (*begeistert*) by the body that it touches, travels with it through heaven and hell to the ends of the earth' (*KW4* 2.3, 220). This is a different type of rapture from kneeling, captivated, awaiting an embrace that will never come. Here, it is as if encountering the body of Hercules has plunged the beholder into an ecstasy of identification, temporarily possessing (or haunted, possessed by) the heroic physicality before him. Such sculpture 'seizes hold of us and penetrates our very being ... We find ourselves, so to speak, embodied (*verkörpert*) in the nature before us' (*Plastik* 4.1).

Another option for the *fühlende Einbildungskraft* or the haptic imagination is to play around with scale. Zooming in on one portion of a sculpture can diminish your kinaesphere in relation to the marble topography that fills your visual field. If you experience yourself as reduced to the pinpoint of your gaze, such that *you* glide over the rounded limbs, *you* traverse the swell and enfolding of the belly and breast – sweeping through canyons and overhangs, slipping down a glacial crevasse – the sculpted figure becomes neither subject nor object but ground, affording the unreal sensation of gliding around it in serpentine loops. Think of Laocoön here not as the exemplum of classical fortitude, not as poetry translated into immobility, but as an opportunity to shed your human skin.[16]

Herder proposes a sensory revolution in the perception of ancient sculpture. Using the haptic 'sense that perceives things in depth', *die fühlende Einbildungskraft* transforms the viewer's detached relationship into the dizzying intimacy of the beholder. There is no temporal depth to these encounters as Herder describes them – they work to distend an immediate moment of contact, rather than situating it at the tip of the *longue durée* – but they furnish nevertheless a valuable sensory foundation for my two subsequent paradigms, both of which concern the contribution made by the perceiver's imagination to the historicity of place. What Herder seeks to reveal, or to

enable you to reveal to yourself, is the invisible third dimension of sculpture, its depth, its *Innigkeit*. This is available not to the eyes, which pick up only surface features, but to your haptic imagination, your sense of corporeal orientation and potential motion. The haptic imagination can produce illusions, such as the sense that you are Hercules, or the sense of an imminent embrace, or the sense of feeling marble glide by beneath you, but they are productive illusions, allowing the artworks to enter and shape you by virtue of your own kinaesthetic participation.

The subterranean imagination

Lake Avernus and the surrounding region provide the vehicle for three potential descents into its past, which Germaine de Staël calls its *trois rapports*.[17] In geological time, the lake formed in the caldera of an extinct volcano; mythological time claims it as the site of Aeneas' descent to the Underworld; and historical time launches Pliny the Elder from nearby Cape Miseno to pursue his fatal scientific investigation of the erupting Vesuvius. Memory, sings de Staël's doomed Sibyl, the improvisatrice Corinne, saturates this landscape. 'If you strike the ground,' she chants, 'the subterranean vault re-echoes. It is as if the inhabited world is no more than a surface about to open' (13.4).[18] The region's vulcanism serves as a powerful metaphor, or indeed as a correlative for its volatile historical strata, the human passions and events that have likewise shaped its current contours.[19] Just as the apparently stable crust conceals boiling magma chambers, the 'inhabited world' of the present rests on an accumulation of past centuries. Neither is visible to the naked eye. Instead, according to de Staël, we can train ourselves to be aware of historicity, using imagination to penetrate superficial appearances and grasp the past that inheres in ancient sites. Although this practice yields no factual information, it serves to consolidate the perceiver's existing knowledge of the site, converting it from abstract data into sensory, sensual, sensible memory. The process is didactic, formative. As Corinne gives her English lover Lord Nelvil an education in Roman history *par l'imagination et le sentiment*, de Staël simultaneously leads her reader through a Rome imaginatively enriched. Nelvil's *Bildung*, his development into a sensitized traveller, can also be yours. A generic hybrid,

Corinne has been criticized for stifling its narrative with travelogue,[20] but this misses the point of its full title: *Corinne, ou l'Italie*. As well as recounting a romance, de Staël's novel offers practical lessons in how to perceive the past.

An imaginative engagement with ruins is neither necessary nor inevitable. Like Herder's *fühlende Einbildungskraft*, it has to be deliberately initiated and sustained by the perceiving subject. In contrast to the enthusiasm of Corinne and her protégé, de Staël sets the obdurate detachment of Nelvil's travelling companion, Count d'Erfeuil. In some respects a conscientious tourist, d'Erfeuil ensures that he has thoroughly 'done' every town *en route* by ticking off each landmark featured in his guidebook; but in spite of (or perhaps because of) this methodical approach, he finds the wretched remains of ancient Rome most unsatisfactory: 'It is just a prejudice to admire those thorn-covered ruins (*débris*),' he declares. 'There is not a monument intact in Europe today which is not worth more than those stumps of columns, than those bas-reliefs blackened by time that can be appreciated only with a lot of scholarly knowledge (*érudition*). A pleasure that has to be gained (*acheter*) by so much study does not seem to me very great (*vif*) in itself' (6.1). D'Erfeuil's displeasure is based on the fundamental misconception that passively viewing the *débris* should suffice to restore its antique splendours. He should not have to contribute to the experience, nor invest (*acheter*) any effort in procuring it, as he regards the acquisition of background knowledge (*érudition*) as inimical to pleasure.

D'Erfeuil is not alone in this tendency to represent scholarship as the antithesis of an aesthetic encounter. As Corinne unfolds the historical narratives embedded in Rome's surviving architectural fabric, Nelvil himself remarks that 'this kind of study is much more interesting than what is acquired in books. It is as if you bring back to life what you discover, and the past reappears from beneath all the dust that buried it' (4.5). Material culture, Nelvil implies, possesses an authenticity lacked by the textual record, putting you back in touch with distant past revived (*l'on fait revivre*) by your presence. Nelvil, however, is in one respect just as mistaken as d'Erfeuil, who can perceive no life (*vif*) whatsoever in the same *débris*. In attributing agency to the ruins themselves (*le passé reparaît*) Nelvil underestimates the contribution of his own increasing *érudition* to this apparently spontaneous reanimation. In a similar fashion, de Staël opposes 'imagination' to 'critical intellect' (*ésprit de jugement*) as modes of knowledge, deriding the pedantic antiquarian who,

'devoid of any imagination', seeks only to compile a disembodied 'collection of names' which he considers the constituent substance of history (11.4).

Imagination, however, does not arise *ex nihilo*. In practice, the apparent dichotomy is resolved if imagination is regarded not as intuitive insight communicated across time by the ruins themselves, but as a process of enhancing the skeletal site with factual knowledge already possessed. Book-bound history alone is reduced to a 'collection of names', and conversely a nameless stone is merely *débris*, but their conjunction can galvanize the understanding. Preparation is therefore vital. If you approach Lake Avernus unaware that Virgil's Underworld lies beneath it, or unwilling to be affected by this awareness, it will only appear to the eye as a placid lake. It is for this reason that Corinne describes their tour of Rome as 'these researches, which are both scholarly *and* poetical, and appeal to the imagination *as well as* to the mind' (4.5, emphasis added). Moreover, in addition to the preparatory nourishment of *érudition*, exercising one's imaginative faculty on the spot requires a 'sustained effort', *un effort continuel de l'imagination*, to keep supplementing, even contradicting the evidence of the eyes with a different type of absorption.[21] It is this state of manufactured hypersensitivity which confers temporal depth upon the surface debris, reconstruing it as constituted by memory. D'Erfeuil is perhaps correct, then, to suppose the fascination of ruins born of preconceptions, and hence illusory; but like Herder's haptic appreciation of sculpture, it is a productive illusion.

The power of the imagination was not, for de Staël and her contemporaries, a trivial matter. As James Engell has shown, imagination became 'the impelling force in artistic and intellectual life, in literature and philosophy ... from 1750 onwards', although the concept remained disputed throughout the century.[22] Sometimes treated as synonymous with creative genius, it became central to Romantic aesthetics. Corinne's use of *l'imagination* as an epistemological medium, a tool for understanding the world, is closely related to her own poetic talent. Unlike mere 'fancy', the meander of vague, insubstantial ideas, imagination has the ability to pin them down and hammer them out into new forms, requiring indeed a cognitive *effort continuel*. Although it leaves no residue perceptible to a third party, perceiving a monument could be an act as creative as composing a poem; de Staël's use of the term appears to insist that *l'imagination* is equally crucial to both.

If an ancient site's imaginary attributes are not genuine emanations from the past but rather the result of preconceptions imported by the visitor, we might usefully consider how such preconceptions are formed. For Herder, *Einbildungskraft* results from sensory 'confluence' in the dark abysses (*Abgründe*) of the body: 'We usually call the depth of this confluence, Imagination' (*Wir nennen die Tiefe dieses Zusammenflusses meistens Einbildung*).[23] The haptic basis of human imagination – that is, the ability to simulate ways of relating to the external world – has recently been affirmed by Vittorio Gallese and George Lakoff. Their study demonstrates that what used to be thought of as 'mental imagery' occurs not in a separate, more rarefied part of the brain but uses the same neural apparatus as overt action and incoming sensation. The 'mental' reorganization of *débris* into Roman palaces, for example, relies on spatial reasoning that occurs – like Jeannerod's covert actions – in the sensorimotor system. Gallese and Lakoff propose that 'imagination, like perceiving and doing, is embodied, that is, structured by our constant encounter and interacting with the world via our bodies and brains ... Imagining is a form of simulation'.[24] These simulations can involve proprioception, kinaesthesia, and/or pragmatic affordance.[25] The way in which objects (or whole environments) are comprehended, then, involves more than visual scanning or disembodied conjecture. The non-existent, historical properties of a structure such as a ruin may be characterized as a sensorimotor simulation: a self-induced haptical illusion.

De Staël's treatment of ancient sites shows how haptic contact with their present condition produces new conceptualizations of Roman experience. In her journal, she records how 'the idea of vanished (*disparues*) generations' is made apparent by Pompeii's surviving domestic architecture: 'private life and the actions of each inhabitant are there before your eyes' (*sous vos yeux*).[26] The vanished generations are somehow made paradoxically 'visible' in what they have left behind; this, I would argue, is because the shapes of the houses and streets imply particular modes of kinetic occupation, appealing via their affordances not to the eyes at all but rather to the interior, self-reflexive, haptic senses of kinaesthesia and proprioception. Expanding on her personal observations in the corresponding passage from *Corinne*, de Staël extrapolates from the contrast between Pompeii's airy peristyle courtyards and the small, stuffy rooms with their dark, windowless interiors, that 'this kind of dwelling

indicates clearly that the ancient peoples nearly always lived in the open air, and that was where they received their friends' (11.4). She also concludes from the designs of both Roman houses and Roman baths that the climate must have been 'even more burningly hot than in modern times' (4.5). The sensory attributes of the Roman bath-house can be imaginatively reconstructed, even to the extent of embedding imaginative practices themselves within the scene one has invented. 'Cool water is so pleasantly refreshing in hot countries,' writes de Staël, 'that people liked combining every luxury and *all the pleasures of the imagination* in the places where they bathed' (4.5). Such pleasures included anthropomorphic sculpture, like the Laocoön group, that would appear animated in the flickering firelight.[27] Having visited Canova's studio at night, Corinne and Nelvil have experienced this effect first-hand, as did de Staël herself at the Vatican.[28] These analogous imaginative experiences are sympathetically nested: you might now imagine de Staël imagining Corinne imagining luxury-loving Romans letting sculpture play over their skin while wandering in the vast, now-arid shell of Caracalla's baths.

Imagining can, however, deceive the perceiving subject, however vivid its transformation of space appears. The Borghese Gardens occasion such a slippage. According to *Corinne*, 'The mythology of the ancients seems to be brought to life there. There are naiads on the banks of streams, nymphs in woods worthy of them, tombs in Elysian shade ... Ovid and Virgil could still be walking in this lovely spot and think they were still in the Augustan age' (5.3). The Borghese Gardens themselves never existed in the Augustan age. Originally a Baroque creation, they had been re-landscaped in the 1780s–1790s to produce a type of neoclassical theme-park.[29] As Villeneuve observes, 'les eaux antiques se confondant avec les eaux admirées par les amants, semblent rejaillir' ('the ancient fountains mingle / blend into / become confused with the fountains admired by the lovers, seeming to leap up again').[30] The potency of the Borghese Gardens is not necessarily diminished by their artificiality, unless the visitor decides that authenticity is a criterion for imaginative engagement and inhibits her response accordingly. Alternatively, however, if recognized as a haptic formulation – that is, a phenomenon interior and bodily – intense responses to synthetic environments are not illegitimate, and a skilful re-production may indeed resonate as powerfully as the genuine article.[31] Endlessly regenerated using materials available in the present, antiquity

emerges as a construct from the convergence of textual information, architectural remains, and a perceiving subject with the will to be led through its subterranean involutions by her feeling imagination. As the product of a selected *rapport*, whether mythological, historical, or geological, its reanimation depends on both the valence and the depth of your involvement.

So far into antiquity?

While aristocratic sensualist William Beckford is 'lingering alone' in the Temple of Isis at Pompeii, he falls into 'one of those reveries which my imagination is so fond of indulging' (Letter XXIV, 178).[32] Informed and inspired by Pliny's *Epistle* 6.16, Beckford 'transports' himself back to the day of Vesuvius' eruption in 79 CE. Initially, he relocates himself to the deck of the Elder Pliny's ship, viewing the 'tremendous spectacle' at a distance from across the bay; but before long he abandons this vantage to mingle with Pompeii's panicking residents, finally homing in on 'a long-robed train of priests, moving in solemn procession, to supplicate by prayer and sacrifice, at this destructive moment, the intervention of Isis':

> Methought, I could distinguish in their hands, all those paintings and images sacred to this divinity, brought out, on this portentous occasion, from the subterraneous apartments, the mystic cells, of the temple. There was every form of creeping thing, and abominable beast, every Egyptian pollution, which the true Prophet had seen in vision, among the secret idolatries of the temple at Jerusalem. (XXIV, 178–9)

The *sacerdotes* is just about to strike his victim when the scene is obliterated, not by a pyroclastic surge but by one of Beckford's companions calling him to rejoin them. This episode is the longest of the hallucinatory riffs played by Beckford in his retrospective travel journal *Dreams, Waking Thoughts, and Incidents*, first published in 1783 but almost immediately withdrawn from circulation.[33] De Staël was one of the few individuals privileged to own a copy of the first edition,[34] thick with unexpurgated testimony to the transfigurative power of the feeling imagination. Pompeii forms the climax of the work, mirroring an earlier, similarly phantasmagorical account of walking the

Boboli Gardens at the Palazzo Pitti in Florence. Both passages show the visitor's imagination activating a latent fourth dimension; in other words, a consciousness of time, germinated by physical presence on-site but deliberately cultivated before, during and after the encounter.

Beckford's choice of the Temple of Isis as setting and stimulus for his reverie gives it a mystical undertone, reinforced by the episode's structure and detail. Prior to his visionary descent, Beckford's *cicerone* has pointed out various items of interest to his tour-group: the remnants of an interrupted sacrifice in the precinct, a marble statue 'pressing her lips with her forefinger' in an apparent injunction to secrecy, and a human skeleton trapped in an inner chamber.[35] These elements, however, remain inert unless an animating sensibility such as Beckford's is brought to bear; whereupon, recontextualized, they assume an augmented significance.[36] Like the Old Testament prophet Ezekiel (the 'true Prophet'), Beckford glimpses the contents of the inner sanctum, the *hiera* disgorged from within the temple's 'subterraneous apartments' and 'mystic cells', erupting into his consciousness just as they are enveloped forever by burning ash. The way the encounter is framed represents it as a circuitous approach from the profane to the profound, from casual tourism to a disclosure of concealed mysteries, to the verge of death itself in the aborted sacrifice. The mechanism that enables Beckford to penetrate the protective membrane of the temple's present aspect and perceive the rites of Isis in full swing is his superbly primed imagination.

Imagination, as mentioned above, makes use of the brain's sensorimotor apparatus. Neurohistorian Daniel Smail argues that human beings, like many other organisms, have a predisposition to take pleasure in neurochemical changes, particularly if self-induced and therefore controllable. In the absence of external stimuli, we can manufacture them for ourselves. Behaviours that induce such changes, perceptibly affecting the levels of neurotransmitters such as adrenalin, serotonin or oxytocin have been termed by Smail 'psychotropic mechanisms'.[37] These behaviours range from massage to aerobics to bungee-jumping to reading Gothic novels, all of which generate pleasurable fluctuations in somatosensory feedback as your neurochemistry responds to the activity.[38] To Smail's list of psychotropic triggers, we might add attendance at locations imbued with historical and/or aesthetic value. In relation to museum exhibitions, it has been remarked that the arrangement of displays inscribes a

particular attitude towards the knowledge they impart (or construct): linear
pathways articulate a didactic relationship in which the visitor receives
information in a designated order, while a more open dispersal of objects
invites participation in sense-making.[39] These epistemological frameworks are
fashioned spatially, the visitor's own movement determining how the museum's
contents are uncovered and subsequently how they are recalled.[40] Similarly, at
a site like Pompeii, the manner in which it is traversed – the directions, the
sequence, the pace, the emphasis, the pauses ('lingering alone') – all affect how
its current configuration is processed, and hence how its former attributes are
conceptualized. Cognitive exploration of the site takes place within the moving
body, consequently reshaping what 'Pompeii' consists of within the perceiving
subject.[41] As you bend your imagination to craft the fourth dimension of your
surroundings, availing yourself of their (your) *Innigkeit*, you are activating a
psychotropic mechanism.

Beckford's account of time travel in the Boboli Gardens illustrates an awareness
that motion through landscape can induce hypnotic 'reverie'. It should be noted
that the Boboli Gardens, like those of the Villa Borghese, have no authentic
foundation in Roman antiquity;[42] but this should not vitiate the authenticity of
Beckford's subjective experience,[43] or at any rate the experience of his pseudo-
naïve, rather fey narrative persona. Suffering from a touch of Uffizi fatigue,
'William' refreshes himself by taking a walk in the grounds of the Palazzo Pitti:

> I ascended terrace after terrace, robed by a thick underwood of bay and
> myrtle ... and a long sweep of venerable wall, almost entirely concealed by
> ivy. You would have been enraptured with the broad masses of shade and
> dusky alleys, that opened as I advanced, with white statues of fauns and
> sylvans glimmering amongst them, some of which pour water into
> sarcophagi of the purest marble, covered with antique relievos. The capitals
> of columns and antient friezes are scattered about, as seats. On these
> I reposed myself, and looked up to the cypress groves spiring above the
> thickets; then, plunging into their retirements, I followed a winding path,
> which led me by a series of steep ascents, to a green platform ...
>
> Still ascending, I attained the brow of the mountain ... I found several
> walks of trellis-work, clothed with luxuriant vines ... A colossal statue of
> Ceres, her hands extended in the act of scattering fertility over the prospect,
> crowns the summit; where I lingered ... Then descending, alley after alley,
> and bank after bank, I came to the orangery in front of the palace, disposed

in a grand amphitheatre, with marble niches relieved by dark foliage . . . This spot brought the scenery of a Roman garden full into my mind. I expected every instant to be called to the table of Lucullus hard by, in one of the porticos, and to stretch myself on his purple triclinias; but waiting in vain for a summons, till the approach of night, I returned delighted with a ramble that had led me so far into antiquity.

Verbs of motion (ascending, plunging) give the narrative momentum, periodically suspended (I reposed, I lingered). Entering the funereal darkness of the alleys, passing through sombre Virgilian *umbrae* punctuated by 'glimmering' white figures and lustrous sarcophagi, Beckford prepares himself to be transported. Classical sculpture – pastoral, architectural, and finally colossal – lines his route. The luxuriant vines of Bacchus and the fecund statue of Ceres (Demeter, another goddess worshipped in mystery-cult and syncretically identified with Isis)[44] greet the initiate at the apex of the ascent that is also the deepest point of his 'plunge' into the winding groves. These factors render Beckford's evening stroll a quasi-mystical penetration into the landscape's past, a journey back in time through topography both imaginary and physical, literal and metaphorical, hidden and plainly apparent. Such connotations are unlikely to have been lost on Beckford, whose fascination with ancient cultures, like that of many of his contemporaries, was predicated as much on a penchant for esoterica as on antiquarian interest.[45] In a 1777 short story, 'The Vision', Beckford had already depicted himself as an initiate gaining 'more than worldly knowledge' through a series of purificatory subterranean trials,[46] and the underground grottoes he later designed for his Fonthill estate may have been constructed with a similar function in mind.[47]

Having laid the groundwork and received divine sanction, Beckford enjoys the fruits of his self-guided initiation rite: a sustained illusion of immersion in the Roman *luxuria* called so diligently to mind as he performed his psychotropic ascent. His fantasy takes place in the grounds of a palazzo that were themselves designed to imitate those of a Roman villa, recalling sources such as Plutarch's *Life* of the renowned voluptuary Lucullus. There are no porticos and no *triclinia* 'hard by' the Boboli Gardens, but the anticipation of their presence is by this point so strong that Beckford feels himself to have arrived at a place where his time and Lucullus' practically coexist, his mind now 'full' of the 'antique Roman garden' which he perceives in the niches and foliage around him.

In the end, the fourth dimension dissolves with the nightfall. Beckford abandons his trance-like cadences, shaking off the spectral scenery, 'delighted with a ramble that led me so far into antiquity'. His sudden archness transforms the episode into an elaborate charade. If the self-induced sense of temporal dislocation was so easy to drop, does this imply that it was always a pose? Beckford, however, adopts an ironic duality of perspective, exhibiting *both* knowing detachment *and* total conviction. Like the Boboli Gardens and their identical Roman twin, identical in every respect including their spatial location, his narrative admits of two coexistent readings: a surface freely available to all (the pleasant ramble) and the inner journey encoded for fellow initiates willing to follow his plunge of faith (so far back, so deep into antiquity).

* * *

On the surface, you see the *débris*, you see the sparkling skin of the lake, and your eyes do not deceive you. But just as you translate flat visual data into three-dimensional affordance, defining objects in terms of their potential interface with your moving, sensing body, so you can also train yourself to perceive their metaphorical depths, their diachronic existence, by exercising your haptic imagination. Although in one sense a simulation, a psychosomatic practice, in another sense it provides a way of encountering what cannot otherwise be perceived, and to contact it intimately, bodily. Your descent may be performed alongside correlative external gestures (circling the sculpture, tracing the serpentine terraces) but ultimately these overt actions serve as co-ordinates or as nourishment for the inner, metaphorical katabasis into four-dimensional matter simultaneously being performed by your imagination.

Notes

1 On the spatial / motor properties of abstract concepts, see Gallese and Lakoff (2005).
2 Norton (1991: 206–8) on the Enlightenment as possessing a 'profoundly visual orientation toward the world', notes at the same time the persistence of a 'subversive strain of thought . . . in which the prevailing conception of the superiority of vision was modified and eventually overturned by a re-evaluation of the ideas we receive through our tactile sense'. For further discussion see Jay (1993: 69–113).

3 An expanded version of this discussion may be found in Slaney (forthcoming).

4 *Viertes Kritische Wäldchen* (*KW4*), although written in 1769, remained unpublished until after Herder's death.

5 'Dass man Bildsäulen sehen kann, daran hat niemand gezweifelt; ob aber . . . Raum, Winkel, Form, Rundung lerne ich als solche in leibhafter Wahrheit nicht durchs Gesicht erkennen.' Translations of *Plastik* are by Gaiger (Herder 2002).

6 A useful definition of the term 'haptic' is given in Candlin (2010: 5); see also Purves (2013a: 28). As Moore (2006: 15) observes, 'Herder does not mean to suggest that we best appreciate sculptural form by groping the marble with our eyes shut.'

7 Herder's description could be applicable to either. Both works were celebrated in the eighteenth century; see Haskell and Penny (1981: 229–32), on the 'Farnese Hercules', and (1981: 311–14), on the 'Belvedere Torso'. The Torso receives detailed attention from Winckelmann (2006: 323).

8 On sculptural nudity, see *Plastik* 2.1 and on its supposed whiteness, *Plastik* 2.2, 56. Winckelmann (1972: 118) likewise praises the absence of colour in ancient sculpture. According to Jockey (2013: 66), white marble was employed in Roman reproductions of Greek bronzes; cf. Hägele (2013: 65–118, esp. 102–3).

9 The idea of the Roman 'copy' is a contentious one. On imperial-era appropriation / reproduction / emulation of earlier Greek sculpture, see e.g. Marvin 1989; Beard and Henderson (2001); and essays in Gazda (2002).

10 Herder makes extensive use of the so-called 'Molyneux Question', similarly addressed by Diderot in his *Lettre sur les aveugles*, postulating that a congenitally blind individual whose sight was restored in adulthood would be unable to tell a cube from a sphere without handling them. Herder and Diderot were right, as it turns out, but for the wrong reasons; for a discussion of the relevant neuroscience see Gallagher (2005: 153–72).

11 'Sensuous cognition' is Moore's translation of Baumgarten's 1735 definition of 'aesthetics' as *scientia cogitionis sensitivae*. On Herder's debt to Baumgarten, see Moore (2006: 1–3); Norton (1991: 22–32).

12 On the 'sensorimotor dependence' of perception, see Noë (2004). As Thompson (2005: 411) points out, 'If something appears perspectivally, then the subject to whom it appears must be spatially related to it. To be spatially related to something requires that one be embodied.' Cf. a slightly different formulation of the process by Rowlands (2010).

13 Jeannerod (1994: 1979–99). The theory of affordances was first developed by Gibson (1977).

14 Jeannerod (1994: 190); cf. Jeannerod (2001: 103).

15 Gallagher (2005: 24) distinguishes between 'body image' (how you believe your body to appear) and 'body schema' (your internal, proprioceptive experience of being in this body).

16 For these contemporary views of Laocoön, see Winckelmann (1972 [1755]: 72–3) and Lessing (1984 [1766]), respectively. For discussion, Richter (1992: esp. 163–82).

17 De Staël (1971: 145).

18 As Didier (1999: 194) writes, 'Corinne est constamment comparée à la Sibylle', particularly as depicted in a painting by Domenichino. For discussion of Corinne's prophetic / Sibylline role see Levy (2002). Translations of Corinne are by Raphael (2008) unless otherwise indicated.

19 Balayé (1971: 144).

20 Gutwirth (1978: 183–9).

21 De Staël's phrasing is possibly a response to Descartes' 'mouvement continu et ininterrompu de la pensée' (*continuum et nullibi interruptum cogitationis motum*). I owe this observation to Audrey Borowski.

22 Engell (1981: 3).

23 From *Erkennen und Empfinden*; quoted and translated by Richter (1992: 103).

24 Gallese and Lakoff (2005: 457).

25 Gallese and Lakoff (2005: 468).

26 De Staël (1971: 124).

27 On the enclosure and roofing of Roman bath-houses, see Vitruvius, *On Architecture* 5.10.3; Nielsen (1993: 41–2 and 153–66) reviews the archaeological evidence. Seneca, *Natural Questions* 1.2.4 attests to artificial lighting (*in balneis quoque circa lucernam tale quiddem aspici solet ob aeris densi obscuritatem*); Statius, *Silvae* 1.5.43–6 also describes baths illuminated by torches (*ignis*) and the unwary sun retreating, 'burned' (*uritur*) by the *alio aestu* within; Seneca, *On the Good Life* 7.3 depicts the *thermae* as dark, humid, and enervating. Nielsen, however, points out that enclosure was more to keep heat in than to shut it out.

28 De Staël (1971: 248).

29 Paul (2000: 34–5).

30 Villeneuve (1999: 160).

31 A neuroscientific study conducted using Rembrandt portraits designated randomly as 'authentic' and 'fake' demonstrated that newer responses were determined more by the designations than by the portraits themselves (Huang et al. 2011).

32 Page references are to Beckford (2006).

33 An expurgated version was published in 1834 but the work did not appear again in its entirety until 1891. Lees-Milne (1990: 19–25, 124); Beckford (2006: 27).

34 Beckford (2006: 22).

35 The statue's purported gesture resembles that of Horus / Harpocrates in Isiac iconography: Donalson (2003: 3, 36). A fresco depicting Harpocrates in this attitude was found in the Pompeii sanctuary: del Maso (2013: 37).

36 The idea that common objects can have esoteric meaning for the initiate is typical of mystery religions: Bowden (2010: 23–4, 214). After relating his initiation, Apuleius' narrator remarks that *ecce tibi rettuli quae, quamvis audita, ignores tamen necesse est* (*Metamorphoses* 11.23, with discussion of the ritual by Griffiths 1975: 294–308).

37 Smail (2008: 155–63).

38 Cf. Damasio (1999: 149–50) on the processing of interoceptive feedback from the 'internal milieu'.

39 Pearce (1992: 136–43).

40 Damasio (1999: 146–7).

41 Compare Rowlands (2010: 199–200) on the exploration of unfamiliar terrain through what he terms the 'amalgamated mind'.

42 The grounds of the Palazzo were landscaped between 1549 and 1599. Gurrieri and Chatfield (1972: 17–31).

43 Compare Huang et al. (2011).

44 Isis was linked with several Graeco-Roman deities, including Demeter, Minerva, Artemis, and Hecate. Apuleius, *The Golden Ass*, 11.5; Witt (1997: 127–8).

45 See del Maso (2013: 9–19) on contemporary responses to the rediscovery of the Pompeian temple; Witt (1997: 157–8) and del Maso (2013: 13) discuss the links between Isis and Freemasonry. The most popular manifestation of this interest is probably Mozart's opera *The Magic Flute* (1791). More scholarly, if still somewhat idiosyncratic treatments of ancient religion were produced by Dilettanti Richard Payne Knight and Charles Townley, both heavily influenced by d'Hancarville's *Recherches sur l'origine des arts de la Grèce* (1785); for discussion of which, see Haskell (1984) and Funnell (1982).

46 Beckford (1993). For comment, see Jack (1993: xi); Craft (1997: 30).

47 Craft (1997); Châtel (1999).

Etymological 'Alterity': Depths and Heights*

Joshua T. Katz

I am by training a shallow classicist – my degrees are in linguistics rather than in Greek and Latin – but my interest in Classics is deep. Indeed, it is in some ways extraordinarily deep. My PhD dissertation, for example, which had the glamorous title 'Topics in Indo-European Personal Pronouns' (Katz 1998), took on the task of explaining the internal morphology of this small class of small words, most of them mono- and disyllables, that made their way from Proto-Indo-European into Greek, Latin, English and the many other related languages flung far across the globe from India to Ireland and from Brno to Bristol – words like *me, you* and *us*. Proto-Indo-European is the reconstructed ancestral tongue spoken on the Pontic-Caspian steppe some 5,500 years ago, thousands of years before our earliest records,[1] and the personal pronouns have been called this language's 'Devonian rocks' because (to quote from the simultaneously delightful and authoritative *American Heritage Dictionary of Indo-European Roots* of Calvert Watkins, who also happened to be the adviser of my pronominal thesis and about whom more will be said later) they 'belong to the very earliest layer of Indo-European that can be reached by reconstruction' and '[t]heir forms are unlike those of any other paradigms in the language' (Watkins 2011: xxii). The metaphor 'Devonian rocks'[2] takes us just two counties and a few dozen miles from Bristol but a good 400 million years back in deep

* My opening sentence makes clear just how personal this paper is. But I make no apologies: the whole conference at the University of Bristol where a version was presented in November 2014 was an avowed and (dare I say) successful acknowledgement, devoid of mawkishness, of how our own deep histories affect how we see the world as we do. My thanks go to my fellow voyagers on the Deep C, especially Josh Billings, Stephanie Frampton, Laura Jansen, Sarah Nooter, Alex Purves and (*sine quo non*) Shane Butler.

time, to what is sometimes called the 'Age of the Fishes', and while the force of
the description is to emphasize the greatly archaic and seemingly impenetrable
nature of the pronominal beast, what my dissertation attempted to do was
delve inside forms such as *you* in English, *nōs* 'we, us' in Latin and the peculiar
Homeric second-person dual σφῶϊ(ν) to figure out where they come from and
how they fit into the larger linguistic system.

As a firm believer in the importance of knowledge for its own sake, I make
no apologies for writing 300 pages on such a topic. Furthermore, from the
point of view of linguistics, no apologies are necessary since there are both
specific and general reasons why my study is, or at least could be, useful to
those who wish to understand the workings of a given language or how
a careful account of phonological and morphological data inside a few
languages could contribute to a wider comprehension of language as a human
phenomenon. The problem, if that is the right way to put it, is that from the
point of view of a classicist – a 'normal' classicist, by which I mean someone
who is interested in data, be it animal, vegetable, mineral, textual or material,
from ancient Greece, Italy and the wider Greco-Roman world of antiquity – it
is not obvious that there is any payoff to knowing something about the
background of Latin *nōs* or Greek σφῶϊ(ν). So these are deep issues that are in
one important way not deep at all.

All of this is a roundabout way of saying something that one can easily
determine by looking in a good dictionary, or contemplating the matter on
one's own: the majority of words, *deep* among them, have multiple meanings
(or shades of meaning). For example, the *Oxford English Dictionary* classifies
most senses of *deep* (adj.) as either '[l]iteral' (I), starting with 'Having great or
considerable extension downward' (1.a), or '[f]igurative' (II), starting with
'Hard to fathom or "get to the bottom of"; penetrating far into a subject,
profound' (6.a). Analysing the Devonian rocks of Greek and Latin obviously
has great temporal extension downward, but doing this does not automatically
result in penetration far into the intellectual heart of classical studies. Time
depth is not the only depth, what is deep need not be profound and
perhaps (though this is not a matter I address here) what is profound need not
be deep.[3]

One might suppose, then, that a privileged intellectual position – or, as the
Deep Classics call for papers put it (see Shane Butler's Introduction), in a

phrase quoted also in Morales (2014) (see below), a 'pose by which the human present turns its attention to the distant human past' – is one that is doubly deep, having great temporal extension downward and being at the same time exciting, amazing, panoramic: in a word, sublime. Sublimity is often thought of as having to do not with depth but with height (cf. Greek ὕψος), though it is fundamentally a matter of greatness – of size, scale and wonder – and greatness is not tied to a single direction. Rather than try (and fail) to say anything interesting about the definition of 'the sublime' from pseudo-Longinus to modernity (see now Doran 2015 and Porter 2016), I point out merely that no classicist will be surprised by the juxtaposition, even quasi-synonymity, of depth and its apparent opposite, height, thanks to the famous fact that the Latin word *altus* is, from the perspective of English, a so-called auto-antonym: a form that has two seemingly contradictory translations, both 'high' and 'deep'. The reason is straightforward and shows that the Roman perspective is different from our own: *altus* is historically the past passive participle of the verb *alere* 'to nourish'[4] and hence means 'grown great', which (to quote from Lewis and Short's *Latin Dictionary* s.v. *alo*) can be '[s]een from below upwards' (*altus* A), that is to say, high or lofty, or can be '[s]een from above downwards' (*altus* B), that is to say, deep. The deep sea that Shane Butler has asked us to watch out for – in Latin, simply *altum* 'the deep' – is at the same time the high sea(s), a fossilized phrase in English that translates the post-Classical Latin collocation *altum mare*. 'High C(lassics)' and 'Deep C(lassics)' certainly have different rings to them, and it is useful to consider what the point of view embodied in the words *altus* and *altum* has to tell us about the critical stances we assume when we look at the remains of the classical world. By the way, this point of view also explains the Latin adjective *sublīmis* 'high', which has that curious prepositional prefix *sub-* (cf. Greek ὑψ-) that means both 'under' and 'from below up to'; the Indo-Europeanist will see it even in our own word *deep* (and in Lithuanian *dubùs* 'deep') since its cognates in Tocharian A and B, two closely related languages spoken in Chinese Turkestan that are preserved in sixth- to eighth-century CE texts, most of them Buddhist, are *tpär* (A) and *tapre* (B) – and these mean 'high'. Such facts remind me of the amazement I felt as a child when I learned that Mount Everest was not the tallest mountain in the world after all: Mauna Kea in Hawaii is far taller, but much of it is underwater and hence not instantly noticeable to those of us who dwell on the surface.

A goal of Deep Classics is to avoid dwelling on the surface, and I come now to the matter of 'etymological "alterity"'. Etymology is a subject close to my heart, but 'alterity' represents a departure from the norm, even a coming out of sorts since this is the first time I have used the word in print – and in a title, no less! To be sure, it is there in scare quotes, but the reasons for these distancing marks of punctuation may be unexpected. I hope in what follows to make real and appropriate use of the word, and to two purposes: both as a kind of language game and in an intellectually wholly serious way. As we will see, the two are more closely connected than one might expect.

Let me start with the language game. The word *alterity* certainly appears Latinate and looks as though it might be connected to the Latin word for 'high' and 'deep', *altus*. As it happens, however, modern etymologists do not believe that *altus* has anything to do with *alter*, the Latin word for 'other' that lies behind *alterity*, though the two do go back to homophonous roots in Proto-Indo-European:

- Latin *altus* 'high, deep' < PIE [1.] *h_2el- 'grow, nourish'
- Latin *alter* 'other' < PIE [2.] *h_2el- 'beyond',

where the first root *h_2el- gives rise also to such native English words as *old* and *elder* and the second is responsible for *other* and *else*.[5] One reason for the scare quotes, then, is that etymological 'alterity' is not the same thing as etymological 'altitude' – or depth. At the same time, they are also there because I firmly believe that there is more to etymology than the modern scientific method. While it is unfortunate that most classicists do not know enough about the history and prehistory of Greek and Latin to be able to evaluate etymological arguments put forth by linguists,[6] it is nearly as unfortunate, in my opinion, that linguists tend to scoff at the frequent use classicists make of the poetic and allegorical etymologies that fill our texts and fill our world: etymologies that come to the fore in Plato's *Cratylus* and on which ancient scholars from Varro to Isidore wrote treatises that are today considered famous and infamous in more or less equal measure. Not only is folk etymology (i.e. the 'other', alternative, kind of etymology) a major force in the shaping of language, but the line between scientific etymology, which is often deep but not always profound, and folk etymology, which is sometimes shallow but often profound, is not as clearly drawn as many of my linguistic colleagues seem to believe.[7]

When I was young, for example, I really did believe that the word *adultery* – borrowed from Latin *adulter* 'adulterer', which goes back to the proximate preform **ad-altero-*, a compound of *alter* ([2.] **h₂el-*)[8] – owed its form to the fact that it was a practice engaged in by *adults* ([1.] **h₂el-*); even now I find it hard not to see the connection, specious though it is from the point of view of deep history. One might, of course, cry that etymology, a word whose very own etymology has to do with truth, should not be false. But like Hesiod's Muses, we know how to tell many things that ἐτύμοισιν ὁμοῖα, that sound like truth and yet are lies. The fact is that the connection between adults and adultery is hopelessly fixed in my mind, and thanks to the insouciant manual *Adultery for Adults: A Unique Guide to Self-development* (Peterson and Mercer 1968), I know that I am not alone, though the authors, children of their time, were using a language game to make their breezy point that 'sexual adventure' is not merely 'the province of the young' (9), whereas I had some vague understanding that adultery was for grown-ups, not children, long before I comprehended that wordplay lay behind it.[9] 'For all intensive purposes' (as they say) the connection between *adult* and *adultery* – like the connections between *asparagus* and *sparrow grass* (the latter common enough to have received the honour of an entry of its own in the *OED*[10]), between the eponymous hero of the *Odyssey* and the Greek verb ὀδύσσομαι* 'hate' (see the references in *Lexikon des frühgriechischen Epos* s.vv. ὀδύσ(σ)ασθαι and Ὀδυσ(σ)εύς) and between many hundreds of other look- and sound-alikes in every language – though quite temporally shallow and thus beneath (or, rather, above) the notice of most historical linguists, has affected in a slight but real way my and others' usage of the words and my and others' picture of the world.

And it's a big and deep world out there. In a review of a pile of Classics books that appeared in the *Times Literary Supplement* in September 2014, titled 'Deep Down', Helen Morales has some provocative things to say about the conference, then two months in the future, whose proceedings are collected here. The points she raises are interesting, and I quote in full one of her paragraphs, with a few remarks of my own added in square brackets (Morales 2014):

This "world literature" approach [Morales means looking at classical texts from a geographically and temporally wider perspective without regarding them as 'prime movers'] would seem to be another, if not directly acknowledged, target of Silk, Gildenhard and Barrow['s 2014 book *The*

Classical Tradition: Art, Literature, Thought]. It is part of a broader trend in Classics to decentre Greece and Rome. Take, for example, a new initiative at the Institute for Greece, Rome and the Classical Tradition at Bristol University (where Zajko and O'Gorman are based [an edited volume of theirs is under review here as well]) called "Deep Classics" – a name that manages to raise eyebrows both by implying that other approaches to the discipline are superficial, and by "reflexing", as Silk, Gildenhard and Barrow might put it, "Deep Throat". According to the website blurb, Deep Classics "neither begins with antiquity itself nor ends with what uses subsequent ages have made thereof. It focuses instead on the very pose by which the human present turns its attention to the distant past". The key question: do these approaches expand and redefine Classics or do they take the Classics out of Classics? World literature and Deep Classics appear to lose sight of, or even oppose, the centrality of ancient Greece and Rome to Western traditions. Here is where *The Classical Tradition* will be important: a reminder that ancient Greece and Rome have had an unparalleled influence on the Western world, whether we like the idea of a hegemony of cultural impact or not.

There is much here to comment on, and two things on which an Indo-Europeanist may have a special perspective are worth noting. The one has to do with the idea of 'the centrality of ancient Greece and Rome to Western traditions'. No one would dispute that Greece and Rome are at the centre of a sphere of influence – by no means the only sphere, but a substantial one. Spheres are, however, not the only shapes that one can imagine in this context; there are also simple lines, such as timelines. One of the things Indo-European linguists like to point out is that while Homer is indeed in one sense the start of a tradition, one that began 2,800 or so years ago, from another perspective, Homer is in a different sort of centre: the middle. He is a bard, an author, a text that we can study not just in itself and not just for what it would become – its reception – but also for what it was before, some 7,500 years ago: its 'preception', as it were. Studying the background of Greek language and culture – of the language and culture present in what was not yet but would become Greek – does not do any harm to such notions as 'the wonder that was Greece' or 'the genius of Homer' or to any of the other jingoistic slogans that used to be so popular; at the same time, they do not help these notions either. Sometimes another perspective is just another perspective, not one that is inherently better or inherently worse.

The other point to make concerns Morales's claim that the name 'Deep Classics' 'raise[s] eyebrows ... by "reflexing" ... "Deep Throat"'. It had not occurred to me before reading these words in the august pages of the *TLS* that there was a connection between the present enterprise and Linda Lovelace;[11] shortly before the conference, however, Alex Purves and I had dinner with a fellow classicist who admitted that the link did exist in his mind.[12] More seriously, though, there is the matter of 'reflexing'. What does it mean that 'Deep Classics' would 'reflex' 'Deep Throat' (a gross thought)? To understand what Morales is driving at, it will be helpful to quote from what she writes earlier in the piece:

> Silk and his co-authors ... stress that the classical tradition comprises not just deliberate appropriations of ancient material, but also "reflexes" of the classical. "Reflexes", a term borrowed from historical linguistics, conveys lineage, without implying any deliberate transmission or reinvention. To take a simple example: any modern dome is a "reflex" of the ancient Roman dome, whether or not the architect intended to make the allusion.
>
> It is certainly true that including "reflexes" of the classical broadens the scope of the cultural legacy of ancient Greece and Rome. But it raises problems of definition. We may wonder: is everything a "reflex"? Is anything excluded from the classical tradition?

When one is inside a field – the field of historical linguistics, say – one has a tendency to become immune to its jargon, and I am grateful to Morales for reminding me that the linguistic use of the word 'reflex' (*OED* s.v. *reflex*, n. 3.c: 'A word, sound unit, etc., derived by development from an earlier form') is not on the tip of everyone's tongue. She is right that 'reflexes' have to do with lineage and that they do not 'imply[] ... deliberate transmission'.[13] But once she brings in domes, the choice to extend the meaning of 'reflex' so that it refers to extra-linguistic matters – not her choice but in the first place that of Silk, Gildenhard and Barrow (2014) – starts to show real strain.[14] The reason for this is quite simple: there is something special about *linguistic* lineage.[15] The amazing thing about language – something that everyone who stops to think realizes is amazing but is so basic to human experience that we tend to take it for granted – is that it is passed, in the form of speech, entirely naturally from parent to child, generation after generation after generation.[16] It is almost magical that children learn language and grow up to be fluent native speakers; and they

then have children of their own, who grow up to be fluent native speakers; and the cycle repeats. Over time, languages change, but many of these changes are imperceptible to speakers at the moment in question – and yet these changes over decades, centuries and millennia multiply and become clear enough so that what was a single mode of speech becomes, breaks into, many: Proto-Indo-European becomes or breaks into English, Tocharian and Latin; Latin later becomes or breaks into French, Spanish and the other Romance languages; etc. This is emphatically not 'deliberate transmission'. It is not deliberate that the Proto-Indo-European word for 'father', *ph_2ter-, develops into, is transmitted as, *father* in English, *pācer* in Tocharian B and *pater* in Latin; and it is not deliberate that Latin *pater* develops in turn into *père* in French, *padre* in Spanish and *pai* in Portuguese. But how are we to assess the transmission of domes (on which see Silk, Gildenhard and Barrow 2014: 253–62)? Recall that Morales speaks of 'intention', writing that, according to one view, 'any modern dome is a "reflex" of the ancient Roman dome, whether or not the architect intended to make the allusion'. The thing is, though, that one does not need to delve deep into the contested thickets of intention and authorship, of allusion and intertext, to realize that it is often no easy task to decide whether an architect intended her dome to resemble the dome of the Pantheon in Rome or whether an author in some way consciously or unconsciously modelled his epic poem directly on the *Odyssey*. Whatever the mechanisms of transmission of literary or architectural design may be, they involve learned cultural rather than natural behaviour. Silk, Gildenhard and Barrow have the right to broaden the meaning of 'reflex' and try to persuade colleagues of its utility (on semantic change, see below), but I do not myself find it terribly useful to think of 'Deep Classics' as a 'reflex' of 'Deep Throat'; and, more generally, the analogy between the development of language and the development of everything that is not language is, in my opinion, difficult to maintain.

Let me return now to 'etymological "alterity"', or the 'othering' of etymology, and exemplify what the phrase can mean by presenting sketches of three case studies. First, I consider the balance between the pleasure of a good etymology and the danger inherent in building too much of an edifice on top of it: deep derivation is at the best of times a risky and controversial business. Second, I point out what is sometimes called the etymological fallacy, according to which it is not always wise to build on an etymological edifice even when it is secure.

And third, I suggest some potentially interesting links between etymology and contemporary poetry. Each of these topics would be worth a paper of deep thoughts on its own, especially the last.

To begin: good etymologies and their pitfalls. While there are of course plenty of words whose deep history does not lead to classical heights – Latin *nōs* and Greek σφῶϊ(ν) come to mind, but examples are easy to find among nouns and verbs – there are others for which an understanding of the background can really help.[17] A high-profile case is the first word of the *Iliad*, μῆνιν, the accusative of the word for 'wrath', about which Leonard Muellner has written an entire book that is heavily based on linguistic research and includes an appendix titled 'The Etymology of *mênis*' (Muellner 1996: 177–94). There is also the next word, ἄειδε, the imperative of a verb for 'sing', whose Indo-European background – and specifically its background in connection with μῆνιν – I have suggested in a couple of papers (Katz 2013a, esp. 15–23, and 2013b) tells us something deep about the sounds humans use when they hymn divinities, including θεά 'goddess', which in its vocative form is the third word of the *Iliad* and about whose background in connection with both μῆνιν and ἄειδε I intend to write a piece as well. The details of the various etymologies are important – it matters whether μῆνιν is ultimately derived from PIE *men-* 'think (*vel sim.*)' and ἄειδε from *h_2weid-* 'sing'; see immediately below – but it is not surprising that what makes μῆνιν, ἄειδε and θεά more interesting than everyday pronouns is not the fine print but the simple fact that each carries heavy cultural weight on its own, never mind as a group occupying a 'privileged position' at the very start of a poem whose historical background, or 'preception', is no less striking than what has come of it in the millennia since it was first sung. Put simply, if you want to study something etymological that is not only deep but also high, you have to choose accordingly, for while every word has an etymology, not all etymologies are created equal.

To follow up on this: it is also the case that not all etymologies of a given word are created equal. This is hardly unexpected: a word should by rights have just one etymology, one source of 'truth'. However, a dirty little secret of etymological 'otherness' is that most interesting words have multiple stories told about them, with each individual scholar fighting for the acceptance and validation of his or her version, his or her picture of word and world.[18] In the

case of the word for 'wrath', for instance, as Muellner points out in the course of telling his book-length tale, there have been at least three derivations in the last hundred years, three separate (lies like) truths: the one I favour, put forth by Eduard Schwyzer in 1931 and revived, with new arguments, by Calvert Watkins in 1977 (PIE *$mneh_2$-'keep in mind' [a presumed derivative of *men-], with nasal dissimilation/taboo deformation); a somewhat different second one put forth most vehemently by Patrick Considine in a couple of publications in the mid-1980s (details not easy to follow, though *men-* plays a role here as well); and – to add a further twist – a third one that Schwyzer, having come to doubt his original idea, proposed in passing in 1939 (somehow related to μαιμάω 'am very eager', itself of unclear origin).[19] People remember, accept and build on etymologies, but what are the consequences when, as happens all the time, an idea is judged wrong – when, to put it another way, a would-be deep etymological story turns out to be a tall tale? To put myself under the spotlight: I like to think that many things I wrote in Katz (2013a, b) will stand the test of time even if it should turn out that μῆνιν and ἄειδε do not come from where I claim they come from, but it is undeniable that a refutation of either etymology would be a heavy blow to the overall argument.[20] Certainly I have published etymologies that I now believe are wrong (compare e.g. Katz 2010c: 38 n. 22); few historical/comparative linguists, if any, would be able to say otherwise. As I have already noted, the lines between etymology and folk etymology are not clearly drawn, and it turns out that the lines between true etymological scholarship and falsehoods are also highly contested territory. So today's etymologies, which each year fill literally thousands of pages of scholarship for Greek and Latin alone, really are a lot more like, say, Varro's than we are usually willing to admit.

My second point follows immediately. The adverb *literally* in the phrase 'fill literally thousands of pages of scholarship' is an intensifier (*OED* s.v. I.1.c: 'Used to indicate that some (freq. conventional) metaphorical or hyperbolical expression is to be taken in the strongest admissible sense: "virtually, as good as"; also "completely, utterly, absolutely"').[21] This usage is decried by many sticks-in-the-mud, but sometimes it is used in a manner that is potentially more appropriate: for example, *The army was literally decimated* (I.1.b: 'Used to indicate that the following word or phrase must be taken in its literal sense, usu. to add emphasis'). And yet I hardly need to point out the real difficulty: it is not

only the meaning of *literally* that has changed but that of *decimate* as well, so coupling the two words and understanding the former in something like its primary definition (I.1.a: 'In a literal, exact, or actual sense; not figuratively, allegorically, etc.') results in something very strange. Outside explicit reference to ancient Rome (*OED* s.v. *decimate*, v. 1.a: 'Chiefly *Roman Hist.* With reference to military punishment: to select by lot and put to death one in every ten of (a body of soldiers found guilty of desertion, mutiny, or other crime)'), the verb these days is very rarely used to mean 'To kill, destroy, or remove one in every ten of' (1.b) rather than 'More generally: to reduce drastically or severely; to destroy, ruin, devastate' (1.c). While the *OED* adds to 1.b the comment, 'In later use usually with an indication that the more general sense 1c is not intended, esp. by use of *literally*',[22] the fact is that *literally* these days often has the sense 'not literally', even 'figurately' (compare *OED* s.v. *literally* 1.1.c), which means that it can be difficult to know out of context just how to parse the phrase *literally decimate*. And this is to say nothing of the further problem, pointed out by Shea (2012), that 'it is not at all clear that th[e] punitive sense [of *decimate* in English] is indeed the earliest definition of the word' rather than 'to tithe'. So, does etymology not matter? From a deep historical point of view, etymology matters a lot, but in a case of this kind, it would be ridiculous for anyone – classicist or non-classicist alike – to insist that knowledge of the Latin word *decimus* 'tenth' has much of a role to play in our understanding of English today. Those who disagree are clinging to the etymological fallacy, the idea that present usage should conform to past (deep) meaning;[23] they are the pedants whose remarks on *literally* and *decimate*, both stylistic bugbears, fill books and blogs – and inspire their antagonists to fill books and blogs in turn.

Where etymology does play a really interesting role – and I come now to my third and final kind of alterity – is in modern poetry. This will not surprise classicists, who consider 'poetic etymologies' as a matter of course (see e.g. Tsitsibakou-Vasalos 2007), and I confine myself to three observations about the intentional use of word-derivations in the history of English verse.[24] First, Mark Liberman, a highly respected linguist at the University of Pennsylvania who is, among other things, a regular contributor to the blog *Language Log*, has commented in a post titled 'Extreme Etymology' on Watkins's *American Heritage Dictionary of Indo-European Roots* as a possible source of what he calls 'found poetry'.[25] Consider, for example, the extraordinary range of

words that have come from the two homophonous roots that have given us *alterity* and *altitude*. I am no poet, but what a great children's book it could be to tell a story of '*abolishing* the *prolific eldest alderman's adolescent's haughty proletarian alto*' and then another one about how 'the *hidalgo alarmed* the *alien alligators* with his *outré hoopla*'.[26]

Still, poetry is better left to poets. Here, in its entirety, is one example of a poem that plays – brilliantly and profoundly – with language's often unexpected semantic depths, Heather McHugh's 'Etymological Dirge' (McHugh 1998, with permission):

> '*Twas grace that taught my heart to fear* . . .

> Calm comes from burning.
> Tall comes from fast.
> Comely doesn't come from come.
> Person comes from mask.

> The kin of charity is whore,
> the root of charity is dear.
> Incentive has its source in song
> and winning in the sufferer.

> Afford yourself what you can carry out.
> A coward and a coda share a word.
> We get our ugliness from fear.
> We get our danger from the lord.

Take just the first stanza: *calm* does come from burning, in Greek (καίω 'burn' < PIE *keh_2u-) via various Romance languages; *tall* goes back to the Old English word *getæl* 'quick, prompt', itself of uncertain origin; *come* has the Proto-Indo-European root *g^wem- 'go, come' (cf. also Greek βαίνω 'go' and Latin *uenīre* 'to come'), while the pre-Germanic origin of *comely* is unclear; and *person* is borrowed from Latin *persōna* 'mask', which may itself be a borrowing of a derivative of the Etruscan word φersu, presumed to mean something like '(masked) performer'.[27] In a personal communication of 12 July 2015, McHugh gives an account of 'etymological "alterity"' that is similar to mine – 'I can't imagine a more lovable destiny than to look forever at etymologies, false or not (or even the successions of fashion in their assigning!!!)' (compare above, esp. n. 18) – and explains, in response to my query about how she went about

writing the poem, that she was not specifically inspired by Watkins's book (ellipses in original):

> I have to fess up – there's no scholarly merit in my methods – I ran across an old etymology dictionary – something whose title I don't even recall now that I've given away all my books and something I doubt anyone ever uses now – it was more in the way of an accidental befalling somewhere, books for 10 cents whose bents or bindings appeal to me, that sort of thing . . . and then the comedies and half-truths and unrecognized lurking truths and false gods and more therein kept prompting the pattern of the poem . . . Later I was informed by more professorially-exacting friends that the book was unreliable as reference resource. You can't prove that (or almost anything) by me. I'm moved by love, and wowed by the cloud of unknowing.

There is, however, one recent example of inspiration by Watkins, or perhaps I should call it instead chagrined perspiration. This example brings us full circle back to pronouns and pitches two titans of Classics against each other, neither one in his – or her – capacity as classicist. In the 10 February 2014 issue of the *New Yorker*, Anne Carson, like McHugh a MacArthur Fellow and certainly the most celebrated living poet who is also a scholar of Greek (she has been a professor of Classics at Princeton, McGill and the University of Michigan), published a poem titled 'Pronoun Envy' (Carson 2014, quoted below with permission) that opens with Watkins (d. 20 March 2013), who besides editing a dictionary that could be used for found poetry was certainly the most celebrated Greek, Latin and Indo-European linguist of his generation (he retired from Harvard in 2003 as Victor S. Thomas Professor of Linguistics and the Classics and moved to UCLA, where he was at the time of his death Distinguished Professor-in-Residence in the Department of Classics and the Program in Indo-European Studies):

PRONOUN ENVY

is a phrase
coined by Cal Watkins
of the Harvard Linguistics Department
in November 1971

to disparage
certain concerns

of the female students
of Harvard Divinity School.

In a world
where God is "He"
and everyone else
"mankind,"

what chance
do we have for
a bit of attention?
seemed to be their question.

Going on to object to the very idea of 'masculine as the / unmarked gender,' Carson criticizes the would-be deep historical explanation for the problem – 'It's the Indo- / European system of markedness' – with the words,

As if all
the creatures in the world
were either zippers

or olives,
except
way back in the Indus Valley
in 5000 B.C. we decided
to call them zippers

and non-zippers.

By 1971
the non-zippers
were getting restless.

There is much to say about restlessness in Cambridge, Massachusetts in late 1971. In short, this is what happened: two students in a course taught by Professor Harvey Cox of the Harvard Divinity School, Linda Barufaldi and Emily Culpepper-Hough, got their classmates to support the women's liberation movement by agreeing, among other things, to avoid using masculine pronouns when referring to God; the *Harvard Crimson* published an article about this (Dionne 1971); seventeen people at Harvard – most of them linguists and a good number of them on the faculty[28] – wrote a letter to the

editor of the *Crimson* that talks about the concept of linguistic markedness and ends with the words, 'There is really no cause for anxiety or pronoun-envy on the part of those seeking such changes' (Goddard et al. 1971); *Newsweek* picked up the story ('Pronoun Envy' 1971), though without mentioning that two scholars at nearby MIT had in the meantime written a letter to the *Crimson* in opposition to 'the apologia for "he" as the generic pronoun' (Valian and Katz 1971[29]); no fewer than five letters, all of them unhappy about the Harvard linguists' claim and one of them by a linguist at the University of Washington (Armagost 1971), appeared in a subsequent issue of *Newsweek*;[30] and a Harvard English professor and medievalist weighed in as well (Bloomfield 1972).[31] I regret that I never spoke to Watkins about what he thought about 'pronoun envy' decades later,[32] once the use of generic *he* had gone into serious decline under societal pressure (though divine *He* has proved harder to dislodge) and once the etymologically mysterious (but possibly Scandinavian-influenced) *she*, a Middle English innovation, had been proclaimed 'Word of the Millennium' by the American Dialect Society in January 2000.[33] I am confident, however, that Watkins would not have been happy about Carson's deployment of the term 'markedness', and he would certainly have scoffed at the phrase 'in the Indus Valley / in 5000 B.C.' since no reputable scholar believes this to have been the cradle of Indo-European.[34] Of course Carson's work is a poem, not a conventional piece of scholarship. Whatever one thinks of her 'poetic imagination' (Liberman 2014) or license, the issues that 'Pronoun Envy' brings out – above all that pronouns *can* be deeply interesting – are, I believe, a good final example of what I have been calling 'etymological "alterity"', of etymological otherness, of past and present brought together in a matter of perspective and depths and heights. Such matters are what Deep Classics is about.

Notes

1 The geographical and temporal details are controversial; Fortson (2010) provides the best overview.
2 Which goes back to Lancashire native Joshua Whatmough (thus Watkins *apud* Katz 1998: 1).

3 I am reminded of what Jake says in his diatribe to Dr Rosenberg near the end of *Jake's Thing*: '[W]hat makes you think that what's deep down is more important than what's up top?' (Amis 1978: 265).

4 De Vaan (2008: 35), referring to work by P. Schrijver, is sceptical of the connection between *altus* and *alere*, whose synchronic past passive participle is sometimes *alitus*.

5 See Watkins (2011: 3, s.vv. *al-*³ and *al-*¹ respectively). The symbol *h_2 stands for one of the sounds in Proto-Indo-European known as laryngeals: these are pronounced deep in the throat and not found in anything like their consonantal urforms after the deep dark second millennium BCE.

6 Good recent guides to classical linguistics, both historical and otherwise, include the following: Bakker (2010), Horrocks (2010) and Giannakis (2014) for Greek and Clackson and Horrocks (2007) and Clackson (2011) for Latin. Weiss (2009) is an outstanding professional-level survey of what is known about the development of Proto-Indo-European into Latin.

7 I have written sharp words about this in Katz (2010c); see also Katz (2010a).

8 According to Paulus ex Festo (p. 22 M), '*adulter*' et '*adultera*' *dicuntur, quod et ille ad alteram et haec ad alterum se conferunt*, '*adulterer*' and *adulteress* are so called because he gets together with another woman and she with another man'.

9 For links between etymology and wordplay, see Katz (2010a, c), Katz (2013c: 23–5) and especially Attridge (1987), a wonderful paper that I discovered only recently, thanks to another relevant and fascinating article, Gurd (forthcoming). I very much like the following formulation: 'Word-play . . . is to etymology as synchrony is to diachrony' (Attridge 1987: 193).

10 *OED* s.v. *sparrow-grass, sparrowgrass*, n.: first attested for *asparagus* in the 1650s and '[n]ow *dial.* or *vulgar*'.

11 In an attempt to restore dignity, Sarah Nooter suggested to me that perhaps Morales was referring (also ?) to the pseudonym of the informant in *All the President's Men*: the deep background that Mark Felt provided to two reporters for the *Washington Post* during the Nixon presidency would bear a (superficial) resemblance to the deep background to Greek and Latin that comes from a knowledge of (e.g.) Proto-Indo-European.

12 The process by which the word *deep* in a neologism of the form 'Deep X' acquires a special sense for some speakers thanks to the prior existence of a collocation 'Deep Y' is not dissimilar to the way in which folk etymologies take hold; see above.

13 The phrase 'derived by development' in the *OED* definition of *reflex* just cited presumably means 'derived by natural, non-deliberate development'; this is

consistent with the use of the word in the six exemplary passages cited from 1880 to 1999.

14 Silk, Gildenhard and Barrow are explicit from the start about what they are doing: 'We borrow – and extend – this use of "reflex" from historical linguistics, where the word stresses the fact of descent without any implication of purposeful transmission or adjustment . . . In our extended usage, the word is reapplied from particular linguistic forms to whole language systems and other large behavioural structures. Thus, the Italian language *per se* is (largely) a reflex of Latin *per se* . . ., and medieval Italian carnival (partly) a reflex of ancient ceremonial or ritual' (2014: 4 n. 3). I appreciate the care they take to be nuanced – e.g. '[W]e should certainly acknowledge the distinction between continuations (survivals, 'reflexes'), as in carnival and the *commedia dell'arte*, and receptions (direct or indirect), in fiction, film, and elsewhere' (135) – but am not convinced by the utility of their extended understanding of carnival and the *commedia dell'arte* as 'reflexes'.

15 For what follows in this paragraph, compare Katz (2010b: 357–9).

16 I use 'speech' as a convenient shorthand, wholly intending for its meaning to include the manual rather than vocal gestures of sign languages.

17 Let me choose, not quite at random, two recent etymological studies of Greek and Latin onomastics: Barnes (2009) and García Ramón (2013: 108–15). The former vindicates Martin Peters's suggestion that the name of the Greek war god, Ἄρης 'Ares', goes back to a Proto-Indo-European root *h_2reh_1- 'grind' and notes that the Homeric formula μῶλον Ἄρηος, generally translated as something like 'moil of war', matches the Hittite collocation *mallai ḫarrai* 'mills (and) grinds'; the latter points out that the form FERTER in the Old Latin name FERTER RESIVS, inscriptionally attested, should not be emended to **fertor* and instead makes a perfect match with the Homeric adjective φέρτερος 'better, braver; prominent' (PIE *$b^h\acute{e}r$-tero-* '*ertragreich').

18 This is one reason why having multiple etymological dictionaries of a given language makes sense; it is also, in my opinion, why considering etymologies from the point of view of intellectual history is so interesting. See Katz (2010c) and also Katz (2010a).

19 See Muellner (1996: 186–94) for references to the works of Schwzyer (*recte* 1939, not 1968), Watkins and Considine, as well as C.D. Buck and J.-C. Turpin; the idea of a connection between μῆνις and μαιμάω, which has not won wide acceptance, makes an appearance also in one of Considine's papers. Muellner ignores the entirely implausible suggestion of Ehrlich (1907: 294) that μῆνις is 'der verlorene Singular' corresponding to Latin *mānēs* 'deified shades of the dead'.

20 For the idea that the word for 'sing' goes back a Proto-Indo-European root of the shape *h_2wed-* rather than to *h_2weid-*, see e.g. Sihler (1995: 56, 86 and 499).

21 Which is not to say that there aren't an awful lot of etymological ideas out there. There are.

22 As for 1.c, the *OED* accurately notes that '[t]his use has sometimes been criticized on etymological grounds . . ., but is now the most usual sense in standard English'.

23 How far in the past is rarely specified, but in the case of classical words, it tends to be some idealized normalization of fifth/fourth-century BCE Athens and Rome around the turn of the era; it is all but never based on Proto-Indo-European (much less suppositions about what came before that). The reason for this is that Western grammar mavens tend to pride themselves on their classical education and act as though civilization began, in Europe, sometime in the first millennium BCE. There is something especially amusing about the cartoon by E. Flake (*New Yorker*, 85 (15), 25 May 2009: 68) in which two bloodied Vikings (they are wearing horned helmets) stand together with a scene of destruction in the background and one asks the other, 'Did *you* know that "decimate" means kill just one out of every ten?'

24 The classic paper is Ruthven (1969); for Early Modern English (Spenser, Jonson, Donne and Milton), see now Crawforth (2013). See also Curtius (2013: 495–500) for a brief but influential survey of etymology as 'an obligatory "ornament" of poetry' (497) in the classical tradition.

25 As he puts it, 'The dictionary of Indo-European roots, whatever its other uses, has value as a source of found poetry' (Liberman 2009).

26 All words except the few not in italics (*the*, *with* and *his*) go back (or have components that go back) to [1.] *h_2el- and [2.] *h_2el- respectively.

27 The most interesting of these sets of words, or at least the one on which there is the largest literature, is the last. It is likely that *φersu* is a borrowing as well, from Greek πρόσωπα, the plural of πρόσωπον 'face', which is attested in the meaning 'mask' from the fourth century BCE and has an excellent Indo-European pedigree (root *h_3ek^w- 'see', as also in Greek ὄψις 'appearance, sight', Latin *oculus* 'eye' and English *eye* (Old English *ēage*)). For the relationships among the Greek, Etruscan and Latin words, see Watmough (1997: 66–7, with references); see also Wallace (2008: 129–30).

28 Watkins, who is the third signatory (after Ives Goddard and Michael Silverstein), is listed as 'Chairman, Department of Linguistics' though he was also in the Department of the Classics, which supplied one other endorser: then-Assistant Professor of the Classics Gregory Nagy, who had the previous year published his first book, on a linguistic topic, Sievers' Law (see n. 31).

29 I am not related to the distinguished philosopher and linguist Jerrold Katz.

30 Two of the letters were sent from Cambridge, including a monosyllabic one, 'Hex!', signed by the 'Women's Inspirational Theology Conspiracy from Harvard (WITCH)'.

31 For most of this, see Miller and Swift (1976: 71–82, with notes on 175–6, esp.
74–7), Martyna (1980: 483–4), Hill (1986: 50–65, with notes on 149–51, esp. 50–2;
the chapter bears the title 'Pronoun Envy'), Livia (2001: 3–4, with notes on 203; the
book by Dublin-born feminist Anna Livia – born Anna Livia Julian Brawn – is
titled *Pronoun Envy: Literary Uses of Linguistic Gender*), and Liberman (2014:
'Pronoun Envy'). See also Romaine (1999: 105–6 and 122). As Hill (1986: 5–6 and
51) notes, she wrote a PhD dissertation on a technical topic in Indo-European
linguistics, Sievers' Law, before making 'a startling transition between 1969 and
1974 from teacher of Sanskrit and Indo-European linguistics to teacher of
Women and Language' (6). While her claim that 'an ancient Indo-European
pattern seldom has a bearing on English usage today' is perhaps overstated,
what I have been saying about the need not to confuse depth and profundity
jibes with what she goes on immediately to write: 'It is enlightening to learn about
the history of a given locution, but it does not follow that whatever has been
established as the norm since prehistoric times should be maintained without
"anxiety"' (51).

32 Livia (2001: 203 n. 3) writes, kindly, that '[r]eaders should bear in mind that
Watkins et al.'s letter to the *Harvard Crimson* was written a quarter of a century
ago and can hardly be taken as an expression of its authors' current opinions on
the subject of language and gender'. Curiously (?), the article in *Newsweek*
('Pronoun Envy' 1971) suggests that the Harvard linguists' 'den[ial]' that language
is sexist' was '[t]ongue in cheek'. Ben Zimmer, in a comment to Liberman (2014),
notes that '[i]t appears that Watkins has been given the credit/blame for coining
"pronoun envy" simply by virtue of being the most prominent signatory, though
I gather the letter was very much a group effort'; to this Andrew Garrett adds,
'Indeed, given the order of the signatories (Cal is not listed first) and some of the
style and details of the letter (not least the mention of Tunica), I would guess that
Ives Goddard was the main author. He can no doubt clarify, or some of the other
famous apparent co-authors of the term "pronoun envy" (Steve Anderson, Sandy
Chung, Jay Jasanoff, Michael Silverstein)'. I am grateful to Jay Jasanoff for
providing me with his memories of the composition of the letter: his recollection
is that Goddard did indeed write the original draft, to which others then
contributed.

33 The best account of gender in the history of English is Curzan (2003), which
begins with an account of the triumph of *she* (1) and has a chapter on 'generic *he*'
(58–82; see also Wales 1996: 110–33) that briefly mentions '[t]he Harvard
"incident"' (58). The most recent discussion by a linguist of the relationship
between grammatical gender and biological sex (a topic Corbeill 2015 now
considers at length for Latin) is McConnell-Ginet (2014), which has much to say

about English pronouns and about 'the rather different linguistic strategies that have been taken by English-speaking feminist activists and most of those in languages with grammatical gender' (35). [Note added in proof. At the January 2016 meeting of the American Dialect Society, *they* as a gender-neutral singular pronoun was voted '2015 Word of the Year'.]

34 Compare various issues brought up by Liberman (2014) and some of the commentators.

Shut Your Eyes and See: Digesting the Past with Nietzsche and Joyce*

Adam Lecznar

Woe be to him who, in Antiquity, studies anything besides pure art, logic and general method! By plunging into the past he may well lose the memory of the present. He abdicates the values and privileges provided by actual circumstance, for almost all our originality stems from the stamp that time prints on our sensations.

Charles Baudelaire, *The Painter of Modern Life*[1]

When Friedrich Nietzsche died in Weimar, Germany, on Saturday 25 August 1900, he had not written anything for over ten years since suffering a psychological breakdown in January 1889. Despite this prolonged immobilization, his celebrity as a philosopher had grown so rapidly in the intervening decade that newspapers across the world were keen to mark his demise. *The Times* of London rushed an obituary into print only two days after his death that described his philosophy as 'revolutionary and altogether unpractical'; the *New York Times* waited just one day to publish its assessment of him as an 'apostle of extreme modern rationalism', drawing attention to the 'brilliancy of his thought and diction and the epigrammatic force of his writings [which] commanded even the admiration of his most pronounced enemies, of which he had many'.[2]

But in Vienna the response was different: on Sunday 2 September the *Neues Wiener Tageblatt* published an interview with one of Nietzsche's former

* Deep thanks to Josh Billings, Shane Butler, Pantelis Michelakis, Sarah Nooter, Jim Porter and Camilla Temple for their comments and advice.

teachers, Otto Benndorf (1838–1907). At this point Benndorf was the director of the Vienna Archaeological Institute; he had first met Nietzsche while teaching him at Schulpforta from 1862–4, the final two years of the six that Nietzsche spent at the prestigious *Gymnasium* from 1858. These were formative years for Nietzsche, and among Benndorf's recollections came this intriguing scene from an early encounter between teacher and student:

> I came into contact with Nietzsche because I had set up a plaster museum of reproductions of ancient statues in Schulpforta and every Sunday after church I gave explanatory lectures on the reproduced artifacts, such as the statues of Dionysus and Apollo, the Laocöon group, etc., for the most talented students, who attended voluntarily … As I said, only the most talented students attended, and the occasion often arose, through questions of individual listeners, to develop discussions of an aesthetic and philosophical nature, in which Nietzsche often engaged. His wide reading was astonishing even then, no less than the deep understanding with which he approached all things.[3]

Face-to-face confrontations with the physical remains of antiquity have given birth to many of modernity's most compelling meditations on the ancient world: Winckelmann in front of the plaster-cast statues in Dresden, E.R. Dodds before the Parthenon marbles at the British Museum, Freud standing on the Athenian Acropolis. Benndorf's recollection suggests that we could add Nietzsche to this list. Perhaps it was while he stood in front of the statue of Laocöon and his sons, during a debate among the students about Winckelmann's claim that it represented the 'noble simplicity and calm grandeur' of Hellenic antiquity, that Nietzsche looked over at the nearby statues of Apollo and Dionysus and felt for the first time that they might provide an alternative way of understanding the ancient world.

In this essay I want to explore the significance of the firsthand face-to-face encounter between modern subject and ancient object. In particular I want to focus on the almost imperceptible transition within this moment of contemplation from the immediate sensory perception of the object to an intellectual response that transports that object's human observers far from the here and now of their existence. I would suggest that this dislocation is produced by the competing temporalities inherent in the experience: when those observers stand in front of an ancient statue, they are forced to understand the object both

as a product of the historical context in which it was created and as a tangible part of the present in which it is observed.[4] This is particularly the case when plaster-cast reproductions are involved, since it is here that the layering of different time-periods becomes most obscure and most manifest, as ancient and modern hands come together in the creation of an object that is simultaneously of the past and of the present. A rift appears in the fabric that binds the time and space of the present moment into an unbreakable totality, as the gaze of the statue reminds its present beholders that what is immediate to them has been immediate before to the observers of the past and will be immediate again in the future, and that they hold sole ownership neither of the 'here', nor of the 'now'.[5]

Rilke traces the metaphysical connotations of this meeting in the poem 'Archaic Torso of Apollo'; here, his narrator senses a 'brilliance from inside / like a lamp, in which his gaze, now turned to low / gleams in all its power' before concluding:

> Otherwise this stone would seem defaced
> beneath the translucent cascade of the shoulders
> and would not glisten like a wild beast's fur:
> and would not, from all the borders of itself,
> burst like a star: for here there is no place
> that does not see you. You must change your life.[6]

In Rilke's poem, the narrator allows his presence in the current moment to outweigh his participation in a historical tradition of perception: though he acknowledges that the 'defaced' statue before him has suffered in its journey through history, he perceives that this past is overshadowed by the deep glow emanating from its core that forces him to reassess the conditions of his own modern life. In what follows I want to examine two other writers, Friedrich Nietzsche and James Joyce, who confronted more openly the manifest difficulties of forming relationships with the remnants of the classical world that do not result in alienation from the present. I treat Nietzsche and Joyce together because they both came to understand that a confident grasp of the lived reality of modernity could only come out of an engagement with antiquity, as shown by Nietzsche's first career as a classical philologist and Joyce's decision to model what would come to considered the high text of Modernism on an

ancient Greek epic.[7] But as we will see, their deep commitment to this cause also made them aware of the possible obstacles to their attempts to use the past for the present. How they conceptualized these obstructions is the subject of this essay, and we will see that while Nietzsche believed they were potentially insurmountable, Joyce imagined a sensitive and embodied understanding of the surviving substance of antiquity.

Nietzsche's Greeks: gaining an impression

Two examples from Nietzsche's writings illustrate vividly the potential challenges that he associated with bridging the gap between antiquity and modernity. The first can be found in the surviving lecture notes for a course on Aeschylus' *Choephori* that he gave seven times between 1868 and 1879, during his tenure as Professor of Classical Philology at the University of Basel.[8] In one particular passage Nietzsche asks his students to imagine the experience of seeing the ancient play performed:

> No one among us has seen the *Oresteia*; no one has heard it: an elaborate and backbreaking *guesswork* is required to understand things that would have been simple and easy [to follow] at the performance. Here goes one attempt to view things as they were in their *actuality*: I will tell you what I saw there. Naturally, much of this will be sheer fantasy. But we need to experience an *effect*; once we have that we can form an opinion about the artist. I want to sit in the theater not as an ancient but as a modern: my observations may well be pedantic; but at first I have to wonder at everything so as to comprehend it all afterward.[9]

Although Nietzsche recognizes that the original performative context is inaccessible, he thinks that it is possible to recreate the scene of spectatorship presupposed by the tragic text. But it is not that he wants his students to close their eyes and become Athenians: rather, he wants them to take their seats in the Theatre of Dionysus with their eyes wide open as inhabitants of nineteenth-century Switzerland and to bring their own particular timeliness, that is the structure of feeling that they have developed through the course of their individual lives, into dialogue with the ancient matter of the play. He proceeds:

I have a certain impression of the *Choephori* and this is what I want to describe. But what does it matter to us, you will say, what my impression is? Why don't I appeal to yours? Or to the work? – An impression is something rare. To attain it one has to add so much – which not everyone is able and willing to do.[10]

Nietzsche suggests that this method is not common in the reading of ancient Greek tragedy because it is difficult, and it relies on acknowledging that in their received forms the tragedies of Aeschylus, Sophocles and Euripides have lost many of the qualities that originally made them compelling. Trying to reconstruct these qualities requires an imaginative and personal input on the part of the viewer that is impossible if the tragedy is understood solely as a product of its historical framework, where the process of finding its meaning is the same as uncovering the understanding of its original Athenian viewers. Nietzsche does not want his students to follow the common practice of deriving ideas from a scholarly tradition: rather, he encourages them to embrace their own immediate wonder at the texts they are reading and to use that as a starting point, as a means of overcoming the potentially impassable distance between their personal lives and the objects of their study.

The second example of how Nietzsche conceptualizes the potential obstacles to an understanding of antiquity comes from his 1874 essay 'On the Uses and Disadvantages of History to Life'. Here again, Nietzsche invokes the fantasy of an encounter between antiquity and modernity, but this time with a very different conclusion. Nietzsche begins by describing the abundance of knowledge that is available to people of his era:

In the end, modern man drags around with him a huge quantity of indigestible stones of knowledge, which then, as in the fairy tale, can sometimes be heard rumbling around inside him. And in this rumbling there is betrayed the most characteristic quality of modern man: the remarkable antithesis between an interior which fails to correspond to any exterior and an exterior which fails to correspond to any interior – an antithesis unknown to the peoples of earlier times.[11]

Nietzsche views with horror the inability of modern man to deploy his 'huge quantity' of knowledge for the purposes of life; this becomes clearer when he describes the confusion that would ensue if time-travel allowed a modern man to experience antiquity and an ancient Greek to experience modernity:

That celebrated little nation of a not too distant past – I mean these same Greeks – during the period of their greatest strength kept a tenacious hold on their unhistorical sense: if a present-day man were magically transported to that world he would probably consider the Greeks very "uncultured" – whereby the secret of modern culture, so scrupulously hidden, would be exposed to public ridicule: for we moderns have nothing of our own; only by replenishing and cramming ourselves with the ages, customs, arts, philosophies, religions, discoveries of others do we become anything worthy of notice, that is to say, walking encyclopedias, which is what an ancient Greek transported into our own time would perhaps take us for. With encyclopedias, however, all the value lies in what is contained within, in the content, not in what stands without, the binding and cover; so it is that the whole of modern culture is essentially inward: on the outside the bookbinder has printed some such thing as "Handbook of inward culture for outward barbarians."[12]

Nietzsche invokes this tableau to point out the incommensurability of what he views as the ancient and modern relationships to history. The apparent absence of a modern historical consciousness in antiquity would make it seem 'uncultured' to modern eyes, while the unavoidable presence of tradition would make the modern world seem overladen to ancient eyes, weighed down by things that are extraneous to the lived experience of the present and which have been taken from the past in order to assign to that same present some place in a prestigious historical tradition.

Nietzsche's introduction of the idea of the encyclopedia here recalls the title of a lecture series that he gave during his time at Basel called 'Encyclopedia of Classical Philology'. The idea of 'Encyclopedia' lectures on classical antiquity had become increasingly popular over the course of the nineteenth century, and by the time that Nietzsche came to give his version, the genre was already torn between the limits of an individual philologist's knowledge and the pretention towards total understanding that its title implied.[13] As James Porter suggests, 'each new encyclopedia not only redistributed and rearticulated the material of the ancient world; it altered the image of the world'.[14] Porter proceeds to argue that Nietzsche used his particular 'Encyclopedia' lectures to explore this dissonance: rather than offering an avowedly 'encyclopedic' account of antiquity, Nietzsche's lectures are 'ultimately a study in the modern shapes of desire. It is a study in the modern imaginary and its fascinations'.[15]

As Jean-Michel Rabaté puts it, 'For Nietzsche, modern man is encumbered by a dusty historical lore that hides the intensity of the present moment. We must learn to forget and live in the present the way animals do, so as to be able to affirm "life" in all its vivacity.'[16] In his comments on the *Oresteia*, Nietzsche had suggested to his students that it was possible to recapture this 'intensity of the present moment' in ancient Greek tragedy by holding on tight to the effect that they experienced while reading the play and then projecting that back into the original performative context. There it was possible, though difficult, to overcome the distance between antiquity and modernity. But the encounter between the weighty encyclopedic modern and the lively unhistorical ancient that Nietzsche describes in his essay discloses a different sort of gulf, one that exists *within* modernity, between internal knowledge and external action, which is much more difficult to cross.[17] Nietzsche's metaphor of indigestion is key here: antiquity becomes a mirror in which the modern age sees itself as a bloated and uncomfortable creature in contrast to the rude health of the Hellenic past.[18]

Joyce's *Ulysses*: intimations of totality

While Nietzsche believed that the potentially unlimited amount of knowledge available in modernity could form an insurmountable obstacle to the understanding of antiquity, James Joyce's 1922 novel *Ulysses* made a virtue of this information overload.[19] One way in which he did this was by attempting to enshrine the total comings and goings of the city of Dublin on a single day, 16 June 1904, the day when he first met his wife-to-be Nora Barnacle. This desire for totality is further evidenced in Joyce's claim, recorded by his friend Frank Budgen, that 'I want to give a picture of Dublin so complete that if the city one day suddenly disappeared from the earth it could be reconstructed out of my book.'[20] But as the person to whom Joyce addressed this comment explains, *Ulysses* does not create this picture through an exhaustive description of Dublin as a collection of physical objects: 'it must grow upon us not through our eye and memory, but through the minds of the Dubliners we overhear talking to each other'. Budgen continues:

Here and there we get a clue to the shape and colour of this place or that, but in the main Dublin exists for us as the essential element in which Dubliners live. It is not a décor to be modified at will, but something as native to them as water to a fish. Joyce's realism verges on the mystical even in *Ulysses*.[21]

This account locates Joyce's mystical realism in the way that he presents the myriad perspectives that make up the traffic of Dublin's human striving across the course of a single day. Were the city to be obliterated, *Ulysses* would not help those who were trying to rebuild it from ruins; rather, it would help those who were trying to remember what it meant to be an inhabitant of Dublin and to recreate the city as a subjective experience, not as an objective entity.

The eagerness with which Joyce set about recreating Dublin as it was in 1904, in a novel written more than a decade later in the years between 1914 and 1921, suggests that he believed that the obstacle posed by the intervening ten years was relatively easy to overcome. But what is crucial here is that Joyce chose to build his monumental feat of recent memory on the epic foundations of Homer's *Odyssey*, and his decision to model the eighteen episodes of his novel on different events from the Homeric epic, even borrowing character traits and plot developments from the ancient text, has long exercised the novel's commentators.[22] T.S. Eliot believed that Joyce's method in *Ulysses* worked by 'manipulating a continuous parallel between contemporaneity and antiquity' to offer 'a way of controlling, of ordering, of giving a shape and a significance to the immense panorama of futility and anarchy which is contemporary history'.[23] For Eliot, Joyce uses Homer to sharpen the anarchic and incomprehensible blur of contemporary existence into a manageable form, leading to the conclusion that only the dead certainties of the past can help us gain any control over the confusions of the present. A different way of understanding the relationship between *Ulysses* and ancient Greece becomes apparent if we focus on the details of how Joyce integrates antiquity into his vision of Dublin. The first example of this comes in the novel's opening exchange between Buck Mulligan and Stephen Dedalus in the city's Martello Tower. When Dedalus talks to Mulligan as the latter shaves, Mulligan asks Dedalus to borrow his handkerchief to wipe his razor. Dedalus obliges, and Mulligan comments on the state of the lent cloth:

Stephen suffered him to pull out and hold up on show by its corner a dirty crumpled handkerchief. Buck Mulligan wiped the razorblade neatly. Then, gazing over the handkerchief, he said:

 – The bard's noserag. A new art colour for our Irish poets: snotgreen. You can almost taste it, can't you?[24]

Contemplating this new national colour, Mulligan moves to the window, where he gazes out from high up in the tower over the Irish Sea:

He mounted the parapet again and gazed out over Dublin bay, his fair oakpale hair stirring slightly.
 – God, he said quietly. Isn't the sea what Algy calls it: a great sweet mother? The snotgreen sea? The scrotumtightening sea? *Epi oinopa ponton*, Ah, Dedalus, the Greeks. I must teach you. You must read them in the original. *Thalatta! Thalatta!* She is our great sweet mother. Come and look.[25]

The series of descriptors that Mulligan uses here for the sea has led one critic to call this passage 'a caricature of a blustering Hellenizer'.[26] In fact, it is tempting to see Mulligan's suggestion that he teach Dedalus to read Greek as a parody of a certain form of snobbery (especially since Joyce evidently intended Mulligan to be a parody of his one-time friend and artistic rival Oliver St John Gogarty). But something more complex is contained in these lines, and it has to do with the order and nature of Mulligan's adjectives.

 Mulligan begins and ends with quotations, first from the work of Algernon Swinburne, 'Algy', then from the ancient Greek of Homer and Xenophon before returning finally to Swinburne. These references stand in direct contrast to the two adjectival phrases that interpose between Swinburne and the Greeks, 'snotgreen' and 'scrotumtightening'. These offer something more than an attempt to describe the Irish Sea via half-remembered quotations; rather they act as an effort to relate the sight before his eyes to the minutiae of human experience. In these two instances, Mulligan describes the sea with reference to the colour of the snot that he had seen moments before on the borrowed handkerchief, a hue derived literally from within the human condition, and to the feeling of the cold water on the (male) body that enters the sea. Mulligan is torn between literary allusions that have no immediate connection to the scene before him and physical descriptions that go to the heart of his particular present: his decision to repeat his invocation of Swinburne suggests he is more

comfortable with the former and with the Hellenic ideals they represent, even though they pose an obstacle between his senses and the realities that surround them.

As the novel progresses we see that Joyce seizes upon the adjectives that Mulligan passes over in order to offer his readers an alternative mode of apprehending the world. This becomes clear in the third episode of *Ulysses*, commonly known as 'Proteus', where Joyce first eschews the traditional elements of dialogue and narrative for the stream-of-consciousness approach that takes the reader directly into the mental processes of the characters. Joyce depicts Dedalus walking along the sea shore and contemplating what he can see:

> Ineluctable modality of the visible: at least that if no more, thought through my eyes. Signatures of all things I am here to read, seaspawn and seawrack, the nearing tide, that rusty boot. Snotgreen, bluesilver, rust: coloured signs. Limits of the diaphane. But he adds: in bodies. Then he was aware of them bodies before of them coloured. How? By knocking his sconce against them, sure. Go easy. Bald he was and a millionaire, *maestro di color che sanno*. Limit of the diaphane in. Why in? Diaphane, adiaphane. If you can put your five fingers through it, it is a gate, if not a door. Shut your eyes and see.[27]

Stephen structures the chaos of his thoughts through the simple act of closing and re-opening his eyes to check that the colours and objects surrounding him on Sandymount Strand persist even if they are not seen. This complex passage combines terms derived from the philosophies of perception of Aristotle and St Thomas Aquinas with Dante's description of Aristotle in the *Inferno*, and continues through detours into Gotthold Ephraim Lessing and William Blake. But despite this mass of allusions, it is not necessarily Joyce's intention to have his readers identify the influences: in Rabaté's words, 'We should not rush immediately in desperation toward a guide or annotation: this type of text is meant to let the reader participate in Stephen's experiment; we have to "shut our eyes and see".'[28]

And it is here that Joyce looks back to Mulligan's earlier comments to demonstrate how Dedalus's fragmented memories of the day are shaping his current experience. 'Signatures of all things I am here to read, seaspawn and seawrack, the nearing tide, that rusty boot. Snotgreen, bluesilver, rust: coloured signs.' While Mulligan had regurgitated the products of his own literary

consumption in the quotations he spewed out in the Martello Tower, Dedalus construes the objects of his own reading more expansively to include the phenomena of the sensible world. Following this, the hue that Mulligan had invented as parody, 'snotgreen', has recirculated to correlate directly with the *oinopa ponton* of Homer: Stephen becomes Achilles, the Irish Sea the Aegean, and the text invokes Dedalus's own poetic and national hopes to represent the way that the rendering of intangible concepts and beliefs can become entwined with the raw stuff of empirical reality. That Dedalus uses this term without the literary buttressing deployed by Mulligan reveals something about Joyce's epic register: he strains for the quotidian rather than the ineffable, or at least to locate the ineffable within the quotidian in a way that takes into account the interplay between our intellectual intentions and our embodied existences.

My second example of Joyce grafting Greek antiquity into the immediate reality of human perception comes from the eighth episode of the book, 'Lestrygonians', where Leopold Bloom, the Odysseus to Dedalus's Telemachus in Joyce's Homeric schema, sits in Davy Byrne's pub eating a cheese sandwich with a glass of red wine. As he stares out of the window, Bloom's thoughts drift to a romantic picnic that he once had with his wife Molly Bloom. I quote at length to give an idea of the embodied sensuality of Joyce's remembering:

> Glowing wine on his palate lingered swallowed. Crushing in the winepress grapes of Burgundy. Sun's heat it is. Seems to a secret touch telling me memory. Touched his sense moistened remembered. Hidden under wild ferns on Howth below us bay sleeping: sky. No sound. The sky. The bay purple by the Lion's head. Green by Drumleck. Yellowgreen towards Sutton. Fields of undersea, the lines faint brown in grass, buried cities. Pillowed on my coat she had her hair, earwigs in the heather scrub my hand under her nape, you'll toss me all. O wonder! Coolsoft with ointments her hand touched me, caressed: her eyes upon me did not turn away. Ravished over her I lay, full lips full open, kissed her mouth. Yum. Softly she gave me in my mouth the seedcake warm and chewed. Mawkish pulp her mouth had mumbled sweetsour of her spittle. Joy: I ate it: joy. Young life, her lips that gave me pouting. Soft warm sticky gumjelly lips. Flowers her eyes were, take me, willing eyes. Pebbles fell. She lay still. A goat. No-one. High on Ben Howth rhododendrons a nannygoat walking surefooted, dropping currants. Screened under ferns she laughed warmfolded. Wildly I lay on her, kissed

her: eyes, her lips, her stretched neck beating, woman's breasts full in her blouse of nun's veiling, fat nipples upright. Hot I tongued her. She kissed me. I was kissed. All yielding she tossed my hair. Kissed, she kissed me.[29]

Bloom's memory of the bursting physical intensity of his encounter provides a painful counterpoint to his present situation, since he believes that Molly is now having an affair with another man: as he continues, 'Me. And me now.'[30] The disjuncture between these two states lead Bloom's thoughts towards antiquity:

> His downcast eyes followed the silent veining of the oaken slab. Beauty: it curves: curves are beauty. Shapely goddesses, Venus, Juno: curves the world admires. Can see them library museum standing in the round hall, naked goddesses. Aids to digestion. They don't care what man looks. All to see. Never speaking. I mean to say to fellows like Flynn. Suppose she did Pygmalion and Galatea what would she say first? Mortal! Put you in your proper place. Quaffing nectar at mess with gods golden dishes, all ambrosial. Not like a tanner lunch we have, boiled mutton, carrots and turnips, bottle of Alssop. Nectar imagine it drinking electricity: gods' food. Lovely forms of woman sculped [*sic*] Junonian. Immortal lovely. And we stuffing food in one hole and out behind: food, chyle, blood, dung, earth, food: have to feed it like stoking an engine. They have no. Never looked. I'll look today. Keeper won't see. Bend down let something fall. See if she.[31]

Downcast in both physical and emotional senses, Bloom's eyes read the curves in his wooden bench as representing 'beauty'; the curves of his imagination proliferate as he remembers the Graeco-Roman plaster-casts standing in the entrance hall to Dublin's National Museum.[32] Placed in the round, these statues leave 'all to see'; and in an echo of Nietzsche's dream of direct engagement with antiquity, Bloom envisions a lived encounter between the statues and their admirers that leads him to consider the opposition between mortal and immortal forms of existence. The contrast between his own lunch and the god's, this one 'a tanner lunch', that one 'golden dishes, all ambrosial', begets contemplation of human and divine digestion (picking up on his earlier comment that the statues themselves are 'aids to digestion', presumably since people would commonly visit them after their lunches). Compared to the goddesses, the human body is a brute mechanism that requires constant refuelling, 'stuffing food in one hole and out behind', and this idea leads Bloom to wonder whether or not the statues have anuses.

Joyce thus uses Dedalus and Bloom to offer two different and yet extremely human responses to common manifestations of the sublime: while Dedalus invokes human snot to describe the infinity of the sea, Bloom contemplates the anus of a goddess as part of his ideas about the ultimate beauty of ancient statues.[33] But Bloom cannot bring himself, even with an internal voice, to actually give a name to this anus: and this silence continues when he finally arrives in the portico of the National Museum and secretly gazes at the statues. Joyce depicts Bloom in perpetual avoidance of the object of his search. At the start of a series of breathless sentences, he describes Bloom's 'eyes beating looking steadfastly at cream curves of stone' before the character comments 'Look for something I.' Bloom proceeds to catalogue the contents of his pockets, 'I am looking for that. Yes, that. Try all pockets. Handker. *Freeman*. Where did I? Ah, yes. Trousers, Potato. Purse. Where?' before quickly leaving the building on his way to the National Library.[34]

Joyce leaves it open as to whether Bloom actually sees the element of the statue that he is looking for: but in the next episode, 'Scylla and Charybdis', a conversation between Mulligan and Dedalus reveals that Mulligan had indeed caught Bloom looking for the anus of Aphrodite, who is given the epithet by which one of her ancient statue types was known, Kallipyge, 'of the lovely buttocks':

> – Jehovah, collector of prepuces, is no more. I found him over in the museum where I went to hail the foamborn Aphrodite. The Greek mouth that has never been twisted in prayer. Every day we must do homage to her. *Life of life, thy lips enkindle.*
>
> Suddenly he turned to Stephen:
>
> – He knows you. He knows your old fellow. O, I fear me, he is Greeker than the Greeks. His pale Galilean eyes were upon her mesial groove. Venus Kallipyge. O, the thunder of those loins! *The god pursuing the maidens hid.*[35]

Mulligan was there too, looking at the statues: and Joyce again uses the contrast between the responses of Mulligan and Bloom to emphasize different ways of understanding antiquity. In the spirit of Matthew Arnold, Mulligan uses the lexicon of Hebraism and Hellenism to recount Bloom's actions. At first, Mulligan seizes on Bloom's Jewish identity to call him 'Jehovah, collector of prepuces' and to describe his 'pale Galilean eyes'; but the sight of Bloom looking 'upon her mesial groove' effects a conversion, where Bloom's close inspection

of the statue makes him 'Greeker than the Greeks'.[36] Here again Joyce creates a contrast between different modes of integrating the remnants of Greek antiquity into a vivid understanding of the present; for while Mulligan is obsessed with fitting these statues and Bloom's actions around them into pre-existing schemas of meaning, Bloom tries to fashion a new perspective that incorporates these surviving elements of the ancient world into an understanding of immediate sensory experience.

And it is this obliteration of temporal distance through the invocation of brute human realities that brings Joyce's rendering of antiquity closer to reaching truly sublime dimensions. We see evidence of this in a letter of October 1921, sent by the sixty-five year old Irish playwright George Bernard Shaw in response to a letter from Joyce's publisher asking him to purchase a subscription to *Ulysses*, which was to be published early the next year. Shaw responds, declaring:

> I have read several fragments of *Ulysses* in its serial form. It is a revolting record of a disgusting phase of civilization; but it is a truthful one ... In Ireland they try to make a cat cleanly [*sic*] by rubbing its nose in its own filth. Mr. Joyce has tried the same treatment on the human subject. I hope it may prove successful ...[37]

Shaw describes *Ulysses* as the excrement of Irish modernity due to the unsavoury truths that it preserves. Unlike Nietzsche's moderns, who were unable to excrete their potentially limitless knowledge in life-enhancing ways, Joyce presents a version of what it means to see and think about antiquity that is always passing through the bodily experience of its beholders. Bloom's fascination with a plaster-cast anus represents the fantasy that permeates Joyce's novel but which Nietzsche thought impossible, the idea that there is a way of understanding antiquity from the perspective of modernity that does not immobilize the reader but which empowers them with a constant understanding of how the example of the ancient world might actively augment the full richness of their lived experience. What Nietzsche and Joyce both tackle in their different ways is the possibility that, despite all its manifold attractions, antiquity is something that modernity must digest, pass through itself and excrete before it can move on into life. They suggest that we should weigh the immense cultural value assigned to the remains of antiquity against

the potential blockage that they can cause, so that we can reach a well-informed decision about how (or if) we should integrate those remains into a form of total presence in the world around us that lives up to Joyce's encyclopedic desires while cancelling Nietzsche's encyclopedic fears.

In this way Joyce practices what Nietzsche had advocated to his students in his lectures on the *Choephori*: Joyce brings *Ulysses* as close as possible to bypassing the obstacle of historical difference by reformulating Homer's ancient epic as something that can be perceived immediately in modernity.[38] For what Nietzsche desires, and what Joyce achieves, is an antiquity made (literally) sublime, destroyed and yet exalted in its combination with the raw and sensuous concerns of its viewer. Neil Hertz has described the significance of the idea of a mental blockage overcome to theories of the sublime in the eighteenth and nineteenth centuries, and it is this dynamic that Nietzsche gestures towards but that Joyce enacts.[39] Bloom and Dedalus offer models of reception that do not require visible and manifest links to antiquity, because they gesture towards the deepest sort of reception possible: the tight implication of the texts of the ancient world into the very spirit of sense that animates antiquity's readers throughout their lives.

And it is precisely at the moment when Dedalus stares at the sea and rejects the *oinopa ponton* in favour of snot, and when Bloom stares at a statue and rejects the ineffable beauty described by Rilke for the sake of an anus, that we are invited to make decisions about what constitutes our human condition and what we want our turn to antiquity to do in relation to those elements. Because if we want to unravel the riddles of tragedy, knowledge and beauty, then we need to take into account that they are simultaneously ideas that have always pressed at the limits of what is expressible in intellectual terms, and concepts that have also always come about in response to physical drives that demand an articulation transcendent of their enfleshed origins. Nietzsche and Joyce demonstrate how difficult it is to bring anything of our lived experience into understandings of the past, but they also suggest that if we put faith in the value of our responses then we might be able to recapture some flash of the vivid immediacy that has propelled these texts ever onward during their long reception histories, all the way to the here and the now of our own existence. The tension they exploit is fundamentally that between form and content, matter and its appearances, between what a person says and what a person

means: and it is here, in exploring this tension, that the imperative to be deep must begin.

Notes

1 Quoted in translation by Paul de Man (2003: 208).
2 See Martin (2003: 378) and Henrichs (2004: 115) for these texts.
3 Gilman (1987: 16).
4 I envisage this as similar to the 'jarring juxtapositions of distant past and immediate presence' that Shane Butler describes in the introduction to this volume. See also Slaney, this volume.
5 Cf. Walter Benjamin (1999: 252–3) and his idea of the *Jetztzeit*.
6 See Rilke (1987: 61); Jaeger (2012: 267–87) offers further context to the poem.
7 See Slote (2013) for discussion of their relationship.
8 See Porter (2014: 28–31).
9 Translated in Porter (2014: 31).
10 Translated in Porter (2014: 31).
11 Nietzsche (1997: 78).
12 Nietzsche (1997: 79).
13 For details on this lecture series, see Porter (2000: 167–224).
14 Porter (2000: 170).
15 Porter (2000: 196).
16 Rabaté (1996: xi).
17 See Blom (2004) and Blair (2010) on the history of the encyclopedia.
18 Nietzsche uses the metaphor of indigestion throughout his writing, something possibly related to his own experience of the illness: see Pasley (1978: esp. 142–5).
19 See further Bell (1997: 87–88); Kenner (2005: 30–66); Moretti (1996: 218–21).
20 Quoted in Budgen (1937: 69).
21 Budgen (1937: 71).
22 For good introductions to Joyce's relationship to Homer see Kenner (1980: 19–30); Bell (1997: 67–92); Schork (1998); Arkins (2009).
23 Eliot (1975: 177).
24 Joyce, *Ulysses* 1.70–4 (1998: 5). All references to *Ulysses* cite from the critical edition (with line numbers), Joyce (1984); I have also given page references to the easily available Oxford World Classics edition, Joyce (1998).
25 Joyce, *Ulysses* 1.75–81 (1998: 5).

26 Schork (1998: 29). For another parody of the nineteenth-century obsession with the sea, see Flaubert (1976: 325).

27 Joyce, *Ulysses* 3.1–9 (1998: 37).

28 Rabaté (1996: 15).

29 Joyce, *Ulysses* 8.897–916 (1998: 167–8).

30 Joyce, *Ulysses* 8.917 (1998: 168).

31 Joyce, *Ulysses* 8.919–32 (1998: 168).

32 For Joyce's broader interest in statues see Garrington (2013: 76–90); for the recurring theme of Venus and Aphrodite in his work see Schork (1998: 44–8).

33 For the significances of anuses in *Ulysses*, among other body parts, see Staten (2004). For another theoretical treatment of the same body part, see Bataille (1985), with commentary at Krell (2012: xi–xiii); see also Freud (1955: 166) for another conspicuous avoidance of the word 'anus', in his notes on the 'Rat Man'.

34 For this passage see Joyce, *Ulysses* 8.1180–93 (1998: 175).

35 Joyce, *Ulysses* 9.609–17 (1998: 192–3).

36 See Leonard (2012: 3–9 and 105–38) for Joyce's and Arnold's response to the Hellenism and Hebraism schema respectively. Gifford (1988: 228) glosses this as: 'In other words, he indulges in pederasty'. For a theoretical discussion of the link between anality and homosexuality see Hocquenghem (1978: 79–98).

37 Quoted in Seidel (1977: 123–4).

38 Cf. Danius (2001: 139) and her idea of Joyce's 'aesthetics of perceptual immediacy'. See further Danius (2008).

39 See Hertz (2009: esp. 39–57); reference found in Blair (2010: 4–5). See also Anderson (1972).

The Loss of *Telos*: Pasolini, Fugard, and the *Oresteia**

Sarah Nooter

To what *telos*?

A *telos* is an ending, but not just an ending. In early Greek literature, a *telos* is imbued with a sense of intentionality or purpose. When the poet Hesiod allows that the gods might destroy someone's ship even if he sails at the right time, he adds the explanation, 'for with them is the end [*telos*] of good and bad things alike'.[1] The term *telos* is often used in similar contexts to gesture toward the workings of the divine – it is gods who provide intent and whose purposes are fulfilled – and indeed *telos* can be used merely to denote the fulfillment of a prayer.[2] Accordingly, a piece of Greek literature that ends with a clear *telos* tends to imply the involvement of divine powers. One that does so in the contemporary world can assert subtly that a similar system of fulfillment is at hand, such as the teleology of history.[3] A *telos* is also an end that seems (retrospectively) to fulfill the promise of its beginning, which suggests that a plan has connected the passage of events and, further, that any suffering experienced along the way has happened for a worthwhile reason.

There is perhaps no work of Greek literature that better exemplifies such teleology than Aeschylus' *Oresteia*. In the final moments of *Eumenides*, the third tragedy of the *Oresteia*, the chorus previously known as Furies (or Erinyes) change their stripes to become Eumenides, gracious guardians of

* It is a pleasure to thank Shane Butler for dreaming up Deep Classics, and the other conference attendees for being such fun and stimulating interlocutors. I owe a further debt of gratitude to Shane and to Adam Lecznar for their incisive and terrifically helpful comments on this paper.

Athens. Along the way, they are joined by a brand new chorus, who wrap them in red robes, accompany them with torches, and sing a joyous song to cries of ululation to usher the Eumenides off the stage and into their new roles. Here's Athena, giving these instructions:

φοινικοβάπτοις ἐνδυτοὺς ἐσθήμασι
τιμᾶτε, καὶ τὸ φέγγος ὁρμάσθω πυρός,
ὅπως ἂν εὔφρων ἥδ' ὁμιλία χθονὸς
τὸ λοιπὸν εὐάνδροισι συμφοραῖς πρέπηι. (*Eumenides* 1028–31)[4]

With red-dipped robes donned,
honour them, and let the torch of fire be seen,
so that this gracious company in our land
ever after may shine forth with good fortunes for men.

As many commentators have noted, the red of the robes answers, almost antiphonally, the rivers of red blood that have run through the trilogy, to say nothing of the red carpets that Agamemnon has walked on to his death. The torches respond to a score of images of light opposed to darkness, starting with the constellations observed by the very first speaker of the first play. Further, this new chorus end the play with a song in which they call for joyous ululation twice in a repeated refrain: 'Ululate now to our songs!' (ὀλολύξατε νῦν ἐπὶ μολπαῖς [1043, 1048]). The mention of ululation echoes the corrupted ululations heard or invited in the first two plays, each time used to foreshadow, mark, or even celebrate a violent death.[5] Now the same sound seems to close the annals of such slaughters and becomes, rather, a means of reparation, sung by attendants whose only role is to give voice to this utterance. These final lines, then, are striking in their simultaneous resurrection and reformation of manifold elements of imagery and meaning from earlier in the trilogy.[6]

What becomes of such a finely honed *telos* when the trilogy is received in the fractured post-classical world of the twentieth century? This paper examines two adaptations of the *Oresteia* from around 1970 in view of how they do, or do not, reach such closure. I argue that Pier Paolo Pasolini's production of 'notes' on an African *Oresteia* expresses his desire for but also his resistance to the *telos* that ends the *Oresteia*, in view of his questions and doubts about political progress. Further, a similar sort of resistance to this *telos* can be seen in a work that was performed almost simultaneously with Pasolini's, with a somewhat

similar goal: in 1971 in South Africa, Athol Fugard and a few actors produced a version of the *Oresteia* that handled a recent, violent protest against apartheid. The performance itself was staged with very few words, was never written out fully, and is recorded now only through Fugard's notes and a description in a letter he wrote to a friend and later published. Both of these adaptations, then, exhibit an aspect of being unfinished, but in strikingly different ways. Pasolini's initial ambition to achieve a *telos* like the one he found in Aeschylus' *Oresteia* stymied him, at least until he decided to relinquish his planned film in favour of a documentary of his thoughts on that film, a work that assents to fragmentation. By contrast, Fugard declared a sort of revolt against the polished entity of the *Oresteia*, and found a way to his own *telos* of return through this artistic insurrection. Both Pasolini and Fugard strip away the finality from the *Oresteia* and leave in its place a sense of possibility urgently rooted in the emergent present. The film and the play that result might be thought of less as versions of the *Oresteia* than as portraits of the artists denying the *telos* that the *Oresteia* seems to impose.

Pier Paolo Pasolini's *Appunti per un' Orestiade africana*

'I am looking through the camera at my reflection,' narrates Pier Paolo Pasolini, 'in the window of a shop in an African city.' So begins Pasolini's *Appunti per un' Orestiade africana*, or *Notes Toward an African Oresteia* (*Notes* hereafter). The first image on screen is the director's face, blurred and indistinct due to reflections of other images caught on the surface of this window. The shot changes and we see more of the inside of the shop, more of the street, a faint impression of the hulking camera, and an outline of Pasolini, with his voice still talking to us over the image, now telling his viewers that he has come to Africa to film not a film, but 'notes for a film'. The visual metaphors here are fairly accessible: a scene from an African city and Pasolini's face are superimposed on each other, fused and inseparable on this reflected surface – not a deep image to be sure, but a complex one. Pasolini knows as well as anyone that his own view of Africa will inevitably be filtered through a distorting lens that cannot be removed. He embraces this distortion and aims to deliver, firstly, a picture of what he calls a 'typical' country in modern Africa;

secondly, the story of Aeschylus' *Oresteia*, and, thirdly, some sense of himself. Since, however, Pasolini never returned to film the film that would have been his African *Oresteia*, the work that we have instead is both an achievement itself and a sign of unfulfilled ambition. It is almost literally a reflection of himself in an inchoate and deeply imperfect form, thinking things through and frequently changing directions. Pasolini clearly decided, somewhere along the way, that he would show exactly this: the state of being unfinished, imperfect and interrogative about representations of the past in the present.

Pasolini's *Notes* is itself a complete vision of a work whose deferral of the real film (an actual 'African *Oresteia*') is a part and parcel of its achievement, evoking, with a shift, Jacques Derrida's idea of the *différance* inherent in any kind of sign.[7] The notion of shift and deferral that Derrida describes applies to any adaptation, in that an adaptation openly draws audiences to consider both an earlier work and the distance between it and the adapted work. An adaptation like Pasolini's that advertises itself as intending, rather than as brought to fruition, also mobilizes the idea of future adaptations in a chain of interpretations that is never concluded. Pasolini's version of the *Oresteia* that he insists is *not* actually the true version – though it does in fact tell the whole tale of the *Oresteia* from start to finish – teeters between announcing itself as an intentional, interpretative artistic product and dismissing itself as mere preparation.

The film itself is arranged in accordance with the plot of the trilogy, beginning when Agamemnon returns from war, moving into a version of Orestes' visit to his father's grave in the *Choephori*, and ending with speculations about Athena's decision on Orestes' case in the *Eumenides* and the transformation of Furies into Eumenides that follows. It displays the process of speculative casting, as Pasolini seeks out the right kind of people to embody the roles from the *Oresteia*, identifying possible Agamemnons, Electras and so on, and even goes so far as to stage scenes like those that would appear in a full-fledged narrative of the same material. The final voice-over of Pasolini's narration includes the following passage:

> The new world is established. The power to decide its own fate, at least formally, is in the hands of the people. The ancient, primordial divinities co-exist with the new world of reason and freedom. But how to conclude? Well, there is no ultimate conclusion. It is suspended.[8]

Ostensibly, Pasolini is discussing the inconclusive state of a newly democratic Africa, but he is also thinking aloud on the state of his film/non-film of the *Oresteia*, which itself exists in a state of inconclusive suspension.

Why, then, is its final form so provisional? Pasolini's prior thinking on the topic would lead one to expect the opposite. He had published a translation of the trilogy in Italian in 1960, with a brief introduction that forecasts certain ideas that show up in the film:

> The peak moment of the trilogy is definitely the climax of the *Eumenides*, when Athena institutes the first democratic assembly in history. No event, no death, no anguish of tragedy gives a deeper and more absolute emotion than this page.[9]

This statement seems to soar with the glory of the climax, transformation and absoluteness of the end of the trilogy. As Massimo Fusillo writes, 'Pasolini basically *stresses the moment of synthesis*. The final transformation of the Erinyes into Eumenides becomes then a metaphor for a political and social programme.'[10] Why, then, in his own work, is an absolute conclusion so elusive?[11] Is Pasolini drawn to and yet at the same time reacting against that striking finality that closes the *Oresteia*? Or is it that the complexities of African politics in the twentieth century make him hesitate to give final pronouncements?[12]

At least initially, such political caution seems to have been wholly foreign to Pasolini. He is very direct in stating that Africa is the perfect place to illustrate the archaic, tribal qualities he sees in the beginning of the *Oresteia*. He seemingly regards sub-Saharan Africa as a largely indistinguishable group of countries with an enviable hold on the past, a time before the unromantic, bureaucratic capitalism of the modern world had taken hold.[13] Indeed, the critique of Kevin Wetmore on all of Pasolini's attempts at setting Greek tragedy in 'primitive' countries is apt, if easy:

> [H]e constructs these nations in the same way that the Cambridge anthropologists did at the turn of the century, seeing civilization as an evolutionary development in which the third world nations of today are where Europe was during the age of Greece. It is a way of privileging Europe and denigrating the cultures and civilizations of African and Middle Eastern nations.[14]

Yet, while Pasolini considered his primitivist perspective on Africa to be a positive one, his film admits of opposing views, ones more in keeping with an

updated postcolonial politics, voiced by a group of young men from different parts of Africa who were studying in Rome at the time. The power of these opinions is not acknowledged explicitly by Pasolini in the film, but their influence seems to seep into the project as it proceeds and may underlie its very lack of fruition.

In two compelling scenes, Pasolini is heard, and then seen, asking these African students for their comments on fairly minor aspects of his project and then deflecting their unsolicited criticism on its fundamental premises. Pasolini first asks the students whether they think he should set his film in the present or ten years previously, so as to best capture the movement on the continent from 'tribalism' to 'democracy'.[15] (The exchange is in Italian.) The students ignore the question and take issue with the following assumptions: that democracy has come to Africa and that European influence has been beneficial; that Africa is 'tribal'; and that 'Africa' is one people,[16] configured as a race rather than as a group of nationalities. Their critique is wide-reaching and sophisticated, delivered spontaneously by students who are not identified at any point in the film.

We hear Pasolini defending himself against these criticisms and trying to appease the students, but his responses seem to cause them even more frustration. Pasolini claims not to be suggesting that democracy is necessarily good, just one particular form of government. In reply to the suggestion that he discuss African individuals according to their nationalities, not as one people, he argues that these nationalities were set by the colonial powers and are, thus, arbitrary and invalid. Thus, having invited these students to an intellectual discussion of his film on the arrival of democracy in Africa – democracy *qua* an end to tribal violence – Pasolini does not hesitate to deprive them of their right to claim these democratic states as their own. He adjudges himself the arbitrator of their identities and uses this position, defensively, to strip his interlocutors of the political qualities that validate their presence as students in Rome. His claim not to equate democracy with goodness is itself specious in light of the project he aims to complete – one which equates Europe's importation of 'democracy' with Athena's granting of the same to Orestes and to Athens at the end of the *Oresteia*.[17]

It is easy to dismiss Pasolini, as Wetmore does above, as a racist or imperialist for not only the assumptions that underlie his whole project but also his

condescension and mistreatment of the African students in his film. But to do so – or to do only this – is to ignore the fascinating fact that he includes these scenes in his film at all. There he, the director, is blatantly and embarrassingly contradicted; his ideas are shot down. His notion that he is fit to adjudicate the people and nations of Africa as he sees fit and that he is rather culturally generous to do so – all of this is exposed as deeply problematic and even hypocritical by these students. Why did Pasolini preserve and include these scenes? Can it be that he does not know he loses this argument? Certainly some aspects of his own attitudes are considered less tolerable now than they were then, but it is hard to believe that Pasolini does not display these conversations to admit to some complexities – even mistakes – in his vision and version of events. It is perhaps not that Pasolini truly objected to the finality of the *Oresteia* but that he found himself unable to contradict or silence, a multiplicity of voices to achieve such a *telos*. What Pasolini's *Notes* shows most completely, then, is how Pasolini has changed in the course of filming. Inasmuch as the work acknowledges itself as a failure – for it is not the intended product – it shows not a *telos*, but the productive process of not reaching one.

Athol Fugard's *Orestes*

Athol Fugard's *Orestes* was his first attempt at adapting a classical play and also marked a sharp turn from a scripted, conventional approach to a more collaborative and improvisational method.[18] Superficially it presents itself as an unfinished, or at least inaccessible, work. We have no real script of Fugard's *Orestes*, but only impressions and stories about the production, rather as we have only scraps and stories about many Greek tragedies. Fugard's *Orestes* must be viewed from our vantage point, some decades later, with the same limitations as many lost or fragmentary ancient works.[19] Like a viewer of Pasolini's film, an admirer of Fugard's plays is made deeply aware of what she cannot have: namely, the experience of the finished or performed work. The only way to have known *Orestes* is to have been there when it happened. One can speculate whether this unrepeatability is a result of a deliberate effort by Fugard to keep the work from being repeated, adapted, or even too much interpreted by others. Either way, its particular artistic impact has been limited

by this lack of dissemination. The contrast is striking when viewed against *The Island*, Fugard's momentous retelling of Sophocles' *Antigone*. *The Island* followed *Orestes* several years later and was performed in Cape Town, London and New York. It has since been published and frequently restaged, as opposed to *Orestes* which is hardly known at all in text or performance. Yet the impact of *Orestes* on Fugard, and thus on the history of theatre in South Africa, was considerable, for this production acted as the breakthrough to the method that brought about Fugard's later significant theatrical work.

The play's tangible effect is easily grasped: not only did the production mark the beginning of a new creative direction for Fugard, but it also resulted in the creation of the Space Theatre in Cape Town, which became a renowned force of influential and interracial performance in the darkest days of apartheid. Brian Astbury, Fugard's sometimes producer, later published a history of the Space Theatre from its start. Under the heading 'BEGINNINGS', he writes:

> It all began with "Orestes".
> Without "Orestes" there would have been no Space.
> It is important that this fact is recorded.
> Without "Orestes" many of us would not have received the opportunities
> that we did.[20]

Astbury prefaces these semi-poetic (that is, end-stopped) lines with the book's dedication, which is for 'Athol', among others, but first for 'Orestes', by which he presumably means the production, not the mythic, matricidal figure, since the experience of preparing for the performance of *Orestes* and watching it 'literally changed [his] life'.[21] The reader of Astbury's text whose appetite is piqued by this gesture will want to know more about *Orestes*: what sort of adaptation of Aeschylus' trilogy was it? What particular quality of this play had such a deep, searing and long-lasting effect on Astbury and, presumably, on other audience members as well? There are no such answers in Astbury's text, however. *Orestes* rests at the head of his work with crowning opacity – inviting wonder, refusing explanation.

Fortunately, Fugard himself filled in some of these holes in his letter to an unnamed American friend[22] that was later published in the journal *Theatre Quarterly*, in which he also prints the programme notes from the production:

> *From Greek mythology comes the story of Clytemnestra. Her husband was Agamemnon. She had two children, Electra and Orestes. Agamemnon*

sacrificed their third child, Iphigenia, so that the wind would turn and the Greek fleet could leave Aulis for the Trojan War.

Agamemnon returned to Clytemnestra ten years later when she murdered him. Orestes and Electra avenged his death by killing their mother.

From our history comes the image of a young man with a large brown suitcase on a bench in the Johannesburg station concourse. He was not traveling anywhere.[23]

Fugard's description shows that he privileges Clytemnestra's side of the story (her grief over the slaughter of Iphigenia) over Agamemnon's (Artemis' demand for the Iphigenia, Clytemnestra's adultery), thus stripping down Aeschylus' complexities. Further, we learn that Fugard's play also reframes a historical incident involving a white South African named John Harris. Harris, the 'young man' mentioned in the programme notes, had detonated a bomb in a suitcase on a 'whites-only' platform at a train station in Johannesburg to protest apartheid, killing an old woman and injuring twenty-three other people. After this, Harris was hanged.

Fugard goes on to state in the letter that he had wanted to use the story of the *Oresteia* to refract the facts of his society as he saw them. In his notebooks from the period, he explains that his characterization of Clytemnestra grew out of a soliloquy delivered spontaneously by the actress Yvonne Bryceland that he describes as 'a long unbroken monologue compounded of the clichés, lies, hypocrisies, of our society (Clytemnestra as reflected in the cracked, tormented mirror of our twentieth-century awareness of the self)'.[24] Fugard's description of the mendacity and treachery of his particular society echoes another passage found just a few pages previously in his notebook, in an early stab at what would become *The Island*. He refers to this proto-*Island* as '[a] chance to examine the myths, clichés, lies – the reality of this society, this time./ There is nothing sacred left! Beware! (Wild laughter.)'[25] At this stage of his thinking about *The Island*, there is no reference to ancient literature or to the use of analogy by way of adaptation. Fugard simply wants to make specific points about his own culture. Yet in both the cases of *The Island* and *Orestes*, the generalizing force of adaptation, or perhaps the tautologies of teleology that adaptations awaken, became Fugard's means toward this end – or at least partway there. An adaptation, after all, should provide an ending that is

inevitable, existent even when it is not exactly copied. The *telos* at the end of an adaptation of the *Oresteia* might be expected to include a divine sense of teleology like Aeschylus' trilogy and also the *telos* of any imitative work that strains towards – or away from – the expected end. And yet Fugard appears only interested here in breaking away from the meanings of his society, not in adopting a new kind of consequence. Why does he turn to these ancient tragedies?

The language Fugard uses in both cases to describe the corrupt world he means to portray ('clichés, lies, hypocrisies, of our society' and 'the myths, clichés, lies') can be traced to another source: the words of Peter Brook in his introduction to Jerzy Grotowski's *Towards a Poor Theatre*, when he states that the 'work' of participating in Grotowski's plays had this effect on its performers: 'The shock of confronting himself in the face of simple irrefutable challenges./ The shock of catching sight of his own evasions, tricks and clichés.'[26] Fugard seemed to decide that applying the classical frame of the *Oresteia*, or *Antigone*, would be an ideal way to strip back a surface constituted by hypocrisy and lies – even just of language – and reach into the depths of experience. Yet he also viewed his use of classical literature as throwing a disguise over his story: 'The whole story – but disguised? It would be impossible to get the specifics onto a stage at this point. No, not disguised, simply *unspecified*.'[27] This obfuscating lack of specificity also allowed something like access to what Fugard perhaps ironically called the 'sacred' in his notes that sketched out *The Island*: 'One of the prisoners after a macabre alienation from some sacred myth: "What do we take seriously?"'[28] Fugard's use of Greek tragedy thus not only allowed him to evade censorship but also gave him a way to show his (and others') profound alienation by lending him something serious enough – a 'sacred myth' – to show the depth of this alienation, something to be alienated *from*. Showing how far is the hypocrisy of the moment from Aeschylus' *telos* (and later Sophocles') becomes a new kind of end.

Fugard's method of displaying hypocrisy is not so much to perform it, but to reveal what lies behind it, or what violence might be exposed if society's ability to obfuscate through language could be removed. Yet perhaps 'removal' is too strong a word; rather, Fugard removes most of the business of linguistic commerce in order to frame a very small number of utterances. As he explains in his letter, the action of *Orestes* commences and proceeds through pantomime for some number of minutes, with two actors – a young woman and a young

man – playing together in a pile of sand, and the third actor, an older woman, observing them. The first utterance of the play comes at last from the young woman and is '*Let's dream about the sea!*'; it appears to be intended to mark the childlike innocence of these two younger characters. The next words spoken several minutes later are also from the girl, and here I will quote from Fugard's letter to his friend:

> She, however, finally traps him permanently in her dream by smoothing a patch of sand with her feet and then looking up at the older woman and asking innocently:

> *How do you spell Orestes?*

> The older woman spells the name slowly and simply, but somehow it still manages to sound like a relic dug up out of Agamemnon's tomb at Mycenae . . . green and encrusted with age.
> As she spells – and what can we do now except call her Clytemnestra – our Electra starts to write in the smooth sand. The boy is stopped short at the mention of the name, his name.[29]

This moment marks the identification of these characters to the audience and, it appears, to the characters themselves, with the act of articulation – in speech and in sand – marking out not only their names but also their horrible fates. (In an adaptation, after all, character is not fate as much as name is.) After more pantomime of play, pantomime of birthing follows:

> The woman gets heavier and heavier. The moment arrives and Iphigenia is born . . . Apart from what she did with her body, she took the name Iphigenia, broke it down into its elements – grunts, snarls, groans – and used these as her text. With great labour she put them painfully together and the name Iphigenia was born.[30]

The name 'Iphigenia' is produced through the elemental grunting of its syllables and the corporeal enactment of giving birth to it. Iphigenia is not a character in this play and not even a character *not* in this play, so much as a collection of sounds harnessed into a cultural product: a name. At this point in the letter, Fugard departs from his description to relate to his friend the story of Agamemnon's sacrifice of his daughter Iphigenia, in short swift sentences that are posed from Clytemnestra's point of view. He explains that Clytemnestra

was left behind 'desolate ... with the name Iphigenia on her lips' and then transcribes the following series of cries and silences:

first called, as a mother would to a child in the next room ...
silence
then called a little louder as if she were playing in the garden ...
silence
louder still, as if she was quite far away ...
silence
and still louder, shouted, screamed, whispered ...
silence
then broken down again into its elementary syllables to provide a vocabulary
 for grief ...
silence

There can be no other possible response.[31]

This is a striking series of word-images and vocalizations, which powerfully reverses the series of sounds into name from which Iphigenia was born.[32] The devastation of Clytemnestra through the loss of her daughter brings destruction in turn, with the materiality of sound translating now into onstage violence: the actress is made to destroy a chair, a new one every night of the performance run, to represent Clytemnestra's murder of Agamemnon. Fugard explains this as 'an awesome and chilling spectacle' and adds, 'You cannot destroy without being destroyed ... you cannot witness destruction without being damaged.'[33] Fugard clearly meant for his audience to change and be damaged, at least a little bit, through this act of witnessing. In his notebooks, he records instances of feeling damaged himself to a formative degree by his own witnessing of violence – sometimes heard through walls, sometimes encountered on the street or at the beach or a park, and also most chillingly (if implicitly), in courts of law.[34] One of the most striking examples is his witnessing of a group of people who are themselves witnessing a snake being beaten to death:

So much of South Africa in that moment – the watcher and the watched. The snake beautiful and dangerous, deadly; our senseless killing of it, our moral complacency in watching; the sea, sun and sky and indifferent to us as we to the snake.[35]

Fugard construes the onlookers' observation of a snake's suffering and death as a moment of theatre – a comfortable act of watching – one oddly echoed in the name that he and his troupe chose for themselves: the Serpent Players.[36] He also ties this witnessing of violent observation to the character of South Africa itself. In staging his own act of violence on a chair, crucially one that is not simulated but actually carried out, Fugard attempts not to void violence of its power, but to deploy its transformative effect.

The characters in the play are changed by this violence. Fugard writes that the play ends with the girl and boy trying to call to each other, now blinded. Unable to help one another, they become enemies: the girl sings nursery rhymes in a manner that is clearly intended to be threatening to the boy. He, described as 'mute, foetal', breaks his silence to ask and answer a series of questions that identify him more or less as he would be identified at a border or checkpoint in the South African apartheid state: by name, by sex, by race, by nationality, and by place. The old woman speaks one coherent sentence – to which we will return – and then starts singing, 'barely audible snatches from "White Cliffs of Dover", "Ferry Boat Serenade", "Begin the Beguine" ... echoes of other times, good times, and other places, now far away'.[37] Finally, a bombing on the bench is pantomimed, with the actors silently playing out the horror. When this is done, the actors relax, sit down, and recite a few texts: one passage is from the actual testimony of the bomber and two are rather apocalyptic entries from the works of R.D. Laing. Laing was a psychiatrist active at this time who received the reputation for being an 'anti-psychiatrist' by sympathizing with his schizophrenic patients to the degree of suggesting that they might simply be viewing the world correctly. The final words in *Orestes* are drawn from Laing's *The Bird of Paradise*:

> If I could turn you on, if I could drive you out of your wretched mind, if I could tell you, I would let you know.[38]

Laing's *The Bird of Paradise* is something like a prose poem of about fifteen pages that ends a book of rather more traditional essays. This quote appears two times, with slight variations of capitalization and punctuation, both following on desperate questions about the workings of language:

> This writing is not exempt. It remains like all writing an absurd and revolting effort to make an impression on a world that will remain unmoved as it is

avid. *If I could turn you on, if I could drive you out of your wretched mind, if I could tell you, I would let you know.*

There is really nothing more to say when we come back to that beginning of all beginnings that is nothing at all. Only when you begin to lose that Alpha and Omega do you want to start to talk and to write, and then there is no end to it, words, words, words. At best and most they are perhaps *in memoriam*, evocations, conjurations, incantations, emanations, shimmering, iridescent flares in the sky of darkness, a just still feasible tact, indiscretions, perhaps forgivable . . .

City lights at night, from the air, receding, like these words, atoms each containing its own world and every other world. Each a fuse to set you off . . .

If I could turn you on, if I could drive you out of your wretched mind, If I could tell you I would let you know.[39]

The first passage here comes around four pages from the end of *The Bird of Paradise*; the last one is the end of the text and the book. The first is a statement of despair – even this utterance, this prose poem itself, is felt to be 'absurd, revolting', and ineffectual. The second passage, however, suggests that if one could step out of the loop of cultural and religious history – as marked here by the Greek letters alpha and omega, long since appropriated in the Book of Revelation to mean the be-all and end-all that is God – that if one could step away from all this, such a person, driven from his 'wretched mind', and 'turned on' (like a light switch, perhaps, and of course in sexual terms), this person would start to talk and write words that would shimmer and flare in the darkness, words that could contain worlds. Thus out of a mindset of apocalypse comes an almost absurdly hopeful – if contrafactual – projection of language set free of its cultural burdens, its myths, lies, and clichés, and launched into the heavens.

And this *cri de coeur* to let go of the past and its horrifying hold on language is the text that Fugard cites as the 'provocation' for Fugard's *Orestes*, named in place of Aeschylus' *Oresteia*; it is the last word.[40] Is this a way for Fugard and his performers to suggest that they want to cut ties with the baggage of literary history, along with apartheid and state-inflicted expectations? Is the *telos* of this play to be found in its disavowal of the complexities of linguistic expression, in favour of palpable sounds, palpable movements or, at best, the words of others? Perhaps this is an intended message, but it is complicated by its context.

One point of complication is the older woman's last statement just before she shuffles to the bench to be bombed by the boy onstage: *I want to go back now.* This statement, this longing for return, could be dismissed as Fugard's ironic or tragic suggestion that a return to the past is impossible, but of course it is spoken within an adaptation of an ancient play, itself both a return to and a departure from the past. Fugard wanted something different than a break from the past: he sought to undermine, or mine under, the shallow past to a deeper stratification.

And herein lies the tension of adaptation with which both Pasolini and Fugard wrestle so richly. Tradition presents itself as teleology, with the expectation that justification for present suffering will come with an end that makes sense of its beginnings. But these two artists, looking to re-apply the *telos* of the *Oresteia*, found instead the violence that such certainty can impose, the degradation that accompanies the comforts of an ending. Fugard's view on such finality comes across most clearly in his view of another play that confronts social injustice:

> Just read *A raisin in the sun* by Lorraine Hansberry. My initial reaction: two-dimensional. Why do I feel this? The theme, the things concerned with, are big and in their way deep, in fact terrifyingly so – dreaming, aspiring, wanting, the overall concern with human dignity. But the final statement is comfortable – the audience will leave feeling good and this makes me enormously suspicious.[41]

On this view, a *telos* is an end that is in actuality a perpetuation, an endorsement of the present, an acceptance of the past – all charges that have been laid at the feet of Aeschylus' *Eumenides*. Both Pasolini and Fugard rejected the comforts of Aeschylus' *telos* and, through this rejection, placed the teleology of the present into tension with the past.

Notes

1 Hesiod, *Works and Days* 669. Translations from the Greek are my own.
2 E.g. Homer, *Odyssey* 17.496 and Pindar, *Olympian* 13.105.
3 Grethlein usefully shows how such teleology is in play in ancient history too, when history is told from the perspective of its outcomes. He writes, '[t]he look

back permits us to master the contingencies to which we are subject in life, to replace vulnerability with sovereignty. Teleology can thus serve as a means of coping with temporality' (Grethlein 2013: 5).

4 All text of Aeschylus' *Eumenides* is from Page (1972).

5 Aeschylus, *Agamemnon* 587, 595, 1118, 1236; *Libation Bearers* 387, 942.

6 Cf. Lebeck (1971: 131) on language in the trilogy: 'Two factors govern the growth and evolution of recurrent imagery in the *Oresteia*. First, images developed on a verbal level in the other two plays are dramatized and acted out in the last. Second, the trilogy's resolution, the transformation of Erinyes into Semnae, is reflected in resolution and transformation of imagery. Images hitherto adverse, possessed of an ominous quality, are turned into their auspicious equivalents.' However, see various scholars, such as Goldhill (1984a) and (1984b: 277–83), for a sharply dissenting view on how or whether the *Oresteia* is resolved. Porter (2005: 301–5) usefully summarizes the scholarship on this issue until fairly recently.

7 Derrida (1981: 26, 28–9). See also Derrida (1982: 3–27) where he discusses the idea of the 'sign' as deferral: 'The sign, in this sense, is deferred presence. Whether we are concerned with the verbal or written sign, with the monetary sign, or with the electoral delegation and political representation, the circulation of signs defers the moment in which we can encounter the thing itself, make it ours, consume or expend it, touch it, see it, intuit its presence' (9).

8 Pasolini (1970).

9 Pasolini (1960: 3): 'Il momento piú alto della trilogia è sicuramente l'acme della Eumenidi, quando Atena istituisce la prima assemblea democratica della storia. Nessuna vicenda, nessuna morte, nessuna angoscia delle tragedie dà una commozione piú profonda e assoluta di questa pagina.'

10 Fusillo (2004: 224). The emphasis is mine.

11 It is useful but not enough, in my opinion, to note with Fusillo (2004: 227–8) that Pasolini was prone to leaving things incomplete: 'In every artistic genre of Pasolini's late production one can sketch a true poetics of the unfinished: a predilection for notes, projects, fragments, conceived not as preparation for real works, but as new forms that negate and subvert artistic conventions, that is to say the Aristotelian idea of an enclosed organism.' But since some of Pasolini's works *did* come to fruition, one can justifiably wonder why (or whether) this one remained in such an inchoate state.

12 Some support for this latter view might be found in the fact that another project set in Africa, a screenplay called *Il padre selvaggio* (*The Savage Father*), went unproduced.

13 See Michelakis (2004: 18) on Pasolini's turn to Africa as an attempt to 'de-westernize the power-struggles of the *Oresteia* by exploring the encounter

between modern democracy and tribal culture in the post-colonial context of the newly-born nations of Africa'. Also cf. Fusillo (2004: 228): '[i]n Pasolini's poetic imagination, Africa always played an important role as escape from the "horrible universe" of technological neocapitalism.'

14 Wetmore (2003: 28). By the time Pasolini began percolating his thoughts on an African *Oresteia*, he had already accomplished a version of *Oedipus the King* (*Edipo Re*) in 1967 set in Morocco and would soon film *Medea* in Turkey, both of which communicate his primitivist take on Greek tragedy. A reviewer for the *New York Times* called his *Medea* an 'attempt to translate into film terms the sense of a prehistoric time, place and intelligence in which all myths and rituals were real experiences' (Canby 1971).

15 Pasolini has apparently made his own decision on this score, however. Later in the film, he announces that the story will be set in 1960: 'My film will be very appropriate,' he narrates, panning over wild flowers. He goes on to suggest that 1960 is the right year for his movie, since it is when many African states made up for their 'delay . . . of centuries of millennia by achieving independence and democracy'.

16 The fact that a viewer of *Notes* can decipher specific African countries in the film – such as Nigeria at one point and Uganda in another – does not clear Pasolini of this charge, since his ideas about the film are always framed in terms of Africa as a whole.

17 Given Pasolini's own passionate and complex devotion to Marxism, it is possible that he was in fact critical of democracy as such, but his view of the end of *Eumenides* is wholly positive and his equating of changes in Africa with changes at the end of the trilogy seems to suggest that he views Africa as having 'progressed' into its democratic present. On Pasolini's nuanced political and religious views, cf. Greene (1990), Francese (1999), and Ravetto (2003).

18 Cf. Vandenbroucke (1985: 95–114) on this shift in Fugard and the importance to it of *Orestes*, which he calls a 'performance piece rather than a conventional play' (110).

19 This fragmentation stands in stark contrast to our view of the *Oresteia*, the only Greek trilogy that is extant in full, though it is corrupted in places and is missing its satyr play.

20 Astbury (1979: 1).

21 Astbury (1979: 1).

22 The friend is Bruce Davidson, an American photographer. Cf. Vandenbroucke (1985: 111).

23 Fugard (1979: 3). All the italics in this section are Fugard's.

24 Fugard (1983: 188–9). Yvonne Bryceland played Clytemnestra, while Val Donald and Winston Dunbar played Electra and Orestes respectively. Cf. Vandenbroucke (1985: 111–14) and McDonald (2006: 23–9) for further description and details of

the production and Kruger (2012: 360–3) on the influence of Brecht on the work. Cf. also Van Zyl Smit (2010) and (2003) for analysis of *Orestes* in the greater political context of South Africa.

25 Fugard (1983: 185).

26 Brook (1968: 13). Brook's preface had previously been published as an article in *Flourish*, the newspaper of the Royal Shakespeare Theatre Club (1967).

27 Fugard (1983: 184).

28 Fugard (1983: 185).

29 Fugard (1979: 4–5).

30 Fugard (1979: 5).

31 Fugard (1979: 5).

32 McDonald (2006: 25–6).

33 Fugard (1979: 5). These lines on the destruction of a self through the witnessing of destruction are almost an inverse of a quote from R.D. Laing (1967: 24), '*If our experience is destroyed, our behavior will be destructive*' [Laing's emphasis here] to whom I will return presently.

34 Cf. Fugard (1983: 46, 54–5, 57–8, 86, 90, 113–14, 118, 124–6, etc.). Fugard (1983: 90) interprets this never-ending parade of violence as particularly South African: 'We were in the room, reading, when a sudden uproar broke out in the street. This is such a South African sound . . . Somebody screaming – oaths, abuse – and invariably somebody crying.'

35 Fugard (1983: 113–14).

36 The name was chosen by location: their first production was staged in an abandoned snake pit. Cf. Vandenbroucke (1985: 98).

37 Fugard (1979: 6).

38 Fugard (1979: 6).

39 Laing (1967: 152, 156). (My emphasis here.) The last ten words of this passage have a prior literary life in a poem published in 1940 by W.H. Auden called 'If I could tell you', of which this is the first stanza: 'Time will say nothing but I told you so,/ Time only knows the price we have to pay;/ If I could tell you I would let you know.' Cf. Auden (1989: 110–11). Neither Laing nor Fugard cites Auden. While either (or both) may be alluding to his poem nonetheless, the possibility remains (or is signaled) of a completely unintended echo from a shared cultural artifact, a poem which, as a villanelle, exacts its own kind of *telos*: the poem's structure of repetitions frames the return and resurrection of sounds, images, and thoughts in ways that illuminate changes in their meanings as they accrue new associations.

40 Fugard (1979: 6).

41 Fugard (1983: 71).

8

Kings of the Stone Age, or How to Read an Ancient Inscription*

Stephanie Ann Frampton

Lapidum natura restat, hoc est praecipua morum insania.

Pliny the Elder, *Natural History* 37.1

Stones keep materializing in the articulation of Deep Classics. In Shane Butler's introduction to this volume, the geologists James Hutton and John Playfair stood at the rocky edge of the abyss of time, providing a model for our own ways of thinking about the past and the pastness of Graeco-Roman literature and culture. So, too, was the study of the geological history of the continental United States grist for John McPhee's resonant coinage of 'deep time' in the pages of the *New Yorker*, which offers a close analogue and partial source for the 'deep' of this volume's title.[1] Beyond conceiving the nearly unfathomable time-scale of evaporated Mesozoic seas and creeping Pangaean plates, geology also draws our attention to what information historian Geoffrey Bowker has recently dubbed science's 'mnemonic deep'[2] – yet another instance of the depth 'reflex' that Joshua Katz discusses in his paper in this volume (see chapter 5). Taking the invention of geology as his starting point, Bowker in principle reiterates the constructivist understanding that scientific knowledge and its production are historically contingent and indelibly human.[3] Like other human endeavours, the sciences are seen to operate on the precipice of history, hardly immune from their own disciplinary habitus. 'There's a little bit of the humanities that

* The author would like to give warm thanks to Catherine Chin, Joseph Howley, Joshua Katz and especially Shane Butler for commenting on earlier drafts of this paper, as well as to all of the participants in the Deep Classics conference, with whom it was truly a pleasure to spend a long weekend in chilly Bristol. All errors that remain are of course my own.

creeps into geology,' says one of McPhee's informants, 'and that's why I'm in it.'[4] So too, it turns out, does a bit of geology creep into the humanities.

It can be tempting to think that Classics emerged fully formed, perhaps in the Renaissance, in contemplation of more or less the same 'antiquity' studied today.[5] Geology, however, teaches us that even the most venerable objects may be forever in flux. Indeed, new studies of the 'classical tradition' have helped to situate the various 'inventions of antiquity' in Renaissance humanism or Enlightenment secularism or European Romanticism.[6] We can also see growing interest within Classics in the fact that the ancients, too, had a classical past.[7] That is, the Greeks and Romans, whom we study as the basis of a variegated and collective Western *Kulturgeschichte*, themselves identified with a cultural heritage that was distant but knowable, and one that they moreover saw to be connected ethically and aesthetically with their own world. It is this idea – of Classics' classics – that I would like to address, if somewhat obliquely, in this chapter.[8] My own scholarly formation may particularly incline me to see the structure of our thinking about the past as fundamentally recursive: a Romanist, perpetually belated and loath to allow anything new under the sun, I am also very much a product of the constructivist zeitgeist. Certainly my scholarly community in Roman cultural history is currently questioning the contours of an area of classical intellectual life that has for some time been called 'antiquarianism'.[9] We are beginning to plumb the depths of ancient scholarship not just to recover synchronic evidence, but also to trace the diverse conceptual landscapes and ways of thinking (*Geistesgeschichten*) of those whom we study.

It is more than the convenient echo of 'mnemonic deep' in Deep Classics that draws me to Bowker's work. His materially-inflected study of memory practices in the sciences highlights the connections that exist between methods of inscription, the making of cultural memory and the creation of disciplinary knowledge that can be productively expanded to address some of the problems presented by considering the long history of the study of classical antiquity. For example, seeing the lapidary layers to which John Playfair referred in his eloquent description of Siccar Point (see introduction) or Darwin's account of the variegations of the beaks of Galapagos finches, Bowker recognizes in them a corollary of the industrialist's clock. Natural evidence offered a physical archive and a legible history of the globe in parallel with the records of the New

York and Erie Railroad or the Royal Mail. By analogy with the technocrats, natural scientists would forever after see nature as her own record-keeper.[10] So too, in antiquity, do we begin to find a series of metaphors imagining history in terms of human records: the world was a book to be read (e.g. Lucretius, *On the Nature of Things* 1.196–8, 1.823–7, 1.907–14, 2.688–99; Plotinus *Enneads* 2.3.7, 3.1.6, 3.3.6); memory, a surface to be inscribed (e.g. Plato *Phaedrus* 276d; Aristotle *On Memory and Recollection* 450a; Cicero, *On the Orator* 2.354, *Partitiones oratoriae* 7.26; Quintilian, *The Orator's Education* 11.2.22); time, measured by the survival of inscribed monuments (e.g. Simonides, *Poetae Melici Graeci* 581; Isocrates, *Antidosis* 7; Lucretius, *On the Nature of Things* 5.306–18; Horace, *Odes* 3.30.1–5; Ovid, *Fasti* 5.131; Seneca, *On the Shortness of Life* 15.4; Rutilius Namatianus, *De reditu suo* 1.411; etc.).[11] In the field of classical philology especially, the writtenness of much of our evidence means that we, too, see Classics through the lens of inscriptional epistemes that belong not only to the nineteenth century, the Renaissance or the Middle Ages, but to antiquity itself. We are at the mercy of the intentional and unintentional memory practices of the ancient world: the setting-up of inscribed memorials as much as the laying-down of garbage heaps, the accumulation of book collections as much as the production of epitomes, what was copied in schoolrooms as much as what was commissioned from *librarii*. All of these conventions affect the texts left behind, leaving traces in the very forms of classical evidence.

Already in the quotation with which Butler opens this volume's introduction, Alberto Manguel suggests the troublesome connection between texts and objects: 'Each one of our readings [of Homer] is done through layers of previous ones that pile upon the page like seams in a rock until the original text (if there ever really was so pure a thing) is hardly visible.'[12] In Butler's treatment, Manguel's image of the reader encountering 'layers that pile upon the page' of the Homeric poems evoked geological and ultimately archaeological strata, requiring the reader's imaginative excavation and opening the dialogue between deep time and Deep Classics. But what if we were to read the image of rock somewhat differently? Perhaps Manguel does not think of 'seams in a rock' as layers per se, but rather only *like* layers. How would we go about construing the image then, and what new possibilities for our ideas of reading, the Classics, and reading the classics would that afford? As an epigrapher (for I am that, too), someone who reads both writing and rocks, I found something

deeply familiar in the image: *like seams in a rock until the original text is hardly visible*. That difficult experience of trying to read a text marked by fractures and 'hardly visible' is all too common to those of us who study ancient material texts, whether on stone or papyrus, plaster or wax, slip or bronze. They often survive beaten, battered, and bruised. If the decipherment Manguel imagines is not just an excavation of text under the layers of its histories of reception, but also a kind of reconstruction of a text that has somehow been torn apart, this demands a kind of reading – no anomaly for scholars of antiquity – that treats a text not only as the words out of which it is composed, but also as a physical body in the world. Such bodies arrive to us marked by their histories as objects. Disuse, reuse, rupture, continuity, loss and recovery all leave their traces on the substance of an inscription or even on the page of a book. How does thinking this way – about classics as *objects* – help us to think about Classics as such?

To quote Pliny, *lapidum natura restat*: it remains to think about the nature of stones. For, beyond Deep Classics, I see again and again within our own disciplinary discourses *and* within that of the Greeks and the Romans the image of stone serving as a symbol for humanity's experience of history, caught between nature and culture. In the study of Greek (but particularly Hellenistic) aesthetics, we have already seen materialism put back at the centre of classical *Wissenschaft*. The materiality of inscribed monuments as 'ruins *in potentia*', for example, is one of the major axes in the discussion of the sublime.[13] Similarly, the materiality of gems is a primary concern of several major studies of the ekphrastic epigrams of Posidippus's *Lithika* – itself one of the most exciting 'new' texts to enter the classical canon as a collection of poems whose extraordinary survival on papyrus equally calls attention to its own materiality.[14] At the same time, new studies of Greek and Roman epigram are increasingly sensitive to the fact that this most classical of genres (appearing already in Homer and popular straight on into the Middle Ages) imagines itself always as having latent epigraphic potential, alive to the fact that it might be, have been, or be about to be carved in stone.[15] Stones are ancient and natural, but when we meet them in literature – as intricately carved gems or inscribed marble surfaces or even as nature's adornments (one thinks of Ovid's *antrum arte laboratum nulla*, *Metamorphoses* 3.156–7) – they have been forged and fashioned: it is when stone is shaped by human hand or intellect that it becomes of interest to ancient poetics. Differently from Bowker's geological

formations, but still tied intimately with practices of knowledge production and memory making, classical stones provide a foil for human timeliness: registering the mark of our craft and our art, and ultimately long outlasting us.

Even so, the ancients were well aware that stones and books were not immortal. The study of 'poems on stones' (that is, poems written either *about* or *upon* stones) has focused on the materialist epigram as the particular purview of the Hellenistic period. But descriptions of such poems or the poems themselves require a different kind of temporal understanding. Such texts are explicitly not isolated in time. Rather, they call attention to their own trans-historical possibilities. As long lasting as stone and papyrus might have been,[16] neither was out of time's reach, and hand-in-hand with epigram's claims to material longevity is its implicit embeddedness in the physical world. One of the images that appears frequently in epigram, then, is an epigram's own physical destruction. It is to a series of poems that testify to this trope that I would like to turn in the remainder of the paper.

Just as the literary fragment elicits a desire for completion,[17] and the classical past elicits a desire for reception,[18] the classical inscription elicits a desire for a reading that fulfils the wish of a monument itself to be read.[19] A short poem transmitted in the earliest manuscript of Ausonius of Bordeaux (and usually published among his *epigrammata*, if published at all) dramatizes this kind of reading as an invitation to bring disjointed pieces together. (The first meaning of *legere*, after all, is 'to collect'.)

De nomine cuiusdam Lucii sculpto in marmore

Una quidem geminis fulget set dissita punctis
　littera; praenomen sic nota sola facit.
post 'M' incisum est, puto sic; non tota videtur.
　dissiluit saxi fragmine laesus apex;
nec quisquam Marius seu Marcius anne Metellus
　hic iaceat certis noverit indiciis.
truncatis convulsa iacent elementa figuris;
　omnia confusis interiere notis.
miremur periisse homines? monumenta fatiscunt;
　mors etiam saxis nominibusque venit.[20]

On the name of a certain Lucius inscribed in marble: Only one letter shines forth, set-off by double points. This mark alone gives the praenomen ['L' for

Lucius]. After it, 'M' is carved: yes I think so. It cannot be seen completely. The top part, which is cracked, is broken-off on a fragment of stone, and no one could know by certain signs whether a Marius or Marcius or Metellus lies here. Letters, overturned, lie among broken shapes. Everything has been destroyed among disordered letters. Should we marvel that men perish? Monuments wear out, and death comes even to stone and names.

More than a commentary on the ineffability of death and memory, the poem is also a poignant exploration of the classicist's task vis-à-vis the written record.[21] All but the single initial 'L', which identifies the dead man as 'a Lucius', has been rendered illegible on the stone by the ravages of time, leaving the owner of the tomb, whom the site and the inscription were meant eternally to memorialize, unknown and unknowable. The perspective of the poem is an epigraphic one, the speaker engaged in the act of looking, trying to decipher what is seen. Insofar as the poem explicitly thematizes the contingency of reading on the physical survival of the text itself, it is an object-lesson in the kinds of reading practices that are evoked – intentionally or not – by Manguel's simile, making a reader deeply aware of the material contingency of her own reading practice.

I specify that the inscription is a classical one because this seems an essential point. In Ausonius's poem, the distance between the poet-witness-reader-epigrapher and the Lucius he strives to know and to name creates the scenario of poetic speculation (one that James Porter would associate with the sublime) that mirrors our own desires for knowing the classical past. Despite the disorder and obscurity with which the poems ends, it begins full of light: Lucius, the name of light itself; 'marble' (*marmor*), related to a Greek verb (μαρμαίρειν) that means 'to shine'); and a Latin verb of similar meaning, *fulget* (cf. Posidippus, *Lithika*, *passim*). Yet, an initial desire for transparency and clarity is frustrated by confusion and disruption in the visual field as the possibility of complete knowledge is foreclosed by the poor state of textual transmission, the destruction of the physical object. The text (*littera*, *elementa*, *nota*) is not imagined to be a metaphysical bearer of meaning, but rather is figured as a physical artifact coextensive with the rock upon which it is written. Where the rock is broken and made un-whole (*fragmine saxi*), so too does text dissolve into pieces (*laesus apex*; *truncatis figuris*; 'M' and 'L' apart from the whole). Text and material are neither discrete nor inherently separable. The

specific materiality of a fragmentary inscription demands more than just reading, requiring its viewer to take account of the state of the physical object as well as of the text that it is missing.

Moreover, Ausonius's interest in the inscription is motivated by its classicism: recognizably Roman, following Latin epigraphic conventions, and thereby connected to a 'classical' past in which Ausonius himself was heavily invested. In particular, in its native habitat, the pages of a ninth-century manuscript, the poem appears among a series of epigrams (most of them imaginative epitaphs for Trojan heroes) that serve as an appendix to Ausonius's better known book of poems commemorating Bordeaux's fourth-century classicists, the *Professores*. Making clear the connection he draws between formal education in Greek and Latin and the study of epigram, the author writes:

> When I brought to completion the previous book (i.e. the *Professores*), which contains the commemorations of those who were professors either as visitors to Bordeaux or as Bordelais abroad, I considered what follows to pertain to that theme and to be of complementary matter, even if it constitutes only a small little work (*opusculum*). I have added these epitaphs of heroes who participated in the Trojan War (*epitaphia heroum qui bello Troiaco interfuerunt*): ancient poems that I encountered in the work of a certain scholar. I have translated them into the Latin tongue, not in such a way as to be slavish in following their arrangement, but so that I obey them with some freedom and do not stray far from the model they offered.

Ausonius's commemoration of Bordeaux's professors is a *monumentum* of the author's own classical education. It also elicits his memory of certain texts that themselves profess to be the *monumenta* of Greek heroes, a sub-genre of epigram familiar to scholars of antiquity today from collections like the *Greek Anthology* and the Aristotelian *Peplos*.[22] Such epitaphs purport to be sepulchral inscriptions, but unlike the one that is described so vividly in *De nomine cuisdam Lucii*, the author's interaction with these inscriptions is purely literary. Taken from a Greek compendium, translated freely into Latin, the poems are thus doubly removed from their notional (if not original) epigraphic form. Readers of the *Anthologia* will know that such poems revel in the literary and scholarly aspects of their own transmission. To take a representative somewhat at random from Ausonius's short cycle, his epitaph for Odysseus, for example, resolves in a celebration of Homer's poem, turning from tomb to

book: 'In this tomb is buried Ulysses, son of Laertes; if you want to know all about him, read the *Odyssey* to the end' (*Epitaphia* 5).[23] The spatially and physically limited specificity of *hoc tumulo* contrasts with the comprehensive and relatively disembodied textual distribution of Odysseus in and as the homonymous poem. Even before the physical inscription is subject to the ravages of time, the epitaph is already just a fragment.

Such an acknowledgment ties the heroic poems of the *Peplos* tradition to the more original epigrams with which Ausonius's *opusculum* ends: five poems in a series that includes *De nomine cuiusdam Lucii*, all taking the form of secondary descriptions of monuments rather than the direct discourse of *oggetti parlanti*.[24] The epitaphs and the epigrams that follow are thematically linked. For example, the insufficiency of the epitaph to represent 'all of the man' (*omnia: Epitaphia* 5.2) is reflected in the metaphor of the degraded monument. In the one case, the epitaph of the hero is but a trace of the fuller life described in the epic poem; in the other case, the two letters 'L' and 'M' are the only remaining signs of what was once the final and notionally complete record of a certain Lucius (again *omnia: De nomine cuiusdam Lucii*, line 8). In the Lucius poem, the corruption of the physical substrate of inscription – the stone on which the funerary epitaph was written – is thematized metaphorically as representing, on the one hand, the limitation of human life (*miremur periisse homines*) but also the limitation of human memory (*mors etiam saxis nominibusque venit*). While the inscription and the very stone to which it is attached are entrusted with the task of allowing the dead to be recalled by way of his name, even stone, says the poet, wears away, as do the names of those long dead in the minds of the living. Although Ausonius's Anglophone editors conspicuously label the sentiment 'trite', Peter Kruschwitz reminds us that the fear of being forgotten after death was a genuine part of the worldview and life-experience of people in the late Roman Empire.[25]

The multivalent and, as it were, multimedia status of literary epitaphs seems to have made them especially mobile in manuscript and in print. Their transmission in the Ausonian corpus is a case in point. It is in only a single ninth-century manuscript now held at the University of Leiden (**V**) that the *epitaphia heroum* are found as a coherent series, preceded by the introduction addressed to the reader and followed by the five original epigrams of which *De nomine cuiusdam Lucii* is the second.[26] Elsewhere in the manuscripts – namely

the family of Italian compilations (**Z**), followed in nearly all printed editions
– an assortment of these poems is mixed with other lyrics under the general
heading *epigrammata*.[27] While many editors have considered the group of
which *De nomine* is a part to be an interpolation into the *epitaphia heroum*
because of their diverse character from the epitaphs that precede them,[28] the
Leiden manuscript offers the reader the opportunity to consider them of a
piece with the epitaphs they follow. Indeed, a contemporary scribe responsible
for correcting this section of the manuscript has written definitively *finiunt
epitaphia* in the margin beside the final line of the fifth and last of these
poems.[29] In the specific context of the Leiden manuscript, then, it is possible to
see poems as contiguous with the fabric of the translated epitaphs and thus
also of the commemorative *Professores*. Their distinct position in this important
manuscript encourages us to read them as a commentary on the classically
themed works that they follow, united by their interest in poetry's limited
potential to serve as a permanent monument to the past. The unity of theme is
reflected in – and made apparent by – the codicological configuration when
we read the manuscript book itself as a marked object. Thus, the textual life of
De nomine cuiusdam Lucii as a poem in and of itself, captured on animal skin
rather than stone, has a history that in turn reflects the very subject of the
poem: its author only half-known, its readership not guaranteed, its
interpretation dependent on the materiality of a single inscribed object.[30]

Across the Mediterranean and more than a millennium on, Constantine
Cavafy read the Ausonian poem, using it to structure his own rumination on
death and survival, published in 1917.[31] The poem Ἐν τω Μηνί Αθύρ ('In the
Month of Athyr') bears a striking resemblance to *De nomine cuiusdam Lucii*,
one that has not, as far as I know, been discussed in print:

Εν τω Μηνί Αθύρ

Με δυσκολία διαβάζω	στην πέτρα την αρχαία
«Κύ[ρι]ε Ιησού Χριστέ».	Ένα «Ψυ[χ]ήν» διακρίνω.
«Εν τω μη[νί] Αθύρ»	«Ο Λεύκιο[ς] ε[κοιμ]ήθη».
Στη μνεία της ηλικίας	«Εβί[ωσ]εν ετών»,
το Κάππα Ζήτα δείχνει	που νέος εκοιμήθη.
Μες στα φθαρμένα βλέπω	«Αυτό[ν] ... Αλεξανδρέα».
Μετά έχει τρεις γραμμές	πολύ ακρωτηριασμένες·
μα κάτι λέξεις βγάζω —	σαν «δ[ά]κρυα ημών», «οδύνην»,

κατόπιν πάλι «δάκρυα», και «[ημ]ίν τοις [φ]ίλοις πένθος».
Με φαίνεται που ο Λεύκιος μεγάλως θ' αγαπήθη.
Εν τω μηνί Αθύρ ο Λεύκιος εκοιμήθη.

In the month of Athyr

It is hard to read. . . . on the ancient stone.
"Lord Jesus Christ". . . . I make out the word "Soul".
"In the month of Athyr. . . . Lucius fell asleep."
His age is mentioned. . . . "He lived years" –
The letters KZ show. . . . that he fell asleep young.
In the damaged part I see the words. . . . "Him. . . Alexandrian."
Then come three lines. . . . much mutilated.
But I can read a few words. . . . perhaps "our tears" and "sorrows."
And again: "Tears". . . . and: "for us his friend mourning."
I think Lucius. . . . was much beloved.
In the month of Athyr. . . . Lucius fell asleep. . . . [32]

Like his Ausonian model, Cavafy uses the conceit of the fragmented inscription to incite a meditation on the classical. Cavafy writes in the form of the fragmentariness that *De nomine cuiusdam Lucii* only describes, breaking up his own lines across a seam that runs down the page. No other poem in Cavafy's *oeuvre* is structured in this way. Construed by one editor as belonging to a series of sepulchral epigraphs for young men of Alexandria,[33] Cavafy's version of the Lucius poem instead has hybrid status, like its late antique source. It records what is left of an inscription, real or imagined, and thus serves as an epigraphic record.[34] But as a poem, it is both more and less than the 'original'.

A recent installation at the American Academy in Rome, *Material Narratives*, captures the spirit of this type of reading as an opportunity for artistic creation (Figure 8.1). In a work conceived by landscape artist Adam Kuby and conservator Anna Serotta, the artists carved an inscription in Roman capitals onto a clean marble slab that was subsequently broken apart. Fragments were removed by members of the community, and a pair of ad hoc epigraphers (the novelists Krys Lee and Liz Moore), were asked to fill in the gaps. Each gave a different restoration of an 'original' text in and among the words that remained: 'CITY', 'PLANS', 'WITNESS' and 'RECORD'. One reading seems to connect urban ruins with the fossil record, archaeology with palaeontology: 'A city disappears – | No long

Figure 8 *Material Narratives*. Installation by Adam Kuby in collaboration with Anna Serotta, Krys Lee and Liz Moore. American Academy in Rome, 2015. Photograph by Adam Kuby. Reprinted with permission.

wilful plans | Will save us now | Wanderings Bungling | Witness a fossil | Flower keens beyond time | Leaves a bony record | We the false witnesses.' The other offers a surprising jump across media, from stone to stereo: 'A city inside itself— | And all my plans | Everything broken, when | The dregs burn and | I witness it all, then I | can't stop, I can't. I'll play | On until the record | Ends.' *Material Narratives* explores the aesthetics of the fragmentary via the familiar visual repertoire of the monumental Roman inscription, and yields interesting results at the level of interpretation and artefact. Even if the event of textual dissolution and the performance of epigraphic supplementation are fundamentally artificial, the piece draws attention to the cultural and historical significance of the fragmentary nature of material evidence in the same way that *De nomine cuiusdam Lucii* and ʿΕν τω Μηνί Αθύρ' do: we write history from the pieces.

Up to this point, it has been only in the materiality of marble and in the passage of time that we have seen the natural world appear in our observations of the poetics of the ancient lapidary fragment. Yet, as we know from Posidippus's *Lithika*, as well as the technical discussions of stone in Theophrastus's *On Stones*

and Pliny's *Natural History*, the ability of stone to mediate between nature and culture was one of the most interesting aspects of stone in antiquity. A final example – Cicero's account of seeking out the inscribed sepulchre of Archimedes while governor of Syracuse – puts fragmentary inscription back in its natural environment:

> When I was quaestor I tracked down Archimedes' grave, which was unknown to the Syracusans, as they entirely denied its existence. I found it enclosed all round and covered with brambles and thickets. I remembered certain hexameter lines, which I understood were inscribed upon his tomb, that stated that a sphere along with a cylinder had been set up on the top of the grave. Accordingly, after taking a good look all round – for there is a great throng of tombs at the Agrigentine Gate – I noticed a little column not much taller than the briar bush, on which there was the figure of a sphere and a cylinder. And so at once I said to the Syracusans, whose leading men I had with me, that I believed it was the very thing of which I was in search. Slaves were sent in with sickles to clear the ground of obstacles, and when a passage to the place was opened we approached the pedestal fronting us. The epigram appeared: hardly half was visible, since the latter part of the verses had worn away. Thus, a most famous city of Greece, although once it was the most learned, would have been ignorant of the monument of one of its wisest citizens, unless they had learned of it from a man of Arpinum. (*Tusculan Disputations* 5.64–6; trans. adapted freely from King)

In Cicero's story, the loss of knowledge of a virtuous man of the past through the degradation of his memorial is not the fault of unthinking time alone, but also of unthinking men. Although Cicero decries Archimedes as an enemy of the Roman state, he still regrets that the Syracusans neglect to remember one of their most illustrious citizens. The irony that Archimedes himself was killed by Roman soldiers and that Syracuse from that time on was subject to Roman rule can not be lost on the 'man from Arpinum' who here commands not only a fleet of slaves, but also the state of Sicily itself, represented by the Syracusan *principes* with whom he travels. His ethical worthiness for the post is signalled by his ability to school them in their own classics, which he knows by way of epigram: hexameter lines that would have circulated in antiquity in literary form as an heroic epitaph.[35]

Like other literary inscriptions that programmatically make reference to their own physical material,[36] the remembered epitaph of Archimedes also

refers to its own appearance: in this case, the cylinder and the sphere that represent science's command over the forms of nature. It is by his knowledge of the text that Cicero is able to recognize Archimedes' tomb. Beyond merely the epigraphic gaze, then, here we find a script for archaeological or even topographical study. Having recognized signs known and knowable through a literary text, the *doctus* seeks out access to the physical monument of the *doctissimus*. His knowledge of the words of poetry allows him authority to recognize their objective correlative in the physical world, laying bare the natural accretion of vegetation in that place and opening the object and its text to new inspection: *aperuerunt locum … apparebat epigramma*. Study of the classics conquers not only time, but nature herself.

As with the inscriptions of Ausonius's Lucius or Cavafy's Λεύκιος, not all of the text of Archimedes' epitaph can be read: 'hardly half was visible, since the latter part of the verses had worn away'. Though the new reading only partially confirms what is known of the text already, the fragmentary quality of the inscription does nothing to undermine the status of that reading. Rather than implying only that literary circulation allows cultural knowledge to transcend a singular embodiment in a physical artefact, vulnerable to the natural wear of time in the physical world, Cicero reaffirms the value of maintaining the original monument as a model for future generations, drawing an implicit connection between the loss of knowledge of Archimedes' tomb and the loss of Syracuse's status as *civitas doctissima* in the present: 'Thus, a most famous city of Greece, although once it was the most learned, would have been ignorant of the monument of one of its wisest citizens, unless they had learned of it from a man of Arpinum.'

As I have tried to suggest with this constellation of evidence, from the ancient to the modern, the specific materiality of written poetic inscriptions is one of the fields on which the battle of over the classical has been waged. Poems on stones thematize their own trans-historicism by their attentiveness to the longevity of physical materials. They call attention to their writtenness, and are particularly mobile in and between media. In this way, they resist standard forms of canonization (as big books in big libraries), but, in their very proliferation, they are some of the most successful forms of literature to survive from antiquity. Most of all, they highlight the fact that Classics is not a body of material at all, but rather a set of questions, a procedure of reading, and a

practice of engaging with the past through its physical traces. If Nicholas Carr can reframe our reliance on media as a kind of 'shallows',[37] Deep Classics offers a rejoinder. Are we Cicero, gaining authority from the incompleteness of the record we restore? Are we Ausonius, with a melancholic attitude and a nostalgia that desires an impossible return? Or are we Cavafy, spinning new art out from the gaps in the record? Perhaps Classics as a discipline, as we see throughout the studies presented in this volume, is authorized by all three postures: the authoritative, the nostalgic, and the creative. It does us well to become self-aware of this ecology of memory practices, as Deep Classics asks us to do. Moreover, to think explicitly about the implications of the material instantiations of ancient Graeco-Roman texts on the study of antiquity reminds us how deeply contingent on such incomplete forms our own knowledge is. Such awareness is salutary as we frame Classics for a future that will entail a new set of media protocols and material manifestations. To that end, we should learn what we can from the study of ancient inscriptions, even when the texts we read are only written on the surface of the page.

Notes

1 'Deep time': McPhee (1981: 20, 104, 127, 130 and 142), first used in the *New Yorker* (20 October 1980): 68. It is Stephen Jay Gould who credits McPhee with the coinage of the term the former would make famous in Gould (1981).

2 Bowker borrows the term 'mnemonic deep' from the pastiche of eighteenth-century scientific humanism in Pynchon (1997), in which the narrator attempts to characterize the tension between fact and meaning in the making of history: 'History is no Chronology, for that is left to lawyers – nor is it Remembrance, for Remembrance belongs to the People. History can as little pretend to the Veracity of the one, as claim the Power of the other, – her Practitioners, to survive, must soon learn . . . that there may ever continue more than one life-line back into a Past we risk, each day, losing our forebears in forever, – not a Chain of single Links, for one broken Link could lose us All, – rather, a great disorderly Tangle of Lines, long and short, weak and strong, vanishing into the *Mnemonick Deep*, with only their Destination in common' (Bowker 2005: 192, emphasis added).

3 See especially Kuhn (1962) and Latour (1987b).

4 McPhee (1981: 12).

5 Throughout the paper I use 'Classics', capitalized, to denote the academic field that focuses on the study of Graeco-Roman antiquity, also known as classical studies, *Altertumswissenschaft, classische Philologie*, etc. They are distinguished here from 'classics', miniscule, which I use to denote the literary materials that are the object of their study, i.e. ancient Greco-Roman texts. Following the convention of the volume, Deeps Classics is always capitalized.

6 See for example, Harloe (2013); Klaniczay, Werner and Gecser, (2011). 'Classical tradition': Grafton, Most and Settis (2010); Silk, Gildenhard and Barrow (2014). Some of these approaches are usefully discussed by Güthenke (2013).

7 E.g. Schnapp (1996); Miller (2007).

8 See already the essays in Porter (2006c).

9 I have seen forthcoming work by Duncan McRae, Dan-el Padilla Peralta and Joseph Howley that does just that. In my own sub-sub-area of material textual studies, the new collection of Liddel and Low (2013) gives us a way to think about material texts as part of the practice of the study of antiquity in antiquity.

10 Bowker (2005: 36): '[A] rock can be read as an object that constitutes part of the lithosphere, and equally as a document that contains its own history written into it: striations on the surface indicate past glaciations, strata indicate complex stories of deposition over time, and the relative presence of radioactive isotopes of various kinds indicates . . . journeys through the mantle.'

11 Frampton (forthcoming).

12 Manguel (2007: 3).

13 Porter (2010); Porter (2011b).

14 See the wonderful facsimile edition of Bastianini and Gallazzi (2001), as well as Acosta-Hughes, Kosmetatou and Baumbach (2004), especially Smith (2004); Gutzwiller (2005); Elsner (2014).

15 Three new collections in English are Baumbach, Petrovic and Petrovic (2010); Keith (2011); Liddel and Low (2013).

16 For the antiquity of papyrus see Houston (2014: 120–1).

17 Most (1997: v–viii).

18 See Purves in this volume; Güthenke (2013).

19 Svenbro (1976).

20 The poem is no. 37 of the *Epigrammata* in Green (1991) and Green (1999), the latter of which I follow here, and no. 32 of the *Epitaphia heroum* in Prete (1978). More on the transmission history follows below. For clarity, I refer to the poem by the abbreviated title *De nomine cuiusdam Lucii* throughout this paper. Unless otherwise indicated, translations in this chapter are my own.

21 The classic account is Fowler (2000: 193–219).

22 Gutzwiller (2010).

23 *Conditur hoc tumulo Laerta natus Ulixes:* | *perlege Odyssean omnia nosse volens.*
 The Odysseus epitaph given above is not one of those for which a Greek original
 exists in manuscript. Stahl suggests it is Ausonius's own creation, though it is
 perhaps more likely the work of the unnamed *philologus* of Ausonius's preface,
 often thought to be Porphyry, or another Greek collection (Stahl 1886: 26).

24 In the manuscript, thirty *epitaphia heroum* (the last four of which do not, in fact,
 treat Trojan heroes but Niobe and Diogenes) are followed by five seemingly original
 poems, of which *De nomine* is the second. The others are *In tumulo hominis felicis*
 (On the Tomb of a Happy Man), *Iussu Augusti equo admirabili* (For a Remarkable
 Horse, by the Order of the Emperor), *De sepulchro vacuo* (On an Empty Tomb), and
 In tumulum sedecennis matronae (On the Tomb of a Sixteen Year Old Wife).

25 'Trite': Green (1991: 394), and Kay (2001: 153). Kruschwitz (2014).

26 MS Voss. Lat. 111. Cf. de la Ville de Mirmont (1917–21), of which vol. 3 provides a
 very useful facsimile.

27 For example, in Green's editions (Green 1991 and Green 1999), the poems are
 Epigrammata (XIII) nos. 8, 37, 7, 38, and 13 respectively. On Z, of which the
 earliest example dates to after 1385, see Reeve in Reynolds and Marshall (1983: 27).

28 E.g. Green (1991: 363).

29 This is an expansion of an even earlier annotation that read, simply, '*finit*'.

30 In fact, the text of the poem in V is equally fragmentary, since its name, too, is
 missing in the transcription, and supplied only by the later witnesses of Z.
 Elements of the manuscript discussed here can be seen in the facsimile edition of
 La Ville de Mirmont (1917–21: vol. 3, folio 15ʳ).

31 On its themes of fragmentation and loss, see Nagy (2010: 265–72).

32 Trans. Valassopoulo, originally published in Forster (1923: 96).

33 Keeley (1976: 81–4).

34 Kruschwitz (2014) reminds us that the first editors of the *Corpus Inscriptionum*
 Latinarum took Ausonius's testimony seriously enough to supply
 'D· M·L· M' (*dis manibus Lucius M.*) as an entry, *CIL* XIII 791, in the volume
 on inscriptions from southern France.

35 On Archimedes in Roman literature and this passage in particular, see Jaeger
 (2013: 32–47).

36 The *locus classicus* is surely Simonides' famous commentary on the bronze of
 Midas's epitaph (*Poetae Melici Graeci* 581).

37 Carr (2010).

Queer Unhistoricism: Scholars, Metalepsis, and Interventions of the Unruly Past

Sebastian Matzner

Prelude

'So what's your field?'

> 'I mostly work on interactions between ancient and modern literature. I'm particularly interested in the theory and poetics of intercultural encounters across time.'

'Ah ... so ... not straight Classics.'

* * *

Classical reception studies, as is widely acknowledged, is by now fully integrated into the discipline of Classics insofar as the key institutional parameters that typically indicate such status are concerned. Yet institutional status does not neatly correlate with discursive status. A new rhetoric surrounding the status of what is classed as 'reception' within the discipline seems to have emerged. Gone are the days when classical reception could (and would) be easily and outright dismissed as not 'real' Classics, but the need to somehow add qualifiers and maintain boundaries seems to persist. 'Straight Classics' is an expression that recurs particularly frequently in the context of such moments of intradisciplinary demarcation of intellectual territory and policing of scholarly positionings. Ponder the phrase: *straight* Classics – as opposed to? The implication seems to be that there is a 'straight' form of Classics whose 'Other' is 'not-straight', in other words: queer.

The regularity with which I have encountered this phrase,
and the way it inadvertently resonates with my own research
on the history of sexualities,
has made me wonder whether there might actually be
a critical potential in these off-the-cuff remarks:
could there be some mileage in thinking of
the sort of diachronic comparative criticism that characterises
much of my engagement with classical literature
as an altogether queer enterprise?
And if so, what implications might this have
for the unique contribution such comparative approaches can make
to the study of classical literature, the classical tradition and classical receptions?

This essay sets out to probe the critical potential of comparative studies and reception studies as the queer Other of traditional Classics, and it does so by drawing on one controversy and two novels: the controversy is the debate on the 'New Queer Unhistoricism'; the two novels are José Luis de Juan's *Este latente mundo* (1999) and Jeremy Reed's *Boy Caesar* (2004). Both are examples of historiographic metafiction whose queer protagonists are themselves scholars, thus inviting reflections on the construction of knowledge within the academy.[1] I hope to show that these novels resonate with the concerns of queer unhistoricists, and I will explore how they thereby problematize our own scholarship and critical practice.

The starting point is Valerie Traub's recent article 'The New Unhistoricism in Queer Studies' in which Traub reflects critically on a programmatic position and methodology developed and advanced by scholars such as Carla Freccero, Jonathan Goldberg and Madhavi Menon. These critics, she argues, have gone too far in aligning (if not conflating) chronology, genealogy, teleology and 'straight temporality' in their efforts to free historical queer studies from 'a lingering attachment to identity that unduly stabilizes sexuality and recruits earlier sexual regimes into a lockstep march toward the present . . . and through a kind of reverse contamination conscripts past sexual arrangements to modern categories'.[2] The advocates of the new queer unhistoricism of her title object to scholarly approaches that implicitly assume consolidated identities on *either* end of the historiographical enterprise. That is, they equally object to the fiction

of a homogenous 'modern homosexuality' in the present *and* to the use of this notion as a solid and reliable Archimedean point for the assessment of erotic regimes of the past. In Traub's formulation, 'these scholars resist historicism on the grounds that it exaggerates the self-identity of any given moment and therefore exaggerates the differences between any two moments. Against what they view as a compulsory regime of historical alterity, they elevate anachronism and similitude as the expressions of queer insurgency.'[3]

Queer unhistoricists, therefore, seek to productively disturb schemas of development and progress by pitching sexual and temporal dissonance against sexual and temporal normativities.[4] Their objections to historicism are indebted to post-colonial critiques of the academic disciplines formed in the nineteenth century as not only institutionally but also conceptually implicated in the project of Western imperialism. Thus Freccero notes that 'altericism is sometimes accompanied by an older, more familiar claim that periods – those confections of nineteenth-century disciplinarization in the West – are to be respected in their time- and context-bound specificity. This is the historicism I speak of, the one that, in the name of difference, smuggles in historical periodization in the spirit of making "empirical" claims about gender and sexuality in the European past.'[5] Confronting a familiar post-colonial question – 'Is it not indeed possible that alteritism at times functions precisely to stabilize the identity of "the modern"?'[6] – from the perspective of queer historiography, these scholars conclude that distance in space *and* time *equally* serve as a vehicles of othering, which, in turn, consolidates modern Western identity;[7] and on this basis, they formulate their key critique that 'our embrace of difference as the template for relating past and present produces a compulsory heterotemporality in which chronology determines identity.'[8]

In the light of this assessment, these critics call for a 'temporal version of decolonization – what may be termed dechronolization – [which] would involve taking anachronism seriously and defying difference as the underwriter of history.'[9] For Goldberg and Menon this requires 'acts of queering that would suspend the assurance that the only modes of knowing the past are either those that regard the past as wholly other or those that can assimilate it to a present assumed identical to itself':[10] '[H]omohistory ... would be invested in suspending determinate sexual and chronological differences while expanding the possibilities of the nonhetero, with all its connotations of

sameness, similarity, proximity, and anachronism.'[11] Freccero suggests that one way to achieve this is to read and write metaleptically. Metalepsis is here understood as the rhetorical strategy that links A to D but elides the intervening steps of B and C, thereby skipping, as it were, chrono-logical distance.[12] She argues that the rhetoric of metalepsis 'could be seen to embody the spirit of queer analysis in its wilful perversion of notions of temporal propriety and the reproductive order of things.'[13]

In my assessment of the queer unhistoricism at work in the two novels, however, I wish to foreground the notion of metalepsis made canonical by Genette: metalepsis as a breaking of narrative frames.[14] Intrafictional metalepses of this kind shape both de Juan's and Reed's novel:[15] in each, we witness how two narratives – one ancient, one contemporary – gradually dissolve into each other, thereby leaving the reader wondering about their relative fictional status and the degree (and direction) of any mutual influence. In de Juan's novel, the seemingly separate stories of the sexually voracious Syrian scribe Mazuf in imperial Rome and of a present-day American named Laurence, who recounts his erotic exploits while studying at Harvard, entwine – with sex in libraries, crimes of passion and the manipulation of classical texts serving as a connecting nexus. Only in the final chapters, a unified narrative framework retrospectively emerges: all along, Laurence has been telling the entire story, incorporating in the process excerpts from his one-time lover Jonathan's diary as well as a 'tragedy' written by Jonathan. This 'tragedy' progressively turns out to be the novel's own ancient narrative strand, which, as the diary makes clear, is in turn itself based on contemporary events: Jonathan's sex life, his 'experiment' with a library copy of Gibbon's *Decline and Fall of the Roman Empire*, and his involvement with Laurence. This complex narrative set-up creates several interesting curvatures of time. A case in point is Jonathan's work on Gibbon:

> With huge black scissors, Jonathan started cutting the pages of the book in half ... As if he were a cardiovascular surgeon, he began deftly selecting pages and, one after the other, cutting them lengthways down the middle ... I noticed he followed a careful system ... And he did this with dozens of pages, whose numbers he seemed to check against a table. After a while, he took a roll of Scotch tape out of his satchel, and with great precision, as if he were assembling a time bomb, used pieces of tape to join the divided pages.

The whole thing was done meticulously yet quickly; he was finished in half an hour at most . . . Wasting no time, I started looking for the book I thought he had put back amongst the others . . . Finally, I found it: Gibbon's *Decline and Fall of the Roman Empire* . . . About one-twelfth of these [pages] were stuck together down the middle with transparent tape, the words underneath still legible. Obviously, it wasn't the first time that Jonathan had worked on the volume. It was an admirably clean job . . . I then saw the point of so much precision and industriousness: it was a joke, a manipulation. They were false sutures. It was not the voice of Gibbon that spoke on those pages, but another, superimposed voice. And what that voice said was very different from what the English author had intended. I sat at the desk Jonathan had left. I wanted to bury myself in reading those pages that Gibbon would have never recognised, though they were his own words, his own ideas cut in half and jumbled in such a grotesque way, just like many days of the Roman Empire must have been.[16]

Jonathan's cutting up of pages from Gibbon's book and reassembling them 'as if he were assembling a time bomb' has the effect that Gibbon's voice, which had imposed a narrative order, is so radically reconfigured that a new, 'superimposed' voice emerges, whose disjointed prose is considered to be 'just like many days of the Roman Empire must have been'. Precisely in its non-linearity and incoherence, the resulting representation of the past is considered more adequate than Gibbon's streamlined, teleological narrative, so that it seems as if 'through mutilation, the facts acquired a more plausible and truthful meaning. By chance or deliberate action, unexpected connections came about between characters, and events of the Roman decadence.'[17] Jonathan's notion that, 'the events were more or less true, but not the way they were told'[18] betrays a scepticism towards thick narrative,[19] which he seeks to undercut by creative rearrangement. As the same passage makes clear, Jonathan's Gibbon project (narrated in the novel's modern narrative strand) is closely linked to the novel's ancient narrative strand, which is likewise concerned with the destabilization of textual certainties: here, Mazuf lets his mysterious inner voice speak as he dictates literary texts to his scribes, thereby not merely copying but amending the texts, at times beyond recognition.[20] Mazuf expands this project and, with a team of collaborators, begins to systematically manipulate library copies of classical texts, which, as the novel imagines, might have been a pervasive practice:[21]

How many times do the clients receive texts they take to be identical copies of a particular book, but, in fact, are not? ... Who would suspect that the very seat of the censors themselves, our own Atrium Libertatis, whose magnificence has been so exalted, and which contains busts of all the greatest authors, has scrolls stored on its shelves which are filled with falsifications and sabotages, perhaps works substantially different from those written by their original authors? Let's imagine what may have happened if the imitative powers of the copyists had already taken hold. Let's imagine that in fact the contagion dates back to antiquity and that forgeries have been multiplying as each of the great libraries opened: in the library of the Palatine licensed by Augustus; the Domus Tiberianae patronised by Tiberius; in the one founded by Vespasian; or in the wealthy Ulpian Library, which Trajan built for his forum; and so on until the number of public libraries in Rome reached twenty-eight. How many works, altered, improved upon perhaps, but more likely damaged beyond repair by the copyists, do we attribute today to immortal authors? And what can we say of those we wouldn't be mistaken in calling *ventriloquus*, whose inner voice expresses itself in false writing and may come to transform itself, thanks to the skill of its imitative art, into that of a poet?[22]

This is, of course, a typically postmodern fantasy, a novelistic reification of the notoriously unstable text, which is here anachronistically imposed on an ancient context

'Or is it?' says Martial (1st *c.* AD):
'Reader, if it seems to you that something in these pages
has too much obscurity or too little Latinity,
I am not the one at fault: *the copyist damaged them*
while hastening to count out the verses for you.'[23]

Meanwhile, Jonathan's diary presents the novel's ancient narrative (as produced by the modern narrative) as at least in part motivated by a desire to explore questions of the transmission of texts and their ability to speak across time and beyond their original context:

19 November: I destroy two scenes of the tragedy. Starting again, in a lighter tone and with a new protagonist: the ventriloquist of a caustic Rome, decaying unnoticed. How does a masterpiece of Latin or Greek literature reach us? I don't mean palaeography, but the power of the many-cadenced

voice which defies destruction and reaches us intact as molecules of marble. I should read *Decline and Fall of the Roman Empire* by Gibbon, if only to cut out pieces from his chronicle and glue them back together as I please.[24]

The molecular image used here connects to the earlier thoughts on pre-narrative factoids, but combines it with the more important notion of a travelling 'voice' and its associated metaphor of the 'ventriloquist'. These two constitute the novel's main themes: Mazuf's voice enthrals his collaborators; they inextricably inscribe their voices, shaped by his voice,[25] into the works they manipulate; their story is voiced by Jonathan as a means of articulating his own thoughts and experiences; it is transmitted only orally, having been memorised by his girlfriend Vera, who recounts it – imitating Jonathan's voice – to Laurence, who records it in his own voice onto a tape recorder; yet even this recorded voice is unstable: 'Now, as I record these words that I won't recognise tomorrow (whose voice is being recorded on the tape?).'[26] The novel overall thus gives rise to the impression of an impossibility to establish solid and unambiguous correlations between voices and subjectivities, expressed most explicitly in a dialogue between Mazuf and his collaborators:

> 'Yet aren't we simply replacing the subjectivity of the author, which we deem inappropriate or tired, with another one, our own, which may be just as inappropriate or tired as the original, perhaps even more so?' Cassius had aimed straight for the waterline. 'Not at all,' said Mazuf. 'If it was all about subjectivity we wouldn't be talking about writing but, perhaps, phrasing, diction. No, the authors we are going to immerse ourselves in have written from places we all share and are common to us all. We have a right to rectify their work because they've written masterpieces which no longer belong to them.'[27]

It therefore feels distinctly like a parody of historicist wishful-thinking when Mazuf instructs some boys in the library to smell from the scrolls the original, authentic scent of their writers:

> 'Why does Pliny not smell the same as Demosthenes, or Terence not arouse the same sensation as, say, Seneca?' he would ask as the boys, their nostrils open, prepared to verify his words. 'Do you know why?' 'Tell us, Mazuf.' 'Because a true writer doesn't wash his hands to write, and the dirt from those hands, covered in semen, food, and who knows what else, even transfers itself to the copies. The scribes add nothing.'[28]

Yet consider the portrayal of Mazuf's own activities earlier in the novel:

> Mazuf chooses his alterations carefully, slipping his words in at the right
> moment . . . [I]s the copyist a stranger? Can someone who writes what others
> read consider himself uninvolved just because he hasn't thought it up
> himself? . . . Mazuf noticed a few logical errors . . . – Mazuf gave a surprising
> turn to a few paragraphs in the second dialogue and completely changed the
> ending of the third. In fact – and this took real nerve – in the third he
> invented a new speaker . . . It so happened that one of the copies to which
> Mazuf had lent his voice acquired unusual popularity at the Palatine library,
> where it was regularly requested.[29]

Is Mazuf the textual critic's worst enemy – or is he nothing but a textual critic,
a practice that in itself amounts to weaving one's own voice and notions of
perfection into a classical text? In the character of Mazuf, the production,
reception and transmission of texts coincide, and in this respect he resembles
the professional classicist who co-constitutes an already many-cadenced text
and in the process of working with it, infuses it with further voices, from
commentaries, secondary literature and, not least, her or his own.

Have a look at this essay.[30]
A more or less conventional piece of academic writing, isn't it?
As virtually all academic prose,
it juxtaposes snippets from primary literature
with snippets from scholarly literature,
glues them together with some new writing,
and thereby creates a collage
out of which a new, superimposed voice emerges
that manipulates the (perception of the) texts it engages with.

Doesn't that make me, too, a ventriloquist?

A particularly striking act of ventriloquism occurs during a display speech,
which Mazuf performs in the theatre of Marcellus. Here, he lets his mysterious
belly voice that guides his editorial work, speak in public. The content of this
speech, as the reader learns later, was the modern part of the novel's narrative:
a reception of modernity in antiquity, as it were. 'He had even plagiarised
posterity, poets who had not even been born! Such was Mazuf's boldness.'[31] The

subsequent description of the ancients' struggle to make sense of the intruding modern narrative in their own terms derives its poignant defamiliarizing effect precisely from the novel's inversion of the conventional direction of reception criticism. By the same token, the novel demonstrates here how new perspectives, readings and modes of engagement become possible, as soon as compulsory adherence to chronological linearity, genealogical development, and 'the reproductive order of things' is taken out of the equation.[32]

> *. . . which is just the sort of thing*
> *the juxtapositions of diachronic comparative literary enquiry,*
> *subsuming (inter alia) reception studies,*
> *enable us to do . . .*

Mazuf, for one, defends his anachronistic performance by arguing:

> 'Friends, fellow booksellers, I have appropriated nothing . . . This tragedy, this story I told at the Marcellus theatre belongs to us all. Voices flow in a limitless space, coming and going from places which are not anchored in time . . . They only need a belly to be born from.'[33]

This endorsement of free-floating voices that momentarily occupy stories is present at all levels of the novel and is most poignantly put in the metaleptic opening of the ancient narrative: 'Here for example is Mazuf. Mazuf's story is ours, so let's take possession of it before anyone else.'[34]

Jeremy Reed grabs another story. In his novel, chapters alternate between the reign of emperor Heliogabalus in Rome and the experiences of graduate student Jim, who writes a PhD thesis on Heliogabalus at King's College London. As Reed states in the introduction to his book, the novel 'is aimed at giving Boy Caesar another bite at the apple'.[35] This is also Jim's motivation, who refers to his thesis as 'his work of recreating a post-biological afterlife for Heliogabalus'.[36] Yet he soon realizes: 'I find myself writing a defence of an emperor who has to all purposes become a fiction.'[37] The scarce and heavily biased source material triggers reflections on the limitations of traditional scholarship:

> He wondered about the process of reading and what sort of access it provided as a tool to jump across centuries and handle blocks of deconstructed time. That Heliogabalus had become a fiction, a character in part invented by his biographers, was clear to Jim from reading the contradictions inherent in

the works of Lampridius, Cassius Dio and Marius Maximus ... Jim chewed
on the notion of history as continuous fiction ... If he was to retrieve
Heliogabalus from a past to which he had no proper access, then it was
necessary in recreating him to make him real. In writing about his subject he
would have to earth him in the London milieu in which he worked and lived.
That way he hoped to get a better purchase on the youthful emperor he was
reincarnating for the purpose of his dissertation.[38]

This 'rehabilitation' of Heliogabalus 'in contemporary terms' is not an arbitrary
decision, but based on the axiom that '[n]obody to his mind could relate to a
past that wasn't in some way linked to the present'.[39] This principle may strike
fear and trembling into the historicist mind but

> 'What is the value
> of going to the trouble
> of remembering that past
> which cannot become a present?'[40]

Jim's PhD supervisor is sympathetic to his approach: past and present
historiography are equally deemed to be imagination-dependent re-creations,[41]
and Jim draws on his ability to 'empathize' and 'identify' as means of 'dissolving
boundaries' of time.[42] Overall Jim is portrayed as acutely aware of his own
positionality and its fundamental role in *constituting* the object of his study.[43]
This allows him to actively embrace anachronism and to openly acknowledge
his revisionist agenda. Alongside this presentist perspective, Jim incorporates
further lateral connections: noting affinities with Pasolini, Rimbaud and the
theatre of the absurd, Heliogabalus is seen as a 'gay archetype' and a 'pre-pop
icon'.[44] The ancient storyline is also markedly shaped by anachronisms, notably
in the form of the widespread use of anachronistic imagery (especially from
the spheres of film,[45] information technology,[46] and genetics[47]); the marked
retrojection of modern sexual identities, their associated terminology, and the
theme of HIV/AIDS;[48] and, most importantly, Heliogabalus' portrayal as an
advocate of a radical queer individualism.[49]

All this creates a proximity of the modern and ancient storylines which
gains narrative significance as the story progresses. While working on his
Heliogabalus thesis, Jim's boyfriend Danny introduces him to a sex cult whose
masochistic saint-leader, named Slut, is ritually crucified on an orgy tree on

Hampstead Heath. Danny suggests a transhistorical connection with Heliogabalus: "'I'm not suggesting that Slut is his counterpart," Danny insisted, "but there's a resemblance in the way that psychological types recur over the centuries.'"[50] Soon enough Jim finds himself stalked by Slut, is abducted and forcibly initiated into the cult. Jim escapes to Rome, where Heliogabalus makes his presence felt again. In various stages, he moves from being a flashing image in Jim's mind,[51] to a desired presence,[52] to an actual character encountered in the flesh – now living under the name Antonio, but with total recall of his past identity.[53] The novel's surreal finale sees Antonio/Heliogabalus returning to London with Jim, where he offers himself up as a sacrificial victim to Slut and is rescued at the last minute by Jim and his friend Masako.[54] The twin narrative set-up is now doubly clarified: Antonio/Heliogabalus explains that Slut's S/M cult is a re-enactment of a scene from his own final days in ancient Rome,[55] prompting Jim to describe the scenario as a 'perfect instance of synchronicity, or the fusing of two separate incidents into a shared time ... a way of having past and present unite through a singular theme.'[56]

> ... *a description that also applies*
> *to what literary scholars do in their writings*
> *when they pair, group and juxtapose texts from different periods*
> *for thematological criticism* ...[57]
> (*Scissors and scotch tape!*)

Academic writing on literary themes can be seen as metaleptic
insofar as it dissolves boundaries
between (previously) separate narratives and chronotopes
and collapses them *ad hoc* into a shared time/space
(in the discussion of the theme).
Such academic writing, then, might be said to be
creating and operating in a decidedly queer chronotope.
As queer as the chronotope of literature itself,
subsuming both
the act of reading
(reception theory: every text is read vis-à-vis all other texts)
and the act of writing

(intertextuality: all texts are a mosaic of quotations).

It is as if literature's own peculiar historical sense

'involves a perception, not only of the pastness of the past, but of its presence;

the historical sense compels a man to write [and read] not merely with his

own generation in his bones, but with a feeling that *the whole of the literature*

of Europe from Homer and within it the whole of the literature of his own

country *has a simultaneous existence and composes a simultaneous order.* This

historical sense, which is a sense of the timeless as well as of the temporal and

of the timeless and of the temporal together, is what makes a writer traditional.

And it is at the same time what makes a writer most acutely conscious

of his place in time, of his contemporaneity.'[58]

In Reed's novel, the surrealism of this queer temporality which sees 'past and present unite in a singular theme' is not resolved; instead, Jim merely acknowledges a need to radically readjust his own thinking.[59] The novel's central metaleptic twist, however, hinges upon a scene in which Heliogabalus reads Jim's PhD thesis on Heliogabalus – a twist every bit as postmodern as

Lucian (2nd *c.* CE)

who has already been there

in *his* myth-busting interview with Homer:

'Hardly two or three days had passed before I went up to Homer the poet

when we were both at leisure, and questioned him about everything.

"Above all," said I, "where do you come from?

This point in particular is being investigated even yet at home."

"I am not unaware," said he, "that some think me a Chian, some a Smyrniote

and many a Colophonian. As a matter of fact, I am a Babylonian,

and among my fellow-countrymen my name was not Homer but Tigranes.

Later on, when I was a hostage (*homeros*) among the Greeks,

I changed my name." I went on to enquire whether the bracketed lines

had been written by him, and he asserted that they were all his own:

consequently I held the grammarians Zenodotus and Aristarchus

guilty of pedantry in the highest degree.'[60]

In Reed's case, Heliogabalus offers the following verdict on Jim's scholarly efforts: 'Most facts are errors,'[61] but, 'You've got a novel here.'[62] Having

continuously challenged the distinction between primary sources, scholarly and creative writing, the entire novel is now retrospectively reframed as the result of Jim 'deconstructing his thesis and converting it into a novel'.[63] Jim has given up on the 'dead world of academe ... a scheme of stored knowledge, pedantic footnotes and quotations shoplifted from the correct sources', whose reductive form of reason is cut off from the complexities of reality: 'reality was multi-track ... He could no longer believe in a world of commonly shared experience'.[64]

Both novels, then, pose a challenge to 'straight' classical scholarship (and do so in ways reminiscent of the methodological gauntlet thrown down by the pioneers of classical reception studies): de Juan's by illustrating the built-in instabilities of any historicist endeavour, Reed's by rejecting academic scholarship outright as inadequate for meaningful interaction with the past. Both embrace the subjective present as the only possible yet in itself unstable point from which to write; both insist that scholarly writing, too, is a form of reception (albeit one that is conventionally governed by distinctively different protocols);[65] both stage the crucial role of desire in all our engagements with the past. In this latter respect, they also echo the turn from effective to affective history in queer studies, where, according to Love, '[e]xploring the vagaries of cross-historical desire and the queer impulse to forge communities between the living and the dead ... has made explicit the affective stakes of debates on method and knowledge'.[66] Studies in queer history are often marked by a desire for and a rhetoric of recuperation, which characterize not only scholarly work in this field (given the social, political and cultural investments of individuals and communities at stake here) but also much of the studied material itself (given that much of queer history is itself deeply invested in projects of forging communities, in the present and across time, by turning to past articulations of erotic desire). Yet as discussions of the 'erotics' underlying both classical receptions and the discipline of Classics by Josh Billings and Sally Humphreys, respectively, indicate, such desires (for recuperation, communion and community) also motivate and drive engagements with the past in these fields.[67] One notes, for instance, that the desire to recuperate (from malignment, distortion, marginalization, etc.) and the concomitant rhetoric likewise permeate much classical scholarship (whatever the underlying erotics in each case may be). After all, how many books or articles are published year after

year that seek to 'reappraise' or 'do justice' to certain texts, authors, genres, periods?

Given these parallels and points of contact, how might the perspectives of queer unhistoricism inform the project of 'Deep Classics'? For one thing, in the light of Lee Edelmann's view that '[q]ueerness can never define an identity; it can only ever disturb one',[68] this sort of classical reception studies comes into view as indeed the queer Other of 'straight' Classics – not a sub-discipline of Classics, but a disturbing way of doing Classics: decidedly un-disciplined; obstructing historicism's compulsory othering of the past; critiquing tacit teleologies; and resisting genealogies of who-read-what-where that reduce reception studies to glorified source criticism.[69] The inherently oppositional dimension of queerness (at any moment in time) underscores how important it is, especially in diachronic criticism, to perpetually challenge *both* the consensus of knowingness about a consolidated present *and* reductive representations of incommensurable strands of the past. Yet, as the proponents of queer unhistoricism remind us, if we resist the homogenizing consolidation of historical moments *and also* resist the heterogenizing segregation of those engaged in encounters across time, then this leaves us not with an utterly fragmented universe of unconnected, individual voices (a key charge raised against queer theory, not least by community activists). What emerges instead is a complex and shifting web in which proximity and distance, similarity and difference are constantly (re-)negotiated and in which changing desires give rise to moments of communion and of forging community, both in and across time. Such 'queer' connections are frequently brought about by acts of bending time, productive mobilizations of anachronism, and momentary or sustained transitions from temporal normativities into osmotic temporalities – moves we often see at work when analysing 'the very pose by which the human present turns its attention to the distant human past'[70] and which Deep Classics seeks to explore.

What both the two novels and the controversy on queer unhistoricism have to offer to discussions of issues such as the ones addressed by the various essays in this volume is that they emphasize our own deep involvement in these matters and the need to bring ourselves into the picture that Deep Classics promises to open up. They squarely locate scholars and scholarly voices as active agents *inside* the 'classical tradition', which, re-imagined along queer

unhistoricist lines, might best be viewed as a permanently destabilized transhistorical continuum: a continuum that does not conscript individual voices into a linear script of historical continuity, but one within which transhistorical 'elective affinities' (those of others *and* our own) continually surface, are explored, transformed, undone, reconfigured – *and created.* In negotiating, accounting for, and productively mobilizing their own positionality within this continuum, the deep classicists can take encouragement and inspiration from Traub's kaleidoscopic vision of a new kind of historical hermeneutics:

> Poised between the options of attempting to manufacture a coherent, seamless, successionist meta-narrative or of eschewing chronological temporality altogether, the genealogy I envision would derive out of and retain the questions, issues, arguments, and contradictions of our fragmented, periodized, discontinuous research. This process of piecing together would encourage us to scrutinize the multiple points of intersection, both temporal and spatial, forged from a variety of angles, among different erotic [and other] regimes, while also requiring analysis of the ways these linkages are disrupted or cross-cut by other angles. Viewed from a wide angle but with all the rough edges showing, this genealogy of fragments would necessitate a method of historiography that is literally dialogical; it would be motivated, in both form and content, by the question: how do we stage a dialogue between one queer past and another.[71]

– and, we might add, between the classical past and our own classicist present: for with *all* classical scholarship *also* situated within the classical tradition's continuum, we are well advised to keep a queering reception eye on our own anachronistic acts of ventriloquizing and embodying the classical past.

Postlude

'This, my friends, is fiction. And the best thing about fiction is that it lets you speak the truth without knowing it's the truth; a truth which, in other circumstances, you would never defend.'

De Juan, *Este latente mundo,* 69

We all have those moments (myself, now, in this house in Cambridge, Massachusetts, recording my own voice, perhaps for no-one), moments in which we see our own actions from the outside, from a fictitious distance, and they seem inconsistent and grotesque.

Reed, *Boy Caesar*, 179

And fiction can be valuable not because it answers such questions, but because it leaves them as problems for the reader. There are no consensual answers; this is the way we live now.

Stevens, 'Normality and Queerness in Gay Fiction', 92

Notes

1 On the concept of 'historiographic metafiction', see Hutcheon (1989).
2 Traub (2013: 24).
3 Traub (2013: 29).
4 Cf. Traub (2013: 22).
5 Freccero (2007: 487).
6 Fradenburg and Freccero (1996: xix).
7 Cf. Fabian (1983); for important discussions of the implications of this perspective for the discipline of Classics, see Humphries (2002) and Humphries (2009); forthcoming work on the formation of Classics as a discipline within its nineteenth-century context by Güthenke and Vasunia promises to give us an increasingly clear picture of the foundational investments that continue to shape Classics as a contemporary collective enterprise; currently available literature that sheds light on the issues at stake here (albeit largely from a historical rather than methodological perspective) includes Marchand (1996); Gildenhard and Rühl (2003); Goff (2005); Güthenke (2008); Güthenke (2010); Güthenke (2014) and Güthenke (2015); Hallett and Stray (2009); Bradley (2010); Fox (2013) and Vasunia (2013).
8 Menon (2008: 1).
9 Menon (2006: 839).
10 Goldberg and Menon (2005: 1616).
11 Goldberg and Menon (2005: 1609).
12 Quintilian defines metalepsis in this rhetorical sense as follows: '[M]etalepsis or transumption, which provides a transition from one trope to another. It is (if we except comedy) but rarely used in Latin, and is by no means to be commended,

though it is not infrequently employed by the Greeks, who, for example, call
Χείρων the centaur Ἥσσων [both words translate as 'inferior', 'weaker'] and
substitute the epithet θοαί (swift) for ὄξειαι in referring to sharp-pointed islands
[θοός is used elsewhere to express sharpness]. But who would endure a Roman if
he called Verres *sus* ['pig'; *verres* = 'boar'] or changed the name of Aelius Catus to
Aelius Doctus ['learned'; *catus* = 'wise']? It is the nature of metalepsis to form a
kind of intermediate step between the term transferred and the thing to which it is
transferred, having no meaning in itself, but merely providing a transition. It is a
trope with which to claim acquaintance, rather than one that we are ever likely to
require to use . . . We need not waste any more time over it. I can see no use in it
except, as I have already said, in comedy.' Quoted from Quintilian, *The Orator's
Education* 8.6.37–9, trans. Butler in Quintilian (1921); see also Quintilian, *The
Orator's Education* 3.6.46 for metalepsis as a species of juridical stasis and,
especially important for what is at issue here, 6.3.52, which explains the logical
structure underlying a witticism as metaleptic according the pattern Freccero
invokes in her argument. For a helpful broader survey of notions of metalepsis in
ancient rhetoric, see Nauta (2013). Quintilian's standoffish attitude towards
rhetorical metalepsis (claim acquaintance, yes; put to use, better not) finds an echo
in Puttenham's English rendition of the term, which he refers to as a far-fetched
expression: 'Metalepsis, or the Farrefet. But the sense is much altered & the hearer's
conceit strangely entangled by the figure Metalepsis, which I call the *farfet*, as
when we had rather fetch a word a great way off than to use one nearer hand to
express the matter as well & plainer' (Puttenham 1589: 152). Traub feels similarly
ambiguous about the queer unhistoricists' appeal to metalepsis, criticizing that
'[m]etalepsis can be rhetorically powerful, but it is vulnerable to critique as a fuzzy
logic' (Traub 2013: 30).
13 Freccero (2006: 2).
14 Genette (1972: 234–5).
15 Roughly corresponding to 'weak metalepsis' in the sense of Whitmarsh (2013: 5–6).
16 De Juan (2007: 119–20).
17 'The alterations distorted the logical sequence of events. With each new truncated line
 appeared a shocking phrase, another ending, the spark of suggestion and the fragile
 depth of a mystery. It was a book with a syntax of its own: it reeled off an astonishing
 story, opened up lines of inquiry only to close them down again with blunt answers.
 In reading it one understood that history was no longer a distant nightmare, but was
 made of the details of flesh and bone . . . If one persevered, a certain coherence
 seemed to emerge from the chaos Jonathan and the girl had imposed on the book, as

if, through mutilation, the facts acquired a more plausible and truthful meaning. By chance or deliberate action, unexpected connections came about between characters, and events of the Roman decadence' (de Juan 2007: 157–8).

18 '"... He explained to me that the progress of the tragedy he was writing had a lot to do with Gibbon's book. He wanted to rearrange it. According to him, the events were more or less true, but not the way they were told." He wanted to rearrange it to find its true meaning, according to Vera. He told her that the protagonist of his story, [Mazuf,] an amanuensis from the booksellers and copyists' quarter in Ancient Rome, did something similar: he altered and re-wrote books he was meant to copy. Jonathan wanted to feel like him. *Decline and Fall* brought out in him similar feelings to those of the character who founded a secret society to alter books in the Roman libraries' (de Juan 2007: 184–5).

19 Cf. Geertz (1973).

20 'When he reads to the scribes, Mazuf uses his own voice, though he adapts it according to the voice of the text ... He only used to be a ventriloquist of the quill: the voice of his stomach speaking quietly, so quietly only his writing hand would hear. Now his voice is unfettered: it speaks to others and other hands, to different quills, which set down what it brings from an unknown source ... In the case of little known and minor authors, his work involved altering the entire text. More than a few fashionable authors ... owed him everything without realising' (de Juan 2007: 53–4).

21 Elsewhere Mazuf moreover recognizes changes made in a hand resembling, but different from, his own; see de Juan (2007: 64–5).

22 De Juan (2007: 34–5).

23 Martial, *Epigrams* 2.8.1–4 (trans. Williams); italics added.

24 De Juan (2007: 51–2).

25 Note the debate among Mazuf's collaborator-disciples as to whether they act independently or merely ventriloquize their master's voice (even without him directly influencing them); see de Juan (2007: 171).

26 De Juan (2007: 177).

27 De Juan (2007: 68).

28 De Juan (2007: 60).

29 De Juan (2007: 4–5).

30 Startled by this sudden direct address? No need to be: in fact, most academic writing is metaleptic (in Genette's sense). Compare the use of 'compare' and see the use of 'see' for two prime examples of the pervasive strategies of academic prose to draw readers into the text and to move them to participatory action, thereby undermining the illusion of the author/text offering a self-contained, self-sufficient argument.

31 De Juan (2007: 133). Compare this scenario with that in David Lodge's novel *Small World*, where Persse McGarrigle's MA thesis permutates from one about Shakespeare's influence on T.S. Eliot into one on the subject of T.S. Eliot's influence on Shakespeare and later still on the influence of T.S. Eliot on the modern reception of Shakespeare; see Lodge (1984: 51–2 and 156). Cf. Borges (1970: 236): 'The fact is that every writer creates his own precursors. His work modifies our own conception of the past, as it will modify the future.'

32 De Juan (2007: 163–6).

33 De Juan (2007: 200).

34 De Juan (2007: 2).

35 Reed (2004: 9).

36 Reed (2004: 44); see also Reed (2004: 71).

37 Reed (2004: 34); similarly Reed (2004: 44, 71).

38 Reed (2004: 30–1).

39 'What he aimed to do was to rehabilitate Heliogabalus in contemporary terms. Nobody to his mind could relate to a past that wasn't in some way linked to the present. His own work was being done in a small West End flat, the windows grilled by pollution, and the whole sonic overdrive of the city collecting as noise in his head. He was conscious, in writing terms, that his subject was involved in the variables of his biochemistry and in the fluctuations of energy he brought to the work, together with their opposite – periods of disillusionment in which work was temporarily abandoned. He had got Heliogabalus in his blood, and he liked it that way. He was confident, too, that he could coerce his supervisor into seeing things from his point of view' (Reed 2004: 71).

40 Kierkegaard (1843: 30).

41 E.g., 'Martin King was a fortysomething academic, sometimes pedantic but more often laid-back and wonderfully unconventional in his approach to history. While trying to steer Jim away from too psychological a take on his subject, he was none the less committed to treating history in part as fiction. While his business wasn't to authorize Jim to write a novel about Heliogabalus, he was sympathetic to blurring the boundaries between history and imagination ... "I've no objection to your partially inventing history," Martin replied. "I'm all for students being original. What I don't want is a purely psychological thesis. One that uses Heliogabalus as a base-line for a case history"' (Reed 2004: 78–9). Or: 'He carried on walking, his mind full of his thesis. It was odd, he reflected, to be out in London with a little-known emperor in his head and to be preoccupied with restructuring his life. It was the business of imagination to recreate history and he got off on the thought of feeding this outrageous third-century Syrian youth some of his own intransigent ideas about the nature of the individual in contemporary society. He

saw the two of them bonded by a conspiratorial pact. They were subversives, and their weird hyperlink was maintained by a sort of cyber-telepathy' (Reed 2004: 83).

42 'He wondered how Danny [his boyfriend] would like his platinum-blonde hair, a characteristic he had adopted in imitation of his subject. Jim reflected on how the faculty of empathy had been a dominant trait in him since childhood. He had to his knowledge always possessed the gift of dissolving boundaries and of being able to identify with his particular cast of heroes. This time it was Heliogabalus with whom he had chosen to bond' (Reed 2004: 32).

43 As is evident, for instance, in Reed (2004: 71) and Reed (2004: 83).

44 'For some reason he found himself linking Heliogabalus with Pasolini ... [B]oth had been murdered in public toilets and ... both had survived as metaphors for a distinct archetype in the gay world' (Reed 2004: 47); 'That Heliogabalus had managed in such a short time to stamp his individual signature on history, given that no facts were recorded of his life prior to becoming an emperor, was what had drawn Jim to his subject. Heliogabalus lived on as an image coded into the collective, a pre-pop icon who seemed somehow to have been committed to film. And the way the film rolled, scratches and all, from century to century, its contents continuing to come up, was what he found fascinating.' Reed (2004: 67); 'There was also a loose theory of his that found affinities between the youthful emperor and the subversive life and work of the schoolboy poet Arthur Rimbaud ... It mattered to Jim to make the connection, no matter how tenuous ... Jim regarded these anarchic gestures [by Heliogabalus toward the Senate] as belonging to the theatre of the absurd ... (Reed 2004: 68).

45 'The city was visible now beyond the grounds, its architecture appearing to have been assembled overnight like a filmset' (Reed 2004: 120).

46 'Crossing town was like connecting to the city's modem' (Reed 2004: 122).

47 '[N]obody could explain to him the mystery of why he, a Syrian youth who had never seen Rome, should be in line to be its future emperor. If the secret was coded in his genome, then he doubted he would ever know' (Reed 2004: 21); 'The Senate was likely to disapprove, but that was half the fun. Defiance and refusal to conform were coded into him like a blood type' (Reed 2004: 58).

48 'He despised them for their scheming. He was only too aware that the empire he was inheriting was itself responding to a tropism of decay, a sort of ideological AIDS in which a pernicious retro-virus policed a declining organism' (Reed 2004: 52); 'Most of the women invited into his company had realized quickly that he was gay and had given up any attempts at attracting his attention ... And there was the undiagnosed virus he had caught, which his doctors suspected was sexually transmitted ... He had heard it rumoured that gay people all over the empire

were going down with a form of plague said to have come out of North Africa. He hoped he was free of it but couldn't be sure' (Reed 2004: 56); 'Heliogabalus felt free to abandon himself to camp. He lay across the bed in the exaggerated pose of a fallen angel, hamming it up as a diva whose tempers left him shredded by passion' (Reed 2004: 86).

49 'He [Heliogabalus] was quick to add that "deviation originates from within that which it perverts" and that the reaction to male prostitution was invariably conditioned by the normal being hung-up on the perverse ... He spoke of society's fear of the individual and of how he as emperor had refused to compromise, no matter the opposition from the government and Army. He encouraged them to remain true to their calling, in the knowledge that even if all civilizations ended in ruin the individual was the unit which counted' (Reed 2004: 125).

50 Reed (2004: 36).

51 '[H]e kept having the mental image of a youth with bleached hair and a made-up face flash into his mind. It was the recurrence of the image, always the same and always precise in detail that made him feel unnerved. The thought crossed his mind that Heliogabalus as a psychic entity had taken it on himself to be his guide in the city' (Reed 2004: 137).

52 'He found himself against all reason hoping to encounter Heliogabalus in the crowd, half expecting that the image which had burned itself into his mind would become a reality' (Reed 2004: 141).

53 'When he caught the young man's eyes he felt zapped by the exchange. The face was exactly the same as the one that he had seen in his visions since his arrival in Rome' (Reed 2004: 171).

54 I am grateful to Ellen O'Gorman for drawing my attention to the fact that the presence of *prima facie* heterosexual female characters in both novels – Vera in de Juan's, Masako in Reed's – both of whom having romantic-erotic relationships with the (predominantly) same-sex loving protagonists, disturbs the reader's identification of these protagonists as 'uncompromisingly gay', but also renders these (superficially hetero) relationships queer. The importance of these female characters for each novel's resolution of the desire/knowledge/time complex at the heart of the two texts (and for their protagonists' developing understanding of themselves and their own position) is vaguely reminiscent of the startling appearance of Diotima in Plato's all-male *Symposium*.

55 Antonio/Heliogabalus considers Slut's crucifixion on the Heath to resemble a supposed moment in 218 CE, in which Zoticus, one of Heliogabalus' *onobeli* (particularly well-endowed lovers) with a Christ-fixation, had staged a same-sex sex-game (involving the emperor) and the entire group had got caught by patrolling soldiers; see Reed (2004: 175).

56 Reed (2004: 176).

57 Thematology (also known as 'thematics') is one of the traditional core areas of
 (especially continental European) Comparative Literature that focuses on the
 contrastive study of themes in literary texts across national borders. Classic works
 in this subfield of comparative literary studies include Bisanz (1973; 1980) as well
 as Frenzel (1980; 1988); for more recent developments in this field, see Bremond,
 Landy and Pavel (1995), Louwerse and Peer (2002) and Wolpers (2002). Though
 not always acknowledged (and theorized) as such, thematological criticism
 also features prominently in classical studies, including the study of themes
 across (all/much/some of) Greek *or* Latin literature, Greek *and* Latin literature,
 or either or both in the broader context of Near Eastern, European or global
 literature.

58 Eliot (1921: 14); my italics.

59 'The knowledge that they were . . . linked by some form of psychic network was
 still something to which Jim needed to adjust . . . He struggled with its possible
 meaning, knowing at the same time that it was necessary to make radical shifts in
 his thinking' (Reed 2004: 178).

60 Lucian, *A True Story* 2.20; trans. A.M. Harmon in Lucian (1936: 323).

61 '"Most facts are errors," Antonio said . . . He [Jim] felt embarrassed about
 presenting his version of a life to someone who claimed to have been its subject'
 (Reed 2004: 200).

62 '"You've got a novel here," said Antonio, reading the idea that had been circulating
 in Jim's mind. "My advice would be to colour it up." He put the dissertation down'
 (Reed 2004: 204).

63 Reed (2004: 203). The only earlier indicator for Heliogabalus' story being in fact
 told by Jim (other than the pervasive anachronisms mentioned above and the
 close correlation between Jim's reflections on how to engage with Heliogabalus
 and Heliogabalus' 'actual' presentation in the ancient strand of the narrative)
 consists in Jim imaging Heliogabalus – beyond the descriptions of the emperor he
 finds in ancient source texts – as leading lions on a jewelled leash (see Reed 2004:
 135), shortly followed by Heliogabalus 'actually' leading his pet panther on such a
 leash in the ancient narrative (see Reed 2004: 150). This internal link between the
 two narrative stands also creates a further external connection with decadence
 literature and art, which frequently looks to Heliogabalus as an icon of amoral
 aestheticism; one might think here in particular of the jewel-encrusted tortoise in
 Huysmans' *À Rebours* (1884), one of the key works of the Decadent movement,
 whose second chapter features a colour-coded banquet partly inspired by accounts
 of Heliogabalus' extravagant dinner parties (see *Historia Augusta*, Elag. 19). A full
 assessment of Heliogabalus' place in the imaginary of the European decadence

movement remains a *desideratum*; for a preliminary overview of such receptions, see Icks (2011: 148–223).

64 'Jim was left to wonder what his supervisor would think if he told him that he had an inside knowledge of his subject, having met the reincarnated Heliogabalus. Any such claim would put an end to his academic credibility and call into question his state of mind. Not that he any longer entertained illusions about joining the dead world of academe. On the contrary, he now saw institutions as the enemy of imagination, devoted to reason rather than the thrust of life energies that came from risking the edge. The changes that had come about in his life had taught him that reality was multi-track and that each conscious state is selected from a repertory of billions of alternative possibilities. He could no longer believe in a world of commonly shared experience . . . He had even played with the idea of deconstructing his thesis and converting it into a novel. He didn't want to be a part of a scheme of stored knowledge, pedantic footnotes and quotations shoplifted from the correct sources. He wanted to break loose and discover the real meaning of life within himself' (Reed 2004: 203).

65 Protocols which also play an important role in obscuring, precisely through their marked difference from contemporary forms of 'creative writing', the status of scholarly writing as *in fine* another form of reception.

66 Love (2007: 31).

67 See Humphreys (2002) and Billings (2010).

68 Edelmann (2004: 17).

69 In this sense, just as comparing modern literatures unsettles and challenges the ideological boundaries set up by the nineteenth-century 'national philologies', so comparing classical and modern literatures unsettles and challenges the ideological boundaries set by nineteenth-century historicist notions of Classics as *Altertumswissenschaft*.

70 See the introduction.

71 Traub (2007: 137–8).

10

Medea's Erotic Jealousy*

Giulia Sissa

'Do not read ancient authors through tinted lenses. (Women) had a role to play that is veiled to us, but that for them was the most eminent one – the active role, purely and simply. The difference between the ancient woman and the modern woman is that ancient woman demanded her due, she attacked the man. And this is also why learned love, so to speak, took refuge elsewhere.'[1] Paris 1960. This is Jacques Lacan speaking, in his seminar on *Transference*, which is in fact a commentary on Plato's *Symposium*.

'We are ashamed to admit that we feel jealousy, but we are honoured to have been jealous, and to be able to be jealous.'[2] We are still in Paris, but three centuries earlier. This is one of François de La Rochefoucauld's *Maxims*, to which we might add an even more disenchanted gloss: 'What makes the pain of shame and jealousy so acute is that vanity cannot be used to endure them.'[3] In the words of the great nineteenth-century French novelist Stendhal (who knew and quoted these maxims) in his essay *On Love*, 'To allow yourself to be seen with a great unfulfilled desire is to allow yourself to be seen as inferior, which is impossible in France if not for people who are beyond everything, and it lays oneself open to every possible joke.'[4]

These witty words will frame nicely what I would like to argue: desire in the singular – namely erotic individuation and its failure – has undergone a meandrous history, from ancient pride to modern shame. The first twist was the Stoic turn. I will focus on this early transformation. And I will do so in a fashion that diverges from current, prevailing approaches to the history of the emotions.

* The argument developed in this essay belongs to a larger historical framework: *La jalousie. Une passion inavouable*. Paris: Éditions Odile Jacob, 2015.

Classicists who study the affective experience in ancient cultures (whom I will quote in due time) tend to emphasize distance and discrepancy, between incommensurable and incompatible contexts. They do so as a matter of principle, and as a self-imposed vaccination against a capital sin: humanistic naïveté. Both history and anthropology are invoked, in order to pre-empt such error. Lexical specificity underscores the arguments: across different languages, the absence of a word is supposed to reveal the inexistence of the corresponding thing. If the term that designates an emotion is not translatable *verbatim* from English to Greek, then that particular emotion allegedly does not exist in ancient Greece. This has been said of amorous jealousy.

Good will, however, is not enough. We can be earnestly committed to relativism, and still miss the point. Language gives us access to the representations of a remote society, to be sure, but a language is not just a dictionary. More precisely: even a dictionary is made up of definitions. Definitions are articulated, interconnected utterances. People define, and redefine, what they mean. They speak and write in sentences. As soon as we become aware of this elementary evidence (which we practice anyway), we realise that, as historians, we have to pay attention to processes of codification, not merely to ready-made codes. An emotion such as erotic jealousy may be expressed, described, narrated in terms that we (scholars writing in English, today) might apply to a different emotion, namely anger. This does not mean that, in antiquity, there is no jealousy but only one emotional experience, anger, which we recognize at first sight, in our own vocabulary. It rather means that Greek culture encodes the pain of disappointment, loss and rivalry, by selecting the failure to recognise expectations of respect, reciprocity and gratitude as the most relevant aspect of such pain. Ancient anger, in erotic situations, is what we happen to call jealousy. It is up to us to see that 'our' jealousy might be less well defined. We might discover that an unfamiliar understanding of love is actually more complex, more honest, and more interesting than what religious, political and cultural stratifications offer to 'us'.

Perhaps we have learned to misrepresent something that the ancients knew better. Perhaps we have been taught never to admit, or never to confess (as La Rochefoucauld put it), the shameful emotion now called 'jealousy'. Perhaps we have grown used to denying our erotic anger.

A 'Deep Classics' perspective helps us to appreciate this engagement with the past. This means attention to manners of thinking/speaking that change either quickly and massively, or slowly and imperceptibly, via idiosyncratic intellectual choices and linguistic alterations. Decisive redefinitions can occur locally. This also means trust in the profound intelligence of past readers who were not professional scholars. Their insight is not merely a matter of curiosity in reception studies but an inspiring source of relevant questions and exemplary interpretations. We feel free to core and excavate intellectual artefacts, which do not emerge pre-packaged in monolithic 'contexts'. Of course, there are layers and surroundings, but there are also powerful agents of metalinguistic creativity. They belong in their worlds, but they also focus on what is essential. They get the point. La Rochefoucauld and Jacques Lacan help us better to understand Euripides, Aristotle and Seneca, but also what we owe to this tradition – which means, as Shane Butler reminds us, discontinuous handing over.

On erotic jealousy, La Rochefoucauld's maxim says it all – and very well. How many of us, over a lifetime, can swear never, ever, to have experienced a wave, a surge or a simple twinge of that pain which is commonly called 'jealousy'? That pain is not only excruciating, but also humiliating; not only distressing, but also embarrassing. In short: unspeakable. Something has happened to our experience of love and self-love, so that we blush to assert our erotic dignity. Over time, we have become ashamed of being jealous. More to the point: women ceased to be 'ancient', and therefore to require their due, as Lacan (who probably was thinking of Medea) put it.[5] My question is why, and when. I want not only not to silence, mitigate or embellish jealousy, but also to recognize it for what it is – without euphemisms, without denial, without kitsch stoicism. And I want to understand this experience in light of the Deep Classics perspective.

Zēlos

Jealousy has a very rich philosophical and literary history. I'm not the first to be aware of this – far from it. But I have chosen an approach that would have appeared obvious in the seventeenth century (or, at least, to connoisseurs of love) but that has become for us a blind spot: the unconfessable.

Let us travel to ancient Greece, with La Rochefoucauld and with Lacan. Let us take a linguistic path. At first glance, we will feel disoriented. The English word 'jealousy' derives from the Greek word *zēlos*. *Zēlos* means competitive emulation. This meaning has come down to us, in English, in French and in other modern languages, as the word 'zeal'. The jealous person sins, or is distinguished by, an excess of zeal. We can play the etymological game, but verbal correspondence will not be of much use to us. A language is not a dictionary, I said. To recognize relevant distinctions of meaning, we need definitions. So let us make a detour via the metalanguage. Let us open the great encyclopaedia of Greek culture, which is to say: the works of Aristotle.

In his *Rhetoric*, Aristotle offers the first systematic classification of the passions. As a specific emotion, *zēlos* figures among the unpleasant *pathēmata*. *Zēlos* is the displeasure of seeing someone other than us, but who is like us, enjoys goods that we covet, and we believe that we could obtain. We will therefore strive to emulate that lucky person. Aristotle distinguishes 'zeal' from two contiguous passions: first, *nemesan*, which means 'to feel indignation', or the suffering caused by the good fortune of another, when it seems to be undeserved; second, *phthonos*, which means envy, or the suffering we experience when confronted with the good fortune of another, simply because the other person is like us, *homoios*. The indignant person protests: 'Them? What a scandal!' The envious person complains: 'Them? And why not me?' And the zealous person shouts: 'Them? Okay, well, me too!' All these forms of displeasure when challenged by the pleasure of others relate to material, but above all symbolic, goods such as power, fame, honours, friendship. Aristotle makes not the least allusion, however, to erotic situations. We'll see why.

It is the compound *zēlotupia* that carries the meaning of intense, exclusive and combative attachment, between lovers.[6] One is struck (*tuptein*) by *zēlos*. *Zēlotupia* occurs, first of all, in a comic context. Aristophanes used the word, apparently for the first time, in *Wealth*. An old woman who is blind to the real interest which her young, and impoverished, lover has for her, is astonished that he leaves her, as soon as he ceases to have need for money. But he loved me, she exclaims! The proof is that, when she went to the Mysteries, the young man threatened to strike anyone who dared to ogle her. 'He was violently jealous!'[7] Plato uses the verb *zēlotupein* in the *Symposium*, this unusual dialogue, composed of speeches in praise of love, offered by Socrates and his

friends, among whom is Aristophanes himself. By late evening, a handsome young man, drunk and staggering, Alcibiades son of Cleinias, knocks on the door. Socrates knows him well, and is even in love with him, or so he says. And yet he mocks him mercilessly. Since he began to love him, Socrates says, Alcibiades has become impossibly possessive: every time he (old, ugly Socrates) looks at a handsome boy, or initiates a conversation with him, Alcibiades exhibits both *zēlotupia* and *phthonos*. Alcibiades makes a scene, complains Socrates, and almost comes to blows. In short, he is mad![8]

Product of the linguistic invention of Aristophanes, echoed by Plato in a dialogue, strongly marked by the witty presence of Aristophanes himself, the term *zēlotupia* stages jealousy as comic illusion. It is a ridiculous passion. A young man pretends to be possessive of an older woman; another young man fails to understand Socratic Eros. In both cases, *zēlotupein* is nothing but folly and vanity. We witness, in short, the birth of the cuckold, so dear to vaudeville. His feelings are stupid; his torments, useless; his assaults, derisory. From his first inception, the *zēlotupos* will stay in character.

In Latin, the same Greek words are simply transliterated to become *zelotypia*, *zelotypus*. They survive in literary genres such as comedy, satire, and romance. 'Do not get caught in the trap of an adulteress who pretends to be jealous, *zelotypa moecha*!', warns Juvenal, in an invective against love and women. Beware! This type of woman complains and wails, about your alleged boyfriends and mistresses, but this is only to hide her own infidelities.[9] In the *Satyricon*, a story that takes us through the labyrinth of debauched Rome by night, Petronius can only laugh ceaselessly at devoted love, and the suffering that ensues.[10]

It is therefore not this language that expresses the pain of disappointed and deceived love, a pain that is not in the least funny. When taken seriously – for oneself, as well as for others – jealousy becomes something quite different.

On the tragic scene, Medea, a woman devastated by the betrayal of a husband she loves with erotic love – to the point of killing their own children, to make him pay for his desertion – will certainly not be represented in the register of *zēlotupia*. Neither Euripides, nor Seneca attribute to her that emotion. In the elegiac poets of Rome and the *Art of Love*, jealousy is, of course, an object of discourse, but never in terms of *zēlotupia*. This also applies to Roman tragedy. In elevated genres, and especially when we stop making fun of

other people's love, we choose other words, we see something else. *Zēlotupia* acquire a positive value in the twelfth century, in the Latin of Andreas Capellanus.

Anger

This short repertory of texts and contexts might persuade us that, in ancient Greek, there never was a technical term which corresponded exactly and exclusively to the meaning of what we call 'jealousy', a wide semantic field that includes, among other specifications, 'jealousy in love'. It has been argued that, for the ancients, what matters is a conceptual network centred on honour and power, not sex.[11] Some have spoken of 'before jealousy'.[12]

I disagree. Certainly the vocabularies do not coincide. The ancient Greeks did not know one word the value of which overlaps perfectly what we call 'jealousy'. And there is no doubt that this is significant and quite remarkable. I would even say that since we can only think historically, in the plurality of languages, we have to question this 'un-translatability'. And yet: it would be a mistake to stop there. To stop at the dissonance between lexica would prevent us from understanding an even more remote and distinctive aspect of ancient erotic culture – of ancient culture, period.

This is because the ancients knew very well, to say the least, the experience of sorrow, humiliation and violence caused by the sexual inconstancy of one's beloved, a defection which puts us, against our will, in a situation of loss, rivalry and defeat. This situation, and the passionate reaction that it triggered, was a powerful narrative engine.[13] Only, in order to find the right words, and the thing, we must not look for terms that we could *translate* as 'jealousy'. The problem is not to translate, but rather to understand. We must immerse ourselves in the stories, in the poems, in the theatre and in the theories of love, in Greece and Rome. We have to recognize the agonistic pugnacity of passion, no doubt, but especially its narcissistic coherence in all those texts where it is portrayed and analysed. If we do that, then we will discover that, in ancient Greece, serious jealousy is anger.

Aristotle, as often and as we have already seen, is the best cultural interpreter. It is he who offers the most illuminating definition of Greek anger. *Orgē* is the

perception of undue offense, which one suffers, but one intends to revenge. It is a terrible pain, because we are forced to swallow humiliation at being treated as a negligible person, worth little or nothing (*oligōria*); but it is also a pleasure because it arouses in us the hope to reciprocate. Passive and active, painful and pleasant, this seemingly impulsive and thoughtless passion requires, in fact, a complex and dramatic chain of thoughts and responses. It is a paradoxically reasonable and, above all, a noble passion.[14] In Aristotle's eyes, whereas irascible individuals exaggerate, people who never get angry, whatever happens to them, deserve a stinging rebuke: they show not a placid nature, but the temperament of a slave.[15] This definition accounts for the great furors which we find in Greek poetry.

Think of the *Iliad*, whose action begins when King Agamemnon deprives Achilles of a captive woman, Briseis. Achilles is angry. As we all repeat, his *mēnis* (another term for anger) is the very first word of the poem. It is even the subject of the entire story. Now, we do not have here a romantic triangle, true. But this does not make the erotic source of Achilles' anger insignificant. It is a point of honour, of course. It is a slight. But the warrior, aristocratic and competitive context that makes this kind of insult intolerable does not obliterate the subjective tone of the pain. Certainly, young Briseis is not a pampered mistress, described in a language of sentimentality and idealism, but she is not a bronze tripod either. Achilles is furious because he loves this young woman. She was a dear wife in his heart, he said. He loved her (*philein*) passionately, with his *thumos*.[16] His *thumos* is the affective component of his personality. *Thumos* is also the source of courage and ire.

The *Iliad* offers us the very first example of the passion that is unleashed in amorous disappointment. Fifth-century Athenian tragedy deploys a wide range of scenarios and nuances on this same motif. On the tragic stage, Deianira, Clytemnestra and especially Medea 'were honoured', to paraphrase La Rochefoucauld, to proclaim their erotic dignity in the form of anger. A variety of words, *thumos, cholos, orgē*, expressed the fury of violated pride. Achilles is angry, Clytemnestra and Medea are angry.

The erotic nature of the situation, in which these women experience contempt, does not change the structure of their passion. Anger in love is still what the (Homeric and Aristotelian) Greeks understood as 'anger': the feeling of having received an affront (*oligōria*), unfair and unjustified because it denies

respect, and destroys reciprocity. It is an affront that hurts, but one that we are eager to repair. The repair will be targeted. We suffer; we will make suffer. In love as in war, that is to say, bravely and intelligently.

In tragedy, therefore, a woman who has been replaced in the marital bed by a mistress or another wife, receives an injury that she will not tolerate and which she intends to redress. Hence dejection, prostration and collapse but also lucidity, wisdom and determination to act. In Greek, in short, this is anger. Confronted with men who do not hesitate to behave as they wish, these women take up the challenge: first, they shout loud and clear that this is not right. Because, they say, there is a 'justice of the bed'. Because there is, at the heart of their *erōs*, an expectation of gratitude. These women can be dangerous – and I am not attempting here to make murderesses into models to emulate. Tragic choruses are categorical on this point: murder (voluntary or involuntary, of an unfaithful husband or innocent children) is not a good thing in itself. But these women are not bound by a prohibition against jealousy, nor, even less, are they bound to remain silent. Of their distress, they have no shame. They are not embarrassed to confess their pain. They suffer; they are proud of it.

Medea

In this world, it is not ignoble to admit to suffering. Quite the contrary. The greatest of these jealous women, Medea, lays claim to it and exalts in it: 'I am in my torments, and I do not fear that they may be insufficient.'[17] For to express her *ponoi* is to denounce the outrage, the mortification, and the injustice. It is to demand recognition from the other. On stage, the full extent of the damage is exposed: first this ravaged body, this emaciated face, this 'pale skin'; then the raw sensation, in inarticulate cries; and finally, the sentences that explain, in detail, what happens, what it is, in order to give the measure of the lived experience, in real time. Medea screams. 'Woe! Distraught, destroyed by pain, Woe is me, me! How to die?'[18] Everyone hears her voice, *phōnē*, and her cry, *boa*, and her chant, *melpein*. The theatre of Dionysus must have resonated with all of those: *Io! Aiai!*

Medea is not ashamed. Many passions shake her: anger in all its forms (*thumos, orgē, cholos*), but also fear (*phobos*); love (*erōs*); maternal affection.

Among all these passions, however, there is not the slightest trace of *zēlos,* or *phthonos,* or much less, 'shame to admit'. La Rochefoucauld's maxim would make no sense for her. In the pathetic language of ancient Greece, shame, *aischunē,* is a torment caused by 'evils' – that is to say, actions and vices, such as cowardice, flattery, weakness, greed – which bring dishonour.[19] Medea has done nothing of the kind. Instead, she plays the role of the innocent victim, proud of her pain. It is her word that drives the drama, because what she says gives weight to Jason's acts – while Jason himself seems to be unaware of the effects of what he is doing. *Her* words convey the severity of *his* act: the unforgivable gratuitousness/ungratefulness of such an act, its painful impact and, ultimately, Medea's own reasons for reacting. Here's what it is for me, she keeps on saying; these are the consequences! She has nothing with which to reproach herself, Medea, except to have loved her husband too much. Jason is the only one to blame. She has no hesitation in letting him know. Everything Medea feels goes into speech.

This speech is a cry, but also an analysis. Others, on stage, share this perception. She suffers (*paschein*) an offence, she says, which affects her honour. She is the target of an undeserved injustice: 'Jason is unfair with me, who have done him no harm.'[20] This injustice is a betrayal. And everyone agrees. 'It seems to me that by betraying your wife you do not act rightly,' the chorus comments.[21] But since she is already thinking about how to reverse her situation, through action, Medea is in no danger of losing her honour. Certainly, she has received a *hubris,* a stinging humiliation. But in admitting to it, she shows the dignity that she attributes to herself; she expresses her self-respect.

Never as in the text of Euripides can we see so well the distance that separates jealousy-as-anger, which is farsighted and courageous – in short: heroic – from *zēlotupia,* the trivial pretention Aristophanes and Plato used to make people laugh, or smile.

Laughter remains a threat, but tragedy bypasses it. Euripides goes so far as to suggest a comic response to the distress of his protagonist. Medea herself speculates: someone might make fun of me! The thought of becoming the laughingstock of her enemies, especially of her hateful rival, torments Medea, but instead of paralyzing her, it makes her act. 'But what has come over to me?' she asks, overwhelmed with anguish. 'Do I deserve their mockery, while leaving my enemies to go unpunished?'[22] Once again, she has no qualms in confessing

her anguish, for it is precisely to avoid laughter that she dares to kill. And to get to that action, she must acknowledge what she suffers. Not to take revenge: that would be ridiculous. In acting, on the contrary, she achieves her *kleos*, her heroic glory.

The 'total bastard', the coward without virility and without shame, he who reaches the height of infamy (in the words of the king of Athens, Aegeus) is Jason. Lucid, straightforward and dignified, Medea interprets to perfection this double emotion – passive and active, painful and pleasant, positive and negative – that anger is in Greek: desire for revenge, in the consciousness of having been insulted. Her 'jealousy' has no other name but anger – the passion of warriors and kings, the noble response to misfortune.

In Athens and Corinth, in the fifth century BCE, we are in another world. Granddaughter of the Sun, a barbarian princess, a magician and a witch, Medea is not the woman next door. She is not a bourgeois, of course, but not because she would not be 'a simple jealous wife', as if the very word 'jealousy' summoned up the most conventional image of conjugality, in the nineteenth century, and as if jealousy were a trivial emotion.[23] On the contrary, Medea is heroic, because she is indeed a jealous wife – which, in Greece, was said and thought otherwise. When reading a classical text, we ought not to misidentify the emotions. It should be understood that the jealousy of the ancients was a protest against ingratitude, a call for a reaffirmation of reciprocity and dignity. In all her *kleos*, her reputation and the hope of victory, Medea is furious. This is not only legitimate, but also admirable.

To find ethical qualities in anger may seem to be inconceivable, dangerous and pre-modern. We have passed the time of vengeance; we live in societies governed by the law and respect for the freedom to love whom we want, when we want. Before we become too agitated about this, however, let us look a bit more closely at how Aristotle speaks about anger.

Whatever the degree of violence involved in the act of vengeance, what really matters is the social and emotional dialectic: I expect to be respected. I expect this, for reasons that have to do with my status, but also with my actions. Because of what I have done for the sake of a person, I am entitled to demand recognition and gratitude. Instead of receiving what I am due, I receive only contempt. I am ignored, what I hold most dear is belittled, and I am mocked. But I cannot stay still and just mope. An insult is a challenge. An obligation has

been breached. I have to get over it: my honour is at stake. For Aristotle, this is why we praise those who (while not being excessively irascible and not allowing themselves to be carried away by passion) know how to be angry as one ought to be (*dei*), following reason (*logos*). Their character is serene (*praos, atarachos*). Since they tend to forgive, you would think they lean towards indifference. But they are not indifferent. On the contrary, their virtue consists in experiencing *orgē* for good reason, against those with whom anger is reasonable, at the right time and for as long as it should.[24] Those who never get angry prove unable to meet all these requirements. They are, literally, insensitive, stupid, and slavish:

> Those who do not get angry for reasons for which one needs to be angry seem to be fools (*ēlithioi*) as well as those who do not get angry against those against whom one ought to be angry, or when necessary. Indeed, it seems that they do not feel anything (*ouk aisthanesthai*) and do not feel pain (*ou lupeisthai*). And it seems that a man who never gets angry cannot defend himself, because it seems that to be dragged through the mud, or not to worry about (the way others treat) his family is worthy of a slave (*andrapodōdes*).[25]

The man who excels in anger knows how to behave. But taking all these micro decisions – why, against whom, when, for how long – in order to become angry, as 'one ought', *dei*, is very difficult. Some incline towards too little, others towards excess. We appreciate the latter, calling them 'manly and capable of command'.[26] Between irascibility and apathy, we must identify the middle position which is virtue, but default is worse than excess. It is even ignoble.

A small surplus of anger is associated with valiant and compelling manliness. The purest kind of courage is the willingness to overcome fear and to take risks in the pursuit of what is 'beautiful', *to kalon*. The intent to be courageous, however, must be accompanied by passionate energy, *thumos*. 'Brave men act because of the beautiful, but *thumos* helps them, *sunergei*.'[27] Those who act solely in the heat of anger, *orgizomenoi*, are rather bellicose than truly brave. And yet, Aristotle concludes, 'they have something similar' (*paraplēsion d' echousi ti*) – something similar to true courage.[28] Heroic action requires 'synergy': it needs *thumos*.

To behave not like a slave, who is insensitive to pain and dignity; to allow oneself to be 'covered in mud', without flinching; to live like a manly man; to feel a passion, which contributes to the political virtue *par excellence*, courage;

to feel the passion exactly 'as it should be', so that the effect, well-tempered, becomes a virtue in itself: that is anger, in all its moral and psychological complexity. Aristotle, I will add, offers a true phenomenology of anger, and a theory of the emotions as experiences to be felt, although they hurt.

Anger leads me to action, for Aristotle, but to reach the remedial act, it is first necessary that I become aware of the offense itself. Everything starts because it appears to me that I have been slighted, and this perception causes me pain. The slight is presented to me (*phainomenē*). I recognize it as such. I wish for revenge, and that thought gives me pleasure. Consequently, it is absolutely crucial not to pretend that I feel nothing: it would be a stupid anaesthesia. It would be the worst of servilities. Indifference would prevent me from acting. It is therefore up to me to register the infringement in respect and reciprocity. I must acknowledge the fact and, above all, its painful quality. Pain triggers the dynamic of anger. Now pain is essential in Aristotelian ethics: happiness requires pleasure – the pleasure of what one ought to enjoy. This ethics also calls for an offended person to have the courage to suffer, because only the recognition of her own suffering – felt, admitted, expressed – prepares the response. To understand that this response is required, one must first take stock of the horror, without self-deception (it's nothing, I'm imagining it, I'm exaggerating, it will pass, it is ridiculous, it's useless, it is bourgeois etc.). One must then go through the sense of annihilation, until the bitter end. And finally, at the right time and the right place, one strikes.

That is why anger is a high-level and high-risk passion. It is an *aristocratic* passion.

The Stoic turn

Aristotle offers a rationalization of anger which fits perfectly what, almost a century earlier, was going on the Athenian tragic stage. Euripides' Medea does not hide the humiliation she suffered. The 'phenomenal' aspect of her pain appears in full light. She cries out loud and clear. It is as if Aristotle had extracted his theory of the passions from dramatic performance. In a very different cultural environment, Rome in the first century of our era, Seneca wrote a *Medea* in which, while following his predecessor, he profoundly

changed the character of the protagonist. As a Stoic, Seneca injected into the composition of his *Medea* his own theory of the passions, especially the principles he formulates in his monograph *On Anger*.[29]

Anger is desire for revenge. Like all strong and disturbing emotions, this desire is unforgivable. It is an error of evaluation: when angry, we give a hasty consent to a perception, instead of taking time to reflect and put what affects us into the proper light. 'Do you know how the passions are born, grow and develop?' asks Seneca. The reply is that there are different movements, from a first impulse to a wish, to a strong feeling that overrides reason.[30] A full-blown passion is nothing but a stubborn will. More specifically, will and passion are triggered by consent:

> There is no doubt that anger is roused by the appearance of an injury being done: but the question before us is, whether anger straightway follows the appearance, and springs up without assistance from the mind, or whether it is roused *with the assent of the mind* (*adsentiente*). Our (the Stoics') opinion is, that anger can venture upon nothing by itself, *without the approval of mind* (*animo adprobante*): for to conceive the idea of a wrong having been done, to long to avenge it, and to join the two propositions, that we ought not to have been injured and that it is our duty to avenge our injuries, cannot belong to a mere impulse (*impetus*) which is excited without our *will* (*voluntas*). That impulse is a simple act; this is a complex one, and composed of several parts. The man understands something to have happened: he becomes indignant thereat: he condemns the deed; and he avenges it. All these things cannot be done without his mind agreeing (*adsensus*) to those matters which touched him.[31]

Pleasure, desire, pain and fear, i.e., the basic affects that underscore all the passions, should be minimized as measured and stable sentiments, *constantiae*. We must especially beware of pain. The Stoic sage does not allow himself to be brought down. He does not yield to suffering. When it hurts, he must reason and talk himself out of what affects him. He must reach the conclusion that the apparent disaster that seems to strike him is nothing. He must come to the point of not even feeling a thing:

> Add to this that, although rage arises from an excessive self-respect and appears to show high spirit, it really is small and mean: for a man must be *inferior* to one by whom he thinks himself despised, whereas the truly great

mind, which takes a true estimate of its own value, does not revenge an insult *because it does not feel it*. As weapons rebound from a hard surface, and solid substances hurt those who strike them, so also *no insult can make a really great mind sensible of its presence*, being weaker than that against which it is aimed. How far more beautiful is it to throw back all wrongs and insults from oneself, like one wearing *armor* of proof against all weapons, for *revenge is an admission that we have been hurt*. That cannot be a great mind, which is disturbed by injury. He who has hurt you must be either stronger or weaker than yourself. If he be weaker, spare him: if he be stronger, spare yourself.[32]

Medea will have to embody, in the eyes of the spectators and/or the readers of the play, the failure of Stoic wisdom.[33] The fury (*furor*) that is ravaging her is the exact opposite of what a philosopher should experience. She has done too much on all levels: too much love, too much desire and, above all, too much pain. All her turbulence arises out of *dolor*. 'Let a heavier pain rise up! . . . Gird yourself with anger and prepare yourself for the ultimate act, with a total fury!'[34] Light is the pain that can be softened by advice: hers, on the contrary, is immense.[35] The crimes that, because of her grief, she was able to accomplish in the past were only a prelude. It was nothing more than the anger of a little girl! 'Now I am Medea!' she proclaims. Her intelligence has grown in misfortune.[36] To give heart to her endeavour, she addresses both Dolor and Ira: 'look for reasons to suffer, O Pain! You do not bring to the crime an inexpert hand. What do you reach out, O Anger, or what weapons do you plan point against the perfidious enemy?'[37] Driven from one passion to another, in a stormy tumult, she will feel love, anger, pity, suffering. 'Pity chases anger; anger, pity. Yield to pity, O Pain!'[38] But the pain does not yield, and finally: 'O Anger wherever you take me, I will follow!'[39] She stabs the first child. And, immediately after, while the anger subsides (*iam cecidit ira*), pleasure takes over.[40] She savours. But to complete the second murder, she needs one last surge of pain: two deaths are not even sufficient for her *dolor*. 'Enjoy the crime slowly, O Pain, do not be so hasty! This day is mine! We will make use of the time allotted.'[41] Murder of the second child. Extinction of pain, finally: 'It's good! That's it! I had nothing else to offer you, O Pain!'[42]

At the mercy of the forces that prevail over her, Medea is tossed by the violent waves and winds of *perturbatio*. But first and foremost, let me insist, she

suffers. *Dolor* is truly the source of her many unruly feelings. It is the suffering that requires murder, and leads her hand – not once, but twice. It is the suffering that she must 'satisfy': by 'enjoying' unhurriedly, by giving to Dolor everything he asks. Anger only precipitates the acting out. Anger is the intentional turn that suffering will take: when pain leads to a thoughtful, unstoppable plan of action – that is anger.

Medea *dolorosa* enacts *perfectly* the Stoic script of passionate disorder. Unlike an invulnerable sage, Medea wears no armour: she does feel the insult, and she agonizes. Unlike a self-assured, great mind, she acknowledges what she feels: revenge will be, indeed, a confession of how much she has been hurt. She gives her assent, and she does admit to – more precisely: she does confess – that *dolor*. Confession, the all-important notion that is inherent in the normative definitions of jealousy, emerges here.

In *On Anger*, Seneca argues that, for a Stoic, the crux of emotional experience is a preliminary moment, when we sense that we begin to feel something. Either we accept this initial premonition, or we reject it.[43] This instant is decisive. It is the time to say 'no'. Allow nothing to anger! Why? Because anger wants to take everything. Without the permission of the soul, without consent, the passions cannot take the momentum in which they consist. If we feel love, desire, hate or fear, it is because we have given our approval to a very first perception – which was a mistake. One had, therefore, a choice. Seneca's morality demands that we make that choice. It demands, more precisely, that we bury the anticipatory signals of the emotion, and that we keep them concealed and secret, as deep as possible inside of our soul.[44] It will cost arduous efforts, because anger in particular wants to explode, spreading over the whole face. Once we let it overflow outside, it dominates us. It is too late. Anger is time-sensitive.

In *Medea*, just before Medea says 'yes!' to her desire to pursue revenge, and kill the children, there is a moment when she senses that a decision is growing in her. 'My ferocious soul has decided I don't know what, inside,' she says, 'and my soul does not yet dare to confess it to itself' (*nescio quid animus ferox decrevit intus, nondum sibi audet fateri*).[45] There is an instant, uncertain, suspended, open-ended, when she still could stop – when the wise stoic man would recoil. On the contrary, Medea opts for murder. This is how she espouses the movement of anger. Passion and will, in one stubborn thrust, take over.

This is how the desire to retaliate fits the pain that is its cause: by a quasi-unconscious thought – a thought that should not be *confessed*.

So here emerges, for the very first time, the most crucial idea in the history of jealousy: the idea that this emotion is better left unspoken. There is, in erotic anger, something truly unacceptable: something we should not say.

Seneca, the philosopher, theorizes the categorical imperative to say 'no!' to passion. Fight against yourself! Stop the motion as soon as possible, from its earliest signs. Keep it all in, repress! Do not let it overflow. Clean your act! Seneca, the tragedian, puts on stage the visible, vivid, hyperbolic spectacle of the same imperative. The theatre shows how easy it would have been to resist, *earlier*; how definitely impossible it is to do so *now*. Now it is too late. Seneca, the philosopher, intimates that 'revenge is the *confession* of suffering'. It is a confession we must forestall, because we ought rather to fight (*pugnare*) the actual feeling of pain, as well as its admission. To admit is to consent, which means to approve, and, ultimately, to reinforce the feeling itself. To confess is a performative speech-act: when I confess, I do something. Seneca, the tragedian, captures Medea on the threshold, in-between, in a chiaroscuro: '*je ne sais quoi* has been decided in my soul', she hints, 'that my soul dares not confess (*fateri*) yet'. As if she could choose whether to accept this *nescio quid* or to push it deep into her soul. As if she could deny access to her conscience to this almost-nothing. Fight! Just say 'no!' And one could be saved. Not Medea, however, whose mission is to expose – in that magnifying mirror which is the stage – the failure of wisdom, for us to enjoy in horror.

The normative prose of the *On Anger* should accompany our reading of *Medea*. It is its most eloquent commentary. A remedy to the passions, Seneca claims, is the contemplation of their effects on us: on our face, on our behaviour. But we should not look at ourselves in an actual mirror, as some would recommend. The appropriate 'mirror' is literature and, therefore, his own theatre.[46] The dilemma of passion – to consent, or not to consent – comes to life there, staged and magnified, in extra-large scale.

Later, as La Rochefoucauld will claim, we became 'ashamed to confess' jealousy, an embarrassing passion which hurts our vanity because it exposes our inferiority. Modern jealousy will be something very different from ancient anger: it will cease to be noble and formidably effective, and be perceived, on the contrary, as mere impotent rage. And women will learn to blush, instead of

claiming their due. This transformation started in Rome, on the stage of Stoic theatre, where the emotions ought to be caught on the threshold, remain unspoken, and be rejected deep down.

This takes us far away from Euripides, and Aristotle. For them, the *phainomenon* was there, in the open. I suffer, I know why and I know what I want. I say it. I mean it. I'm not an idiot or a slave.

I'm jealous.

Notes

1 Lacan (2001: 44–5).

2 La Rochefoucauld (1964: 465). See Bertaud (1981).

3 La Rochefoucauld (1964: 461).

4 Stendhal (1980: 149).

5 On the paradigmatic character of Medea for Lacan, see Miller (1997).

6 Fantham (1986: 45–57).

7 Aristophanes, *Wealth* 1014–15.

8 Plato, *Symposium* 213d.

9 Juvenal, *Satires* 6.278.

10 Petronius, *Satyricon* 45.7, 69.3.

11 Brisson (1996: 13–34).

12 Konstan and Rutter (2003); Konstan (2006).

13 On the importance of focusing on the situation, not merely the word, and for a fruitful reading of a wide corpus of texts: Pizzacaro (1994); Sanders (2014).

14 Aristotle, *Rhetoric* 2.2.

15 Aristotle, *Nicomachean Ethics* 4.5.

16 Homer, *Iliad*, 9.336–42: ἄλοχον θυμαρέα ... ἐκ θυμοῦ φίλεον.

17 Euripides, *Medea* 334. Out of the vast scholarship on Medea, see Euripides (2012); Seneca (2014); Boedecker (1991); Clauss and Johnston (1997: in particular John Dillon and Martha Nussbaum, on tragedy and philosophy); Bodei (2011); Stuttard (2014). See also: Artaud (2007).

18 Euripides, *Medea* 96–7.

19 Aristotle, *Rhetoric* 2.6.

20 Euripides, *Medea* 692.

21 Euripides, *Medea* 578; see also 17, 489, 778.

22 Euripides, *Medea* 1049–50; see also 381–3, 404–6, 797.

23 Dupont (2000: 5).

24 Aristotle, *Nicomachean Ethics* 4.5.
25 Aristotle, *Nicomachean Ethics* 4.5.
26 Aristotle, *Nicomachean Ethics* 4.5.
27 Aristotle, *Nicomachean Ethics* 3.8.
28 Aristotle, *Nicomachean Ethics* 3.8.
29 Fillion-Lahille (1984).
30 Seneca, *On Anger* 2.4.
31 Seneca, *On Anger* 2.1.3–6; cf. 2.3.
32 Seneca, *On Anger* 3.5.6–7.
33 On the philosophical ground of Seneca's *Medea*, see Müller (2014). See also Staley (2010).
34 Seneca, *Medea* 49–52.
35 Seneca, *Medea* 155.
36 Seneca, *Medea* 907–10.
37 Seneca, *Medea* 914–17.
38 Seneca, *Medea* 943–4.
39 Seneca, *Medea* 953.
40 Seneca, *Medea* 991–2.
41 Seneca, *Medea* 1016–17.
42 Seneca, *Medea* 1019–20.
43 Seneca, *On Anger* 3.10.2.
44 Seneca, *On Anger* 3.12–13.13.2.
45 Seneca, *Medea* 917–19.
46 Seneca, *On Anger*, 2.36.2–3 (objection to the use of actual mirrors); 2.35.5–6 (exhortation to the use of fictional depictions).

Ghostwritten Classics

Edmund Richardson

'The truth must be unveiled.'

The ghost of Strabo, *c.* 1880[1]

This is an unlikely story. Its protagonists are: an angel, several psychic professors, the ghost of Virgil, a levitating Victorian and at least one con artist. Who the con artist is depends on your point of view.

It is a search for the dead, set within the tangled discourses of spiritualism and classical scholarship. For many spiritualists in the nineteenth and twentieth centuries, the past could be made present once again.[2] Seneca's 'grip of death', explored by Butler in the introduction to this volume, could be broken. The dead were not lost forever – but just out of sight, enduring still. And if we know how to look, the hidden past reveals itself, the dead return, woven like a net through our world. Time becomes shallow, not deep.

Sitting amongst the mediums, listening in hope, one may find some of the most distinguished classical scholars of the nineteenth and twentieth centuries. The term 'telepathy' was coined by the classicist Frederic W.H. Myers.[3] Another classicist, Gilbert Murray, though no spiritualist, served as President of the Society for Psychical Research (SPR), and believed in his own psychic powers.[4] E.R. Dodds, Murray's successor in the Regius Professorship of Greek at Oxford, also served as President of the SPR – and conducted his own experiments. W.F. Jackson Knight, working on his translation of Virgil (one of the bestselling classical works of the twentieth century) sent queries to another classicist in South Africa, Professor T.J. Haarhoff. Haarhoff put them to the ghost of Virgil.[5] These scholars did not, by any means, share a unified set of beliefs – still less did they think of themselves as belonging to a singular movement. Yet there

are some surprising points of contact – in the same way that many spiritualists were both vocal in their differences and notable in their similarities. This chapter, in consequence, aims to take a broad perspective on the dialogues between classical scholarship and spiritualism, highlighting points of contact, in salons and jumbled archives, where a plaster hand sits atop a pile of scholarly papers. It will focus on the heyday of spiritualism, in the later nineteenth century, with a brief consideration of the echoes left by those discourses in twentieth-century classical scholarship. This is uncommon ground, where normal laws of time and history do not apply: a space occupied by magicians, mediums and professors, jostling uneasily together.

This jostling dialogue shaped Classics and spiritualism alike. The ancient world of the spiritualists was, particularly in the last decades of the nineteenth century, in dialogue with the ancient world of classical scholars, each speaking to the other, and being shaped by the other. The scholarly idea of a metaphorical conversation with the dead could – and very often did – become indistinguishable from the spiritualist idea of a literal conversation with the dead. Classics became a ghost-written discipline.

If this was a discourse marked by an almost limitless sense of possibility, it was also one marked by uneasiness and fragility, forever on the brink of collapse, forever under attack. Where scholars often fell hard for spiritualism, magicians did not. Harry Houdini spent a considerable part of his life pursuing and exposing fraudulent mediums. When word reached him of Gilbert Murray's experiments, he immediately set out to debunk Murray, as well.[6] Who should be trusted? Was this a conversation completed by the dead – or a con practiced by the living? In the collisions between spiritualism and the ancient past, boundaries became unstable: between history and pseudo-history, high and low, researcher and con-artist, between Professor Murray (Regius Professor, scholar supreme) and Professor Anderson (The Wizard of the North, magician supreme).

The memory of an angel

Now, don't, sir! Don't expose me!
Just this once! This was the first and only time, I'll swear, –
Look at me, – see, I kneel, – the only time,

I swear, I ever cheated, – yes, by the soul
Of Her who hears – (your sainted mother, sir!)
All, except this last accident, was truth.[7]

The dead walked the streets during the golden age of spiritualism, summoned from beyond the grave to appear in 'spirit photographs', to give testimony through mediums, to levitate tables – even to pick up paintbrushes. Figures from the ancient world were frequent visitors to the séance-rooms of America and Britain.[8] Spiritualism insisted that the past was not truly past. For the classicist and poet Frederic W.H. Myers, this was a promise of perfect recollection: 'I hold that all things thought and felt, as well as all things done, are somehow photographed imperishably upon the Universe.'[9] Not all spiritualists were so certain that nothing was lost forever – as Gutierrez notes, forgetfulness was 'a necessary attribute of the dead'[10] for many. But this was a universe presided over by memory: 'The interior Principle of Justice, whether you know it or not, is the ever-present "bar of God" at which you are arraigned and tried, and deathless Memory is "the accusing angel".'[11] The angel of memory stands in opposition to the irrecoverable, fragmented past; the unfathomable depths of time. It simultaneously embodies – following Butler's definitions in this volume's introduction – both the 'abyss of time' and the 'awe-inspiring presence of the distant past'. In this discourse, old and new, ancient and modern, telescope together. 'Our own thoughts are very old,' as Henry Osborn Taylor wrote. 'They have done duty in the minds of bygone men.' 'Let no one think that he has shaken off the past! We are in and of it, if we are also of ourselves. Our thoughts and the images in which we clothe them, what ancestry they trail out of a dim and ever lengthening distance, back through Rome to Greece.'[12] In the Victorian séance-room, the past was literally close enough to touch.

Of course, it did not always convince. Uncertainty and the unfulfilled – the incomplete picture, the fragment which sparks imagination – is at the heart of almost all relationships with the ancient world, as many scholars including Prins and Billings have argued.[13] Deception – whether the forged text taken as truth, or the truth mistaken for a forgery – is likewise inescapable. In the nineteenth century, even the most distinguished scholar, even the most concrete claim on absolute truth, often did not escape unscathed. As I have argued elsewhere, nineteenth century classicism was defined by fragility as much as by confidence: awash with forgeries, advancing through misdirection.[14]

Some of this trickery was rather transparent. Ann O'Delia Diss Debar, 'of many aliases, a number of husbands, and several prison terms',[15] materialized letters and pictures from beyond the grave. As one of her victims described it: 'Apelles, the Court painter to Alexander of Macedon, said in a communication: "I shall paint you medallions of Plato, Aristotle, Socrates, Pythagoras and Archimedes". All five of them came out together. There they are.'[16] Her trial – and exposure – almost brought New York to a standstill. 'Professor' Harry Archer materialized spirits from a cabinet – until one enterprising reporter seized hold of a ghostly form, and wrestled it to the ground, revealing Archer himself, with wig askew: 'Each and every "spirit" that came from his cabinet was none other than himself decked in nightshirt and whiskers or tresses, as the occasion called for ... A snow-white set of whiskers was identified as the hirsute ornaments of "Spook" E.V. Wilson, a black set as belonging to Rameses II.'[17] Equally derided were letters dictated from the spirit world by Vespasian ('I might as well introduce myself ... My name was Vespasian.')[18] and Strabo ('The truth must be unveiled').[19] Such works found no ready audience – let alone scholarly interest.

But this discourse was rather more subtle – though no less theatrical – than such abortive conjuring tricks might suggest. This chapter is not primarily concerned with the means by which ancient 'spirits' were made present ('the beards of some', remarked one photographer gloomily, 'had been carelessly adjusted'),[20] though Houdini's imitation of Murray will be unravelled. Rather, it explores the claims on scholarly, scientific and intellectual legitimacy set out by spiritualists: how the ghosts crept from séance-room to seminar-room to scholarship; how spiritualism staked out a place at the heart of intellectual culture and of classicism. These claims are not so simple to dismiss as Harry Archer's spirits, for there are no fake beards to seize hold of, but rather a Protean discourse, where frauds appear to be above-board, and scholarly enquiries appear bogus. (The only person who admits to deception, in this chapter, is a Regius Professor of Greek.)

Roger Luckhurst argues that 'dubious, esoteric areas of enquiry' need to be engaged with, in order fully to understand 'the constellated knowledges of the late Victorian era.'[21] The links between historiography and spiritualism in this period have been only partially explored, yet spiritualist periodicals routinely blended history and pseudo-history, discussion of the Oxyrhynchus papyri

and séance reports, bogus 'hieroglyphs' from Atlantis and Alexandrian scholarship.[22] These collisions between history and pseudo-history both established and undermined the boundaries of scholarly understanding:

> There is no field of knowledge that Spiritualism does not invade … This excellence of attainment under the new order of things – the interblending of spiritual and mortal existence – is, and is to be, true of all conditions of life; and the recent inventions of the photograph and the telephone, the introduction of the electric light, and the improvements in photography and telegraphy, are so many indications of the incoming tide of spiritual illumination; they are so many evidences of the new order of things, and are just as much evidences of the "descent of the spirit," as are the speeches of our trance mediums, or any other of the more definite forms of spirit communication and control. Spiritualism has passed out of the period of questioning and belief, and has entered the broader field, the limitless domain of certainty and knowledge.[23]

What can this ghostly pursuit of knowledge have to do with classical scholarship? Across the twentieth century, the legacies of spiritualism have been integral to the ways in which classical scholars have thought about the past, their relationship with it, and how it can be recovered. Recollection and misdirection are inextricably intertwined. For this, we only need to look to the after-shocks left by these Victorian discourses, to their twentieth century legacies – and find Gilbert Murray, Regius Professor of Greek at Oxford, demonstrating his psychic powers.

The ear of Professor Murray

> Who finds a picture, digs a medal up,
> Hits on a first edition, — he henceforth
> Gives it his name, grows notable: how much more,
> Who ferrets out a "medium"?[24]

In the histories of British classical scholarship, Murray's name appears in capital letters.[25] Professor, translator, public intellectual, friend of the powerful (and powerful friend), he shaped the field for decades. Throughout his life, as Nick Lowe has explored in fascinating detail, he maintained a belief in his own

psychic powers, his ability to sense the thoughts of those around him.[26] Murray participated in a series of experiments, many with friends, some with distinguished members of the British political and scientific establishment, aiming to put this uncanny skill to the test:

> In 1925 Earl Balfour, the distinguished British statesman, participated in a long series of experiments with Sir Gilbert Murray, famous scholar; Sir Oliver Lodge, the physicist, and others, in which they sought scientific proof of telepathy. Of these tests . . . Balfour said: "No extension of our knowledge of sight and hearing is going to throw the smallest light on these strange phenomena. What I urge everybody to remember is that these experiments conclusively prove that there is a wholly unknown method of traversing space between two conscious organisms."[27]

Murray never claimed that he could communicate with the dead, but in his field he was so successful that, as Lowe remarks, 'older researchers continued well into the seventies to cite the so-called Murray "experiments" as the single weightiest body of evidence for telepathy yet produced.'[28] At the time, the sensation caused by the mind-reading Regius Professor was so great that it caught the attention of Harry Houdini. As Arthur Conan Doyle, a great supporter of Murray and of spiritualism, put it:

> On one occasion [Ralph] Pulitzer, the famous proprietor of the *New York World*, had been interested in the telepathic results obtained by Professor Gilbert Murray in England. Houdini dashed in, in his usual impetuous fashion, and claimed that he could duplicate them. A committee assembled in his own house, and put him to the test, they sitting on the ground floor, and he being locked up in a room at the top of the house, with the door guarded. Out of four tests he got three more or less correctly. When asked for an explanation he refused to answer, save to say that it was "scientific trickery."[29]

Houdini's 'scientific trickery' was deceptively simple: his house had been wired from top to bottom with hidden microphones, and an assistant installed at a listening post in the basement. This assistant listened to the assembled gentlemen – and passed on every whisper to Houdini, at the top of the house.[30] Murray's own method – unaided, it may be presumed, by such accessories – is still a matter of debate.

For E.R. Dodds, Murray's successor in the Regius Chair at Oxford, the unseen world was a lifelong companion. 'If I remember rightly,' he wrote, 'my

interest in the occult was first stimulated at an early age by reading a selection of Poe's tales which my mother had presented to me. But it was towards the end of my schooldays that I embarked on the serious study of psychical research.'[31] Like Murray, Dodds was heavily involved in the work of the Society for Psychical Research and was passionately committed to furthering understanding in the field. When it came to his own dealings with unseen worlds, however, Dodds took a decidedly wry approach. In his memoirs, belief and credulity, fact and fiction, are kept in tension. Even in his own experiments, he is not entirely sure what to believe:

> My best subject in those days was a lady called Mrs. F. I hypnotized her frequently against insomnia – with such success that in the end I had only to send her a postcard bearing the words "Go to sleep" and she would promptly become drowsy ... I hypnotized her one afternoon in Dublin and told her that by reciting a certain magical formula I could send her to London "in the spirit" to see what her husband was doing at that moment. I recited the formula (actually a piece of Greek poetry); she made the imaginary voyage; she brought back a report; and to my astonishment her husband certified it as correct.[32]

The ancient world plays an uneasy role in Dodds' psychic adventures. At times, it provides an intellectual framework (and historical precedent) for his investigations. At others he uses it as unscrupulously as a magician on stage, letting Greek paper over the cracks in what he calls 'my questionable dealings'[33]:

> The S.P.R. had asked me to investigate a "poltergeist" which was giving trouble in a remote and isolated farmhouse in Flintshire ... After taking notes of their evidence and inspecting the premises I was inclined to diagnose the Unseen Agency as rats in the thatch. But the old couple would have none of that ... After hours of fruitless argument I agreed reluctantly to perform an exorcism, and proceeded to recite very gravely a chorus from the *Agamemnon* in the original Greek. I promised them on my faith as an expert that this would ensure a good night's rest for all three of us, and so in fact it did.[34]

Despite (or perhaps because of) being one of the most distinguished classical scholars of the time, Dodds revelled in this piece of ancient misdirection. The investigator one day, the trickster with a convenient line of (classical) patter the next, he constructed a complex persona for himself, both scholarly and questionable – so that when he spoke of 'the reluctance of gifted mind-readers,

from Cassandra to Gilbert Murray, to exercise their gift',[35] he could do so both provocatively and with regret.

For every believer, of course, there were many sceptics. Nevertheless, unseen forces – and unseen voices – echo through the history of classical scholarship, in the twentieth century. W.F. Jackson Knight's translation of the *Aeneid* sold almost half a million copies – and was prepared in consultation with Virgil's ghost. As Wiseman has explored,[36] Jackson Knight corresponded with a colleague in South Africa, Professor T.J. Haarhoff, and Haarhoff corresponded, via séance, with Virgil. 'I managed, yesterday, to keep my appointment, *longo intervallo*, with Vergil. He came accompanied by Euripides and we had a brief preliminary talk. He sends his greetings to you … Are there any specific questions you would like me to ask him?'[37] Jackson Knight sent a number of queries on the Latin back to South Africa – and soon, Haarhoff was pleased to report that: 'He [Virgil] is much interested in your Penguin effort and praises your industry. He thinks very highly of you.'[38]

Here, truly, 'the tradition of all the dead generations weighs like a nightmare on the brains of the living',[39] so much so that the ghosts of scholars past joined Virgil in Haarhoff's séance-room:

> 'Do you know *Benjamin*?'
> Stupidly, I could only think of Benjamin Farrington.
> 'No, one who passed over some time ago.'
> 'Benjamin Jowett'?'
> As I said this I felt a confirmatory touch on my head and the control agreed.[40]

But why was this a haunted discipline? Why is it impossible to engage with much of the history of British classical scholarship without also engaging with spiritualism? Why did the ghost of Benjamin Jowett guide the pens of his successors? The roots of this uncanny dialogue can be traced back to the nineteenth century and, specifically, through a jumbled archive and a disembodied hand, to Daniel Dunglas Home.

The hand of Mr Home

Who was the fool
When, to an awe-struck wide-eyed open-mouthed

Circle of sages, Sludge would introduce
Milton composing baby-rhymes, and Locke
Reasoning in gibberish, Homer writing Greek
In noughts and crosses, Asaph setting psalms
To crotchet and quaver?[41]

In the heyday of Victorian spiritualism, a cultural moment when all the scars of time could, perhaps, be healed, Daniel Dunglas Home stood at the heart of discourse. Much has been said of him:[42] he could fly; he could hear the voices of the dead; he was a 'hypocrite of the deepest dye'[43] for Houdini and the inspiration for Browning's oozing 'Mr Sludge'; he was 'our King of mediums', for others. 'You have been floating in the air a hundred times – a thousand persons must have seen you: make them come forward and testify the truth.'[44] The nineteenth century elite – from Napoleon III to Michael Faraday – packed his séances. As he himself put it:

> People came from a distance, even from the extreme west and south of America, having seen the accounts given of me in the newspapers of the previous year. It was here that one of the Professors of the University of Harvard came and joined some friends in a rigid investigation of the phenomena, and after several sittings they published the following statement of the results of their investigations: *The Modern Wonder – A Manifesto*.[45]

Such was his skill as a medium that some scholars have argued that 'Home's prowess induced a "crisis of evidence" for scientists unable to provide empirical proof for their insistence that he was a charlatan'.[46] He was not the first, or the last, to forge connections between Classics and spiritualism, but he was arguably the most prominent, and most successful. While magicians, including 'Professor' Anderson, 'The Wizard of the North', made war on him,[47] scholars were entranced; indeed, more than a few classical scholars began to look to him for guidance – and for certainty.[48]

Home's appropriation of the ancient world was omnivorous. Classical metaphors can be found throughout his writings. When he levitated a table, an observer remarked, 'the medium was in a state of the completest muscular repose; nor, indeed, had he the toe of Hercules for a lever could he have managed this effect'.[49] This classical name-dropping can be found across nineteenth-century discourse, from politics to the burlesque stage; here, Home

is using it to advance the respectability of spiritualism, to plant a foot in the doorway of high culture for himself and his beliefs. Or rather, a hand in the doorway, for Home's séances were known for their hands – disembodied, mysterious and eager. 'The hand afterwards came and *shook hands* with each one present. I felt it minutely. It was tolerably well and symmetrically made, though not perfect; and it was *soft* and slightly *warm*. IT ENDED AT THE WRIST.'[50] A cast of Home's own hand sits in the archive of the Society for Psychical Research, in Cambridge University Library (as SPR.MS 28/972) – a yellowing, spidery, disruptive presence, next to letters from Murray, Dodds and other classical scholars, offering a provocation to any archival line between history and pseudo-history, scholarship and misdirection. As for the nature of those ghostly members, Home recorded the assertion of one séance participant: 'I should feel no more difficulty in swearing that the member I felt was a human hand of extraordinary life, and not Mr. Home's foot, that that the nose of the Apollo Belvidere [*sic*] is not a horse's ear.'[51]

But Home's engagement with the classical ran much deeper than such glib metaphors might suggest. From his 'Spiritual Athenaeum' in London – where he presided until an unfortunate court case compelled the doors to be closed[52] – he led the battle to write spiritualism into the history of the ancient world. 'When it was discovered [in ancient Greece] that only in the presence of certain persons could spirits manifest themselves, these mediums were set apart, and priesthood had its origin.'[53] His claims for ancient 'spiritualism' are nothing if not sweeping, appropriating 'as spiritual believers such giants as Homer, Hesiod and Pindar; as Alexander and Caesar; as Virgil and Tacitus; as Cicero, Seneca, Pliny, Plutarch, and a hundred more'.[54] Ancient history – for instance, the encounter between Alexander the Great and the oracle of Siwa – is rewritten as a spiritualist morality-tale. Despite Home's sweeping approach, the depth of his engagement with contemporary scholarship is striking: he discusses the work of individual scholars in detail[55] and frequently rubbishes competing mediums' claims on the ancient past. After gulping down Homer, Hesiod, Pindar and all the rest, it is no small shock to find Home scorning 'those apers of antiquity who ... have unearthed from their dusty receptacle the remaining relics of the Pythagorean system, and, clothing these with the fantasies of their own imaginations, have submitted to the notice of a bewildered world the identity-confounding chimaera of re-incarnation'.[56] Like

Dodds turning Aeschylus into flim-flam, the spectacle of Home condemning the abuse of antiquity is jarring: if this is the professor, and that is the medium, what does intellectual authority look like, and how can we recognize it with any certainty?

Home's appetite for antiquity runs parallel to spiritualist claims on legitimacy across the nineteenth century intellectual world. 'Spiritualist manipulations and subversions of scientific paradigms'[57] followed very similar paths to Home's manipulation and subversion of the paradigms of classical scholarship. As Ferguson notes, 'the links between Victorian science and spiritualism are so well established as to be virtually truistic in the scholarship on the movement'.[58] Believers occupied positions of power in virtually every field: Sir William Crookes, President of the British Association for the Advancement of Science, was an ardent spiritualist. The more prominent such voices became, the more difficult it became to tell where one discourse ended and another began, which was spiritualist and which scholarly. In an intellectual culture which privileged the fantastical and the inexplicable ('There is a lady now on exhibition who lifts 500 pounds with her teeth. Can any of our scientists tell where this power resides?'),[59] the spirit of Virgil could (and did) convince a prominent scientist of the truth of spiritualism.[60] The ghosts crept into the pages of classical scholarship. In 1893, for instance, *The Classical Review* borrowed the language of the mediums in order to understand Hesiod:

> Line 750 [of the *Works and Days*], against letting a child of twelve sit on a tomb, would not surprise a modern spiritualist. Some one sends me a copy of *Light*, containing an anecdote of a Mr. Stainton Moses. This gentleman "automatically" wrote communications from a dead lady unknown to him. She explained that he had passed her grave in a walk, hence an "occult influence." Now, as children (compare the Franciscan case in 1534, the Cock Lane Ghost, the Tedworth drummer, and many tales of Increase Mather's, in witchcraft trials, and elsewhere) are peculiarly subject to convulsive fits, attended by "rappings," and explained as "possession," this superstition may conceivably account for the warning in Hesiod.[61]

Home and his fellow mediums pushed the discourses of classical scholarship and spiritualism together, a collision that would shape the history of both fields for decades to come. Just as it could be difficult to talk about Classics without talking about spiritualism, so it became difficult to talk about spiritualism

without talking about Classics. As Gutierrez and others have explored,[62] spiritualism's (often contradictory) belief-systems, and even its language of 'telepathy' and 'psychics', were fundamentally shaped by the classical past. For that, much of the credit is due to one of Home's most ardent admirers, the classicist Frederic W.H. Myers.

The pen of Professor Myers

> There's a strange secret sweet self-sacrifice
> In any desecration of one's soul
> To a worthy end, – isn't it Herodotus
> (I wish I could read Latin!) who describes
> The single gift o' the land's virginity,
> Demanded in those old Egyptian rites,
> (I've but a hazy notion – help me, sir!)
> For one purpose in the world, one day in a life,
> One hour in a day – thereafter, purity,
> And a veil thrown o'er the past for evermore![63]

Myers – classical scholar, Fellow of Trinity College, Cambridge, founder of the Society for Psychical Research, friend of John Addington Symonds, seeker of controversies, Inspector of Schools – was a kaleidoscopic figure, even by the standards of his time. Let us meet him in Paris, taking tea with the widow of Daniel Dunglas Home.

Myers had long been fascinated by reports of Home's feats – and believed that he possessed genuine powers: 'actual excursions of the incarnate spirit from its organism',[64] as he put it. After the medium's death in 1886, Myers travelled to Paris to examine his papers and interview his widow, hoping to uncover something of Home's secrets. Above all, Myers hoped to find evidence for the continuation of the self after death, but on this, he found the evidence elusive: 'Unfortunately the record is especially inadequate in reference to Home's trances and the evidence for the personal identity of the communicating spirits. His name is known to the world chiefly in connection with the telekinetic phenomena which are said to have occurred in his presence.'[65] Myers' fascination with Home ran so deep that his work is now regarded as one

of the chief sources on the medium's exploits,[66] along with Houdini's much less charitable portrait.[67] While the classicist argued for Home's legitimacy and the importance of his work to scholarship, the magician debunked his tricks and attempted to evict him from discourse. Why did Myers find Home to be so seductive? How did the Fellow of Trinity come to sit at the feet of the proprietor of the Spiritual Athenaeum?

Myers, as scholars including Hamilton have recognized,[68] played a pivotal role in the discourses of nineteenth-century spiritualism. He brought the language and training of a classicist to his pursuit of the unseen. Credited with coining the term 'telepathy' in 1882, he invented a classical vocabulary for contemporary phenomena, translating them into Greek.[69] In true late Victorian style, he took the discourses of spiritualism – often dominated by women and by those without academic training or status – and turned them into an academic discipline, complete with (classicizing) technical vocabulary. And – like other scholars who would follow in his footsteps at the Society for Psychical Research – he re-read ancient sources in the light of modern spiritualism:

> But there is one instance, – an instance well-observed and well-attested, though remote in date, – which will at once occur to every reader. The Founder of Science himself, – the permanent type of sanity, shrewdness, physical robustness, and moral balance, – was guided in all the affairs of life by a monitory Voice, by "the Daemon of Socrates." This is a case which can never lose its interest, a case which has been vouched for by the most practical [Xenophon], and discussed by the loftiest intellect [Plato] of Greece – both of them intimate friends of the illustrious subject.[70]

Myers' spiritualism was driven by longing. For him, as noted earlier, the past was not truly past – every moment of history was within our grasp. 'I hold that all things thought and felt, as well as all things done, are somehow photographed imperishably upon the Universe, and that my whole past will probably lie open to those with whom I have to do.'[71] The dead could return to us, undamaged by the passing of time – indeed, enriched by the passing of time. For Victorian classicists coming to terms with the deeply fragmentary nature of their evidence, few promises could be more bewitching than this: nothing was lost forever. Every fragment could be repaired. Every lost text recovered. Every broken thing made whole. Time could be regained. You will gaze upon the face of Agamemnon.

The voices of the dead

And all this might be, may be, and with good help
Of a little lying shall be: so, Sludge lies!
Why, he's at worst your poet who sings how Greeks
That never were, in Troy which never was,
Did this or the other impossible great thing![72]

Nothing was lost forever: this promise was never kept. Even the most confident voices of spiritualism were always under strain. Virgil would forget his lines, the police would show up for the medium,[73] the dematerialized emeralds would be found in a coat pocket. (That last, according to some, was Daniel Dunglas Home's fate, one night in St Petersburg.)[74] Spiritualism's appropriation of antiquity was forever in doubt, but no less fundamental to contemporary intellectual culture as a result. As many scholars, notably Peter Lamont, have observed, the Victorian pursuit of 'fact' was a slippery business. In the heyday of spiritualism, Victorians were negotiating 'what counted as science and, in the process, what did not. And when facts did not fit with existing theories, the line between science and pseudo-science became more blurred'.[75]

In the hands of clumsy mediums, the ambiguities of spiritualist discourse could collapse into grotesque ghostly pageants, which left even Daniel Dunglas Home embarrassed. 'O, shades of Punch and Judy!' he remarked,[76] after one particularly slapdash séance. Yet even such performances could not shake the faith of many. Far from living in fear of the angel of memory, many have lived in longing for it; sitting in silence, listening in hope for its words, waiting for the voices of the past. Many of the scholars who pursued spiritualism so passionately also did so doubtfully, unsure what to believe and whether the ground beneath their feet was secure. For Myers:

> I cannot conclude this paper without making yet another appeal to Spiritualists, in England or elsewhere, for any evidence which they can send me bearing on this question of "spirit identity," – on the possibility of proving from the *content* of automatic [writing] messages – however given – that the mind of some departed friend has in truth inspired them … It seems to me an extraordinary thing that if, as seems clear, there are some thousands of persons in the world who do actually believe that the dead can

communicate with us by messages of this kind, these believers should apparently make so little effort either to prove or to conduct such communication . . .

I think it is possible, too, that the attitude of receptiveness, which spiritualists urge as necessary, may contribute to the attainment of proofs which, when attained, may have an objective and independent value. If so, now is the time to try earnestly to attain them, and to reinforce that alleged evidence to a continuing and ever-present dialogue between the living and the dead.[77]

It is 'receptiveness' that Myers pleads for; a 'receptiveness' in some ways little distant from contemporary ideas of 'reception': recognition completed by the listener. A past that talks back: whether through the 'ever-present dialogue between the living and the dead' or classical reception's equally seductive (and illusory) 'dialogue with antiquity'.[78] The story completed by time. The dead made whole by the living. The past forever in progress: for many spiritualists, the dead could change after death – learning, arguing, thinking through their lives and their values;[79] they were no more static than Charles Martindale's ancient text, shape-shifting as it travels through time.[80]

'It is all very well for you, who have probably never seen any spiritual manifestations, to talk as you do,' remarked Thackeray to a sceptic, after a session with Daniel Dunglas Home. 'But had you seen what I have witnessed, you would hold a different opinion.'[81] The refusal to accept the finality of the fragment and the incompleteness of the past, the desire to bridge Deep Time, has driven scholars into the arms of the mediums and, arguably, into the discourses of classical reception. Reception embodies a promise that Deep Time can be cheated, or even made into an ally: that our own mediumship of history, our own receptiveness, may bring back riches, long-buried. Yet antiquity, as Butler has noted, 'can be extraordinarily resistant to our efforts to know it'. In the collisions between Classics and spiritualism, we can see that resistance at work: both hope and fragility, longing and despair, the presence of the past and its irreparable absence, the space between nothing's lost forever, and forever lost. In these collisions, we can trace the radical subjectivity of reception: had you seen what I had witnessed (a ghostly hand, a glimpse of Homer, goings-on behind the curtain), you would hold a different opinion.

Notes

1 Roberts (1912: 306).
2 Recent key scholarship in this field includes Gutierrez (2009). For a good overview of current debates: Kontou and Willburn (2012).
3 For Myers, cf. Hamilton (2009).
4 Lowe (2007).
5 Wiseman (1992: 199).
6 Doyle (1930: 22).
7 Browning (1864: 171).
8 Richardson (2012: 23).
9 Myers (1921: 1).
10 Gutierrez (2009: 24).
11 Davis (1866: 21).
12 Taylor (1919: 2, 7).
13 Billings (2010); Prins (1999).
14 Richardson (2013).
15 *The New York Times*, 26 August 1909: 16.
16 *The New York Tribune*, 28 March 1888: 5.
17 *The Chicago Tribune*, 24 February 1892: 3.
18 Roberts (1912: 79).
19 Roberts (1912: 306).
20 *The Florida Star*, 29 August 1902: 7.
21 Luckhurst (2002: 278).
22 Cf. *Gallery of Spirit Art: An Illustrated Quarterly Magazine* (New York), August 1882: 39.
23 Cf. *Gallery of Spirit Art: An Illustrated Quarterly Magazine* (New York), August 1882: 1.
24 Browning, 'Mr Sludge, "The Medium",' in Browning (1864: 79).
25 Cf. Stray (2007).
26 Lowe's study, which this discussion is greatly indebted to, is essential here: Lowe (2007).
27 *To You* 2, no.12 (February 1936): 451.
28 Lowe (2007: 352).
29 Doyle (1930: 20).
30 For more on Houdini's methods, cf. Kalush and Sloman (2006).
31 Dodds (1977: 98).
32 Dodds (1977: 100).

33 Dodds (1977: 101).

34 Dodds (1977: 101).

35 Dodds (1977: 110).

36 Wiseman (1992).

37 Letter from Haarhoff to Jackson Knight, 24 February 1954, quoted in Wiseman (201).

38 Letter from Haarhoff to Jackson Knight, 11 March 1954, quoted Wiseman (201).

39 Marx (1898: 15).

40 Letter from Haarhoff to Jackson Knight, 29 November 1947, quoted by Wiseman (1992: 193).

41 Browning, 'Mr Sludge, "The Medium"' in Browning (1864: 197).

42 One of the most important recent studies: Lamont (2005).

43 Houdini (1924: 49).

44 Letter from Baron Seymour Kirkup to D.D. Home, 16 January 1863. Society for Psychical Research Archive, Cambridge University Library: SPR.MS 28/385.

45 Home (1864: 44).

46 Ferguson (2012: 19). This is, in particular, Lamont's position.

47 Cf. Lamont (2005: 54–73).

48 Cf. the discussion of F.W.H. Myers, below.

49 Home (1864: 113).

50 Home (1864: 94) (original formatting).

51 Home (1864: 109).

52 Cf. Lamont (2005: 171).

53 Home (1878: 2).

54 Home (1878: 6).

55 For instance, on Assyria: 'The researches of Layard and Smith, indeed, have of late greatly added to our knowledge of this antique race' (Home 1878: 7).

56 Home (1878: 11–12).

57 Ferguson (2012: 21).

58 Ferguson (2012: 19).

59 *Gallery of Spirit Art: An Illustrated Quarterly Magazine* (New York), August 1882: 15.

60 Gutierrez (2009: 57).

61 Lang (1893: 453).

62 Gutierrez (2009); Hamilton (2009).

63 Browning, 'Mr Sludge, "The Medium"' in Browning (1864: 228).

64 Myers (1918: 337).

65 Myers (1918: 319).

66 Cf. Barrett and Myers (1889).

67 Houdini (1924: 49).

68 Hamilton (2009).

69 Myers (1918: xiii–xviii).

70 Myers (1889: 538).

71 Myers, *Collected Poems*, 1.

72 Browning, 'Mr Sludge, "The Medium",' in Browning (1864: 232).

73 Cf. Richardson (2012), for one such case.

74 Houdini (1924: 44).

75 Lamont (2005: 116).

76 Home (1878: 299).

77 Myers (1888–89: 546).

78 From many potential examples: Armstrong (2005: 5): 'The classic ruptures of modernism are deeply implicated in their dialogue with antiquity.' Grafton, Most and Settis (2010: 838): 'A new dialogue with antiquity'. Martindale and Thomas (2006: 18): 'The ongoing dialogue with antiquity . . . Dante's dialogue with antiquity.'

79 Gutierrez (2009: 11–12).

80 Martindale (1993: 4–6).

81 *The Saturday Review*, 25 February 1865: 232.

Relic | channel | ghost: Centaurs in Algernon Blackwood's *The Centaur*

Mark Payne

In 1911, Algernon Blackwood published a long work of fiction about a man who discovers a lost tribe of centaurs in the Caucasus, and almost turns into one himself. H.P. Lovecraft, who considered Blackwood's 'The Willows' the greatest specimen ever composed of the species of short fiction known as the weird tale, admired *The Centaur* too, but found it hard to categorize. Is it a novel? A hypertrophic story? A very long prose poem?[1] What I mean to show in this paper is that in literature, just as in life, cladistical dilemmas may signal events of the greatest urgency for the pre-human, post-human, non-human thing that Blackwood calls Man: old man, human, Whitman, Hoffmann, German, Irishman, tribesman, spiritual man, crazy man, giddy man, man of science-man, policeman, modern man, man of vision, romantic, perfect man, man in trance, physical man, man who bid for sanity, thinking man, woman, civilized man, gentleman, beggar-man, manuscript.

'Ten men will describe in as many different ways a snake crossing their path; but, besides these, there exists an eleventh man who sees more than the snake, the path, the movement.'[2] The facts of *The Centaur* are sensational and easily stated: an Irishman named Terence O'Malley travels to the Caucasus by ship. On board ship he is introduced to a Russian man and his son, who turn out to be centaurs travelling home in human form. O'Malley follows them to the mountains of the Caucasus, where he glimpses a herd of centaurs running wild, and very nearly becomes one himself.

Blackwood develops this simple story, whose central incident – the would-be transformation – last only a few seconds, into a book length fable about writing and the interlinked fates of poetry, Nature, and the past at the threshold

of modernity. O'Malley is incapable of telling his own story; the novel is the first person account of an unnamed friend who inherits a sack of O'Malley's abandoned notebooks, and attempts to combine their failed attempts to narrativize O'Malley's experience in the Caucasus with his own memories of conversations with O'Malley about this experience.[3] He hopes that by means of these supplementary impressions the salvific content buried in the crazy pages of the notebooks can be rescued and made available to humanity at large, and so finally enable the reorientation of human sociality towards a larger form of shared life that was the project to which O'Malley had unsuccessfully devoted himself after his return from the Caucasus.

In 1800, Friedrich Kittler has argued, Nature is expressive, and the poet voices what it has to say: language is 'only a channel, the true poet only a translator'.[4] In 1900, Nature is no longer transmitting; language consequently ceases to be a channel, and is downgraded to one medium among others.[5] The figure of this de-sourcing of language is Nietzsche, the first, failed, philosopher of the typewriter, and the first 'writer and nothing more'. No longer a translator, a scribe, or an interpreter, Nietzsche in the clinic fills his notebooks with pages of writing exercises – mere writing, in its bare materiality as scratching and inscription.[6]

It is this condition that Blackwood, like other writers of the weird tale, grapples with in *The Centaur*. Almost every chapter has an epigraph which foregrounds the place of Nature in the discourse network of 1800.[7] In his abjection of O'Malley, Blackwood presents him as attuned to the wavelength of the earth, but requiring the intervention of his friend, the narrator, to transpose what he receives into the medium of writing.[8] I do not mean, however, simply to subscribe Blackwood's novel at the critical juncture of discourse networks that Kittler has described, or even to demonstrate how gamely Blackwood grapples with this critical juncture in his re-description of Nature's voice as sound, pulse, current, and other such adumbrations of the incipient contemporary communication technologies. For I think *The Centaur* makes a more provocative intervention in our understanding of discourse networks and media theory.

The linking of poet, Nature and human past in *The Centaur* is operationalized by the presence of the relic: the relic is what should no longer be present in the present, as the leftover from some prior life world, but yet, as the uncanny

persistence of what should no longer be here, it continues to message us in its own, distinctive way. The relic is a modality of communication that operates as a supervenient channel, a ghost channel, whose presence is no longer explicable according to the logic of the discourse network.

The relic makes a disguised appearance in *Discourse Networks* in the figure of magic. Kittler notes that 'magical or theological untranslatability was an ancient topos that became fashionable again circa 1900', and observes that in the contemporary discourse network magical spells or incantations appear as 'isolated, foreign bodies', where they appear alongside entire artificial languages that were deliberately created. As Kittler's own example of the latter indicates, however – a faux-Rhenish hosanna from Stefan George's 'Origins' that sounds 'süss und befeurend wie Attikas choros' – these foreign bodies may not be strays from the future at all, but rather specially marked instances of the more general phenomenon of the relic, and all the more obviously so when they are invented for their occasion so as to provide the relic with the largest arena available for communicative interpellation.[9]

How, then, does the relic interpellate us? Historical philology asserts that the remains of antiquity can only be properly encountered as what once had their place in a historical human life world, and that this life world as it is reconstructed by historical philology is the only channel on which we can properly view them. On other channels they appear staticky, blurred or impoverished, and it is only when they are reintegrated into an imagined form of life that we see them as they really are. Historical philologists operationalize the communicative modalities of the relics of historical life worlds.

In this respect, historical philology works like historical ecology, for which all forms of life are to be experienced as vestiges of the scene of their emergence. So, for example, Aldo Leopold, in 'Marshland Elegy', reflects on the crane as a relic 'of the remote Eocene':

> The other members of the fauna in which [the crane] originated are long since entombed within the hills. When we hear his call we hear no mere bird. We hear the trumpet in the orchestra of evolution. He is the symbol of our untamable past, of that incredible sweep of millennia which underlies and conditions the daily affairs of birds and men. And so they live and have their being – these cranes – not in the constricted present, but in the wider reaches of evolutionary time.[10]

Evolutionary history is a channel on which human beings watch their own deep historicity. The crane as relic, as spectral body in the life world of the present, affords the opportunity for an intimate encounter with this historicity. To hear the crane on this channel is to encounter the relic in its abiding, its perduring. It is passing us by on its journey through time as it has passed others by before us, and this is why the relic is always a figure of possibility, as well as an instantiation of loss. The relic populates our world with ghostly invitations to other ways of being together, other forms of shared life. On this channel, we see other human beings living differently with cranes, with different desires for the birds and for themselves, and their ghostly apparition summons specters of the future: other human beings who might live differently with them once again.

The relic invites us to consider the kinds of experience that once existed alongside it, but are disenacted in the present, and so invites us to intimate reflections on the desirability of possible forms of life. The special appeal of the relic emerges from the relationship between intimacy and isolation in the way that it communicates with us. Because it supervenes upon the logic of the discourse network, it is a figure of interpellation. It reconstitutes the discourse network as a modality of impoverishment with respect to itself. Theodore Roosevelt captures this affinity between historical philology and historical ecology as the ghostly revenance of the book of life:

> I do not understand how any man or woman who really loves nature can fail to try to exert all influence in support of such objects as those of the Audubon Society. Spring would not be spring without bird songs, any more than it would be spring without buds and flowers, and I only wish that besides protecting the songsters, the birds of the grove, the orchard, the garden and the meadow, we could also protect the birds of the sea-shore and of the wilderness ... How immensely it would add to our forests if the great Logcock were still found among them! The destruction of the Wild Pigeon and the Carolina Paroquet has meant a loss as severe as if the Catskills or the Palisades were taken away. When I hear of the destruction of a species I feel just as if the works of some great writer had perished; as if we had lost all instead of only part of Polybius or Livy.[11]

Sitting in a library, standing in a gallery, wading through a crane marsh, we are *moving through a ruin*; our ordinary life world is the ruin of that other, more

real, more life-like life world to which the relic invites us. The book of life is the book of life only insofar as it is also the book of death, a palimpsest underwritten by its erasures and spoilage. So centaurs, in *The Centaur*, are outcomes of the world soul in its primal phase of creativity: 'survivals of her early life', projections, emanations and self-externalizations of the Earth's consciousness that are apprehensible by human beings in the present who themselves possess some element of these *Urmenschen* by which they are able to divine their presence. O'Malley is compared to a 'faun' stranded in modernity. Relic resonates with relic, ghost calls out to ghost.[12]

The call of the *Urwelt* reaches the relics of the *Urmenschen* via a 'channel to the Earth's fair youth, a channel for some reason still unclosed'. This channel is located near the Cycladic islands – by Tinos, in fact – and when O'Malley and his companions tune themselves to its frequency, what they receive is 'a Message, a Summons, a Command that somehow held entreaty at its heart'. Its syllables are 'mothered' by the sea and air and its content is a single sound: 'Chiron!'[13] In its recoding of Nature's maternal voice as signal, channel, and noise, *The Centaur* enacts the communicative modalities of the weird tale that David Toop describes in *Sinister Resonance* under the rubric of the spectral: background vocalizations of nonhuman life that, most of the time, we successfully tune out, but to which, under certain conditions, we may become attuned, with unhappy consequence for our ordinary psychic functioning.[14]

H.P. Lovecraft's 'The Whisperer in the Darkness' is perhaps the best example of what the weird tale does with this possibility. Its opening sentence – 'Bear in mind closely that I did not see any actual visual horror at the end' – is a teaser for horrors to come that are adumbrated by the reader especially as sounds. Nathaniel Hawthorne's 'Roger Malvin's Burial' is a foundational precursor for the weird tale in this regard. A nonhuman voice guides the hapless Reuben Bourne into the forest to kill his own son, just as, in *The Centaur*, spiritual guidance by aural means is literalized in O'Malley's growing awareness as he nears his goal of 'a distinct guidance, even of direction as to his route of travel'.[15]

In the weird tale, tuning to the frequency of the non-human means death, and this is also true in *The Centaur*, where, as the psychiatrist Stahl never tires of reminding O'Malley, becoming centaur is not only an escape from civilization's demon song of terror and desolation into the de-individuation of the primal herd,[16] but also actually, literally, death: the older Russian passenger

dies on board ship, and the split second, full body experience of becoming centaur that O'Malley has when he meets him in centaur form, which unfolds in the time that it takes his Georgian guide to complete a single hand gesture, is a near-death experience from which he is able to extricate himself only just in the nick of time.[17]

What Bernie Krause, in *The Great Animal Orchestra*, calls 'geophony'[18] – the deep sonic background of earth noise that is primordially prior to animal sounds – appears in *The Centaur* as the fulfillment of a recognizable trajectory of the weird tale, in which the voice of the non-human is the agent of a lethal antipathy to human life: the vengeful spirit of the forest that manifests itself as an inner voice in Hawthorne's 'Roger Malvin's Burial', the alien life form in Lovecraft's 'The Whisperer in the Darkness', and the pagan Nature divinity of Roman Britain in Arthur Machen's *The Hill of Dreams*.

On the other hand, *The Centaur* also reaches back behind the weird tale to what Toop has called the 'preternatural hearing' of James Fenimore Cooper's wilderness novels,[19] in which there is an effort to capture not only the look of the American wilderness, but also its sound. In *The Last of the Mohicans*, in particular, Cooper defers visualization to the reader in the thematization of tracking. The miraculous rescues accomplished by Hawkeye and the Indian scouts afford a vicarious experience of what it would be like to be able to find one's way in the wilderness through visual clues thanks to the enhanced visual acuity that comes from living in, and off, the forest. Sound, on the other hand, remains the prerogative of authorial ambition – the ambition to replicate the hearing of the novel's indigenous inhabitants, for whom to hear is to encounter the source of sound without the need for a secondary visualization on the basis of sound. It is the expression of living with the forest, an attempt to body forth the 'breathing silence' of the American wilderness as the distinctive soundscape of the novel. It is here, as much as in its characterology, that *The Last of the Mohicans* realizes its author's aspirational claim that 'the business of a writer of fiction is to approach, as near as his powers will allow, to poetry'.[20]

The Centaur signals the Americanness of the Caucasus as a kind of ur-Greece in a chapter epigraph from Thoreau's *Walden*, and, more immediately, in a comparison of O'Malley's new-found guidance by Nature with the life of the American Indian.[21] Indeed, O'Malley as faun may best be understood in reference to Hawthorne's *The Marble Faun*, whose title in England was *The*

Transformation, and in whose title character Europe's deep classical past is figured with the traits of the American Indian,[22] just as the indigenous Caucasians of *The Centaur* retain possession of what was common to the American Indian and the primordial Greek.[23] A channel open to techno-archaic messaging from the primordial source of life produces dancing, the movement of animals, and the wordless understanding of early humanity, and the novel gestures towards its own openness to this connection by signaling its desire to become something other than prose.[24]

O'Malley is sure that language cannot capture a form of life that flourished before language existed, but his narrator believes he can stage 'essential inarticulateness struggling into an utterance foreign to it'.[25] One obstacle he must cope with in his realization of this ambition is his understanding that O'Malley's reintegration into primordial life involved him in an experience of time that cannot be captured in modes of human narrativity that are ready to hand. To accommodate the absence of 'climax, in the story-book meaning', he must open his prose to the eternal in shared life, like a monk 'for whose heart a hundred years had passed while he listened to the singing of a little bird'.[26] Whereas geophony is the voice of danger, biophony is what *The Centaur* gestures at in order to communicate the experience of a consciousness that has become more capacious in its destructuration. Bird song communicates the eternal of deep time through simple iteration, and the narrator's attempt to enact this possibility in a new kind of prose entails the decomposition of narrative into pictures:

He remembered, for instance, one definite picture: a hot autumn sun upon a field of stubble where the folded corn-sheaves stood; thistles waving by the hedges; a yellow field of mustard rising up the slope against the sky-line, and beyond a row of peering elms that rustled in the wind. The beauty of the little scene was somehow poignant. He recalled it vividly. It had flamed about him, transfiguring the world; he had trembled, yearning to see more, for just behind it he divined with an exulting passionate worship this gorgeous, splendid Earth-Being with whom at last he now actually moved. In that instant of a simple loveliness her consciousness had fringed his own – had bruised it. He had known it only by the partial channels of sight and smell and hearing, but had felt the greater thing beyond, without being able to explain it. And a portion of what he felt had burst in speech from his lips . . . The memory fled away. He shook himself free of it. Then others came in its

place, another and another, not all with people, blind, deaf, and unreceptive, yet all of "common," simple scenes of beauty when something vast had surged upon him and broken through the barriers that stand between the heart and Nature. Such curious little scenes they were. In most of them he had evidently been alone. But one and all had touched his soul with a foretaste of this same nameless ecstasy that now he knew complete. In every one the Consciousness of the Earth had "bruised" his own.[27]

The narrator renders O'Malley's disarticulated consciousness as an iteration of the occasions that adumbrated the connectedness he will eventually experience in the Caucasus. Rather than attempting to become sound, like bird song, in order to communicate the salvific destructuration of O'Malley's mind, the narration analogizes the experience of biophonic sound by becoming imagistic and poem-like. As the writing suggests the experience of psychic restructuring by gesturing at medial transformation, the justice of Lovecraft's observations on *The Centaur* becomes apparent: 'A close and palpitant *approach* to the inmost substance of dream … [that] works enormous havoc with the conventional barriers between reality and imagination.'[28]

The writing is an approach, not an arrival, and it is helpful to compare the thematization of non-realization in *The Centaur* with its thematization in Arthur Machen's *The Hill of Dreams*. The protagonist of that book, Lucian Taylor, moves to London in the aftermath of his geophonic interpellation by a pagan Nature divinity, where we are led to believe that he is hard at work on a masterpiece of decadent writing that will give poetic realization to his drug-fueled nocturnal rambles through the growing city of London. At his death, however, his landlady discovers a volume of writing in his room that consists of nothing but meaningless scribbles. Like Nietzsche at his writing exercises, or the 'all work and no play makes Jack a dull boy' scene at the typewriter in Stanley Kubrick's *The Shining*, this is a moment when writing is exposed as mere graphism. But in the type scene in *The Centaur*, when O'Malley's landlady discovers the sack of his notebooks,[29] the dead writer has a post mortem interpreter at hand to take on the task of turning the barely comprehensible manuscripts that result from his geophonic interpellation into a readable text. As at Delphi, transposition is a second operation that turns what would otherwise be mere graphism into communication, thereby demonstrating the reality, and the truth, of the supervenient channel.

For his interpreter, our narrator, it is the very failure of O'Malley's 'mad campaign' to convince the world of the need to change its form of life by producing a convincing account of what he experienced in the Caucasus that is the index of the genuineness of his 'blinding and unutterable Dream'. It is not the great poets, but 'especially the little poets who cannot utter half the fire that consumes them', who know 'the searing pain and passion and the true inwardness of it all'.[30] Blackwood turns the pathos of non-realization that makes the conclusion of Machen's *The Hill of Dreams* so heartbreaking into an index of the Real. O'Malley's isolation is the strandedness of the centaurs themselves as subjects and expressions of a relictualized primordial life, but the really critical point for the novel's operationalization of this life is that its apprehension no longer requires that language be understood as unmediated translation of what is seen and heard on the centaur channel. Secondary realization allows for the operation of the supervenient channel as a visionary experience that language acknowledges in trans-medial gestures but does not transmit, or translate.[31]

Nature produces the centaurs as subjects of primordial experience that instantiate its own experience of itself. This is what O'Malley is unable to do in his writing, but the gap between his experience and his writing involves the narrator in a second effort to realize what was apprehensibly present in his living voice but has not been made available in his notebooks. Hölderlin, in 'Das Belebende', poetizes that 'the idea of centaurs must be that of the spirit of a river, insofar as it makes a way and a limit, with force, on the originally pathless, outward growing earth',[32] and the narrator hits upon the same idea in his description of O'Malley's voice:

> The litter of disordered notebooks filled to the covers with fragments of such beauty that they almost seem to burn with a light of their own, lies at this moment before me on my desk. I still hear the rushing torrent of his language across the spotted table-cloth in that dark restaurant corner. But the incoherence seems only to increase with my best efforts to combine the two. "Go home and dream it," as he said at last when I ventured a question here and there toward the end of the recital.[33]

What a river makes in its passage is a bank, a strand – a reminder of its passage and a remainder of what has passed; a relic, like the luminous debris of O'Malley's writing. But a river is also a gateway to its primordial origination, if

one can force one's way back upstream, against the current. It is this question of how to inhabit the relationship between source and relic, origination and remainder that *The Centaur* wants us to tarry with. Voice and writing, stream and bank, cannot become the objects of a single cognition, and it is the impossibility of inhabiting them both at once that makes O'Malley an obstacle: both stranded and flowing, like the centaurs themselves.

The nature of the obstacle is manifested in the word that names what O'Malley underwent in the Caucasus: *At-one-ment*.[34] It is a destructured, unsayable word. O'Malley is not reabsorbed into the original, pre-expressive plentitude of primordial Nature, nor does he make good, or offer restitution for, its forgetting by human beings. By the end of the narrative, in fact, the language of plenitude begins to alternate with the language of intermittence in the description of O'Malley, as the signal of the primordial begins to give out in his person and in his writing: 'A sense of interval there was at any rate, a "transition-blank," – whatever that may mean – he phrased it in the writing.'[35]

O'Malley has already alerted the narrator to the impossibility of capturing his experience of time in the structures of novelistic temporality, and the glossing of his incomprehensible 'transition-blank', with the ordinary temporality of 'interval' acknowledges the hard core of incommunicability in the original experience that cannot be modulated into literary prose. The 'transition-blank' is interference, intermittence or blockage of the original signal, and a strong hint that the salvific remainder of the primordial that persists in isolated pockets of the modern world cannot be recovered as the basis of a new form of life actuated by the event of reception.

We lock eyes with Greece as the parting look of the primordial, the last form of Western sociality in which a trace of the human being as a form of Nature's self-externalization can yet be discerned.[36] *The Centaur* offers a number of variations on the theme of being with primordial Nature: feeling with, seeing with, growing with, sharing with.[37] But it is in its staging of a person struggling to enact his feelings for a plenitude that has been evacuated from human life that the novel really excels. O'Malley suffers with Nature through its own diminishment as the mature Thoreau would suffer with the woods of *Walden* after histories of early New England had revealed to him their pre-Columbian fullness: 'Is it not a maimed and imperfect nature that I am conversant with?'[38]

But if Blackwood has one eye on America in *The Centaur* all along, why is Greek mythology the vehicle for imagining the co-patiency of loss? The best answer, unsurprisingly, is the one that the book itself provides. As O'Malley sets off for the mountains of the Caucasus in search of the *Urwelt* whose traces in the Greek imagination are the source of its continuing attraction for Western modernity, he takes Jason as his precursor in this quest:

> Here, where the Argonauts once landed, the Golden Fleece still shone o' nights in the depths of the rustling beech woods; along the shores of that old Phasis their figures might still be seen, tall Jason in the lead, erect and silvery, passing o'er the shining, flowered fields upon their quest of ancient beauty. Further north from this sunny Colchian strand rose the peak of Kasbek, gaunt and desolate pyramid of iron, "sloping through five great zones of climate," whence the ghost of Prometheus still gazed down from his "vast frozen precipice" upon a world his courage would redeem. For somewhere here was the cradle of the human race, fair garden of some Edened life before the "Fall," when the Earth sang for joy in her first, golden youth, and her soul expressed itself in mighty forms that remain for lesser days but a faded hierarchy of visioned gods.[39]

In a sublime act of literary haunting, *The Centaur* is possessed by the Greeks' own sense of the loss of the primordial. The 'quest of ancient beauty' that Jason leads is not the search for the Golden Fleece, but the *Argonautica*, a manifestation of the Hellenistic Greeks' consciousness of the loss of naturalness in human life that Schiller acknowledges in 'On naïve and sentimental poetry' as the originary moment that embarks western sentimental consciousness on the quest for the recovery of Nature that determines the operational modalities of its reflective consciousness.[40]

O'Malley's experience is one of radical alterity to language; 'transition-blank' is a language erratic that experience leaves behind it as it pushes on, a word boulder around which the gloss of narration flows. By contrast, O'Malley's becoming-Jason – which is also Blackwood's becoming-Jason – supervenes upon this putative narrative structuration as the unaccountable experience of haunting. To be aware of the loss of plentitude, and to go in search of lost primordiality, is to be subject to haunting by prior experiences of loss in ways that are unaccountable – unnarratable – in structures of psychic modulation that are ready to hand. *The Centaur* remains true to its allegiances with German

Naturphilosophie: Nature is the ground of historical consciousness, and the loss of Greece as a historical form of human life figures the loss of the primordial whose parting glance can still be discerned in the remainders of this form of life. Yet *The Centaur* also remains true to its allegiances with the weird tale: like the Nature of the weird tale, Greece is an agent in Blackwood's story – her ghosts occupy those who look to her for guidance, and she sets them on paths of her own choosing.

The hauntology of *The Centaur* is not just imaginative and characterological, but writerly: the narrative is a reconstitution of O'Malley's incomprehensible journal entries and inspirational conversation by a narrator who has, without any reasons being given, assumed the task of transmitting O'Malley's message to the world after O'Malley's death. As O'Malley, in setting himself to receive transmissions from the primordial, is subsumed into Jason as a condition of becoming centaur, so the nameless narrator is possessed by O'Malley, and this possession is figured in Blackwood's haunted prose: as the unacknowledged citations that are the connective tissue of the *Argonautica* passage, and its haunting by the late Romantic poetry it has for some reason survived.[41]

Hauntology leaves its mark in *The Centaur* at each level of inscription; it is thematized in the becoming-centaur of O'Malley – his possession by the inoperable discourse of translation, which is then deferred to the editorial work of the narrator. And it appears as a cipher in its drifting, unassigned citations. The past imposes itself as an interpellation, an implicit instruction to suture these relics together so that they might be a permanent gateway to the past, rather than a fleeting portal wandering through the text. But this is the spectral form of life of the relic; the relic that is where we find it: 'sitting in a library, standing in a gallery, *wading through a crane marsh*, moving through a ruin'. This is *The Centaur* as Ghost Box, 'by turns joyous and naive and at other times shot through with terror or supernatural wonder. Parallel world TV soundtracks and nostalgia for an imaginary past'.[42]

Notes

1 Lovecraft (2005: 166): 'Too subtle, perhaps, for definite classification as horror-tales, yet possibly more truly artistic in an absolute sense, are such delicate

phantasies as *Jimbo* or *The Centaur*. Mr. Blackwood achieves in these novels a close and palpitant approach to the inmost substance of dream, and works enormous havoc with the conventional barriers between reality and imagination.' (From the essay 'Supernatural Horror in Literature'.)

2 Blackwood (1938: 8).

3 The division seems to point towards Blackwood himself, who suffered a brief, but traumatic inability to write in consequence of his exposure to the surpassing beauty of the Caucasus, which he visited in 1910.

4 Kittler (1990: 73).

5 Kittler (1990: 265–6).

6 Kittler (1990: 181–2).

7 Novalis features in several of these, as does Gustav Fechner's effort to reconstitute the discourse network of 1800 as psychophysics in his *The Little Book of Life After Death* (cf. Kittler 1990: 268). Schelling's *Naturphilosophie* would seem to be the ultimate point of reference for the panpsychism of *The Centaur*; see, for example, Blackwood (1938: 107–8): 'The Earth, as a living conscious Being, had known visible projections of her consciousness similar to those projections of our own personality which the advanced psychologists of today now envisage as possible.'

8 Cf. Kittler (1990: 265): 'Transposition necessarily takes the place of translation ... The logic of media may be a truism in set theory or information theory, but for Poets it was the surprise of the century.'

9 Kittler (1990: 268–9). As Kittler notes, 'the poem enacts its theme', and George delighted in enacting its enactment, even in ordinary conversation.

10 Leopold (1949: 96–7).

11 Roosevelt (1951: 948).

12 Blackwood (1938: 58–62; 107–8; 208, 259).

13 Blackwood (1938: 118–29).

14 Toop (2010: 125–78). The sound that the sleeping Russians make on board ship is 'precisely the singing cry that wind makes in a keyhole, in a chimney, or passing idly over the sweep of grassy hills'. In it there lies 'some accent of a secret, dim sublimity, deeper far than any other human sound could touch', that catches O'Malley with 'the terror of a great freedom, a freedom most awfully remote from the smaller personal existence he knew today', and he realizes that the thoughts it gives rise to in him are not his own (80).

15 Blackwood (1938: 178).

16 Blackwood (1938: 198, 262). Cf. 'They turned and circulated as by a common consent, wheeling suddenly together as if a single desire actuated the entire mass. One instinct spread, as it were, among the lot, shared instantly, conveying to each at once the general impulse. Their movements in this were like those of birds

whose flight in coveys obeys the order of a collective consciousness of which each single one is an item – expressions of one single Bird-Idea behind, distributed through all' (219).

17 Blackwood (1938: 230). The danger is different from what we were led to anticipate at the outset, where we are told only that, 'complete surrender would involve somehow a disintegration, a dissociation of [O'Malley's] personality that carried with it the loss of personal identity' (11).

18 Krause (2012: 39).

19 Toop (2010: viii).

20 Cooper (2001: 20, xxxi).

21 Blackwood (1938: 113): 'In common with animal, bird, and insect life, all intimately close to Nature, he began to feel as realities those subtle currents of the Earth's personality by which the seals know direction in the depths of a thousand-mile sea, by which the homing pigeons blaze trails through space, birds fly south, the wild bees know their pathways, and all simple life, from the Red Indian to the Red Ant, acknowledges the viewless guidance of the mother's enveloping heart. The cosmic life ran through his being, lighting signals, offering service, more – claiming leadership.' The frequency and interference of 'mother' and 'smother' connects *The Centaur* with the vocative Nature of the weird tale and its ambiguous guidance, whose roots are in the American wilderness. Cf. 217: 'He read the book of Nature all about him, yes, but read it singing. He understood how this patient Mother hungered for her myriad lost children, how in the passion of her summers she longed to bless them, to wake their high yearnings with the sweetness of her springs, and to whisper through her autumns how she prayed for their return . . .!' Nature's 'mothering heart' may produce 'smothered souls' (249–50).

22 Hawthorne (2002: 62): Donatello as faun belongs to the 'happy tribes below us'; cf. Fussell (1964: 306) on Donatello as vanishing Indian.

23 Blackwood (1938: 166): 'Among these old-world tribes and peoples with their babble of difficult tongues, wonder and beauty, terror and worship, still lay too deeply buried to have as yet externalized themselves in mental forms as legend, myth, and story. In the blood ran all their richness undiluted.'

24 Blackwood (1938: 174).

25 Blackwood (1938: 37; cf. 80, 107).

26 Blackwood (1938: 192). Strawson (2008) is exceptionally helpful on why one should not mistake narratives for identities.

27 Blackwood (1938: 223–4).

28 Lovecraft (2005: 166). My emphasis.

29 Blackwood (1938: 275).

30 Blackwood (1938: 269–70).

31 Blackwood (1938: 218): 'Standing aloof from all the rest, in isolation, *like dreams in a poet's mind, too potent for expression,* they thus knew tragedy – the tragedy of long neglect and loneliness. Seated on peak and ridge, rising beyond the summits in the clouds, filling the valleys, spread over watercourse and forest, they passed their life of lonely majesty – apart, *their splendor too remote for him as yet to share.* Long since had Earth withdrawn them from the hearts of men. Her lesser children knew them no more. But still through the deep recesses of her further consciousness they thundered and were glad ... *though few might hear that thunder, share that awful joy ...*.' My emphasis.

32 Hölderlin (2004: 721). 'Der Begriff von den Centauren ist wohl der vom Geiste eines Stromes, so fern der Bahn und Gränze macht, mit Gewalt, auf der ursprünglich pfadlosen aufwärtswachsenden Erde.'

33 Blackwood (1938: 227).

34 Blackwood (1938: 215).

35 Blackwood (1938: 206). Cf., on the dropping of a shutter across O'Malley's mind after his momentary vision, 'Only a hint remained. That, and a curious sense of interval, alone were left to witness this flash of an immense vision – of cosmic consciousness – that apparently had filled so many days and nights' (230).

36 Blackwood (1938: 106–7): 'The land toward which the busy steamer moved he knew, of course, was but the shell from which the inner spirit of beauty once vivifying it had long since passed away. Yet it remained a clue. That ancient loveliness, as a mood of the earth's early consciousness, was buried, not destroyed. Eternally it still flamed somewhere. And, long before the days of Greece, he knew, it had existed in yet fuller and more complete manifestation: that earliest, vastly splendid Mood of the earth's soul, too mighty for any existence that the history of humanity can recall, and too remote for any but the most daringly imaginative minds even to conceive. The Urwelt Mood, as Stahl himself admitted, even while it called to him, was a reconstruction that to men today could only seem – dangerous.'

37 Blackwood (1938: 14, 115, 151, 263).

38 Cited in Nicholls (2009: 4); note the operation of the channel: 'conversant with'.

39 Blackwood (1938: 166).

40 Schiller (1998: 196).

41 'Sloping through five great zones of climate' is from the suppressed stanzas of Tennyson's 'Palace of Art'. The 'vast frozen precipice' and 'Fall' are not.

42 http://www.ghostbox.co.uk/artist/artist_belburypoly.htm. Cf., on 'The Willows': http://www.ghostbox.co.uk/products/product_willows.htm.

Circulation of Spectres: Ghosts and Spells*

Davide Susanetti

1. How can we approach the classics? To which paradigm can we refer? What are we really doing in the act of reading an ancient text? Before answering these questions, let's look at two short scenes where spirits speak.

Odysseus is about to leave Circe's woodland home. It is time, his comrades remind him, to head for Ithaca. But before they set sail, Circe tells Odysseus that he must make one last journey:

> You must go to the house of Hades and fearful Persephone to ask a prophecy of the soul of Theban Teiresias, the blind seer whose mind is still sharp ... Once you have crossed the Ocean, you will find a low bank and the sacred glades of Persephone ... drop anchor and then descend into the terrible house of Hades... When you are near, dig a pit and circle it with an offering for the dead ... sacrifice a ram and a black ewe ... Many souls of the dead will gather there ... But do not let the shades of the dead come near the blood before you have questioned Teiresias ... The seer will tell you the route and the length of your journey and how you can return over the sea.[1]

Once he reaches the site, Odysseus carries out the instructions carefully. At once, a crowd of souls starts to head towards the pit:

> Women, young men, old men wracked with pain, tender brides afflicted with terrible grief, many warriors killed in battle ... their armor stained with blood: they wailed as they flocked to the pit.[2]

The first soul to step forward belongs to Elpenor, Odysseus' recently deceased companion, whose corpse lies unburied at Circe's home. As he is still unburied,

* This chapter is a revised and re-elaborated version of the first chapter of Susanetti (2014), published in Italian. I thank my publisher, Carocci, for permission to reuse that material.

his soul can speak without drinking the sacrificial victims' blood, and he asks
for full burial rites so that he can cross into the kingdom of shadows. The other
shades stay silent, as they wait for the blood that will restore their ability to talk
with the living. Odysseus catches sight of his mother among the throng.
Although his heart is breaking, he does not allow her to drink until he has
spoken to Teiresias. After the seer's soul has drunk the cruel offering, he tells
Odysseus with 'infallible' words what the future holds: the difficulties and risks
of his return, the terrible situation awaiting him on Ithaca, the slaughter of the
suitors, the final journey he must make, and his peaceful death as an old man.
Now that he has received the prophecy, Odysseus can speak to the other souls.
At last, he speaks with his mother Anticlea, who gives him news of his family
on distant Ithaca. He then meets a throng of heroes and heroines who, in the
recent or distant past, have left life on earth. Brandishing his sword, he forbids
the spirits to 'all drink at once'. He makes them line up in order, so that he may
know their names and hear their stories one at a time. Antiope and Alcmene,
Jocasta and Phaedra, Agamemnon and Achilles, all the figures of Greek legend
parade before Odysseus. Some, such as the warriors who fought at Troy, share
his past; many others come from different places and tales. The entire archive
of stories and legends, the mythological arsenal from which Greek poetry
takes its tales, comes to life in a sort of symbolic recapitulation, in a paradigmatic
catalogue of all that is memorable and worthy of celebration. Consulting
shades ties the threads of past and future, restores identities and paths, and
weds subjective events with a broader horizon of feats and genealogy. Odysseus
retraces his own history and pieces together the world to which he belongs.
Armed with this knowledge from the underworld, he can begin to head home,
become himself once more, and face his destiny. He can reveal himself as
Odysseus and become a teller of tales.

But anyone who consults the ghosts of Hades and recounts his adventures is
destined to become a ghost when his time comes. He, too, will become a shadow
who dispenses knowledge and wisdom. Homer, it is said, began the composition
of his poems by summoning Odysseus' soul from the kingdom of the dead:

> When Odysseus came back to earth, Homer asked him to recount what had
> happened at Troy. Odysseus replied that he knew and remembered everything,
> but first Homer had to reward him … by celebrating his wisdom and valour.
> Homer agreed and set about honouring his promise as best he could.[3]

Odysseus gave his account of events 'according to the truth', but he asked Homer never to mention Palamedes in his poem. Odysseus had plotted against this noble, wise hero and unjustly caused his death. He did not want his crime and infamy to be remembered:

> Do not take Palamedes to Troy; do not mention him amongst the warriors, do not say he was wise.[4]

The 'truth' about the past is given, but it is based on a deliberate omission. The gift of the stories and wisdom that Odysseus' ghost promises is conditioned by a request for complicit silence and a lie, to which the consulter acquiesces. The shade's wish and the consulter's needs meet upon the field of their own respective interests. Homer's poems were supposed to restore the image of a long-dead world, but distorted it completely. Homer's authority, and with it the authoritative wisdom that portrays the past, is based on an atrocious pact that blurs true and false. At least, this is the version in Philostratus' *Heroicus*, which was written centuries after Homer supposedly composed his poems. In the *Heroicus*, a simple vinedresser from Thracian Chersonese is visited by the ghost of Protesilaus, the first Greek warrior to fall at Troy. Protesilaus comes to the vinedresser frequently, retelling the events and facts that Homer is alleged to have falsified or embellished. The poetic 'truth' of the *Iliad* and the *Odyssey*, which in the meantime had become accredited tradition, is corrected, supplemented, or totally rewritten on the basis of the eyewitness account of another ghost. The heroes of the past, says the vinedresser, never went away; they are still here and, when they wish, they appear to men, offering signs and succouring them in their ills, adversities and daily tasks. Ghosts are real presences, although not everyone can see them or is lucky and devoted enough to receive a visit. They reveal the truth, but they may also ask for compensation from those who consult them. Ghosts may contradict one another and give conflicting versions of the same events or the same lost origins. It is the responsibility of the living to accept the conditions of this trade and to ask themselves about the nature of their desires whenever a ghost appears or is summoned. The living must also be aware that the ghost's tales may be biased or partisan.

Homer's account of Odysseus' underworld descent has often been used as a model for our relationship with the past: *à la recherche du temps perdu*. Proust

cited these Homeric lines as a metaphor of literary inspiration when he envisioned the task of writing his novel:

> Cent personnages ... mille idées me demandent de leur donner un corps comme ces ombres qui demandent dans l'Odyssée à Ulysse de leur faire boire un peu de sang pour les mener à la vie.[5]

> A hundred characters ... a thousand ideas urge me to give them body, just like those shades in the *Odyssey* who asked Ulysses to let them drink a little blood, and thus come back to life.

In a broader perspective, summoning ghosts can be equated with wisdom, and hermeneutics:

> Die *Hadesschatten* des Homer—welcher Art von Existenz sind sie eigentlich nachgemalt? Ich glaube, es ist die Beschreibung des *Philologen*.

> The *shades of Hades* in Homer—what type of existence do they truly represent? I believe that it is a description of *philology*.[6]

These words belong to Nietzsche, who deplored the inconsistent nature of the images and words of contemporary philology: 'Better the lowest serf,' he writes, paraphrasing Achilles' ghost in Homer,[7] 'than an idle reminiscence of the past.' 'Sacrifice many sheep,' notes Nietzsche by way of conclusion. Summoning ghosts involves spending an enormous amount of energy and life if it is to be effective and meaningful – a vast sacrifice that is anything but anodyne. But the 'many sheep' to which he alludes, we might maliciously suspect, may be the members of the large herd of philologists that would need to be killed in order to establish a different, more dynamic relationship with ancient times.

Ghosts will only be able to speak if they are offered blood from a time and a place unknown to them:

> The spirits we evoke demand the blood of our hearts. We give it to them gladly; but if they then abide our question, a part of us has entered into them; something alien that must be cast out, cast out in the name of truth.

So said Ulrich von Wilamowitz at a famous Oxford conference in 1908.[8] The highly respected scholar, who had written a harsh review of *The Birth of Tragedy*, in which he told Nietzsche to abandon philology for the good of science itself, recognized the need for a blood sacrifice, but he also warned of

the 'alien' element that would be required to summon the ghosts. Blood, which represented the interpreter's subjectivity and the contemporary age, is indispensible in magic, but should also be 'separate' and 'distinct' from the voices of resurrected ghosts. The objective 'truth' of a historical reconstruction may only be learned if the ghostly manifestation is separated from what it does not own. We should ask ourselves, however, whether this separation is feasible, appropriate or just plain sensible. The blood and the ghost's voice are ingredients in an alchemical experiment, the interest and productivity of which rest upon their blending and reciprocal penetration. The problem is not that we must separate alien blood from the spectre's words, but that each time we must observe the nature of the blood, the summoning ritual and their effects upon the immediate circumstance into which the ghost is called. One must have acquired a great deal of experience, says Nietzsche, to be able to face ancient ghosts.[9] 'Experience' of the 'present' and of 'life' combines with a special brand of consciousness that prevents us from taking a metaphor literally, from flattening a symbol or, worse still, confusing the truth with personal interest. This 'experience' prevents us from mistaking for 'science' both the comforting construction of a bourgeois world and the exact opposite discourse which, imprisoned by the same dialectics, pretends to turn this construction on its head, but only reproduces its frame. The ghosts of philology, the phantoms of psychoanalysis, the shades of anthropology are parts of the same movement and the same misunderstanding that demands for itself the title of reliable objectivity.

Odysseus encounters the shades after he has suffered at length and overcome many challenges. Circe, daughter of the Sun, told him how to summon the ghosts, and he does so with a precise goal and an established order. He does not know what they will tell him, but he has a clear direction and objective in mind. The ritual is not an end-in-itself but is designed to reintegrate Odysseus into society and help him win back his kingdom. It is a test within a test that involves initiation into death. Odysseus does not yield to emotion and love, just as he does not yield to fear. With his sword in hand, he wards off his mother's ghost until Teiresias has given him the instructions he needs to continue his journey. But, even after this decisive step, the numerous ghosts he encounters become building blocks in his construction of meaning and belonging and in his return to a heroic universe after a decade of dark,

anonymous wanderings. The past is an archive and a catalogue, but it becomes relevant only because of what it generates and the essential need it satisfies.

Ghosts are different from the living: they are 'others'. This statement is as obvious as it is banal. But rendering this 'otherness' absolute, i.e., establishing that the void is unbridgeable and the separateness permanent, confirms their insignificance and will inevitably lead to oblivion. What is the purpose of naming the ghosts, observing and listing them, telling their stories and giving their characteristics, only to say that they are 'different' from the present and their only relation to it is that they are forerunners to a sequence of events, or representatives of a simple difference in mentality? We might as well forget they exist. This remote, sterile description attempts to neutralize the workings of those who, involuntarily or deliberately, place living and dead on the same plane, or equate shadows with bodies, embracing both without discriminating between the two. Both strategies face and confront one another, one on the 'left', the other on the 'right', in the same disaster-strewn ring. Considering ghosts as 'others', or identifying with them as if they were 'the same' as the living, are complementary features of the same intellectual *bêtise*: an alleged wisdom unaware of its faults, a scientific discourse which still believes in the 'truth' of history and the positive substantiality of the past, despite the deconstruction operated by hermeneutics in the last decades.[10] The only result that both approaches produce is that the ghosts are free to circulate and that this freedom often leads to them deceiving society, or possessing it, with deadly repercussions.

Ancient ghosts linger, indestructible and untameable, regardless of whether we notice their presence, or try to take possession of them as if they were docile and innocuous. Their actions, words and tales appear when they are least expected or least predictable. Ghosts may appear as incognito archetypes, grotesquely misshapen parodies, or bewildering hybrids. And there is no guarantee that the epiphany they bring is benign and enlightening, as it happens in the case of Philostratus' Protesilaus, who visits the devout vinedresser four or five times a month to dispense knowledge and ideas. Nor is there any guarantee that they will tell the 'truth' out of their own good-heartedness, or that the tale they recount is admirable or trustworthy. Their tales may be yet another despicable lie told to those who consult them recklessly or dare to interpret their meaning. In the worst-case scenario, the ghosts may

even tell tales that become the poisoned chalice of a secret agreement made with those who awake them.

Our obsession with ghosts, Derrida says in *Specters of Marx*, may 'mark the very existence of Europe',[11] the result of a cultural and political destiny that has evolved through continuous, wide-ranging trade-offs with ghosts, their apparition and disappearance, metamorphosis and rebirth, breakage and violent upheaval. Consequently, each time ghosts are summoned, the ritual – ever different and contradictory – brings forth regressive preservation strategies, revolutions, or the awaiting of a messiah. Europe's love-affair with ghosts truly took off after the chronotope brought on by the rise of capitalism, which disciplined knowledge and power and triggered upheaval: from industrial triumphs to imperialist expansion; from the wounds of the Great War to the complete redrawing of the geopolitical map; from the economic crises to the proletarian revolution; from the madness of Nazism and Fascism to the massacres of the Second World War; from the rubble of liberation to the Cold War. During the twentieth century, the ghosts of the past, present and future clashed furiously and sometimes blurred into one another, exchanging roles and masks. At the end of this process, the great tales of progress and history become ghostly themselves. The ensuing scenario was littered with what survived, or what came 'after'. No new words were invented to describe this scenario; the word 'post' was simply tacked onto the usual nouns. The result resembles a universal emporium that sells its wares alongside all of the ghosts still in circulation. Sometimes these ghosts are put on display as if they were exhibits in a museum. At other times, they are thrown together in alienating bricolage. Philology continues its work, awkwardly but diligently, as it reiterates the educational value of its spoils, as if that value could be taken for granted in a globalized context and in a radically changed horizon. In an absolute present, everything has equal value and the spectres remain 'bloodless'. But it is precisely against this hypnosis that the politics of memory and cultural legacy must act in the knowledge that 'to articulate what is past' is not the illusion of knowing 'how it really was'; rather – as Walter Benjamin wrote[12] – 'it means to take control of a memory as it flashes in a moment of danger'. 'Flash', 'leap', 'standstill' are the words Benjamin uses in order to describe a different experience of time:

> It isn't that the past casts its light on the present or the present casts its light on the past: rather, an image is that in which the *Then* and the *Now* come into

a constellation like a flash of lightning. In other words: image is dialetics at a standstill. For while the relation of the present to the past is a purely temporal, continous one, the relation of the *Then* to the *Now* is dialectical — not development, but image, leaping forth.[13]

In this perspective, classic texts should be viewed as events that arise at the very moment they are called into action by questions that are clearly our own. They should not, however, be interpreted to comply with preconceived expectations or to confirm inveterate prejudices, but to highlight the inner hallmarks that have special value for the people consulting them. The approach to these texts implies the explicit consciousness of a gaze that is never neutral; on the contrary, their value lies in their becoming part of a circuit of reproposal and interpretation. And that circuit requires a special kind of awareness. In other words, we should always ask ourselves about the perimeters within which our reading is projected and what subjectivities and 'states of consciousness'[14] we want to produce from the various options available (a 'subject supposed to know', who incarnates and reiterates the 'discourse of the Master' – the 'discourse of the university' and the patterns of institutional power;[15] a nomadic subject who crosses all defined borders;[16] a posthuman subject, who evolves towards the 'Supermind'[17] . . .). It is our duty to introduce a new brand of untimeliness in a bid to layer time's smooth surface, knowing that at all times and in every word ever spoken, the present is never contemporary to itself, but permeated by somewhere else, crossed by remote presences, perforated by interstices, and susceptible to a wide range of manifestations. It is interwoven with multiple pasts. Against this setting, ghosts may be a contradiction that intervenes to suspend the present's discourse and automatisms, to undo the inevitability of the historical course and the givenness of ordinary experience, as ghosts mine space in search of discordant and different words. They can be viewed as the breakthrough of something repressed. Ghosts are the contretemps that breaks the surface of life as a shock or as a deferred action: a survival that acts *après coup* in a dynamic of latency and crisis. The ever-present possibility of this deconstruction plunges the modern day's supposed compactness into a crisis and opens up the prospect of a different future. When they are summoned, ghosts send violent shockwaves through the axes of time. 'The time is out of joint', as Hamlet says. Derrida comments and underlines this passage as crucial for understanding the relationship with ghosts: 'Time is

disarticulated, dislocated, dislodged . . . besides itself, disadjusted'[18] when ghosts intervene. In the present, they unleash a counterblow, the meaning and value of which depends on exactly when the ghost appears and why it has been called. Consequently, the relationship with what we call the past is always 'anachronistic'.[19] The relationship with the past becomes a symptomatology of time, a seismographic vibration, a schizoid movement, a fracture from which a vital force re-emerges, because the dead can be more vital than the living.[20] Ancient spectres are neither 'otherness' nor 'sameness', but what is given when they speak through the blood of the sacrificial victim, or what is given as a response to our need for answers and to the accompanying sacrifice.

Trading with ghosts is no anodyne experience, but a costly sacrifice during which the consulter is constantly exposed to risk and may even lose his life. Consequently, we should follow Odysseus' example: be prudent and remember the objective. We need to choose which ghosts should be summoned and which should be kept at a distance with powerful spells. From among summonings and exorcisms, we must pick out the anachronisms and 'events of counter-time' we want to trigger in the present. Our approach must not yield to the alleged objectivity of philological discourse, be seduced by the 'sterilizations' prescribed by anthropology. All that matters is the repetition of a spectral 'difference', one that brings salvation in the face of danger and restores the voice to everyone, including Palamedes. At the beginning of *Specters of Marx*, Derrida expresses a wish (or better, a need): 'Someone, you or me, comes forward and says, I would like to learn to live finally.'[21] Learning to live involves accepting that life and death are not opposed. Ghosts figure this non-opposition. Thus learning to live involves the task of learning spirits: learning when, how, and why they appear and how we conjure or invoke them. 'Learning to live finally' means – as Brown points out in her analysis of Derrida's essay – 'learning to live with this unmasterable, uncategorizable and irreducible character of the past's bearing on the present, and hence with the unmasterable and irreducible character of the present as well . . . Living with ghosts, permitting and even exploiting their operation as a deconstructive device, means leaving with the permanent disruption of the usual oppositions that render our world coherent.'[22]

Once we have enough experience to use the spectral difference, we will be able to make a further leap that changes and reverses this approach. This way, we may discover that spectres are the only real plane of reality, while the world's

events are merely shadows on the stage of a metaphorical theatre. But, at this point, we should call spectres by another less ambiguous and exoteric name. The world of the spectres leads to the world of Hurqalya, to the *mundus imaginalis* with its archetypes and its magic signatures. The art of the *imago vera*, the discipline of the imaginative faculty encompasses all the figures of myth and ancient stories and turns them into the matter of an alchemical *opus* of transformation. Transformation of subjectivity, metamorphosis of self, regeneration of life.[23] The operations made by the use of the imaginal forms are the secret tools that give access to a different vision of the world and show a different way to work on body and soul, as the Hermetic Tradition teaches.[24] Ancient spectres become *umbrae idearum*, constellations of a psychic heaven, epiphanies and seals of true Being. From the ancient imaginary to the Italian Renaissance, from Neoplatonic *phantasia* to Marsilio Ficino's philosophy, from Giordano Bruno's *Heroic Frenzies* to Goethe's *Faust*, the subtle bodies of ghosts, the forms of gods and heroes are sources of wisdom and existence, powerful presences that suspend the laws of space and time, if one knows which key opens the door. After descending to the realm of the Mothers, where there are the shadows of all beings, Goethe's Faust can say: 'Hier sind es Wirklichkeiten', 'Here's reality'. Faust wants to create 'das Doppelreich', the 'dual realm', that intermediary world, where absolute forms and living bodies of men can live together. Thus, evoked from the underworld – after Persephone has given her permission – Helen appears. She is a real and living presence: 'Ich fühle mich so fern und doch so nah, / und sage nur zu gern: da bin ich!, da!!,' 'I feel so far away and yet so near' – she says –'and am so glad to say now: "Here I am! Here!"'[25]

<div align="center">* * *</div>

2. And what about ancient Athens? How can we describe the classical city's relationship with what is called tradition and the ghosts of the past?[26] Aeschylus was accused before the Aeropagus of Athens of revealing the secrets of a mystery religion in his tragedies. One play allegedly acted out a secret initiation ceremony as a heterogeneous public watched from the *cavea*. It was forbidden to speak profanely about this ceremony before anyone who had not participated directly. Aeschylus reportedly defended himself by saying that he did not know that they were 'secret matters' as 'he had not been initiated' into these rites personally. Any allusion would therefore have been completely involuntary and coincidental,

the result of his own imagination and not a betrayal of a secret.[27] Whether this anecdote is true or not, it hints at an important relationship between initiation rites and theatre. Some scholars have posited that tragedy does nothing more than present the esoteric core of initiation in an exoteric manner.[28] The culminating vision of the mysteries had allegedly been turned into a theatre performance by showing light after darkness and unveiling another meaning of life. The 'within' of a secret, which each individual experiences during an initiation and guards afterward, was believed to have been transferred 'without', placed in the public domain and offered to the entire city unconditionally. The sacred stories told during the ritual, the pathway through death and rebirth, had supposedly been used to construct the skeleton of a play, namely the plots, speeches and action which, year in year out, were performed on stage. It was observed that the performance of these 'esoteric' contents strengthened the value of this sacred experience within the city. Each time, it would encourage audiences to travel backwards along a pathway that took them from the allusions of the play to the ecstasy of the mysteries that were its foundations.

Once we have noticed and admitted that there is a relationship, however, we should ask ourselves how long the 'within' can survive in the open space of the 'without', and to what extent the esoteric can last in exoteric visibility and circulation without dissolving or losing its original nature. There is no guarantee that this return journey from performance to the secret domain of the sacred will still be possible as time passes. Democratic Athens, which presents itself as a paradigm of culture, is a space where nothing survives, a backdrop against which profanation is continuous and systematic. The discourse of this democracy – its conflicts, its forces and its very forms of communication – does nothing but corrode history and tradition. In a destructive game, sacred and myth are manipulated, as they stumble from theatre to politics and from squares to courthouses. They are undermined by pretexts, pretence, conveniently twisted speeches, and meanings wrenched from their original context and adapted to new purposes. Being is replaced by the prospect of a void in which truth is merely a simulacrum, the efficacy of which is measured within the confines of situations and individual events. The forms of the divine and valour dissipate into a distant ether, while all that remains above the city is a paper sky. This is why Athens is haunted by restless ghosts that fight for attention and contradict one another. It is a place where the axes of time tangle,

where the present is precariously balanced between a vengeful past and future desire. It is no coincidence that the heroes of Greek tragedy always end up doubting themselves and their past, a symptomatic feature of Euripides' plays. Nor is it a coincidence that parodied mysteries return as a sign of political crises and power struggles, as happened when Athens stood on the brink of a violent coup, but was about to invade Sicily, blinded by the madness of its imperial campaign. It is no coincidence that Socrates, the teacher of the *jeunesse dorée*, is depicted as a mage who could summon the dead as he stood on the edge of a marsh.[29] The trauma produced by the crisis and by the implosion of democracy trigger reactions that are portrayed as exorcisms. One example appears in Plato's writings, in which the recently perished shades of Athens' elite are brought back to life to design a political project that flies in the face of historical experience. The spectres of the recent past are countered with an attempt to strengthen the power of myth and symbol. To deter the profanation of democratic 'theatrocracy',[30] every effort is made to rouse the wisdom of initiation, the nature of which is aristocratic and incommunicable. Modern characters and events are pitted against the exhumed images of a distant age: from the time of Chronos to the empire of Atlantis, and from the kingdom of Minos to Egypt's eternal temples. The bewildering game of simulacra is contrasted by the recurrent memory of heavenly forms.

This conflict of ghosts and spectres – its suppressed images and awoken shapes, its oblivion, and anamnesis, its cancellation and persistence – upsets the present and is why Athens is so contemporary and so anachronistically familiar. Athens is already 'post'; it is already the memory-dissolving 'new', just as it is nostalgia for origins and a quest for lost words.

From ancient ages back to the contemporary world, we may pose a final question: can the 'post' – the modern fluidity of identities, the current dissolution of paradigms – be thought as a useful matter? A dark matter to realize the *opus nigrum, l'oeuvre au noir*, before a new *aurora consurgens*?[31]

Notes

1 Homer, *Odyssey* 10.490–540.
2 Homer, *Odyssey* 11.38–42.

3 Philostratus, *Heroicus* 43.12–14.

4 Philostratus, *Heroicus* 43.15.

5 Proust (1965: 89).

6 Nietzsche (1989: 28).

7 Homer, *Odyssey* 11.487–95.

8 Wilamowitz (1908: 25).

9 Nietzsche (1989: 29).

10 The discourse of history is always a difficult balance between science and fiction: see de Certeau (1987).

11 Derrida (2006: 3).

12 Benjamin (1999: 255), *Theses on the Philosophy of History*, ch. 6: 'To articulate the past historically does not mean to recognize it "the way it really was" (Ranke). It means to seize hold of a memory as it flashes up at a moment of danger ... Only that historian will have the gift of fanning the spark of hope in the past who is firmly convinced that *even the dead* will not be safe from the enemy if he wins.' History, argued Benjanim (ch. 14), is 'the object of a construction whose place is formed not in homogeneous and empty time, but in that which is fulfilled by the here-and-now (*Jetztzeit*). For Robespierre, Roman antiquity was a past charged with the here-and-now, which he exploded out of the continuum of history. The French Revolution thought of itself as a latter day Rome. It cited ancient Rome exactly the way fashion cites a past costume. Fashion has an eye for what is up-to-date, whenever it moves in the jungle of what was. *It is the tiger's leap into that which has gone before*'.

13 Benjamin (1989: 49).

14 Guenon (2004: 53–6).

15 Lacan (1991: 22–4).

16 Cf. Braidotti (2011: 21–66).

17 Cf. Aurobindo (1990: ch. 18).

18 Derrida (2006: 20–1).

19 Cf. Loraux (2003: 173–90).

20 On the relation between the appearance of ghosts and the notion of survival (*Nachleben*), cf. also Didi-Huberman 2002.

21 Derrida (2006: xv).

22 Brown (2001: 146).

23 For these concepts cf. Corbin (1989: xɪ): 'The *mundus imaginalis* is the place, and consequently the world, where not only the vision of the prophets, the visions of the mystics, the visionary events which each human soul traverses at the time of his *exitus* ... but also the *gestes* of the mystical epics, the symbolic acts of all the

ritual initiations, liturgies in general with their symbols ... the spiritual filiations whose authenticity is not within the competence of documents and archives, and equally the exoteric *processus* of the Alchemical Work'.

24 Cf. Bonardel (1985).

25 Johann Wolfang Goethe, *Faust II* 6554–5 and 9411–2. On this section of Goethe's *Faust* cf. Citati (1990: 400–22).

26 For these reflections cf. Susanetti (2014).

27 Aristotle, *Nicomachean Ethics* 1111a.

28 Colli (1974: 173–4); Macchioro (2014: 155–65).

29 Cf. Aristophanes, *Birds* 1553–60.

30 Plato, *Laws* 751a.

31 *Aurora consurgens* is the title of a famous alchemical treatise and, at the same time, an alchemical keyword: cf. Bonardel (1993: 181–3, 354–5).

14

Cosmopoiesis in the Field of 'The Classical'*

Brooke Holmes

Partway through the second of his long interviews with Bruno Latour, in the midst of a conversation about method, Michel Serres comes up with a strange story. A mountain guide disappears into a deep crevasse. Half a century later, he reappears, his body cryogenically preserved in a glacier that has deposited him in a valley. The scene that Serres summons up is a group of brothers in their seventies mourning their thirty-year-old father.[1] The ending of the alpine vignette beautifully illustrates, he concludes, the fact of anachronism. The story seems to rattle Latour.[2] It's precisely this kind of *bizarrarie biographique et philosophique*, he retorts, that sets you off from the modernists and makes you so hard to read. Serres is unfazed. We are archaic, he answers, in three quarters of our actions. Few people and even fewer thoughts are completely congruent with the date of their times. We live many temporalities at once.

Serres' argument about non-linear time takes as its privileged example none other than Lucretius. The *De rerum natura* had been the subject of a study published by Serres in 1977, which takes as its point of departure the provocative statement 'Lucretius is right' or, in Serres' French, 'Lucrèce a raison'.[3] Serres' radical claim is that with the rise of chaos theory in the twentieth century, it has become possible to see just how closely Lucretius' poem, by no

* This essay is the result of a number of happy intellectual convergences over the past three years. I want to thank, in particular, the other members of the 'Postclassicisms' steering committee, Alastair Blanshard, Simon Goldhill, Tony Grafton, Miriam Leonard, Glenn Most, Jim Porter, Phiroze Vasunia, Tim Whitmarsh and especially Constanze Güthenke, as well as the other participants in the five workshops to date. I have learned so much from these encounters and incurred many debts. Special thanks are due to Shane Butler, Caroline Bynum, Joshua Katz, Miriam Leonard, Mark Payne and Jim Porter for their comments and criticisms on an earlier version of this essay and for many stimulating and formative conversations.

means an obsolete artefact in the history of science, hews to the world. The swerve, for example, read in light of a physics of fluids, emerges as the turbulence proper to every instance of laminar flow. Serres' claim that Lucretius is right gets more and more complicated as he starts to work out the less idiomatic sense of the French expression (literally, Lucretius 'has reason'). Insofar as he refuses to judge the reason of Lucretius a failure by the standards of the Enlightenment he insists that the Epicurean poet cannot be summarily carved off from modern philosophy and science as irrational. But that does not mean he thinks the reason of Lucretius is isomorphic with our reason. Difference matters, too. For difference ensures that Lucretius is not made redundant by chaos theory.[4] Indeed, it is what gives the poem its uncommon vitality. The Lucretius who arrives on the threshold of the present via Serres' imagination of what he calls 'liquid history' is, for this reason, not of our world. Yet he is also a body conserved across eons, our living contemporary as much as our predecessor. Latour, in another essay, compares the poem on Serres' reading to Sleeping Beauty, put to bed in the pre-scientific era: 'a kiss; and here it is; yawning, stretching, breathing again, as young as when it was written'.[5]

Serres tells the story of the mountain guide because he wants to make a point about non-linear time. The concept of space-time as topological, more a network than a line, lays down the terrain for Serres' distinctively comparatist method. Hermes, travelling across space-time to elicit and create relations among apparently distant points, is its patron saint. For Serres, what's at stake in the method is half-finding, half-inventing unexpected conjunctions and the common term that serves as their joint: Lucretius and chaos theory, each obsessed with fluids and turbulence; the relation of Lucretius to the twentieth century as analogous to that between the father frozen in his prime and his elderly sons. Yet as the alpine vignette makes clear, Serres isn't just trading time's arrow for liquid history. The genealogical relation doesn't so much disappear as get transposed into a polychronic moment where lines of descent are tangled and subverted. Meanwhile, the logic of analogy asks us to think not just one but two sets of relations: not only the relation of fathers and sons together with the relation of an ancient poem to modern physics, but also the cryogenically conserved body together with a manually preserved text.

In short, uncommon relations proliferate in Serres' story. Latour responds as someone who sees not a web of relations coming into focus but, rather,

insurmountable gaps. I expect that many readers of Serres would feel the same way (not least those readers trained to keep Lucretius well away from the history and practice of science). By contrast, Deep Classics, which is organized around a speculative conjunction between fossils and antiquities forged in the thought-world of deep time, would seem to be encouraging us to take up the scene of Serres' story and push it further, to go deeper still (or, perhaps, returning to Serres' topological model, to spread out over more of a surface). Under the Deep Classical aegis, for example, we might start thinking the reception of Lucretius has something to do with the woolly mammoth encased in ice that Russian scientists discovered on a remote Siberian island several years ago, and of their plans not to give it due burial but instead to collect some of the blood still pooled inside with the aim of cloning the prehistoric creature and bringing it back to life . . .[6]

Now classicism is no stranger to vitalist fantasies. Nevertheless, glaciers and schist are bizarre ground for classicists.[7] Those who break out in hives at the suggestion that we should think about our discipline in broader non-Western or global contexts are unlikely to rush to expand its imaginative scope to the non-human. It is true that for classicists anxious about the need to affirm the 'special value' of '"our" tradition', Shane Butler's description, in the introduction to this volume, of those who took the pose of the student of antiquity as 'paradigmatic of all human questioning about time and its work(s), in and as the world' may be reassuring.[8] But I suspect only superficially so. For by putting geological strata together with archaeological strata, Butler is asking us to rethink temporalities of past and present by trusting in unlikely likenesses and the world that less practiced conjunctions might make.

I therefore want to suggest in this essay that one of the most exciting approaches at stake in Deep Classics and in other promising intellectual projects in and around the field of Classics right now is comparatism as scholarly and intellectual practice. By comparatism, I include the kinds of cross-cultural comparison that are gaining renewed energy, especially in ancient history, and putting pressure on the conventional boundaries of the field.[9] But I'm also interested in comparisons that are less obvious because of the riskiness of their common denominator, as in Serres. I use these riskier comparisons as a way of coaxing into view comparisons that are less obvious for the opposite reason, namely, because they take place on terrain usually

presumed to be unified by the world of classical antiquity itself or its afterlife. In other words, I lean on radical difference as a strategy for upsetting assumptions of sameness. My primary investment in comparatism in this context is as an ethos and a method that can help us start thinking about modes of engaging with Greco-Roman antiquity that neither presume the unity of their object nor even its fragmentation, but instead self-consciously and actively participate in the formation of their objects. The comparatism I have in mind is one overt in its worldmaking, its *cosmopoetic* ambitions. What comes along with these ambitions is a demand that we at least try to articulate the claims that these worlds make on the attention of people in the present as objects of cultural, ethical and political value. Responding to this demand means revisiting the contested terrain of classicism (which includes anti-classicism) to reopen a relation that has been downplayed or simplified by many recent forms of historicism: the relation between past and present. The challenge, as I see it, lies in resisting the reinstatement of classicism at its most conservative without punting on the hard questions of our attachments to (and disavowals of) classical antiquity. The space of working through this challenge is what I would call 'postclassicism'.

Let me state in advance that what I will not be advocating for here is the interdisciplinarity that many Classics departments claim to embody, at least in the national context that I know best, the US. It is true that the model I have in mind tries to capture what I find most promising about a field conceived of ambitiously in terms of time as well as space and genre, what I would call an 'open field'.[10] This is not a field, I would stress, that belongs to the future. Rather, this *is* the field of Classics right now at its boldest and most exciting, reaching to Egypt and India and Iraq and China and Brazil, to Assyrian astrological texts and postwar bioethics, to Boileau and object-oriented ontology, to the Kaguru of east-central Tanzania and Indo-European etymology, to Gemistus Pletho and Moses Mendelssohn and Gilles Deleuze, to John Addington Symonds and Jimi Hendrix, etc. The problem with the assumption that such plenitude can be compassed by interdisciplinarity is that it doesn't ask what a classicist is doing or thinks she's doing when she navigates worlds beyond her discipline or crosses fields within it, nor does it reflect on the ostensibly hybrid objects of her study. Even more fundamentally, there's a problem in assuming that such an expanded field can be compassed as a single unified object of

study. I'm not suggesting that the field of Classics is confronting wild plenitude for the first time (though it remains common for classicists and non-classicists alike to contrast the manageability of the classical archive with the vastness of its modern equivalents).[11] Rather, my point is that the rapid and self-conscious multi-directional expansion of the field in recent years urges us, in the absence of an assumed totality called 'classical antiquity' or 'the classical', to rethink the common denominators that we rely on to define the objects of our study, even when we're working within the conventional spatiotemporal boundaries assigned to Greco-Roman antiquity.

In rethinking these common denominators, we have to rethink, too, our own agency in putting together stories about 'the classical' and 'classical antiquity' along with antiquity's presumed neighbours, predecessors, afterlives and analogues. In light of the purchase of Greco-Roman antiquity on the collective identities we inhabit, whether as privileged Other or genealogical source, rethinking our agency means acknowledging that we are so very often, implicitly or explicitly, tracing lines of affinity and difference between past and present ('the ancients' as children or fathers, friends or lovers, strangers or rivals, primitives or gods, and so on). This logic of likeness and otherness is why I locate the relation between past and present within the larger framework of comparatism that I sketch here. I come back to this relation, and the question of agency more generally, at the end of the essay.

What I'm trying to do here, then, is open up some ways of thinking about, developing, and testing practices of engaging with Greco-Roman antiquity that are self-reflexive about their subjects and their objects.[12] My interest is in a scholarly practice alert to the contingencies of 'the classical' and 'classical antiquity' as categories and the corresponding impossibility of delimiting their boundaries and, *at the same time*, a practice deeply invested in the stories to be told about classical antiquity in its multitudinous facets as powerful forces in the present.[13] These stories may indeed 'act on our time ... for the benefit of a time to come', as in Nietzsche's compelling formulation of the untimely (*unzeitgemäß*). The writing of these stories may equally be akin to the practice of writing as the Brazilian writer Clarice Lispector describes it in the only recorded interview she ever gave: 'I write without the hope that what I write can change anything at all. It changes nothing ... Because at the end of the day we're not trying to change things. We're trying to open up somehow.'[14] The old

pitting of politics against art for art's sake suggests that these are mutually exclusive alternatives. I see them, rather, as different modes of being in the world, modes I would describe as ethical.[15] Engaging with classical antiquity has the power to animate all these modes in unexpected ways. The lines between classical scholarship and art, between classical scholarship and politics, and between classical scholarship and ethics cannot therefore be fixed in advance – as has been true, of course, for much of Western history. By attending more closely to these modes of being, in turn, we may be able to develop richer and more robust accounts of classical texts, objects, ideas, and societies within which past and present enter into dynamic symbiosis.

<p style="text-align:center">* * *</p>

What does it mean to trust in a likeness? Not the way we trust in photographs or paintings or paternal descent – all relationships, of course, that occasion their own brands of skepticism – but in the joint between two objects of indeterminate affinity: the trust, in other words, in the work of comparison. Every comparison, as the Sinologist and practiced comparatist Haun Saussy eloquently reminds us, turns on the postulation of a common denominator, the *tertium comparationis* that one must solve for in Aristotle's account of metaphor qua puzzle (metaphor 'by analogy').[16] One of Aristotle's examples is the cup of Ares. The cup is a puzzle, Saussy points out, because everyone knows the god of cups is not Ares but Dionysus. The canny reader is thus led from a cup to the larger category of 'instrument' or 'attribute', then back to Ares. The cup of Ares, now understood as the instrument of Ares, is nothing other than the shield. Aha! The satisfaction of the solution relies in part on the uncontroversial nature of the *tertium comparationis*, that is, the attribute of a god. Imagine another scenario. Saussy gives the example of Mayan hieroglyphs and the fish markets of Gloucester, Massachusetts. What do they have to do with each other? The answer, this time, is the American poet Charles Olsen or, more properly, the vast poetic network that Olsen creates, within which hieroglyphs and fish markets are brought together by the poet's attention.

Now if we want to gloss these points as two poles of a comparatist spectrum, Aristotle and Olsen, we might label one objective and given (it's a fact of the world that all gods have attributes, and these attributes are themselves fixed and common knowledge) the other subjective and constructed (whatever x

and y have in common is sufficiently incidental that their conjunction requires the force of an individual mind to make sense). In practice, the objective comparison – that is, the comparison that is supposed to be premised on a really existing relationship or similarity – is always created by a mind 'co-remembering' two things, as the Stoics would say. The ostensibly subjective comparison may, in turn, take hold in the world, reshaping how others perceive lines of affinity between objects at a distance (Saussy gives the example of Auerbachian realism, which puts together texts in a manner that some of Auerbach's most distinguished contemporaries – Wellek, Curtius – found wildly capricious but is now conventional). The comparatist is always moving between these two abstract poles: 'the distinction ... between a common denominator that is supposed to be given, and one that is constructed by the exercise itself ... is anything but hard and fast'.[17]

Saussy's primary target of critique is those who would forego comparative literature for world literature conceived of as an 'archive to be explored' rather than 'an as yet nonexistent thing to be constructed'.[18] The problem, he argues, is that the presumption of a single, unified body of material (world literature or literature as a human category) obscures the creative work scholars do in putting x together with y. There's a further risk of being too complacent about the *tertium comparationis*, of failing to test out less obvious common denominators that may end up shedding more light on each side of the equation. The risk is not limited to world literature. Caroline Bynum has recently pointed out that, in view of the widespread skepticism about comparatism in the humanities these days – the result of a now familiar privileging of the particular and the unique – the assumption seems to be that the similarities in any given case are obvious but also superficial. What matters is getting down to differences.[19] Bynum rightly returns the problem of likeness to the foreground.

These matters of concern may seem hardly urgent for classicists. But if we're going to start talking about woolly mammoths and schist once buried at the bottom of 'a superincumbent ocean' in the same breath as Lucretius and Troy, we will have to think harder about how we get from one point to the other. Under the rubric of 'Deep Classics', woolly mammoths in deep freeze become available to contemplation because, like the artefacts of Greco-Roman antiquity, they come out of a distant past and carry that past into the present.

In this respect they are like the antiquities of any culture. Even the fact that we are talking about the dormant lives of long extinct species, rather than the petroglyphs in Werner Herzog's Cave of Forgotten Dreams or poetry composed at a sixth-century BCE symposium, should make no real difference. The comparatist movement across geographical zones of antiquity is already familiar to ancient history, and it's becoming more attractive in the context of the internationalization of the university and globalization itself. Why not go further?

At the same time, the common denominator in these geographical comparative operations is usually fleshed out beyond simply 'antiquity': the structure of premodern societies, the morphology of classical traditions, learned medical practice – that is, terms that begin to approach the ultimate universal, Man, the old guarantor of anthropology's purchase on Classics. As we gravitate towards Man, mammoth carcasses start to feel more out of place as antiquities. It becomes clearer why the persuasiveness of their conjunction calls out for a rubric that acknowledges, as the brief for Deep Classics does, the human observer and, more specifically, the subject who contemplates different kinds of artefacts that arrive in the present from deep time, that is, a subject who creatively puts two things together in order to confront more vividly the paradox of things that are at once buried in layers of time and right here in our hands, animals whose blood can be warmed. The point here is not that we are dealing with one pole where 'premodern society' or 'Man' is a stable *tertium comparationis* and another where we have to resort to free association. Rather, the stubborn difference of the non-human from the human turns our attention towards the act of attention and the labors of care and imagination that bring together two objects of thought and build a common world for them to inhabit – that is, the comparatist work that I want to call cosmopoiesis.[20]

The lateral movement from one ancient society to another, even if it is ultimately premised on presumptions of universal or quasi-universal terms, often comes with the 'comparative' warning. But what about movements within the domains we call classical antiquity or the classical tradition? Are these comparative operations? It is true that in the US, the study of the classical tradition has often been carried out in comparative literature departments rather than Classics departments. But classicists don't usually tend to describe what they're doing when they move across time and space in comparatist

terms (though they may speak of comparison). Though interdisciplinarity is a buzz word classicists like to claim, the field as a whole, especially in its literary spheres, has not fostered a robust discourse for reflecting on what it would mean to imagine the study of the ancient world in the early twenty-first century as a comparatist operation. The reticence can be explained in large part, I suspect, by a working assumption that all the evidence we are dealing with originates in the 'same' place: classical society, classical culture, classical literature, the classical canon, classical philosophy, the classical tradition.[21] It isn't that diversity and difference are ignored – far from it. But most of the time it's allowed, even emphasized, only because the integrity of the society or the tradition or the archive has been assumed in advance. The intertextual turn of the past thirty years, together with ongoing attention to oral traditions, has, if not necessarily in theory then in practice, strengthened this assumption even as it has expanded into reception studies. More recently, 'the classical' appears to be experiencing a renaissance as a way of securing the unity of the field's object and, considering the name change of the largest Anglophone professional organization, the field itself.

Now one might have expected that the remarkable rise of reception studies over the past two decades would have destabilized the idea of a single unified object of study within Classics. I think in fact it has, but some of the most prominent recent accounts of what it means to study antiquity after antiquity suggest instead renewed efforts to define a totality. It's of course true that many practitioners of reception studies have delighted in the case study and the micro-history, often zeroing in on circumscribed national, cultural, and historical contexts.[22] The preference for the local is one reason why the authors of the recently published *The Classical Tradition: Art, Literature, Thought* are so eager to differentiate what they're doing from reception studies in a book that claims to offer, with brash confidence, the big picture: that is, *the* classical tradition as a whole.[23]

It's worth stressing, however, that the opposition of narrowly situated parts (reception studies) to ambitious wholes (classical tradition) is misleading. After all, the premise of reception studies encourages scholars to invest texts and objects with the power to generate and sustain communities transhistorically. The emphasis on transhistoricism can foreground questions about the nature of the thing that creates a series of reception events. It can

also focus attention on the different kinds of communities and traditions created by different kinds of objects (e.g., a Sophoclean play or a text by Galen).[24]

The transhistorical gaze, moreover, need not be bound to a single object or text or genre. Charles Martindale has described the transhistorical more generally as 'the seeking out of often fugitive human communalities across history'.[25] No mammoths or schist deposits here, but Martindale does frame a transhistorical reception studies as a 'new humanism', read via the credo *nihil humanum alienum puto*.[26] Yet everything that has once interested living men and women, to paraphrase Pater, won't establish viable ground for a discipline, as Martindale, skittish about competence in an expanded field, would presumably be the first to point out. Elsewhere, he's more likely to read the transhistorical in terms of an objectively given, narrowly conceived concept of aesthetic value rooted in the Greco-Roman classics, such that the strand that holds the field together even across the vast distances of the Western tradition is, more accurately, a new classicism. Between Milton and Eliot, the *tertium comparationis* is as secure as between Homer and Virgil and, fugitive communalities aside, evident to all classicists worthy of the name.

The Classical Tradition adds 'thought' to art and literature in its subtitle as part of its bid to establish the totality of the terrain held in common from antiquity to the present under the aegis of the emphatically singular classical tradition. The authors do acknowledge, at the outset, the vast scope and diversity of said tradition. They acknowledge, too, the impossibility of covering it in a single book. Fair enough, and the book does offer remarkable range. But the exclusions turn out to be all too familiar: Byzantium, Spain, and (not even mentioned as an exclusion) the medieval Arabic world, all set aside in favour of 'the undoubted heartland' of the classical tradition in the cultural traditions of Italy, France, Germany and the English-speaking world.[27] This creates a serious problem. If by 'classical tradition', we mean the largely nineteenth-century construction of Greco-Roman antiquity as a national heritage to be preserved or that construction qua viewfinder for seeing how antiquity is transmitted through and shapes a good deal of Western European culture, then I think I can make some sense of the authors' claim that 'the classical tradition, on any reading, is European at the outset and Western, through and through' (although the claim would then be tautological, and in no need of the

emphatic 'on any reading' and 'through and through').[28] But if the claim is meant to describe anything like the historical transmission of ancient Greek and Roman objects, texts, and ideas or the many and diverse afterlives of the Greco-Roman world – interpretations that will require Baghdad and Cairo and Damascus and Byzantium – then it is nonsensical. The fear here, *pace* the authors, is not of a big picture. It's of a picture pretty obviously limited by the interest, expertise, and knowledge of its authors, a picture whose omissions are conveniently forgotten so that it can be offered up as a totality to reground the unity of 'the classical' as 'Western'.[29]

What's limiting in these recent recuperations of 'the classical' as a unifying term in the wake of reception studies is that in their attempts to stabilize a field vastly expanded chronologically while at the same time expanding the cultural authority of classicists, they end up reinforcing the narrow vision of the ancient world that some of the most innovative work in the field over the past few decades has blown open: we are returned to Golden Age texts, not epigones; certified literature, not technical or even philosophical works; Greece and Rome, and nothing of their Eastern enemies or barbaric provinces. In some sense, this is no surprise. The very idea of the classical implies a winnowing, whether through the culling that produces a canon or the special conditions of an age in which everything touched turns to gold. But if the only way we can give an ambitious and powerful account of our shared enterprise is by anxiously reinvesting in the unity of the classical conventionally understood – indeed, if the meta-consequences of one of the most active and innovative branches of the field in recent years come down to this – then we will have succumbed to the field's deepest fears of irrelevance in a changing world.

What I'm objecting to are classicists who would not rest at legislating by fiat what has value but want to lock down the borders of 'the classical' and 'classical antiquity' so they can perpetuate defensive fantasies of epistemic mastery and elite judgment. If 'in some quarters, the classical itself elicits suspicion, or even scorn, unless deconstructed or critiqued', it is with good reason.[30] One of the most valuable trends in recent years has been richly sophisticated work uncovering the many scenes over millennia that have determined the tenacious hold of classical antiquity on the minds and imaginations of so many people in so many cultures: that is, the dissection of the classical not as timeless value but as time-bound product of collective attention, care, and disavowal.

Yet the point I'm making is not simply that we need to deconstruct 'the classical'. Just as crucial is that we are thoughtful and creative about what we make our objects of study and how we describe and experiment with our intellectual, scholarly, disciplinary, and creative practices. By disrupting the relationship between 'the classical' and the twin ideals of quasi-organic unity and timeless value, we clear space to resituate 'classical antiquity', 'Greece', and 'Rome' as descriptors made vital by their deployment in freshly imagined visions of a more broadly conceived past, its legacies and its fallout (and its still-falling-out). The classical and classical antiquity are here objects of elective sympathy, a term I use, following the Stoics, to designate any resonant relationship, not just one of kinship or affinity (without following the Stoics in seeing these relationships as inscribed in the cosmic order). In other words, the critique of 'the classical' as fixed and given, far from leaving a void, creates fertile ground for the reworking of 'the classical' as an object of value in a 'postclassicist' mode.

Moreover, once we refuse 'the classical' or 'classical antiquity' as given, the work of mapping a *tertium comparationis* comes to the fore. That is, the *tertium comparationis* between a tragedy and a medical text (or the Periclean citizenship law, or a nineteenth-century German reader, or a production at the Brooklyn Academy of Music) becomes an object of attention and reflection much as it is in the stranger, riskier comparison that Serres gives us between Lucretius and the cryogenically frozen body of the father. The unlikely conjunction exposes the gaps in assumed totalities like 'the classical' and, in so doing, opens up not the abyss but spaces of interpretation, the spaces of cosmopoiesis.

One of the biggest such gaps that anyone who takes classical antiquity seriously faces is that between the past and the present. By subsuming this relationship under a comparatist model, I'm insisting that it, too, is governed by the dynamic play of sameness and difference. The aim here is to try to make more visible to ourselves and those who read us the ways in which claims of genealogy, analogy, inversion, continuity and universalism are activated by the hopes a scholar has for her work's intervention in a given intellectual, disciplinary, or political context.[31] Too often we end up making absolutist claims about the radical difference of antiquity or its unbroken continuity across a tradition of which we are the rightful heirs. Why not recognize instead that different conditions invite different figurations of the relationship of

antiquity to the present (or other times and places)? Why not try to find a model of what we do that acknowledges our agency – or, more accurately, our many different *situated* agencies, an idea I come back to at the end of this essay – in making these decisions under different conditions? Acknowledging agency is the first step in trying to take responsibility for the stories we tell about the past, which I would hazard is the best way to being more open to telling and hearing different kinds of stories about that past. For I'm not saying that the stories we tell shouldn't be tussled over, their assumptions and implications debated and critiqued. My point is simply that I do not want to be told at the outset I have to study Alexandria but not Athens anymore than I want to be told I have to study Athens but not Alexandria. I do not want to have to make a lifetime commitment to the ancients as impossibly alien *or* as people just like me. I do not want to have to decide between damning the Greeks for phallogocentrism or piously praising their art. I welcome endless refractions of antiquity as the very lifeblood of its future, although I confess it is the stories that take on its complexity as a precondition of making sense of its remains that I have found most sustaining in my own work.[32]

The last paragraph ended with a first-personal crescendo: we arrive, finally, at the question of the agency of one who tells stories about the past, who creates worlds. The complex agency of scholars has been well acknowledged by post-structuralist critics and the classicists reading them over the past half century. Yet the imperative to historicize, strengthened not only by the new historicism and cultural studies but also by the historicist roots of *Altertumswissenschaft,* has cast this agency primarily as something to be checked at the door in the interest of 'get[ting] to the bottom of things', as Butler puts it in his introduction to this volume.[33] The work of historicizing may be understood as figuring out what things were really like in ancient Athens. It may be understood as a form of critique that shows the seams in the constructions of ancient concepts like polis or body or citizen or in the very concepts that guide our understanding of classical scholarship and classical scholars. In both guises, such work is, to my mind, highly valuable. Nevertheless, it has often obscured the ways in which any account that tries to make sense of the remains and revenants of classical antiquity is enabled, governed, and enriched by the investments of its author in the presents that she inhabits uniquely and collectively and the questions that govern her interest. That is,

historicist methods have shed plenty of light on the embeddedness of other readers but made it harder for us to make sense of our situatedness as scholars and riskier to think at the level of grander narratives.

I do not think we should repudiate these methods, but I do think they need to be reconfigured. On the one hand, I think that unmasking constructions can only take us so far. I'm more interested in how feedback from the world outside us and our own bodies enables external or non-subjective forces to exercise their own agencies on the ideas and objects we live with in more or less critical ways.[34] On the other hand, though I readily recognize the limits of a historicism that trusts in a reality to be securely reconstructed, I believe that historical technique, like philological technique, is an indispensable part of the worldmaking of classical scholarship. My aim, then, is to rethink how these forms of historicism and critique can be reimagined via a new understanding of objectivity. This in turn can help us better understand the agency of the observer singled out by Deep Classics, that is, the subject who, on my analysis in this essay, in putting two (or more) things together is creating a world to house them both.

The work of cosmopoiesis can be understood in part as a counterbalance to historicism as pure critique. As Donna Haraway writes in her classic essay 'Situated Knowledges', 'We need the power of modern critical theories of how meanings and bodies get made, not in order to deny meanings and bodies, but in order to build meanings and bodies that have a chance for life'.[35] Haraway's target here is what she calls postmodern relativism, which is able to critique the constructions of others but leaves itself no ground to stand on. Her arguments anticipate those made by Latour in an influential article published in 2004, where he decries the schizophrenia of 'the critical mind' that unmasks the fetishes and illusions of others while retaining an 'unrepentant' positivism for the sciences it does believe in and a 'healthy' realism for what it cherishes, including critique itself.[36] On both accounts, critique (or relativism) is a practice unable to touch the point from which it is exercised. In this respect, Haraway argues, it comes full circle to meet the position to which it is ostensibly opposed, that of positivism, either the old-fashioned variety or that of feminist philosophers of science seeking to purge science of bias and violence and rescue its purchase on realism.[37] What vitiates both positions in her eyes is their reliance on the 'god trick': infinite vision located nowhere in particular.[38]

Haraway calls the knowledge claims articulated from an unlocatable position irresponsible, meaning 'unable to be called to account'.[39] In place of this notion of objectivity she instead calls for a feminist objectivity premised on 'situated knowledges' and vision from below. The knower is here embodied in specific and particular ways within a web of possible relations. She takes responsibility for the epistemic positions that she adopts and the limits they necessarily operate under.

The language of situatedness and embodiment may call to mind essentialized identities that one owns up to or embraces. This is not what Haraway means.[40] That is not to say these categories do not matter – on the contrary. Haraway follows a strong line in feminist epistemology that trusts, in particular, in the vantage points of the subjugated insofar as they're structurally immune to blind faith in disembodied objectivity. That fiction, after all, as John Winkler emphasized more than a quarter of a century ago, has never made room for them.[41] But to see from below is never an innocent undertaking (Haraway is well aware of the risks of romanticization). Like all positioning, it requires work: self-reflexivity and self-critique. '*How* to see from below', writes Haraway, requires 'at least as much skill with bodies and language, with the mediations of vision, as the "highest" technoscientific visualizations'.[42] What imposes obligations on us is precisely our mobility as knowers and our capacity to know differently. Through 'techniques of visualization', vision becomes both a creative act and one that operates under constraint, an act informed by a responsibility to the world(s) our knowledge produces and sustains and to the world we hope to bring into being.

Haraway thus emphasizes, on the one hand, certain ethical commitments as constitutive of the knower – most importantly, a commitment to partial perspective and a commitment to worlds 'less organized by axes of domination'.[43] On the other hand, the knower is subjected to techniques that decentre her from herself such that she may know from the perspective of others (and especially subjugated others). Haraway's mapping of a double helix of subjectivity and objectivity is useful for bringing together different aspects of the practices that I have tried to articulate here. Insofar as historical method is understood as a technique of getting outside ourselves and trying to see the different aspects of ancient society, it is a valuable technique of visualization that is crucial to our ability not just to imagine antiquity and its afterlives but

to imagine our own world. The same can be said of training in the ancient languages and philological method, which remain indispensable to classical scholarship. It can be said of training in anthropology, archaeology, political theory, philosophy, art history, epigraphy, gender studies and a range of other fields. The point is not that every one engaged in the study of classical antiquity and its afterlife should command each of these techniques. Rather, these techniques become available as ways to get at particular problems and questions we may ask of our material. In using them to experiment with that material, the objects of study push back on us – they are 'recalcitrant', as Bonnie Honig puts it – the contours of similarity and difference shift, and we and our hypotheses are transformed.[44] At the same time, the questions we ask, the directions we move as knowers, and the conclusions we draw are determined by the world we inhabit and our attachments, values and interests. The idea of 'situated knowledges' asks us to recognize these as limits that preclude total mastery and to discipline ourselves to see from different angles, including, when possible, from below.[45] It asks us to attend to our values and interests as objects of attention and reflection and to see them, too, as constitutive of what matters to us in what we do and, thus, the impetus to make what we do matter.[46]

The emphasis on partiality of perspective suggests that we have traded the forest for the trees. I am indeed in sympathy with what Bynum has described as 'history in the comic mode', a history organized around fragments and clear-eyed about the myths of organic wholes.[47] Yet it is also true, Bynum argues, that we humans have a stubborn drive to create wholes out of fragments, sense out of stimuli, stories out of lives. The work we undertake in producing studies of classical texts, ideas, and societies necessarily refracted through afterlives and our own world can be a provisional, dynamic, and creative whole-making of this type. These accounts function in one sense as created objects that assemble (not *re*assemble) various pieces from antiquity and any number of other times and places into a whole that is larger than the sum of its parts. They function in another sense as worlds for the co-existence of past and present, where the past is at once alive and strange, a prehistoric creature of sorts now among us as distant relative and potential symbiotant. If these are wholes larger than the sum of their parts, it is not because they rebuild lost worlds out of fragments, restoring their organic unity. If they cohere, rather, it is through the creatively conjunctive work of classical scholarship itself, whether undertaken singly or

collaboratively. It is through the affective attachments, the ethical commitments, and the idiosyncratic styles of thought and writing that help form these worlds – the 'traces embedded in the work', as the artist Paul Chan describes them in a discussion of Plato's *Hippias Minor*, that 'illuminate how a way of living has enlivened (or deadened) what was made or written', which Chan compares to the 'grain of a person's voice' (as indeed I think the editor of this volume would).[48] These are wholes, then, but assembled, contingent, and dynamic wholes animated by the lives of their makers and capable, too, of sustaining creatures (texts, ideas, objects, styles) from distant pasts in multiple temporalities.[49]

All this talk of worldmaking may sound grandiose, but given the enormous impact of Greco-Roman antiquity on shaping our own presents and its potential to shape us further, I see our responsibility to classical antiquity and the legacies of 'the classical', whether pernicious or inexhaustible sources of beauty, strangeness, and unexpected futures, as nothing less. I openly admit that I am a lover of grand narratives as well as odd conjunctions. For the cosmopoetic turn is motivated, too, by my own fascination with Greco-Roman texts and ideas and their refractions over the past century, in particular, and I do not know how else to describe what I'm trying to do in my work if not as the building of worlds that bring sometimes unusual constellations of ancient texts together with live elements in the present in creative symbiosis. If the work is necessarily processual, partial and contingent, these are not reasons for refusing investment in the stories we tell and the worlds we make. These qualities are, instead, integral to what the work of cosmopoiesis in the field of 'the classical' contributes to the work of living together and living well.

Notes

1 Serres and Latour (1995: 61).
2 It is worth remembering that the famous claim of Latour (1993) – 'we have never been modern' – only makes sense if we = *we, moderns*, that is, if the challenged but still conventional rupture between pre-modern and early modern science remains in place.
3 Serres (1977).
4 For a fuller analysis of Serres' reading of Lucretius, see Holmes (2016).
5 Latour (1987a: 88).

6 See Payne, writing in this volume on Algernon Blackwood's weird tale *The Centaur*, on the relic as 'what should no longer be present in the present, as the leftover from some prior life world, but yet, as the uncanny persistence of what should no longer be here, continues to message us in its own, distinctive way'.

7 Though what is strange to scholars of texts is far less so for scholars of material culture, as Jim Porter reminds me: see further Porter (2010) on the problematic materiality of classical studies. In this essay, my references to the current state of Classics target classical philology but the open field I aim to describe is one where the trenches that tend to stand between those who study texts and those who study material culture are replaced with a denser network of collaboration and conversation, not just at the level of data but also at the level of methods.

8 See introduction (14); Martindale (2010: 139) ('special value'); Silk, Gildenhard and Barrow (2014: 12) ('"our" tradition' opposed to other cultural traditions that have engaged with Greco-Roman antiquity).

9 Two events that I participated in late in the development of this essay – the 'Globalizing Classics' Summer School at the Humboldt-Universität zu Berlin in August–September 2015 (initiated by Colin King and Philip van der Eijk), where comparatism was a topic of much discussion, and the last Sawyer Seminar in a series on 'comparatism' at CRASSH at Cambridge in September 2015 (organized by Renaud Gagné, Simon Goldhill and Geoffrey Lloyd) – have made me even more convinced of the promise of such an approach. Note that I distinguish 'comparatism' from 'comparison' in that the former takes comparison as a governing methodological principle, while the latter describes an act that can be performed without reflection on the act of comparing itself.

10 On the open field, see further Güthenke and Holmes (forthcoming).

11 For the problem of vastness and knowability as one constitutive of modern Classics, see Güthenke and Holmes (forthcoming). From the vantage of antiquity's afterlife, the study of classical antiquity has the potential to become world history: see the introduction to Grafton, Most and Settis (2010).

12 Although the exercise has clear consequences – indeed, potentially radical consequences – for disciplinary training, I set those aside to focus on practices already part of the repertoire of many professional Anglophone classicists (both self-identified and housed in departments of Classics). For pedagogical suggestions informed by reception studies, see Porter (2008a: 478–9); Güthenke (2013).

13 For the thinking together of antiquity as unstable object *and* object of attachment, I am much indebted to the work of Jim Porter (esp. Porter 2006b; Porter 2008a; Porter 2013).

14 The full interview, recorded in February 1977, is available (with English subtitles) at http://www.theparisreview.org/blog/2014/12/10/it-changes-nothing/. I thank

Maria Cecília de Miranda Nogueira Coelho for bringing the interview to my attention.

15 A rather different triad from that of Stoicism (ethics, physics, logic) but I find congenial their attempts to figure the mutual implication of these branches of philosophy (and so of life) in one another (as an egg, as an orchard).

16 Saussy (2011), citing from Aristotle, *Poetics* 21, 1457b1–30; cf. *Rhetoric* 3.4, 1407a15–18.

17 Saussy (2011: 62).

18 Saussy (2011: 62).

19 Bynum (2014: 344–5). Bynum's main target of critique is the reliance on morphology to establish similarity: 'even before we come to delineating differences, we need to think far more carefully than we often have about the likeness we start with' (345).

20 The literary critic James Wood's perceptive remarks on metaphor pick up on the creative work of comparison: 'independent, generative life . . . comes from likening something to something else . . . As soon as you liken x to y, x has changed and is now x + y, which has its own parallel life' (1999: 51, cited at Bynum 2014: 368). I thank Caroline Bynum for urging me to look at Wood's formulation.

21 The discipline of classical philology, in particular, also secures closed objects of study by organizing pedagogy, graduate training and research around authors, texts, genres, single words, and so on.

22 The approach is eloquently defended at Goldhill (2010a); identified and given a backhanded compliment at Wood (2011: 166–8).

23 Silk, Gildenhard and Barrow (2014, esp. 12–13).

24 Both of these areas of inquiry are taken up in Holmes and Shearin (2012), on the reception of Epicureanism, where Epicureanism is theorized as a pluripotent 'text' in a way that resonates with the 'object-oriented' account of a text at Harman 2012 (though the status of Epicureanism as a textual *object* is complex).

25 Martindale (2013a: 173). The phrase is frequently cited by respondents to Martindale's paper in the special issue of *Classical Receptions Journal* (devoted to a reassessment of *Redeeming the Text*) where it appeared, though Martindale credits his Bristol colleague Kurt Lampe with its felicitous formulation.

26 Martindale (2013b: 248); cf. the quote from Pater that ends Martindale (2013a: 182).

27 Silk, Gildenhard and Barrow (2014: 7).

28 Silk, Gildenhard and Barrow (2014: 245).

29 There is a difference between claiming that the West is thoroughly shaped by classical antiquity and that the transmission and afterlife of antiquity is thoroughly Western. The former is true; the latter is false. The book's parochialism comes

sharply into relief against another recently published book called *The Classical Tradition*, in this case an edited volume that is at once far more wide-ranging in its generic and geographical scope and far more honest about the impossibility of treating its object as a totality: see esp. the prefatory remarks in Grafton, Most and Settis (2010). The editors' reference to the 'unity of classical culture' (ix) reads in the broader context of the preface not as unity to be compassed by a single knower but as a network of possible connections to be navigated by the reader of a book explicitly framed as a 'guide'.

30 Silk, Gildenhard and Barrow (2014: 31). Cf. Wood (2011: 168).

31 The strategic invocation of sameness or difference is especially evident in the post-Foucauldian debates of the 1990s about ancient sexuality. I discuss how claims of sameness and difference played out in powerful but also reductive ways in the 'sexuality wars' at Holmes (2012: 84–110, esp. 104–6).

32 See, e.g., the remarks on the sexed body in antiquity in Holmes (2012: 14–56, esp. 46–56).

33 See introduction (12). The idea of 'checking' one's agency resonates with the account in Daston and Galison (2010) of objectivity, as it was understood primarily in the history of science in the decades after Kant, as a checking of the will.

34 I make this argument at greater length in the context of the body as a 'conceptual object' in Holmes (2010).

35 Haraway (1988: 580).

36 Latour (2004). Haraway, however, does a better job to my mind of balancing the value of critique against a form of realism; cf. Foster (2012) against the 'post-criticism' of Latour. It is true, however, that Latour is responding to different historical conditions and, more specifically, the odd collusion of global warming deniers and the 'critical mind'.

37 The article began as a response to Sandra Harding's *The Science Question in Feminism* at the Western Division meeting of the American Philosophical Association in 1987. Harding's book takes direct aim at a tension inherent in the idea of 'feminist science' that in the mid-1980s was expressed as a conflict between what she calls a (modernist) 'successor science', purged of the bias and violence of science-in-the-service-of-patriarchy, and postmodernist projects premised on radical historical contingency and relativism. Harding (1986: 244) in fact valorizes this tension as productive for feminist epistemology, at least within a particular historical moment. Haraway, by contrast, rejects these poles in favour of 'situated knowledges'.

38 The 'god trick' is, from a classicist's perspective, aptly named: see Holmes (2010, esp. 52–7, 265–74) on sight and invulnerability.

39 Haraway (1988: 583)

40 'Feminist embodiment, then, is not about fixed location in a reified body, female or otherwise, but about nodes in fields, inflections in orientations, and responsibility for difference in material-semiotic fields of meaning' (Haraway 1988: 588).

41 Winkler (1989).

42 Haraway (1988: 584) (emphasis original).

43 Haraway (1988: 585).

44 Honig (2013: 191).

45 I cannot understand the claim that using our sources to reconstruct and imagine non-dominant perspectives or reading against the grain is just political correctness as anything other than willed amnesia or stubborn ignorance. At the same time, I believe we can tell powerful stories about the past, capable of disrupting pernicious assumptions, by reading canonical texts – provided we do not see the affirmation of their value as contingent on blind or socially enforced admiration. The question of reading 'from below' extends of course to antiquity's reception.

46 As Bynum (1992: 23) writes, 'No one of us will ever read more than partially, from more than a particular perspective. Indeed, it is exactly because we admit that we are particular individuals, at a particular historical moment, using and affirming our own standards, that we move with confidence to speak of the beautiful, the cogent, the intellectually courageous and the moral in past writings and events'; see also her n. 22 for arguments about objectivity similar to Haraway but drawn from Thomas Nagel.

47 Bynum (1992: esp. 14, 23–5).

48 Chan (2015: 27). It is precisely because of these traces that a work interests us, Chan suggests. On the grain of the voice, see Butler (2015).

49 In this respect they are like the worlds born of etymologies, poetic or otherwise, described by Joshua Katz in his essay in his volume.

Borges and the Disclosure of Antiquity*

Laura Jansen

Ergo vivida vis animi pervicit, et extra
processit longe flammantia moenia mundi
atque omne immensum peragravit mente animoque,
unde refert nobis victor quid possit oriri,
quid nequeat, finita potestas denique cuique
quanam sit ratione atque alte terminus haerens.

And so it was that the lively force of his mind won its way, and he passed on
far beyond the fiery walls of the world, and in mind and spirit traversed the
boundless whole; whence in victory he brings his tidings what can come to
be and what cannot, yea and in what way each thing has its power limited,
and its deep-set boundary-stone.

Lucretius, *On the Nature of Things* 1.72–6 (trans. Bailey)

The extraordinary intellectual ability with which Epicurus measures the
universe of atoms that ultimately explain the entire fabric of his present world
never ceases to amaze readers of Lucretius: for how does a third-century BCE
thinker from the island of Samos position himself methodologically to
overcome the insurmountable obstacles that come between him and the birth
of the atomic cosmos? By what means is he able to measure the 'immeasurable
universe'? And how is he able to recall fully the knowledge that he has gathered
so as to produce an image that joins past and present together in a perfectly
logical union? In *On the Nature of Things*, Lucretius repeatedly intimates that

* Warm thanks to Shane Butler, who conceptualized Deep Classics, and without whom many of the
ideas entertained in this essay would simply not have come to the surface of my page. Warm thanks
also to James Porter for reading the essay closely and offering characteristically incisive comments,
and to Duncan Kennedy for saving me from a conceptual error!

his addressee, Memmius, lacks the sufficient focus to capture the Epicurean vision in its total depth. Modern criticism has come to understand this characterization of Memmius as a didactic strategy by which the poet presses upon his readers the significance of his philosophical message.[1] Yet one cannot help sympathizing with this young late Roman Republican and the task ahead of him: for how exactly is he to learn Lucretius' lesson after the pose of Epicurus? My use of the preposition 'after' should be stressed at this point. It is meant to convey a sense of methodological anxiety of sorts: the only way in which Memmius can grasp it all – what he is made of, the causes of what he sees, tastes, hears, feels and knows, as well as the cosmic history that gives birth to the natural world and its civilizations – is in the astonishing, albeit daunting, manner of Epicurus. But if Memmius is subject to this methodological anxiety, what can be said about his teacher Lucretius? Where does the poet stand in his own intellectual pursuit of a full vision of the atomic universe? Indeed, we could place Lucretius somewhere higher than Memmius if we were to observe what some scholars call the 'teacher-student constellation', a phrase that designates the often hierarchical role that the didactic master has over his pupil vis-à-vis their object of investigation in Latin didactic texts and, especially, in *On the Nature of Things*.[2] Yet though Lucretius may be equipped with a superior grasp of the Epicurean vision, like all of us, he ultimately is unable to stare directly at the world of atoms.[3] Epicurus' is therefore a project which, though fascinating and tempting, defies our ability to conceive of the whole outside the confines of our world.

We often experience a similar methodological anxiety in our long-standing pursuit of the classical world. As we strive to obtain the fullest image of Greco-Roman antiquity possible, a simple fact stands true for us: the distant past will remain mostly buried or ruined, even lost, and our spoils, unlike those of Epicurus, will only ever amount to a partial haul. It remains true that no matter how many lines we manage to restore or interpolate, how much material we find under the ground or scattered amongst ruins, or what new evidence we uncover, our knowledge of that past will always be transmitted to us in parts. Unless past and present were unprecedentedly to unite in a single moment and place, responses to the lacunose end of *On the Nature of Things*, book 6, will probably continue to be a matter of scholarly conjecture, the inscribed fragment of the *Res Gestae* of Augustus found in Ancyra will likely retain its

beautifully fractured shape, and the reasons for an Ovid in exile will remain a secret (or a ruse!) that the poet took to his grave. If, then, full pictures of past cultures, like those of the classical Greeks and Romans, can only be partially reconstructed, imagined or entertained rather than fully known, why do we insist on pursuing antiquity with Epicurean zeal? Why is this model of cognition so pervasive in our search? We may even venture to wonder: what is it that we are after, after all? For, if we were to recover that classical past in its entirety, we would certainly feel the pleasure of its full disclosure: but would that mean that we have quenched our desire to know – more, and more, and more?

A psychoanalytical view may suggest that our insistence on seeking the classical past fully entails something of a pathology that the French call *la douleur exquise*: that bittersweet pain of realizing, with certainty, that there are marked limits to our ability to obtain something whole, while simultaneously attempting to prevail over those very limits in the hope of succeeding anyway. The pursuit of antiquity as a *douleur exquise* also points to a realization that those involved in the study of the classical world may find hard to accept: we may not be after the end product exactly but rather after the *frisson* of the quest. And the thrill of the quest is by no means a superficial aspect of our approach to knowledge acquisition. It powerfully suggests that what we are after can perhaps be found somewhere in-between: in-between the experience of not knowing and getting to know, and in-between the moments and spaces in which we position ourselves to contemplate the past.

The Argentine author Jorge Luis Borges (Buenos Aires 1899–Geneva 1986), one of the most extraordinary literary minds of the twentieth century, is an important exponent of this idea and approach. Acutely aware of the elusiveness of the past, Borges offers a model for plotting classical antiquity which, as the present volume seeks to explore, neither focuses on the point in which it is said to originate nor attempts to account for its uses at specific points of reception, but instead directs our attention to the texture Greco-Roman literature and culture acquire in time. Yet Borges' classicism has some specific qualities. First of all, the character of his authorship gives a particular feel to his engagement with classical texts. Culturally speaking, he is neither an Argentine nor a European author but, rather, a global author who emerges at the crossroads of two very distinct cultures and understandings of the

West: that of Western Europe and that of early- and mid-twentieth-century postcolonial Argentina.[4] Thus his engagement with antiquity often discloses tensions at play between the two traditions: the Western European, with its tendency to conceive the Greco-Roman world at the very heart of its cultural history, and the Latin American, which aims to plot, challenge, even reject, Western European conceptions of the Classics from a postcolonial, and often decentred perspective.[5] Also key to Borges' dialogue with antiquity is his mode of citation. His references to Greco-Roman texts tend to be brief and accompanied by a kaleidoscope of references to other literatures spanning space and time. In fact, almost all of his fictions, poems, and essays offer the reader an intertextual mosaic of passing, erudite citations of the Bible, the Quran, the *Odyssey*, the *Aeneid*, the *Arabian Nights*, or the *Divine Comedy*, to name just a few, as well as to the last twenty centuries of Eastern and Western philosophy and literature, without a specific concern for the orders of cultural history and its traditions.

An equally central aspect to Borges' appeal to Greco-Roman texts (and texts more generally) is that he regards this literature, without exception, as *fragmentary phenomena*: 'drafts' or 'unfinished texts' whose complete meaning, texture and context will always escape us and be partially subject to spatial and temporal circumstance. Thus, for Borges, Homer's *Odyssey* is as much a redrafting of its previous oral tradition, as the Anglo translations by Chapman (1614), Pope (1725) or Butler (1900) are drafts of the Homeric text itself.[6] In this sense, any subsequent response to the *Odyssey* becomes equally as authoritative as Homer's own response to the oral tradition of Odysseus in the first place. And so on *ad infinitum*. In both challenging the status of a classical text as original and re-conceptualizing that text's entity as an unfinished phenomenon, Borges subtly works to decontextualize the classical tradition, particularly as understood by the Western European world. In the Borgesian literary system, a classical text or theme can be easily located in any shape or form, whether in Chapman's translation of Homer ('The Homeric Versions'), in Kafka's creative adaption of Zeno's paradox of Achilles and the arrow in *The Castle* ('Kafka and His Precursors'), in an Uruguayan *gaucho*'s idiosyncratic reading of Pliny's *Natural History* chapter 24 on memory ('Funes, His Memory'), or in Borges' own identification of Julius Caesar with president Kennedy in '*In Memoriam*, J.F.K.'.

In turn, the configuration of literature as fragmentary phenomena underscores another feature of Borges' reading of antiquity: that of reception without time. By appeal to both the Heraclitean river metaphor and notions of cosmic time, Borges' outlook on the human literary past, whether Eastern or Western, Classical, Medieval, Romantic or Argentine Gauchesque, becomes emphatically atemporal.[7] We shall see that his interest in the literary past is not concerned with how it may be made known and recollected fully within the temporal orders of literary history. His interest is with the question of how we may plot that past as it successively and randomly re-emerges on the ever-changing literary page.

I have discussed above the question of the desires and frustrations that we, like Lucretius and Memmius in their search for the first atoms, experience in our attempt to gain a fuller understanding, even possession, of ancient Greece and Rome. I also introduced the various features that characterize Borges' modality of reading antiquity and past literature more broadly, a modality which, as I will demonstrate below, has points of contact with, but also departure from, that which we find in Lucretius' Epicurus. As is the case of Lucretius, totalizing visions of the universe that fuse past and present into a single point where all things are revealed fascinate Borges utterly. However, unlike Lucretius, Borges is keen to treat this type of putative revelation as an illusion of a reality which is not only outside of our human reach but, also sadly, fraught with an overwhelming sense of frustration and disappointment. But Borges is not content with simply reminding us of the limitations of our gnostic search. Instead, his oeuvre points to an alternative mode of plotting the past, including, fairly extensively, the Greco-Roman past.

At this juncture we may thus consider the notion of a 'Borges after the pose of Epicurus'. This is where the semantics of the preposition 'after' shifts once more, in this instance to convey the idea of *succession*, thinking about the Borgesian stance as a subsequent model for experiencing knowledge of classical literature in particular. I would like to argue that Borges' perceptive responses to the tensions brought to bear by approaches to knowledge acquisition, such as those of Lucretius' Epicurus, not only offer alternative – and indeed therapeutic – receptions of the Greco-Roman past, but also prompt us to think of the Argentine author as a, if not *the*, Deep Classics thinker of our time.

The lessons of 'The Aleph' and the depths of Babel

The four hexameters in which Lucretius narrates the Epicurean project could have easily formed the raw material that Borges incorporates with dexterity in collections such as *Fictions* and *The Aleph and Other Stories*. First published in Buenos Aires in the mid and late 1940s, and subsequently translated into multiple languages, the collections interweave a series of themes also found at the heart of Lucretius' oeuvre: dreams, visions, quests and discoveries, the intellectual crossings of time and space, the nature of reality, as well as the central question of how humans attempt to unlock the mystery of the universe itself. However, unlike Lucretius' insistence that we can succeed in our search for total knowledge as Epicurus did, Borges' fictions are rarely stories of gnostic success. Instead, they collectively tend to dramatize with utmost sensibility the psychology and pathos experienced by those who, coming close to totalizing visions of the world, ultimately fail to gain, let alone retain the memory of, such visions fully.

One story that expands on this idea is 'The Aleph' (1949), whose central theme is man's burning desire and obsession to attain a complete image of the world, even one that contains his own self, a story which Italo Calvino, a self-confessed successor of Borges,[8] brilliantly reworks in his novel *Mr Palomar*. 'The Aleph' is set in Buenos Aires in the 1930s and 1940s bourgeoisie, and its central characters are two literary-inclined men, Carlos Argentino Daneri and a fictional Borges. Structurally speaking, the story is organized into two loosely related narrative halves. The first half relates Borges' visits to Carlos Argentino's home on the successive anniversaries of the death of the latter's cousin, Beatriz Viterbo, with whom Borges had been madly in love.[9] The men have little in common, especially when it comes to their literary taste: Borges admires what a classicist would identify as an Alexandrian sense of brevity and erudition (indeed the story cites the Greco-Roman classics from Homer to Virgil), while Carlos Argentino enjoys verbose and clichéd pieces. As the narrative unfolds, the story metamorphosizes into the subject of universal vision and the question of how each man reacts to the reception of total knowledge disclosed to him. It is at this point that the reader first encounters the Aleph, an object that Carlos Argentino finds in his cellar and consults as he writes a copious encyclopaedic work. The Aleph is the first letter of the Hebrew alphabet and

has important theological associations with the Kabbalah.[10] Yet, in Borges' story, it is described as a curious optical contraption shaped like a small glass sphere through which the whole universe may be glimpsed simultaneously at a single glance from within and without the confines of human history. But the Aleph is not a gadget that many can handle. It requires an astute user, like the fictional Borges, able to grasp the tensions brought to bear between the infinite multiplicity that the Aleph reveals and the limited ability of his human mind to grasp and retain that very vision as time passes. After enumerating the exhaustive catalogue of the things he has seen through the Aleph, Borges next relates a series of final simultaneous visions which include the vertiginous image of the Aleph itself:

> I saw ... I saw ... I saw the Aleph from everywhere at once, saw the earth in the Aleph, and the Aleph once more in the earth and the earth in the Aleph, saw my face and my viscera, saw your face, and I felt dizzy, and I wept, because my eyes had seen that secret, hypothetical object whose name has been usurped by men but which no man has ever truly looked upon: the inconceivable universe.[11]

The Aleph allows humans to achieve what is humanly impossible: to view the universe as Epicurus did: all at once and inside out through its vast multiplicity. But what can a Borges expect to feel after he grasps this simultaneous vision of the whole and returns to the ordinary visions of his mortal world? How can he retell the contents that he saw through the Aleph to the mortal world around him without appealing to our human need for narrative sequence and, crucially, without *forgetting* all that he has seen? How can he make the inconceivable world *conceivable* to the human mind?

> Out in the street, on the steps of the Constitución Station, in the subway, all the faces seemed familiar. I feared there was nothing that had the power to surprise or astonish me anymore, I feared that I would never again be without a sense of *déjà vu*. Fortunately, after a few unsleeping nights, forgetfulness began to work in me again ... Our minds are permeable to forgetfulness; I myself am distorting and losing, through the tragic erosion of the years ...[12]

'The Aleph' taps into a central tension explored by the deep classicist: that of memory as a means to recreate, complete and preserve the past, on the one

hand, and that of memory as a fragile entity that wears away in time and renders our human knowledge hopelessly fragmentary. As time passes, Borges will remember some of the things that he saw through the Aleph and inevitably forget others. His knowledge of the inconceivable universe will then always be necessarily selective, incomplete, partially eclipsed and non-simultaneous. The 'erosion of the years' therefore gives a particular texture to the past, one that renders our memory of it partial and, above all, human.[13] This is perhaps why, Borges would argue, we may sometimes experience the classical past as a kind of *déjà vu*: that bizarre feeling which emerges as we recall a past that appears simultaneously familiar and alien to us.

The lessons that can be drawn from a reading of 'The Aleph' acquire a further dimension in Borges' celebrated fiction, 'The Library of Babel'. The narrative is punctuated by Lucretian allusions and arguably gives us the best insight into the pathology that Borges sees at the heart of those who apply models of cognition in the manner of Lucretius' Epicurus. Unlike our private, public and university libraries, Babel, a metaphor for the universe itself, is laid out in repeated hexagons holding a series of equally repeating texts whose contents are predictable yet unintelligible to the human mind. The librarians in each hexagon, variably referred to as 'pilgrims', 'infidels' or 'inquisitors', persist in their driven search for knowledge of the source of all sources: the Total Book holding the elusive clue to the revelation of all the texts contained in Babel. We learn from the main narrator that the list of what may be disclosed in the Total Library is as deeply vertiginous as that revealed by the Aleph. It spans space and time and contains all that has been or will be lost, forgotten or ignored, as well as all the paratextual guidance to access all forms of literature, which, for Borges, means all branches of knowledge, including philosophy and the sciences:

> The Library is "total" – perfect, complete, and whole ... its bookshelves contain all ... all that is able to be expressed, in every language. *All* – the detailed history of the future, the autobiographies of archangels, the faithful catalogue of the Library, thousands and thousands of false catalogues, the proof of the falsity of those catalogues, the proof of the falsity of the true catalogue, the Gnostic gospel of Basilides, the commentary upon that gospel, the commentary on the commentary on that gospel, the true story of your death, the translation of every book in every language, the interpolations of

every book in all books, the treatise Bede could have written (but did not) on the mythology of the Saxon people, the lost books of Tacitus.[14]

Babel represents the extraordinary concept of what is known in Borges' Spanish as 'la literatura completa', the Universe of Letters which exists in and outside of the world of human letters, as well as in and outside of human time, and where nothing remains unwritten and therefore unread. It is this notion that feeds into the euphoria of the competing librarians of earlier centuries, as their search now is driven by an utterly consuming desire to know:

> When it was announced that the Library contained all books, the first reaction was unbounded joy. All men felt themselves to be the possessors of an intact and secret treasure. There was no personal or world problem whose eloquent solution did not exist – somewhere in some hexagon. The universe was justified, the universe suddenly usurped the unlimited dimensions of hope.[15]

Yet frustration and disillusion follow this omnipotent sense of promise and hope, as the ancient librarians eventually realize that the quest for the Universe of Letters is an unattainable project:

> The unbridled hopefulness was succeeded, naturally enough, by a similarly disproportional depression. The certainty that some bookshelf in some hexagon contained precious books, yet those precious books were forever out of reach, was almost intolerable.[16]

By the end of this fiction, the 'depression' experienced by generations of librarians in the hexagons of Babel is seen as the result of a modality of knowledge acquisition which is spectacularly doomed to fail. And there lies the pathos of Babel: the place is dramatically marked by the profound distance that exists between human endeavour and the impossiblity making the 'all' of Babel *known*. Thus the narrator brings final authority and a moral to his tale:

> Methodical composition distracts me from the present condition of humanity. The certainty that everything has already been written annuls us, or renders us phantasmal. I know of districts in which young people prostrate themselves before books and like savages kiss their pages, though they cannot read a letter ... I believe I have mentioned suicides, more and more frequent every year. I am perhaps misled by old age and fear, but I suspect that the human species – the *only* species – is about to be extinguished, but

the Library will endure: illuminated, solitary, infinite, perfectly motionless, equipped with precious volumes, useless, incorruptible, secret.[17]

Rarely has the insurmountable distance between our desire to know and the pleasure of knowing fully been so acutely and imaginatively articulated. But not all in Babel ends in despair and frustration. For Borges gives us a sense of hope in the form of a methodological consolation:

> *The library is unlimited but periodic.* If an eternal traveller should journey in any direction, he would find after untold centuries that the same volumes are repeated in the same disorder – which, repeated, becomes order: the Order. My solitude is cheered by that elegant hope.[18]

The infinity of Babel makes it impossible for humans to apprehend fully the Universe of Letters, i.e., the total literature, or the 'written' story, that pre-dates the history of our own literary production, but that also somehow explains it. For Epicurus, that story would amount to the textuality of the atomic universe; for Borges' librarians, to the Total Book. However, because Babel operates as a cyclical structure, the librarians may glimpse the Universe of Letters as it emerges randomly and periodically through our own literary productions. It is this cyclical order, Borges contends, that makes our literature an ever-recurring, albeit partial, phenomenon. A part of the whole which it is impossible for us to view in its totality. It is at the core of this notion that we can locate the Borgesian modality of reading, which directs its efforts to plot the literary past and its tradition as a series of texts whose status is always partial or incomplete.

We may imagine that the putatively eternal traveller mentioned by the narrator at the end of this fiction is someone like Epicurus, able to reach and inspect all original volumes, as the philosopher does as he discovers the full textuality of the atomic universe. But I would like to suggest that this traveller is, rather, someone like the Borgesian reader, who brings a sense of interpretative order out of the disorder that she or he knows exists at the core of our engagement with the past. This kind of reader is emphatically not concerned with revealing the sources that can help us grasp past literature in its totality. Instead she or he travels, as it were, through the centuries which have produced human letters, letters always so partially transmitted, with the 'elegant hope' of contemplating how they mean and what texture they acquire successively yet fragmentarily. This approach to the literary past is, I contend, what makes

Borges' approach a model for reading the classical past of the kind explored in this volume: for him, our most productive receptions of literature are those which come to the page's surface through a poetics of reading in-between wanting to know and accepting that we cannot possibly fully know. Virtually all of Borges' oeuvre discloses this philosophy of reading, though it is unlikely that Borges would have called it 'deep reading'; for him, this would have been quite naturally 'reading'. His entire production also reveals a form of reception of the literary past akin to the deep classicist's understanding of how texts' meanings emerge in the tradition. In the Borgesian poetics of reading, literature, whether classical, medieval, modern or world, is by definition *incomplete*.

Ricardo Piglia, who, together with Alberto Manguel, is among the most perceptive readers of Borges himself, points to this notion in a recent public lecture on him:

> Borges most aptly conveys the sense of the unfinished text: the idea that there is always something left to read, even if this is lost or unknown, and that this very part which remains unread determines what and how we actually read.[19]

For Borges, every text forms part of a larger text which we may only get to know partially. From this perspective, Borges insists, the *Odyssey* is not a definitive text that explains subsequent adaptations and translations, but an unfinished text, or a version of an older oral version (of which we know so little), just as subsequent translations in any language of Homer's epic are versions of versions themselves. Like the river of Heraclitus, which Borges so frequently celebrates in his work, all literature is not only incomplete, but also crucially *in flux*.

The river of time and the eclipsed literary past

I would like to close my discussion with one example of how Borges plots the classical tradition as fragmentary phenomena that are either revealed or eclipsed for successive generations of readers. Cultural memory and the transmission of the canon are the central focus of one of Borges' less-well known poems, titled 'To a Minor Poet of the Greek Anthology'. Borges' poem

(which is conveniently available in Spanish with a facing English translation, quoted in the following, by poet W.S. Merwin in Borges 1999: 166–7) imagines a life and an afterlife for a Greek poet whose work we do not know because it is lost to us. The narrator tells us that all we seem to know is that this 'eclipsed' poet heard the nightingale early one evening ('de ti sólo sabemos, oscuro amigo, / que oíste al ruiseñor, una tarde'). As for his afterlife, we learn that he now dwells in oblivion, 'among the asphodels of the Shadow' ('entre los asfodelos de la sombra'), forever listening to the song of the nightingale of Theocritus, 'in the rapt evening that will never be night' ('en el éxtasis de un atardecer que no será una noche'). The fate of this poet moreover is contrasted with the fate of canonical authors, whose lives and works we remember and celebrate. The poem has several things to say about what Borges makes of the role of time and recollection in our knowledge of classical literature and its authors. It does so by opening with a clever appeal to a cultural memory that rests solely on an indexed name in the anthology:

Where now is the memory
Of the days that were yours on earth...?
The river of years has lost them
From its numbered current; you are a word in an index.

The current of time, here expressed by a clear allusion to the Heraclitean metaphor of the ever-flowing river, has not only demoted an ancient Greek author of epigrams into a minor poet but, also pointedly, into a 'word in an index', whose name we, Borges' readers, don't even know. Unlike the memory of other glorified poets, which time has preserved partially through inscriptions of various sorts and the work of 'conscientious historians' ('puntuales historiadores'), we only know, as we have seen, that this elusive poet has heard the nightingale. And here is where the index of his unnamed name can become a threshold of interpretation, to use Genette's metaphor for paratexts.[20] For the nightingale, that bird which in western tradition becomes a trope for sorrow and lament,[21] directs our classical literary memory to the nightingales we know a little more, such as the *philomela* of Virgil, *Georgics* 4, to cite an intertext that resonates strongly in the context of Borges' text, and which, from the shadow of a poplar, laments Orpheus' loss of his wife, Eurydice.[22] This more palpable memory of the Virgilian past stays with us as we continue to read

Borges' poem to its last line, when we are taken even further back in time, to the singing of the *philomela* of Theocritus ('oyes la voz del ruiseñor de Teócrito'), to which the minor poet now listens extra-temporally from his oblivion. And as we retrace earlier lines of Borges' poem, where the asphodels are mentioned, this Theocritean setting is further reconfigured into another well-know image, that of *Odyssey* 11 and 24, in which the *asphodelos* is the symbolic flower of the shades. Yet Borges' poem also seems to be working within a wider allusive network. We may not be wrong to wonder if – especially because the poem alludes to Heraclitus via the river metaphor – in composing this piece he is also specifically thinking about the Heraclitus of the *Greek Anthology* 7.465, the single epigram (and thus the one and only index entry) that we possess by that author. That epigram is also often read in conjunction with 7.80 by Callimachus, which refers to Heraclitus' collected works as *Aēdones*, or *Nightingales*, and which happens to associate spatial and temporal distance with loss, memory, mourning and the favour of the gods:[23]

Εἶπέ τις, Ἡράκλειτε, τεὸν μόρον ἐς δέ με δάκρυ
 ἤγαγεν· ἐμνήσθην δ᾽, ὁσσάκις ἀμφότεροι
ἥέλιον [ἐν] λέσχῃ κατεδύσαμεν. ἀλλὰ σὺ μέν που,
 ξεῖν᾽ Ἁλικαρνησεῦ, τετράπαλαι σποδιή,
αἱ δὲ τεαὶ ζώουσιν ἀηδόνες, ᾗσιν ὁ πάντων
 ἁρπακτὴς Ἀίδης οὐκ ἐπὶ χεῖρα βαλεῖ.

Someone told me of your death, Heraclitus, and it moved me to tears, when I remembered how often the sun set on our talking. And you, my Halicarnassian friend, lie somewhere, gone long long ago to dust; but they live, your Nightingales, on which Hades who seizes all shall not lay his hands.[24]

The Callimachean epigram contains the central themes explored by Borges: nightingales, death, memory, time's passing and the capricious favour of the gods on some and not others. But whether Borges is thinking specifically about Heraclitus' *Nightingales* (we simply don't have enough internal or external evidence to know which author or poem this may be)[25] is perhaps besides the point. His poem functions in such a way that our memory of more allusive literary nightingales, such as those of Heraclitus, or even those of Ovid and

Keats, are equally possible within the network of what Borges regards as the Universe of Human Letters. He has brought some memories of the history of the literary nightingale to the texual surface of his poem, not all, and he will bring other memories elsewhere in his late poetic oeuvre, such as in 'To the Nightingale'.[26] His poem clearly thrives on a kaleidoscope of nightingale citations and memories which may include even the Sufi tradition of the celebrated bird.

While the poem is open to a complex system of allusion and intertext, its more direct content invites us to recreate a collective memory of what we may regard as a most incomplete text: an index in an anthology, whose actual text we don't know. But this index is no simple paratext: it is in this case an entry point into recalling tangible yet distant memories of the classical literary past. Thus we are encouraged to remember not to forget that the eclipsed poet of the anthology has heard the nightingale of Theocritus' *Idylls*, which a Virgil himself hears in his *Georgics* 4, as later does an Ovid in *Metamorphoses* 6, and that we may even hear in Heraclitus and Keats. What is more, the eclipsed poet is now eternally surrounded by asphodels, flowers we know best from our reading of Homer. The narratology of this intertextual memory is, once more, based on the temporality of the Heraclitean river metaphor, which, in its eternally running course, allows some texts to continue to be visible to us (Homer, Theocritus, Virgil), while it eclipses others (such as our minor Greek poet who, we may wonder, could even be Heraclitus, whose *Nightingales* are now lost to us). Most provocatively though, because of Borges' unique form of reading, we can now reconfigure our cultural memory of Homer, Heraclitus, Theocritus, and Virgil, thinking of classical asphodels, rivers, and nightingales also as indexes to our elusive poet of the anthology. It's all about the entry points and meaning in-between, and never about attempting to recuperate fully what we know, and accept, is lost or forgotten.

Classical receptions after Borges

Successive time gives a texture to the way we read the Universe of Human Letters. It also canonizes parts of that universe, while obscuring other parts, as the minor poet whose memory Borges celebrates was obscured for us (and

whom we may only recuperate by allusion and mnemonic intertextuality). And thus the texture of Borges' reading of classical literature as fragmentary phenomena rests on a series of zoomings-in and out. The minor poet, whom he has encountered while running his index finger through the last pages of the anthology, becomes a playful paratext with which he dramatizes the gaps in our memory of the minor poet's tradition and reconfigures the way we read canonical authors. A historicist perhaps would argue that Borges' allusion to Heraclitus' *Aēdones* gives a tangible element with which to reconstruct the context of the mysterious poem and his author. Yet the fact that Borges refuses fairly consistently to disclose the identity of their author should not escape us. The poem and its playful revelations may perhaps more profitably be interpreted as a performance of the very model of reading antiquity which Borges presents to us throughout his oeuvre: he gives us a minor poet of the *Greek Anthology* partially eclipsed, partially lost, but whom we are free to recuperate by allusive memory and connections. And so the knowledge of the lost and unrecoverable (?) books of Tacitus contained somewhere in Babel determines the way we read while recalling the incompleteness of the Tacitean text itself. Or the knowledge of an earlier version of the *Amores*, containing five books (whether in the literary imagination of Ovid or in some lost bookrolls), which seems relentlessly to determine the way we approach our reading of the last of the Augustan elegists.[27] The list of examples of Classics as an unfinished text is vast, from Sappho onwards and beyond.

Throughout this chapter, I have discussed two approaches to reading the classical past: one after the manner of Epicurus, which, as I pointed out in my introductory remarks, can be seen as a rubric for the readerly poses that dominate our pursuit of antiquity, and another after the manner of a reader like Borges. Borges' approach to antiquity and, more specifically, to Greco-Roman literature, has points of contact with and departure from the kind of method and approach one finds in Lucretius' Epicurus. Visions of the whole and the recuperation of original knowledge are themes that abound the Borgesian page. Yet unlike Lucretius' Epicurus, Borges' treatment of these themes warn us about the impossibility of making the past fully known, while suggesting one of the most fruitful alternatives for reading that past. Thus I have built my argument from the perspective of Deep Classics (or quite simply as a fan of Borges' Classics!) to draw attention to an important twentieth-century implicit

response to the Epicurean model of cognition which, in its radical refusal to recollect the classical past fully, directs our attention to our choices as methodological beings. We don't always have to read for the whole: we can read in-between, fragmentarily, accepting the partial disclosures that antiquity presents to us without wanting to bridge the gap between knowing and not knowing. We can read antiquity as a *douleur exquise*. And that is fine too.

<p style="text-align:center">✳ ✳ ✳</p>

Blindness played an important part in Borges' sensorial experience of the world around him, and especially during his world tours towards the end of his life. In an interview with Osvaldo Ferrari in 1984, two years before his death, Borges explains the reasons behind his increasing desire to travel: 'One of the reasons is blindness, the business of sensing countries, even at my old age, without actually seeing them.'[28] In his last tour around continental Europe, Borges was photographed at the ruins of Selinunte in Sicily (Figure 9). The image can be frustrating to those who would prefer to see Borges' facial expression as he encounters the ruins around him. But to those whom I may have persuaded with my argument, the image could not be more evocative of the Argentine author's mode of contemplating antiquity. As we observe the back of Borges' head, what do we see that he may be seeing, even when we know that by the summer of 1984 he is almost fully blind? How does he experience the knowledge of the remains of the Temple of Hera in this ancient Greek city in Sicily, compared to others, who, in their most admirable Epicurean effort, bravely continue to dig the earth and search amongst ruins to make the fragmentary stories of the classical past ever so complete?

Figure 9 Jorge Luis Borges at the ruins of Selinunte, Sicily (1984), by Ferdinando Scianna/Magnum Photos.

Notes

1 Volk (2002: 69–83); Gale (2007: 13–15).

2 Volk (2002: 36–8).

3 On Lucretius' analogical vision of the atomic universe, see Schrijvers (2007: 255–88). On his attempt to reformat that vision in the structure of his text, see Kennedy (2007: 379–98).

4 Sarlo (1993).

5 For the nuanced interplay between the centre and the periphery in Borges, see de Toro (1995: 11–43).

6 'The Homeric Versions', Borges (1999: 69–74).

7 Borges' references to the river of Heraclitus metaphor are numerous in his poetic oeuvre in particular. For an introductory discussion of the trope, see Wilson (2013: 187–8). On his conceptualization of time and the category of cosmic time, see especially 'Circular Time' and 'A New Refutation of Time', Borges (1999: 225–8 and 317–32, respectively). For a general study of configurations of time in Borges' work, see Griffin (2013).

8 Calvino (1999: 237–43).

9 The names of Daneri and Beatriz are often read as a comic allusion to Dante's *Divine Comedy*. Other literary intertexts are suggested by the fiction's structural form. This is especially the case when the narrative reaches the cellar, where the Aleph can be found, and which appears to be a kind of labyrinth whose architectural structure could have been designed by Daedalus. For a discussion of both allusions, see González Echevarría (2013: 127).

10 On Borges and the *Kabbalah* as an ancient tradition of mythical interpretation, see Fishburn (2013: 57–60). On the Aleph and Kabbalistic interpretation, see González Echevarría (2013: 125).

11 Borges (1998: 283–4).

12 Borges (1998: 284).

13 I am aware that there may be a lurking complexity when it comes to the question of narrative of events of human memory, since one can argue that human memory in fact *imposes* simultaneity on sequences of events. In this sense, the vision of the Aleph could itself be regarded as the ordinary, rather than the extraordinary one. I am grateful to Shane Butler for discussing this point with me.

14 Borges (1998: 115).

15 Borges (1998: 115).

16 Borges (1998: 115).

17 Borges (1998: 118).

18 Borges (1998: 118).

19 'Borges, por Piglia', TV Pública, Buenos Aires, Lecture 1 (22 August 2013); my translation.

20 Genette (1997); Jansen (2014).

21 López-Baralt (2013: 73–4).

22 I offer the example of the nightingale of *Georgics* 4 as a particularly resonant intertext in my own reading of Borges' poem, and because Borges' poem calls for a strong Virgilian allusion via Theocritus. The list of classical nightingales is long, however, and my readers may be thinking of other instances when reading Borges' poem above, such Ovid's *philomela* in *Metamorphoses* 6.519–62, in itself a close intertext to Virgil's *philomela* and its tradition.

23 I am thankful to Daniel Anderson for discussing this allusion with me. For a discussion of the potential relationship between *Greek Anthology* 7.80 and 7.465, see Hunter (1992: 113–23).

24 Gow and Page (1965: xxxiv). Trans. W.R. Paton, with minor alterations.

25 Costa Picazo (2010: 526–7).

26 Borges (1999: 355).

27 Jansen (2012a).

28 Borges and Ferrari (2005: 24), my translation.

Bibliography

Acosta-Hughes, B., E. Kosmetatou, and M. Baumbach, eds (2004), *Labored in Papyrus Leaves: Perspectives on an Epigram Collection Attributed to Posidippus (P.Mil. Vogl. VIII 309)*, Washington, DC: Center for Hellenic Studies.

Amis, K. (1978), *Jake's Thing*, London: Hutchinson.

Anderson, C.G. (1972), 'On the Sublime and its Anal-Urethral Sources in Pope, Eliot and Joyce', in R.J. Porter and J.D. Brophy (eds), *Modern Irish Literature: Essays in honour of W. Y. Tindall*, 235–49, New York: Iona College Press.

Apter, E. and E. Freedgood (2009), 'Afterword', *Representations* 108 (1): 139–49.

Arkins, B. (1999), *Greek and Roman Themes in Joyce*, Lewiston, Queenston, Lampeter: The Edwin Mellen Press.

Arkins, B. (2009), 'Greek and Roman Themes', in J. McCourt (ed.), *James Joyce in Context*, 239–49, Cambridge: Cambridge University Press.

Armagost, J.L. (1971), 'Letter to the Editor', *Newsweek*, 78 (26), 27 December: 5.

Armstrong, R. (2005), *A Compulsion for Antiquity: Freud and the Ancient World*, Ithaca, NY: Cornell University Press.

Artaud, A. (2007), 'Compte rendu de la *Médée* de Sénèque (en version d'Unamuno) représentée par la compagnie de M. Xirgu au Palais de Beaux-Arts du Mexico, dans *El Nacional*, 7 juin 1936', in J.C. Sánchez Léon, *L'Antiquité grecque dans l'oevre d'Antonin Artaud*, Besançon: Presses universitaires de Franche-Comté, 101–3.

Astbury, B. (1979), *The Space/Die Ruimte/Indawo*, Cape Town: Space Theatre.

Attridge, D. (1987), 'Language as History/History as Language: Saussure and the Romance of Etymology', in D. Attridge, G. Bennington and R. Young (eds), *Post-structuralism and the Question of History*, 183–211, Cambridge: Cambridge University Press. [Revised version: D. Attridge (1988), *Peculiar Language: Literature as Difference from the Renaissance to James Joyce*, Ithaca, NY: Cornell University Press, 90–126].

Auden, W.H. (1989), *Selected Poems*, New York: Vintage International.

Auerbach, E. (1953), *Mimesis: The Representation of Reality in Western Literature*, trans. W.R. Trask, Princeton: Princeton University Press.

Aurobindo, S. (1990), *The Life Divine*, Twin Lakes, WI: Lotus Press.

Bailey, E.B. (1967), *James Hutton: The Founder of Modern Geology*, Amsterdam: Elsevier.

Bakker, E.J., ed. (2010), *A Companion to the Ancient Greek Language*, Malden, MA: Wiley-Blackwell.

Balayé, S. (1971), *Les carnets de voyage de Madame de Staël: Contribution à la genèse de ses oeuvres*, Genève: Librarie Droz.

Barkan, L. (1999), *Unearthing the Past: Archaeology and Aesthetics in the Making of Renaissance Culture*, New Haven: Yale University Press.

Barnes, T. (2009), 'Homeric μῶλος Ἄρηος, Hittite *mallai ḫarrai*', in S.W. Jamison, H.C. Melchert and B. Vine (eds), *Proceedings of the 20th Annual UCLA Indo-European Conference, Los Angeles, October 31–November 1, 2008*, 1–17, Bremen: Hempen.

Barrett, W.F. and F.W.H. Myers (1889), 'Review of "D.D. Home, His Life and Mission"'. *Proceedings of the Society for Psychical Research* 4: 101–16.

Bastianini, G. and C. Gallazzi, eds (2001), *Posidippo di Pella: 'Epigrammi' (P. Mil. Vogl. 8. 309)*, Milan: Edizioni Universitarie di Lettere, Economia, Diritto.

Bataille, G. (1985 [1994]), 'The Solar Anus', in *Visions of Excess: Selected Writings, 1927–1939*, ed. and trans. A. Stoekl, 5–9, Minneapolis: University of Minnesota Press.

Batteux, C. (1746), *Les beaux arts réduits à un même principe*, Paris: Durand.

Baumbach, M., A. Petrovic and I. Petrovic, eds (2010), *Archaic and Classical Greek Epigram*, Cambridge: Cambridge University Press.

Beard, M. and J. Henderson (2001), *Classical Art from Greece to Rome*, Oxford: Oxford University Press.

Beccadelli, A. (2010), *The Hermaphrodite*, trans. Holt N. Parker, Cambridge, Mass.: Harvard University Press.

Beckford, W. (1993), 'The Vision: manuscript of a romance', in M. Jack (ed.), *Vathek and Other Stories: A William Beckford Reader*, 1–26, London: William Pickering.

Beckford, W. (2006), *Dreams, Waking Thoughts, and Incidents*, ed. R.J. Gemmett, Stroud: Nonsuch.

Bell, M. (1997), *Literature, Modernism and Myth: Belief and Responsibility in the Twentieth Century*, Cambridge: Cambridge University Press.

Benjamin, W. (1989), 'N. The Theory of Knowledge, Theory of Progress', in G. Smith (ed.), *Benjamin: Philosophy, History, Aesthetics*, 43–83, Chicago: The University of Chicago Press.

Benjamin, W. (1999), *Illuminations*, ed. H. Arendt, trans. H. Zorn, Pimlico: London.

Benvenuto da Imola (1887), *Comentum super Dantis Aldigherij Comoediam*, vol. 1, ed. J.P. Lacaita, Florence: G. Barbèra.

Berger, K. (2007), *Bach's Cycle, Mozart's Arrow: An Essay on the Origins of Musical Modernity*, Berkeley: University of California Press.

Bertaud, M. (1981), *Le thème de la jalousie dans la littérature française à l'époque de Louis XIII*, Geneva: Droz.

Best, S. and S. Marcus (2009), 'Surface Reading: An Introduction', *Representations* 108.1: 1–21.

Bewes, T. (2010), 'Reading with the Grain: A New World in Literary Criticism', *differences* 21 (3): 1–33.

Billings, J. (2010), 'Hyperion's Symposium: An Erotics of Reception', *Classical Receptions Journal* 2 (1): 4–24.

Bisanz, A.J. (1973), 'Zwischen Stoffgeschichte und Thematologie. Betrachtung zu einem literaturhistorischen Dilemma', *Deutsche Vierteljahrsschrift für Literaturwissenschaft und Geistesgeschichte* 47 (1): 148–66.

Bisanz, A.J., ed. (1980), *Elemente der Literatur. Beiträge zur Stoff-, Motiv- und Themenforschung*, Stuttgart: Kröner.

Blackwood, A. (1938), *The Centaur*, London: Penguin.

Blair, A.M. (2010), *Too Much To Know: Managing Scholarly Information before the Modern Age*, New Haven and London: Yale University Press.

Blanshard, A. (2001), 'Hellenic Fantasies: Aesthetics, Desire and Symonds' *A Problem in Greek Ethics*', *Dialogos* 7: 99–123.

Blom, P. (2004), *Encyclopédie: The Triumph of Reason in an Unreasonable Age*, London and New York: Fourth Estate.

Bloomfield, M.W. (1972), 'Pronoun Envy (Continued)', *Harvard Crimson*, 154 (86), 5 January: 2.

Bodei, R. (2011) *Ira: La passione furente*, Bologna: Il Mulino.

Boedecker, D. (1991), 'Euripides' *Medea* and the vanity of *logoi*', *Classical Philology*, 86 (2): 95–112.

Bonardel, F. (1985), *L'Hermétisme*, Paris: P.U.F.

Bonardel, F. (1993), *Philosophie de l'alchimie*, Paris: P.U.F.

Borges, J.L. (1970), 'Kafka and His Precursors', in *Labyrinths. Selected Stories and Other Writings*, trans. D.A. Yates and J.E. Irby, 234–6, London: Penguin.

Borges, J.L., (2004), *Obras Completas* II (1952–1972), ed. R. Costa Picazo, Buenos Aires: Emecé.

Borges, J.L. (1998), *Collected Fictions*, trans. A. Hurley, New York: Penguin.

Borges, J.L. (1999), *Selected Non-Fictions*, ed. E. Weinberger, New York: Penguin.

Borges, J.L. (1999), *Selected Poems*, ed. A. Coleman, New York: Penguin.

Borges, J.L. and O. Ferrari (2005), *En Diálogo / I: Edición Definitiva*, Mexico, Madrid, Buenos Aires.

Bowden, H. (2010), *Mystery Cults of the Ancient World*, London: Thames & Hudson.

Bowker, G. (2005), *Memory Practices in the Sciences*, Cambridge, Mass.: MIT Press.

Bradley, M. (2013), 'Colour as Synaesthetic Experience in Antiquity', in S. Butler and A. Purves (eds), *Synaesthesia and the Ancient Senses*, Durham: Acumen Publishing.

Bradley, M., ed. (2010), *Classics and Imperialism in the British Empire*, Oxford: Oxford University Press.

Brady, S., ed. (2012), *John Addington Symonds (1840–1893) and Homosexuality: A Critical Edition of Sources*, Basingstoke: Palgrave Macmillan.

Braidotti, R. (2011), *Nomadic Subjects: Embodiment and Sexual Difference in Contemporary Feminist Theory*, New York: Columbia University Press.

Bremond, C., J. Landy and T. Pavel, eds (1995), *Thematics: New Approaches,* New York: State University of New York Press.

Brinkema, E. (2014), *The Forms of the Affects*, Durham, NC, Duke University Press.

Brisson, L. (1996), *Einführung in die Philosophie des Mythos*. Vol. 1, Darmstadt: Wissenschaftliche Buchgesellschaft.

Brook, P. (1968), 'Preface' to J. Grotowski, *Towards a Poor Theatre*, New York: Simon & Schuster.

Brown, W. (2001), *Politics Out of History*, Princeton: Princeton University Press.

Browning, R. (1864), *Dramatis Personae*, London: Chapman & Hall.

Buchan, M. (2004), *The Limits of Heroism: Homer and the Ethics of Reading*, Ann Arbor: University of Michigan Press.

Budelmann, F. (2007), 'The Reception of Sophocles' Representation of Physical Pain', *The American Journal of Philology* 128 (4): 443–67.

Budgen, F. (1937), *James Joyce and the Making of 'Ulysses'*, London: Grayson & Grayson.

Butler, E.M. (1935), *The Tyranny of Greece over Germany*, Cambridge: Cambridge University Press.

Butler, S. (2015), *The Ancient Phonograph*, New York: Zone Books.

Bynum, C.W. (1992), 'In Praise of Fragments: History in the Comic Mode', in *Fragmentation and Redemption: Essays on Gender and the Human Body in Medieval Religion*, 11–26: New York: Zone Books.

Bynum, C.W. (2014), 'Avoiding the Tyranny of Morphology; or, Why Compare?', *History of Religions* 53: 341–68.

Byron, G.G. (1854), *The Poetical Works of Lord Byron*, vol. 2, London: John Murray.

Calvino, I. (1999), *Why Read the Classics?*, trans. Martin McLaughlin, London: Jonathan Cape.

Canby, V. (1971), 'Callas stars in Pasolini "Medea"', *New York Times*, 29 October.

Candlin, F. (2010), *Art, Museums, and Touch*, Manchester: Manchester University Press.

Carr, N. (2010), *The Shallows: What the Internet is Doing to Our Brains*, New York: W.W. Norton.

Carson, A. (1986), *Eros the Bittersweet: An Essay*, Princeton: Princeton University Press.

Carson, A. (2014), 'Pronoun Envy', *New Yorker*, 89 (48), 10 February: 48–9.

Chadwick, J. et al., *Corpus of Mycenaean Inscriptions from Knossos*, vol. 1, Cambridge: Cambridge University Press.

Chan, P. (2015), 'Introduction' to *Hippias Minor, or, The Art of Cunning: A New Translation of Plato's Most Controversial Dialogue*, 13–34, Brooklyn and Athens: Badlands Unlimited.

Châtel, L. (1999), 'The Mole, the Bat, and the Fairy or the Sublime Grottoes of "Fonthill Spendens": A Brief Study of Beckford's Contribution to Subterranea Britannica', *The Beckford Journal* 5: 53–74.

Citati, P. (1990), *Goethe*, Milan: Adelphi.

Clackson, J., ed. (2011), *A Companion to the Latin Language*, Malden, MA: Wiley-Blackwell.

Clackson, J. and G. Horrocks (2007), *The Blackwell History of the Latin Language*, Malden, MA: Blackwell.

Clarke, M.J. (2004), 'The Semantics of Colour in the Early Greek Word Hoard', in K. Sears and L. Cleland (eds), *Colour in the Ancient Mediterranean World*, Oxford: J. & E. Hedges.

Clauss, J.J. and S.I. Johnston, eds (1997), *Medea : Essays on Medea in Myth, Literature, Philosophy and Art*, Princeton: Princeton University Press.

Coleridge, S.T. and W. Wordsworth (unsigned) (1798), *Lyrical Ballads, with a Few Other Poems*, Bristol: T.N. Longman.

Colli, G. (1974), *Dopo Nietzsche*, Milan: Adelphi.

Cooper, A.A. (Earl of Shaftesbury) (1709), *The Moralists: A Philosophical Rhapsody. Being a Recital of Certain Conversations Upon Natural and Moral Subjects*, London: John Wyat.

Cooper, J.F. (2001), *The Last of the Mohicans*, New York: Modern Library.

Corbeill, A. (2015), *Sexing the World: Grammatical Gender and Biological Sex in Ancient Rome*, Princeton: Princeton University Press.

Corbin, H. (1989), *Spiritual Body and Celestial Hearth*, trans. N. Pearson, 2nd ed., Princeton: Princeton University Press.

Craft, A. (1998), 'Subterranean Enlightenment at Fonthill', *The Beckford Journal*, 3: 30–3.

Crawforth, H. (2013), *Etymology and the Invention of English in Early Modern Literature*, Cambridge: Cambridge University Press.

Curran, J.V. (2000), 'Goethe's "Helen": A Play within a Play', *International Journal of the Classical Tradition* 7: 165–76.

Curtius, E.R. (2013 [1948]), *European Literature and the Latin Middle Ages*, trans. W.R. Trask, Princeton: Princeton University Press.

Curzan, A. (2003), *Gender Shifts in the History of English*, Cambridge: Cambridge University Press.

Damasio, A. (1999), *The Feeling of What Happens: Body and Emotion in the Making of Consciousness*, New York: Harcourt Brace.

Danius, S. (2001), 'Orpheus and the Machine: Proust as Theorist of Technological Change, and the Case of Joyce', *Forum for Modern Language Studies*, 37 (2): 127–40.

Danius, S. (2008), 'Joyce's Scissors: Modernism and the Dissolution of the Event', *New Literary History*, 39 (4): 989–1016.

Dante (1863), *La Divina Commedia di Dante Alighieri*, Florence: G. Barbèra.

Darwin, C. (1859), *On the Origin of Species by Means of Natural Selection, or the Preservation of Favoured Races in the Struggle for Life*, London: John Murray.

Daston, L., and P. Galison (2010), *Objectivity*, New York: Zone Books.

Davis, A.J. (1866), *Death and the After-Life: Three Lectures*, New York: A.J. Davis & Co.

Davis, W. (1996), 'Winckelmann Divided', in *Replications: Archaeology, Art History, Psychoanalysis*, 257–65, University Park: Pennsylvania State University Press.

De Certeau, M. (1987), *Histoire et psychanalyse entre science et fiction*, Paris: Gallimard.

De Juan, J.L. (2007), *This Breathing World*, trans. M. Schifino and S. Packard, London: Arcadia.

De Man, P. (1983), *Blindness and Insight: Essays in the Rhetoric of Contemporary Criticism*, Abingdon: Routledge.

De Man, P. (2003), 'Literary History and Literary Modernity', in F. Lentricchia and A. DuBois (eds), *Close Reading: The Reader*, 197–215, Durham, NC, and London: Duke University Press.

De Staël, G. (1971), *Les carnets de voyage de Madame de Staël: Contribution à la genèse de ses oeuvres*, ed. S. Balayé, Genève: Librarie Droz.

De Staël, G. (2000), *Corinne, ou l'Italie*, Paris: Champion.

De Staël, G. (2008), *Corinne, or Italy*, trans. S. Raphael, Oxford: Oxford University Press.

De Toro, A. (1995), 'Post-Coloniality and Post-Modernity: Jorge Luis Borges: The Periphery in the Centre, the periphery as the Centre, the Centre of the Periphery', in F. de Toro and A. de Toro (eds), *Borders and Margins: Postcolonialism and Post-Modernism*, 11–43, Frankfurt and Madrid: Vervuert Verlag.

de Vaan, M. (2008), *Etymological Dictionary of Latin and the Other Italic Languages*, Leiden: Brill.

De Villeneuve, R. (1999), 'L'eau à Rome: magnificence et mélancolie' in J.-L. Diaz (ed.) *Madame de Staël, Corinne ou l'Italie: "l'âme se mêle à tout"*, Paris: SEDES.

DeJean, J. (1989), 'Sex and Philology: Sappho and the Rise of German Nationalism', *Representations* 27: 148–71.

Del Maso, C. (2013), *Pompeii: Under the Sign of Isis*, Milan: 24 ORE Cultura.

Derrida, J. (1981), *Positions*, trans. A. Bass, Chicago: University of Chicago Press.

Derrida, J. (1982), *Margins of Philosophy*, trans. A. Bass, Chicago: University of Chicago Press.

Derrida, J. (2006), *Specters of Marx*, trans. P. Kamuf, New York & London: Routledge.

Diderot, D. (1757), *Le fils naturel, ou Les épreuves de la vertu*, Amsterdam [Paris]: Marc-Michel Rey.

Didier, B. (1999), 'Corinne et les mythes' in J.-L. Diaz (ed.), *Madame de Staël, Corinne ou l'Italie: "l'âme se mêle à tout"*, Paris: SEDES.

Didi-Huberman, G. (2002), *L'image survivante. Histoire de l'art et temps de fantômes selon Aby Warburg*, Paris: Édition de Minuit.

Dinshaw, C. (1999), *Getting Medieval: Sexualities and Communities, Pre- and Postmodern*, Durham, NC: Duke University Press.

Dionne, E.J. (1971), 'Two Women Liberate Church Course', *Harvard Crimson*, 154 (55), 11 November: 1 + 4.

Dodds, E.R. (1977), *Missing Persons: An Autobiography*, Oxford: Clarendon Press.

Donalson, M.D. (2003), *The Cult of Isis in the Roman Empire: Isis Invicta*, Lewiston: E. Mellen.

Doran, R. (2015), *The Theory of the Sublime from Longinus to Kant*, Cambridge: Cambridge University Press.

Douglas, A. (1894), 'Two Loves', *The Chameleon* 1.1, 28.

Doyle, A.C. (1930), *The Edge of the Unknown*, London: Murray.

Dupont, F. (2000), *'Médée' de Sénèque ou Comment sortir de l'humanité*, Paris: Belin.

Edelmann, L. (2004), *No Future: Queer Theory and the Death Drive*, Durham, NC: Duke University Press.

Ehrlich, H. (1907), 'Zur Mythologie', *Zeitschrift für Vergleichende Sprachforschung*, 41 (3): 283–304.

Eliot, T.S. (1921), 'Tradition and Individual Talent', *The Sacred Wood: Essays on Poetry and Criticism*, 47–59, New York: Knopf.

Eliot, T.S. (1975), 'Ulysses: Order and Myth', in F. Kermode (ed.), *Selected Prose of T. S. Eliot*, 175–8, London: Faber and Faber.

Ellis, H. and J.A. Symonds (1896), *Das konträre Geschlechtsgefühl*, Leipzig: G.H. Wigand.

Ellis, H. and J.A. Symonds (1897), *Sexual Inversion*, 1st ed., London: Wilson & Macmillan.

Ellmann, R. (1987), *Oscar Wilde*, London: Hamish Hamilton.

Elsner, J. (2014), 'Lithic Poetics: Posidippus and His Stones', *Ramus* 43 (2): 152–72.

Engell, J. (1981), *The Creative Imagination: Enlightenment to Romanticism*, Cambridge, Mass.: Harvard University Press.

Euripides (2012), *Médée*, ed. and trans. M. Gondicas and P. Judet dela Combe, Paris: Les Belles Lettres.

Evangelista, S. (2007), 'Platonic Dons, Adolescent Bodies: Benjamin Jowett, John Addington Symonds, Walter Pater', in G. Rousseau (ed.), *Children and Sexuality: From the Greeks to the Great War*, 206–30, Basingstoke: Palgrave Macmillan.

Ewans, M. (2007), *Opera from the Greek: Studies in the Poetics of Appropriation*. Aldershot: Ashgate.

Fabian, J. (1983), *Time and the Other: How Anthropology Makes Its Object*, New York: Columbia University Press.

Fantham, E. (1986), 'ΖΗΛΟΤΥΠΙΑ: A Brief Excursion into Sex, Violence, and Literary History', *Phoenix* 40 (1): 45–57.

Fantuzzi, M. (2012), *Achilles in Love: Intertextual Studies*, Oxford: Oxford University Press.

Ferguson, Christine (2012), 'Recent Scholarship on Spiritualism and Science', in T. Kontou and S. Willburn (eds), *The Ashgate Research Companion to Nineteenth-Century Spiritualism and the Occult*, 19–24, Farnham: Ashgate.

Fillion-Lahille, J. (1984), *Le 'De ira' de Sénèque et la philosophie stoïcienne des passions*, Paris: Klincksieck.

Fishburn, E. (2013), 'Jewish, Christian, and Gnostic Themes', in E. Williamson (ed.), *The Cambridge Companion to Jorge Luis Borges*, 56–67, Cambridge: Cambridge University Press.

Flaubert, G. (1976), *Bouvard and Pécuchet*, trans. A.J. Krailsheimer, London: Penguin Books.

Forster, E.M. (1923), *Pharos and Pharillon*, London: Hogarth Press.

Fortson, B.W. IV (2010), *Indo-European Language and Culture: An Introduction*, 2nd edn, Malden, MA: Wiley-Blackwell.

Foster, H. (2012), 'Post-Critical', *October* 139: 3–8.

Fowler, D. (2000), *Roman Constructions: Readings in Postmodern Latin*, Oxford: Oxford University Press.

Fox, M. (2013), 'Manners and Method in Classical Criticism of the Early Eighteenth Century', *The Cambridge Classical Journal* 59, 98–124.

Fradenburg, L. and Freccero, C., eds (1996), *Premodern Sexualities*, New York: Routledge.

Frampton, S. (forthcoming) *Alphabetic Order: Writing in Roman Literature and Thought*, Cambridge, Mass.: Harvard University Press.

Francese, J. (1999), 'The Latent Presence of Crocean Aesthetics in Pasolini's "Critical Marxism"', in Z. G. Barański (ed.), *Pasolini Old and New: Surveys and Studies*, 131–62, Dublin: Four Courts Press.

Freccero, C. (2006), *Queer/Early/Modern*, Durham, NC: Duke University Press.

Freccero, C. (2007), 'Queer Times', *South Atlantic Quarterly* 106 (3): 485–94.

Freedgood, E. and C. Schmitt (2014), 'Denotatively, Technically, Literally', *Representations* 125 (1): 1–14.

Frenzel, E. (1980), *Motive der Weltliteratur. Ein Lexikon dichtungsgeschichtlicher Längsschnitte,* Stuttgart: Kröner.

Frenzel, E. (1988), *Stoffe der Weltliteratur. Ein Lexikon dichtungsgeschichtlicher Längsschnitte,* Stuttgart: Kröner.

Freud, S. (1955), *The Standard Edition of the Complete Psychological Works of Sigmund Freud. Volume X: Two Case Histories,* trans. James Strachey, London: The Hogarth Press and the Institute of Psycho-Analysis.

Freud, S. (1961), *The Standard Edition of the Complete Psychological Works of Sigmund Freud. Volume XXI: Civilization and its Discontents,* trans. James Strachey, London: The Hogarth Press and the Institute of Psycho-Analysis.

Fugard, A. (1979), '*Orestes* reconstructed: a letter to an American friend', *Theatre Quarterly* 8 (32): 3–6.

Fugard, A. (1983), *Notebooks 1960/1977: Athol Fugard,* ed. M. Benson, London, Boston: Faber.

Funke, J. (2013), '"We Cannot Be Greek Now": Age Difference, Corruption of Youth and the Making of *Sexual Inversion*', *English Studies* 94 (2): 139–53.

Funnell, P. (1982), 'The Symbolical Language of Antiquity', in M. Clarke and N. Penny (eds), *The Arrogant Connoisseur: Richard Payne Knight 1751–1824,* 56–64, Manchester: Manchester University Press.

Fusillo, M. (2004), 'Pasolini's *Agamemnon*: Translation, Screen Version and Performance', in F. Macintosh, P. Michelakis, E. Hall and O. Taplin (eds), *Agamemnon in Performance: 458 BC to AD 2004,* 223–33, Oxford: Oxford University Press.

Fussell, E. (1964), 'Neutral Territory: Hawthorne on the Figurative Frontier', in R.H. Pearce (ed.), *Hawthorne: Centenary Essays,* 297–316, Columbus: Ohio University Press.

Gale, M. R., ed. (2001), *Oxford Readings in Lucretius,* Oxford: Oxford University Press.

Gallagher, S. (2005), *How the Body Shapes the Mind,* Oxford: Clarendon Press.

Gallese, V. and G. Lakoff (2005), 'The Brain's Concepts: The Role of the Sensory-Motor System in Conceptual Knowledge', *Cognitive Neuropsychology* 22 (3–4): 455–79.

García Ramón, J.L. (2013), 'Italische Personennamen, Sprachkontakt und Sprachvergleich: I. Einige oskische Namen, II. Altlatein *FERTER RESIUS | REX AEQUEICOLUS*', *Linguarum Varietas* 2: 103–17.

Garrington, A. (2013), *Haptic Modernism: Touch and the Tactile in Modernist Writing,* Edinburgh: Edinburgh University Press.

Gazda, E., ed. (2002), *The Ancient Art of Emulation: Studies in Artistic Originality and Tradition from the Present to Classical Antiquity,* Ann Arbor: University of Michigan Press.

Geertz, C. (1973), 'Thick Description: Toward an Interpretive Theory of Culture', *The Interpretation of Cultures: Selected Essays,* 3–30, New York: Basic Books.

Genette, G. (1972), *Narrative Discourse. An Essay in Method,* trans. J.E. Lewin, Cornell, NY: Cornell University Press, 1980.

Genette, G. (1997), *Paratexts: Thresholds of Interpretation,* trans. J.E. Lewin. Cambridge.

Giannakis, G.K., ed. (2014), *Encyclopedia of Ancient Greek Language and Linguistics,* Leiden: Brill.

Gibson, J.J. (1977), 'The Theory of Affordances', in R. Shaw and S. Bransford (eds), *Perceiving, Acting and Knowing: Toward an Ecological Psychology,* Hillsdale: Erlbaum.

Gifford, D. (1988), *'Ulysses' Annotated: Notes for James Joyce's 'Ulysses',* 2nd edn, Berkeley and Los Angeles: University of California Press.

Gildenhard, I. and M. Rühl, eds (2003), *Out of Arcadia: Classics and Politics in Germany in the Age of Burckhardt, Nietzsche and Wilamowitz,* London: Institute of Classical Studies.

Gilman, S.L. (1987), *Conversations with Nietzsche,* trans. D.J. Parent, New York: Oxford University Press.

Giuliani, L. (2001), 'Naturalisierung der Kunst versus Historisierung der Kunst', in G. Most (ed.), *Historicization – Historisierung,* 129–48, Göttingen: Vandenhoeck & Ruprecht.

Gladstone, W.E. (1877), 'The Colour-Sense', *The Nineteenth Century* 2: 366–88.

Goddard, I. et al. (1971), 'Pronoun Envy', *Harvard Crimson,* 154 (59), 16 November: 2.

Goethe, Johann Wolfgang (1985–99), *Sämtliche Werke: Briefe, Tagebücher und Gespräche,* 40 vols, Frankfurt: Deutscher Klassiker Verlag.

Goff, B.E., ed. (2005), *Classics and Colonialism,* London: Duckworth.

Goldberg, J. and M. Menon (2005), 'Queering History', *PMLA* 120 (5), 1608–17.

Goldhill, S. (1984a), 'Two notes on τέλος and related words in the *Oresteia*', *The Journal of Hellenic Studies* 104: 169–76.

Goldhill, S. (1984b), *Language, Sexuality, Narrative. The 'Oresteia',* Cambridge: Cambridge University Press.

Goldhill, S. (2010a), 'Cultural History and Aesthetics: Why Kant is No Place to Start Reception Studies', in E. Hall and S. Harrop (eds), *Theorising Performance: Greek Drama, Cultural History, and Critical Practice,* 56–70: London: Duckworth.

Goldhill, S. (2010b), 'Who Killed Gluck?', in P. Brown and S. Ograjenšek (eds), *Ancient Drama in Music for the Modern Stage*, 210–39. Oxford: Oxford University Press.

González Echevarría, R. (2013), 'The *Aleph*', in E. Williamson (ed.), *The Cambridge Companion to Jorge Luis Borges*, 123–36: Cambridge: Cambridge University Press.

Gould, S.J. (1981), 'Deep Time and Ceaseless Motion', *The New York Review of Books*, May 14.

Gould, S.J. (1987), *Time's Arrow, Time's Cycle: Myth and Metaphor in the Discovery of Geological Time*, Cambridge, Mass.: Harvard University Press.

Gow, A.S.F. and D. L. Page, eds (1965), *The Greek Anthology 1: Hellenistic Epigrams*, Cambridge: Cambridge University Press.

Grafton, A., G. Most and S. Settis, eds (2010), *The Classical Tradition*. Cambridge, MA and London: The Belknap Press of Harvard University Press.

Green, R., ed. (1991), *The Works of Ausonius*, Oxford: Clarendon Press.

Green, R., ed. (1999), *Decimi Magni Ausonii Opera*, Oxford: Clarendon Press.

Greene, N. (1990), *Pier Paolo Pasolini: Cinema as Heresy*, Princeton: Princeton University Press.

Gregg, M. and G. Seigworth, eds (2010), *The Affect Theory Reader*, Durham, NC: Duke University Press.

Grethlein, J. (2013), *Experience and Teleology in Ancient Historiography: 'Future Past' from Herodotus to Augustine*, Cambridge: Cambridge University Press.

Griffin, C. (2013), 'Philosophy and Fiction' in E. Williamson (ed.), *The Cambridge Companion to Jorge Luis Borges*, 5–15, Cambridge: Cambridge University Press.

Griffiths, J.G. (1975), *Apuleius of Madaurus, The Isis Book: Metamorphoses Book 11*, Leiden: Brill.

Grotowski, J. (1968), *Towards a Poor Theatre*, preface by Peter Brook, New York: Simon & Schuster.

Guenon, R. (2004), *The Multiple States of Being*, Hillsdale NY: Sophia Perennis.

Gurd, S.A. (forthcoming), 'David Melnick's *Men in Aïda*', *Classical Receptions Journal*.

Gurrieri, F. and J. Chatfield (1972), *Boboli Gardens*, Florence: Edam.

Güthenke, C. (2008), *Placing Modern Greece: The Dynamics of Romantic Hellenism, 1770–1840*, Oxford: Oxford University Press.

Güthenke, C. (2010), 'The Potter's Daughter's Sons. German Classical Scholarship and the Language of Love circa 1800', *Representations* 109.1, 122–47.

Güthenke, C. (2013), 'Nostalgia and Neutrality: A Response to Charles Martindale', *Classical Receptions Journal* 5: 238–45.

Güthenke, C. (2014), '"Enthusiasm Dwells Only in Specialization": Classical Philology and Disciplinarity in Nineteenth-Century Germany', in B. Elman and S. Pollock (eds), *World Philology*, 304–38, Cambridge, Mass.: Harvard University Press.

Güthenke, C. (2015), 'Emotion und Empathie in der Interpretationspraxis der Klassischen Philologie um 1900', in A. Albrecht, L. Danneberg, et al. (eds), *Theorien, Methoden und Praktiken des Interpretierens*, 145–58, Berlin: De Gruyter.

Güthenke, C., and B. Holmes (forthcoming), 'Hyperinclusivity, Hypercanonicity, and the Future of the Field', in M. Formisano and C. Kraus (eds), *Marginality, Canonicity, and Passion*, Cambridge: Cambridge University Press.

Gutierrez, C. (2009), *Plato's Ghost: Spiritualism in the American Renaissance,* Oxford: Oxford University Press.

Gutwirth, M. (1978), *Madame de Staël, Novelist: The Emergence of the Artist as Woman*, Chicago: University of Illinois Press.

Gutzwiller, K. (2010), 'Heroic Epitaphs of the Classical Age: The Aristotelian *Peplos* and Beyond', in M. Baumbach, A. Petrovic and I. Petrovic (eds), *Archaic and Classical Greek Epigram*, 219–49, Cambridge: Cambridge University Press.

Gutzwiller, K.J. ed. (2005), *The New Posidippus: A Hellenistic Poetry Book*, Oxford: Oxford University Press.

Hägele, H. (2013), *Colour in Sculpture: A Survey From Ancient Mesopotamia to the Present*, Newcastle upon Tyne: Cambridge Scholars Press.

Hallett, J.P. and Stray, C., eds (2009), *British Classics Outside England: the Academy and Beyond*, Waco, TX: Baylor University Press.

Halperin, D.M. (1990), *One Hundred Years of Homosexuality and Other Essays on Greek Love*, New York: Routledge.

Hamilton, T. (2009), *Immortal Longings: F.W.H. Myers and the Victorian Search for Life After Death*, Exeter: Imprint Academic.

Haraway, D. (1988), 'Situated Knowledges: The Science Question in Feminism and the Privilege of Partial Perspective', *Feminist Studies* 14: 575–99.

Harding, S. (1986), *The Science Question in Feminism*, Ithaca and London: Cornell University Press.

Harloe, K. (2009), '*Ingenium et doctrina*: Historicism and the Imagination in Winckelmann, Heyne and Wolf' in P.C. Hummel (ed.), *Metaphilology: Histories and the Language of Philology*, 93–116, Paris: Philologicum.

Harloe, K. (2013), *Winckelmann and the Invention of Antiquity*, Oxford: Oxford University Press.

Harman, G. (2012), 'The Well-Wrought Broken Hammer: Object-Oriented Literary Criticism', *New Literary History* 43: 183–203.

Haskell, F. (1984), 'The Baron d'Hancarville: An Adventurer and Art Historian in Eighteenth-Century Europe' in E. Chaney and N. Ritchie (eds), *Oxford, China and Italy: Writings in Honour of Sir Harold Acton on his Eightieth Birthday*, London: Thames & Hudson.

Haskell, F. and N. Penny (1981), *Taste and the Antique: The Lure of Classical Sculpture, 1500–1900*, New Haven: Yale University Press.

Haubold, J. (2007), 'Homer After Parry: Tradition, Reception, and the Timeless Text', in B. Graziosi and E. Greenwood (eds), *Homer in the Twentieth Century*, 27–46, Oxford: Oxford University Press.

Hawthorne, N. (2002), *The Marble Faun*, New York: Oxford World's Classics.

Heller, W. (2004), *Emblems of Eloquence: Opera and Women's Voices in Seventeenth-Century Venice*, Berkeley: University of California Press.

Henrichs, A. (2004), '"Full of Gods": Nietzsche on Greek Polytheism and Culture', in P. Bishop (ed.), *Nietzsche and Antiquity: His Reaction and Response to the Classical Tradition*, 114–37, Rochester and Woodbridge: Camden House.

Herder, J.G. (1969), *Plastik. Einige Wahrnemungen über Form und Gestalt aus Pygamlions bildendem Traume*, Köln.

Herder, J.G. (1990), 'Viertes Kritische Wäldchen', in *Ausgewählte Werke in Einzelausgaben*, Berlin: Aufbau-Verlag.

Herder, J.G. (1993), *Schriften zur Ästhetik und Literatur*, ed. Gunter E. Grimm, Werke 2. Frankfurt: Deutscher Klassiker Verlag.

Herder, J.G. (2002), *Sculpture: Some Observations on Shape and Form from Pygmalion's Creative Dream*, trans. J. Gaiger, Chicago: University of Chicago Press.

Herder, J.G. (2006), *Herder: Selected Writings on Aesthetics*, ed. G. Moore, Princeton: Princeton University Press.

Hertz, N. (2009), *The End of the Line*, Aurora: Davies Group.

Hill, A.O. (1986), *Mother Tongue, Father Time: A Decade of Linguistic Revolt*, Bloomington: Indiana University Press.

Hocquenghem, G. (1978), *Homosexual Desire*, trans. D. Dangoor, London: Allison & Busby.

Hölderlin, F. (2004), *Poems and Fragments*. London: Anvil Press.

Holliday, P.J. (2000), 'Symonds and the Model of Ancient Greece', in J. Pemble (ed.), *John Addington Symonds: Culture and the Demon Desire*, 81–101, Basingstoke: Macmillan Press.

Holmes, B. (2007), 'The Iliad's Economy of Pain', *Transactions of the American Philological Association* 137: 45–84.

Holmes, B. (2010), *The Symptom and the Subject: The Emergence of the Physical Body in Ancient Greece*, Princeton: Princeton University Press.

Holmes, B. (2012), *Gender: Antiquity and its Legacy*, Oxford: Oxford University Press.

Holmes, B. (2015), 'Situating Scamander: "NatureCulture" in the *Iliad*', *Ramus* 4.1–2: 29–51.

Holmes, B. (2016), 'Michel Serres' Nonmodern Lucretius: Manifold Reason and the
 Temporality of Reception', in J. Lezra and L. Blake (eds), *Lucretius and Modernity*,
 21–36, New York: Palgrave Macmillan.
Holmes, B., and W.H. Shearin (2012), 'Introduction: Swerves, Events, and Unexpected
 Effects', in B. Holmes and W.H. Shearin (eds), *Dynamic Reading: Studies in the
 Reception of Epicureanism*, 3–29, Oxford: Oxford University Press.
Home, D.D. (1864), *Incidents in My Life*. New York: A.J. Davis & Co.
Home, D.D. (1878), *Lights and Shadows of Spiritualism*. London: Virtue & Co.
Homer (1883), *The Iliad of Homer*, trans. Andrew Lang, Walter Leaf and Ernest Myers,
 London: Macmillan.
Homer (1967), *The Odyssey,* trans. R. Lattimore, New York: Harper & Row.
Homer (1999), *Iliad*, trans. A.T. Murray, revised by William F. Wyatt, vol. 2,
 Cambridge, Mass.: Harvard University Press.
Honig, B. (2013), *Antigone, Interrupted*. Cambridge: Cambridge University Press.
Horrocks, G. (2010), *Greek: A History of the Language and its Speakers*, 2nd edn,
 Malden, MA: Wiley-Blackwell.
Houdini, H. (1924), *A Magician Among the Spirits*, New York: Harper & Bros.
Houston, G.W. (2014), *Inside Roman Libraries: Book Collections and Their
 Management in Antiquity*, Chapel Hill, NC: University of North Carolina Press.
Huang, M. et al. (2011), 'Human Cortical Activity Evoked by the Assignment of
 Authenticity when Viewing Works of Art', *Frontiers in Human Neuroscience* 5:134.
 doi.10.3389/fnhum.2011.00134.
Humphreys, S.C. (2002), 'Classics and Colonialism: Towards an Erotics of the
 Discipline', in G.W. Most (ed.), *Disciplining Classics – Altertumswissenschaft als
 Beruf*, 207–251 Göttingen: Vandenhoeck & Ruprecht.
Humphreys, S.C. (2009), 'De-modernizing the Classics', A. Chaniotis et al. (eds),
 Applied Classics: Comparisons, Constructs, Controversies, 197–207, Stuttgart: Steiner.
Hunter, R. (1992), 'Callimachus and Heraclitus', *Materiali e discussioni* 28:113–23.
Hutcheon, L. (1989), 'Historiographic Metafiction: Parody and the Intertextuality of
 History', P. O'Donnell and R.C. Davis (eds), *Intertextuality and Contemporary
 American Fiction*, 3–32, Baltimore: Johns Hopkins University Press.
Icks, M. (2011), *The Crimes of Elgabalus. The Life and Legacy of Rome's Decadent Boy
 Emperor*, London: I.B. Tauris.
Jack, M., ed. (1993), *Vathek and Other Stories: A William Beckford Reader*, London:
 William Pickering.
Jaeger, C.S. (2012), *Enchantment: On Charisma and the Sublime in the Arts of the West*,
 Philadelphia: University of Pennsylvania Press.
Jaeger, M. (2013), *Archimedes and the Roman Imagination*, Ann Arbor: University of
 Michigan Press.

Jameson, F. (1981), *The Political Unconscious: Narrative as a Socially Symbolic Act*, Cornell University Press.

Jansen, L. (2012), 'On the Edge of the Text: Preface and Reader in Ovid's *Amores*', *Helios* 39: 1–19.

Jansen, L., ed. (2014), *The Roman Paratext: Frame, Texts, Readers*, Cambridge: Cambridge University Press.

Jay, M. (1993), *Downcast Eyes: The Denigration of Vision in Twentieth-century French Thought*, Berkeley: University of California Press.

Jeannerod, M. (1994), 'The Representing Brain: Neural Correlates of Motor Intention and Imagery', *Behavioural and Brain Sciences*, 17(2): 187–245.

Jeannerod, M. (2001), 'Neural Simulation of Action: A Unifying Mechanism for Motor Cognition', *NeuroImage* 14, 2001, 103–9.

Jockey, P. (2013), *Le mythe de la Grèce blanche: Histoire d'un rêve occidental*, Paris: Belin.

Joyce, J. (1984), *Ulysses: A Critical and Synoptic Edition*, ed. H.W. Gabler, W. Steppe and C. Melchior, New York and London: Garland Publishing.

Joyce, J. (1998), *Ulysses*, ed. J. Johnson, Oxford: Oxford University Press.

Katz, J.T. (1998), 'Topics in Indo-European Personal Pronouns', PhD diss., Harvard University, Cambridge, MA.

Katz, J.T. (2010a), 'Etymology', in A. Grafton, G.W. Most and S. Settis (eds), *The Classical Tradition*, 342–5, Cambridge, MA: Harvard University Press.

Katz, J.T. (2010b), 'Inherited Poetics', in E.J. Bakker (ed.), *A Companion to the Ancient Greek Language*, 357–69, Malden, MA: Wiley-Blackwell.

Katz, J.T. (2010c), '*Nonne lexica etymologica multiplicanda sunt?*', in C. Stray (ed.), *Classical Dictionaries: Past, Present and Future*, 25–48, London: Duckworth.

Katz, J.T. (2013a), 'Gods and Vowels', in J.V. García and A. Ruiz (eds), *Poetic Language and Religion in Greece and Rome*, 2–28, Newcastle upon Tyne: Cambridge Scholars Publishing.

Katz, J.T. (2013b), 'The Hymnic Long Alpha: Μούσας ἀείδω and Related Incipits in Archaic Greek Poetry', in S.W. Jamison, H.C. Melchert and B. Vine (eds), *Proceedings of the 24th Annual UCLA Indo-European Conference, Los Angeles, October 26th and 27th, 2012*, 87–101, Bremen: Hempen.

Katz, J.T. (2013c), 'The Muse at Play: An Introduction', in J. Kwapisz, D. Petrain and M. Szymański (eds), *The Muse at Play: Riddles and Wordplay in Greek and Latin Poetry*, 1–30, Berlin: de Gruyter.

Kay, N., ed. (2001), *Ausonius: Epigrams*, London: Duckworth.

Keeley, E. (1976), *Cavafy's Alexandria: Study of a Myth in Progress*, Cambridge, Mass.: Harvard University Press.

Keith, A., ed. (2011), *Latin Elegy and Hellenistic Epigram: A Tale of Two Genres at Rome*, Newcastle upon Tyne: Cambridge Scholars Publishing.

Kennedy, D.F. (2002), *Rethinking Reality: Lucretius and the Textualization of Nature*, Ann Arbor: University of Michigan Press.

Kennedy, D.F. (2007), 'Making a Text of the Universe: Perspectives on Discursive Order in the *De rerum natura* of Lucretius', in M.R. Gale (ed.), *Oxford Readings in Lucretius*, 276–96, Oxford: Oxford University Press.

Kenner, H. (1980), *Ulysses*, London: George Allen & Unwin.

Kenner, H. (2005), *Flaubert, Joyce and Beckett: the Stoic Comedians*, Normal and London: Dalkley Archive Press.

Kierkegaard, S. (1843), *Frygt og Bæven*; here cited from the English translation by A. Hannay, *Fear and Trembling*, Harmondsworth: Penguin, 1985.

Kittler, F.A. (1990), *Discourse Networks 1800/1900*, trans. Michael Metteer and Chris Cullens, Stanford: Stanford University Press.

Klaniczay, G., M. Werner and O. Gecser, eds (2011), *Multiple Antiquities, Multiple Modernities: Ancient Histories in Nineteenth Century European Cultures*, Frankfurt: Campus Verlag.

Knowles, J. (1831), *The Life and Writings of Henry Fuseli*, London: H. Colburn & R. Bentley.

Konstan, D. (2006), *The Emotions of the Ancient Greeks: Studies in Aristotle and Classical Literature*, Toronto: University of Toronto Press.

Konstan, D. and K. Rutter, eds (2003), *Envy, Spite and Jealousy: The Rivalrous Emotions in Ancient Greece*, Edinburgh: Edinburgh University Press.

Kontou, T. and S. Willburn, eds (2012), *The Ashgate Research Companion to Nineteenth-Century Spiritualism and the Occult*. Farnham: Ashgate.

Krause, B. (2012), *The Great Animal Orchestra: Finding the Origins of Music in the World's Wild Places*, New York: Little, Brown and Company.

Krell, D.F. (2012), 'Foreword' in R. Gasché, *Georges Bataille: Phenomenology and Phantasmology*, trans. R. Végsö, ix–xvi, Stanford: Stanford University Press.

Kruger, L. (2012), 'On the Tragedy of the Commoner: Elektra, Orestes, and Others in South Africa', *Comparative Drama* 46 (3): 355–77.

Kruschwitz, P., 'Remember Lucius M-whatsisface?' (Blog post), https://thepetrifiedmuse. wordpress.com/2014/09/12/remember-lucius-m-whatsisface/, 12 September 2014.

Kuhn, T.S. (1962), *The Structure of Scientific Revolutions*, Chicago: University of Chicago Press.

La Rochefoucauld, F. de (1964), *Maximes* (édition de 1678), *Œuvres Complètes*, ed. L. Martin-Chauffier and J. Marchand, Paris: Gallimard.

La Ville de Mirmont, H. de (1917–21), *Le Manuscrit de l'Ile Barbe (Codex Leidensis Vossianus Latinus 111) et les travaux de la critique sur le texte d'Ausone: L'oeuvre de Vinet et l'oeuvre de Scaliger*, Paris: F. Pech/Bordeaux: Hachette.

Lacan, J. (1991), *Le séminaire, livre XVII: L'envers de la psychanalise (1969–1970)*, Paris: Seuil.

Lacan, J. (2001), *Le Séminaire, livre VIII: Le Transfert*, Paris: Seuil.

Laing, R.D. (1967), *The Politics of Experience and The Bird of Paradise*, Middlesex: Penguin Books.

Lamont, P. (2005), *The First Psychic: The Peculiar Mystery of a Notorious Victorian Wizard*, London: Little, Brown.

Lang, A. (1893), 'Folk-Lore in Hesiod', *The Classical Review* 7.10: 453.

Latour, B. (1987a), 'The Enlightenment Without the Critique: A Word on Michel Serres' Philosophy', in A.P. Griffiths (ed.), *Contemporary French Philosophy*, 83–97, Cambridge: Cambridge University Press.

Latour, B. (1987b), *Science in Action,* Cambridge, Mass: Harvard University Press.

Latour, B. (1993), *We Have Never Been Modern*, trans. C. Porter, Cambridge, Mass.: Harvard University Press.

Latour, B. (2004), 'Why Has Critique Run Out of Steam?: From Matters of Fact to Matters of Concern', *Critical Inquiry* 30: 225–48.

Lattimore, R. (1951), *The Iliad of Homer,* Chicago: University of Chicago Press.

Lattimore, R. (1963), *The Odyssey of Homer,* New York: Harper and Row.

Lebeck, A. (1971), *The 'Oresteia': A Study in Language and Structure*, Cambridge, Mass: Harvard University Press.

Lees-Milne, J. (1990), *William Beckford*, 2nd edn, London: Century.

Leonard, M. (2012), *Socrates and the Jews: Hellenism and Hebraism from Sigmund Freud to Moses Mendelssohn*, Chicago and London: The University of Chicago Press.

Leopold, A. (1949), *A Sand County Almanac*, Oxford: Oxford University Press.

Lesjack, C. (2013), 'Reading Dialectically', *Criticism* 55.2, 233–77.

Lessing, G.E. (1984), *Laocoön*, trans. E.A. McCormick, Baltimore: Johns Hopkins University Press.

Lessing, G.E. (1990), *Laokoon*, ed. Wilfried Barner, Werke und Briefe 5/2, Frankfurt: Deutscher Klassiker Verlag.

Levy, G.A. (2002), 'A Genius for the Modern Era: Madame de Staël's *Corinne*', *Nineteenth-Century French Studies* 30.3–4: 243–54.

Liberman, M. (2009), 'Extreme Etymology', *Language Log*, http://languagelog.ldc. upenn.edu/nll/?p=1032, 18 January.

Liberman, M. (2014), 'Pronoun Envy', *Language Log*, http://languagelog.ldc.upenn. edu/nll/?p=10324, 8 February.

Liddel, P. and P. Low, eds (2013), *Inscriptions and Their Uses in Greek and Latin Literature*, Oxford: Oxford University Press.

Liddell, H.G. and R. Scott (1996), *A Greek-English Lexicon*, 9th ed., Oxford: Clarendon Press.

Livia, A. (2001), *Pronoun Envy: Literary Uses of Linguistic Gender*, New York: Oxford University Press.

Lodge, D. (1984), *Small World: An Academic Romance,* London: Warburg & Seeker.

López-Baralt, L. (2013), 'Islamic Themes', in E. Williamson (ed.), *The Cambridge Companion to Jorge Luis Borges*, 68–80, Cambridge: Cambridge University Press.

Loraux, N. (2003), *La tragédie d'Athènes*, Paris: Seuil, 2003.

Louwerse, M. and W. van Peer, eds (2002), *Thematics. Interdisciplinary Studies*, Amsterdam: John Benjamins.

Love, H. (2007), *Feeling Backward: Loss and the Politics of Queer History,* Cambridge, Mass.: Harvard University Press.

Love, H. (2010), 'Close But Not Deep: Literary Ethics and the Descriptive Turn', *New Literary History* 41 (2): 371–91.

Love, H. (2013), 'Close Reading and Thin Description', *Public Culture* 25 (3): 401–34.

Lovecraft, H.P. (2005), *At the Mountains of Madness*, New York: Modern Library.

Lowe, Nick (2007), 'Gilbert Murray and Psychic Research', in *Gilbert Murray Reassessed*, ed. C. Stray, 349–70, Oxford: Oxford University Press.

Lucian (1936), *A True Story*, in *Lucian*, collected works, vol. 1, trans. A.M. Harmon, 247–357, London: Heinemann.

Luckhurst, R. (2002), *The Invention of Telepathy*, Oxford: Oxford University Press.

Lucretius (1947), *Titi Lucreti Cari De Rerum Natura Libri Sex*, ed. and trans. C. Bailey, Oxford: Oxford University Press.

Macchioro, V. (2014), *Zagreus: Studi intorno all'orfismo*, Milano: Mimesis.

Manguel, A. (2007), *Homer's 'The Iliad' and 'The Odyssey': A Biography*, London: Atlantic.

Marchand, S.L. (1996), *Down From Olympus. Archaeology and Philhellenism in Germany, 1750–1970*, Princeton: Princeton University Press.

Martial (2004), *Epigrams: Book 2*, trans. C.A. Williams, Oxford: Oxford University Press.

Martin, N. (2003), '"Fighting a Philosophy": The Figure of Nietzsche in British Propaganda of the First World War', *The Modern Language Review* 98 (2): 367–80.

Martin, R. (1997), 'Similes and Performance', in E. Bakker and A. Kahane (eds), *Written Voices, Spoken Signs: Tradition, Performance and the Epic Text*, 138–66, Cambridge: Cambridge University Press.

Martindale, C. (1993), *Redeeming the Text: Latin Poetry and the Hermeneutics of Reception*, Cambridge: Cambridge University Press.

Martindale, C. (2010a), 'Leaving Athens: Classics for a New Century? (Review of Page duBois, *Out of Athens*)', *Arion* 18: 135–48.

Martindale, C. (2010b), 'Performance, Reception, Aesthetics: Or Why Reception Studies Need Kant', in E. Hall and S. Harrop (eds), *Theorising Performance: Greek Drama, Cultural History and Critical Practice*, 71–84, London: Duckworth.

Martindale, C. (2013a), 'Reception – A New Humanism?: Receptivity, Pedagogy, and the Transhistorical', *Classical Receptions Journal* 5 (2): 169–83.

Martindale, C. (2013b), 'Response to Forum Debate', *Classical Receptions Journal* 5 (2): 246–51.

Martindale, C. and R. Thomas, eds (2006), *Classics and the Uses of Reception*, Oxford: Blackwell.

Martyna, W. (1980), 'Beyond the "He/Man" Approach: The Case for Nonsexist Language', *Signs*, 5 (3): 482–93.

Marvin, M. (1989), 'Copying in Roman Sculpture: The Replica Series', in *Retaining the Original: Multiple Originals, Copies and Reproductions* (*Studies in the History of Art* 20), 29–45, Washington: National Gallery of Art.

Marx, K. (1898), *The Eighteenth Brumaire of Louis Bonaparte*, trans. Daniel De Leon, New York: General Publishing Company.

McConnell-Ginet, S. (2014), 'Gender and its Relation to Sex: The Myth of "Natural" Gender', in G.G. Corbett (ed.), *The Expression of Gender*, 3–38, Berlin: de Gruyter.

McDonald, M. (2006), 'The Return of Myth: Athol Fugard and the Classics', *Arion* 14 (2): 21–48.

McHugh, H. (1998), 'Etymological Dirge', *American Scholar*, 67 (2): 80. [Reprint: H. McHugh (1999), *The Father of the Predicaments*, Hanover, NH: Wesleyan University Press/University Press of New England, 77.]

McPhee, J. (1981), *Basin and Range*, New York: Farrar, Straus, Giroux.

Menon, M. (2006), Reply in 'Forum', *PMLA* 121.3, 837–9.

Menon, M. (2008), *Unhistorical Shakespeare: Queer Theory in Shakespearean Literature and Film*, New York: Palgrave MacMillan.

Michelakis, P. (2002), *Achilles in Greek Tragedy*, Cambridge: Cambridge University Press.

Michelakis, P. (2004), 'Introduction: Agamemnons in Performance', in F. Macintosh, P. Michelakis, E. Hall and O. Taplin (eds), *Agamemnon in Performance 458 BC to AD 2004*, 1–20, Oxford: Oxford University Press.

Miller, C. and K. Swift (1976), *Words and Women*, Garden City, NY: Anchor Press/Doubleday.

Miller, J-A. (1997), 'Des semblants dans la relation entre les sexes', *La Cause freudienne* 36. 7: 7–15.

Miller, P.N. (2007), *Momigliano and Antiquarianism: Foundations of the Modern Cultural Sciences*, Toronto: University of Toronto Press.

Mitchell, W.J.T. (1986), *Iconology: Image, Text, Ideology*, Chicago: University of Chicago Press.

Montiglio, S. (forthcoming 2016), 'Hands Know the Truth: Touch in Euryclea's
 Recognition of Odysseus', in A. Purves (ed.), *Touch and the Ancient Senses*,
 London: Routledge.
Moore, G. (2006), *Herder: Selected Writings on Aesthetics*, Princeton, Princeton
 University Press.
Morales, H. (2014), 'Deep Down', *Times Literary Supplement*, 5814, 5 September: 22.
Moretti, F. (1996), *Modern Epic: The World System from Goethe to García Márquez*,
 trans. Q. Hoare, London and New York: Verso.
Most, G.W. (1997), *Collecting Fragments = Fragmente Sammeln. Aporemata; Bd. 1*,
 Göttingen: Vandenhoeck & Ruprecht.
Most, G.W. (2010), 'Laocoons', in J. Farrell and C. J. Putnam (eds), *A Companion to
 Vergil's 'Aeneid' and its Tradition*, 325–40, Chichester: Wiley-Blackwell.
Mueller, M. (2016), 'Recognition and the Forgotten Senses in Homer's *Odyssey*', *Helios*
 43.1.
Muellner, L. (1996), *The Anger of Achilles: "mênis" in Greek Epic*, Ithaca, NY: Cornell
 University Press.
Müller, J. (2014), 'Did Seneca Understand Medea? A Contribution to the Stoic
 Account of *Akrasia*', in J. Wildberger and M. Colish (eds), *Seneca Philosophus*,
 65–94, Berlin and Boston: Walter de Gruyter.
Müller, K.O. (1839), *The History and Antiquities of the Doric Race*, trans. H. Tufnell
 and G.C. Lewis, 2nd ed., London: Murray.
Myers, F.W.H. (1921), *Collected Poems with Autobiographical and Critical Fragments*,
 ed. Eveleen Myers, London: Macmillan.
Myers, F.W.H. (1918), *Human Personality and Its Survival After Bodily Death*, London,
 Longmans.
Myers, F.W.H., 'Automatic Writing. – IV – The Daemon of Socrates', *Proceedings of the
 Society for Psychical Research* 5 (1888–9): 522–47.
Myrone, M. (2001), *Henry Fuseli*, London: Tate Publishing.
Nagel, A. and C.S. Wood (2010), *Anachronic Renaissance*, New York: Zone Books.
Nagy, G. (2010), 'Poetics of Fragmentation in the Athyr Poem of C.P. Cavafy', in
 P. Roilos (ed.), *Imagination and Logos: Essays on C.P. Cavafy*, 265–72, Cambridge,
 Mass.: Harvard University Press.
Nauta, R. (2013), 'The Concept of "Metalepsis": From Rhetoric to the Theory of Allusion
 and to Narratology', in U. Eisen and P. v. Möllendorff (eds), *Über die Grenze:
 Metalepse in Text- und Bildmedien des Altertums*, 469–82, Berlin: de Gruyter.
Nicholls, S. (2009), *Paradise Found: Nature in North America at the Time of Discovery*,
 Chicago: University of Chicago Press.
Nielsen, I. (1993), *Thermae et Balnea: The Architecture and Cultural History of Roman
 Public Baths*, Aarhus: Aarhus University Press.

Nietzsche, F. (1989), *Nachgelassene Fragmente 1875–1879*, ed. Giorgio Colli and Mazzino Montinari, Berlin: de Gruyter.

Nietzsche, F. (1997), *Untimely Meditations*, ed. D. Breazeale and trans. R. J. Hollingdale, Cambridge: Cambridge University Press.

Nietzsche, F. (1999), *The Birth of Tragedy and Other Writings*, ed. R. Geuss and R. Speirs, trans. R. Speirs, Cambridge: Cambridge University Press.

Nisbet, G. (2013), *Greek Epigram in Reception: J.A. Symonds, Oscar Wilde, and the Inventon of Desire, 1805–1929*, Oxford: Oxford University Press.

Nochlin, L. (1994), *The Body in Pieces – The Fragment as Metaphor for Modernity*, London: Thames & Hudson.

Noë, A. (2004), *Action in Perception*, Cambridge, Mass.: MIT Press.

Nooter, S. (2012), *When Heroes Sing: Sophocles and the Shifting Soundscape of Tragedy*. Cambridge: Cambridge University Press.

Norton, R.E. (1991), *Herder's Aesthetics and the European Enlightenment*, Ithaca: Cornell University Press.

Nussbaum, M.C. (2008), 'The "Morality of Pity": Sophocles' *Philoctetes*', in R. Felski (ed.), *Rethinking Tragedy*, 148–69, Baltimore: Johns Hopkins University Press.

Orrells, D. (2011), *Classical Culture and Modern Masculinity*, Oxford: Oxford University Press.

Page, D., ed. (1972), *Aeschyli septem quae supersunt tragoediae*, Oxford: Oxford University Press.

Pasley, M. (1978), 'Nietzsche's Use of Medical Terms', in M. Pasley (ed.), *Nietzsche: Imagery and Thought: A Collection of Essays*, 123–58, Berkeley and Los Angeles: University of California Press.

Pasolini, P.P. (1960), *Eschilo: Orestiade*, Torino: Quaderni del Teatro Popolare Italiano.

Pasolini, P.P., director (1970), *Appunti per un' Orestiade africana* [Film], Italy: IDI Cinematografica.

Paul, C. (2000), *Making a Prince's Museum: Drawings for the Late-Eighteenth-Century Redecoration of the Villa Borghese*, Los Angeles: Getty Research Institute.

Pearce, S.M. (1992), *Museums, Objects and Collections: A Cultural Study*, Leicester: Leicester University Press.

Petersen, U. (1974), *Goethe und Euripides: Untersuchungen zur Euripides-Rezeption in der Goethezeit*, Heidelberg: Winter.

Peterson, J. and M. Mercer (1968), *Adultery for Adults: A Unique Guide to Self-development*, New York: Coward-McCann.

Piglia, R. (2013), *Borges por Piglia*. Clase 3, 'La biblioteca y el lector en Borges', http://www.tvpublica.com.ar/programa/borges-por-piglia.

Pizzacaro, M. (1994), *Il triangolo amoroso. La nozione di 'gelosia' nella cultura e nella lingua greca arcaica*, Bari: Levante.

Playfair, J. and A. Ferguson (1997), *James Hutton and Joseph Black: Biographies from Volume V of 'Transactions of the Royal Society of Edinburgh', 1805*, Edinburgh: RSE Scotland Foundation.

Poliziano, A. (1498), *Omnia opera*, Venice: Aldus Manutius.

Pop, A. (2015), *Antiquity, Theatre, and the Painting of Henry Fuseli*, Oxford: Oxford University Press.

Porter, D.H. (2005), 'Aeschylus' *Eumenides*: Some Contrapuntal Lines', *American Journal of Philology* 126.3: 301–31.

Porter, J.I. (2000), *Nietzsche and the Philology of the Future*, Stanford: Stanford University Press.

Porter, J.I. (2001), 'Ideals and Ruins: Pausanias, Longus and the Second Sophistic', in S. Alcock, J. Cherry and J. Elsner (eds), *Pausanias*, 63–92, Oxford: Oxford University Press.

Porter, J.I. (2006a), 'Feeling Classical: Classicisms and Ancient Literary Criticism', in J.I. Porter (ed.), *Classical Pasts: The Classical Traditions of Greece and Rome*, 301–52, Princeton: Princeton University Press.

Porter, J.I. (2006b), 'What is "Classical" about Classical Antiquity?', in J.I. Porter (ed.), *Classical Pasts: The Classical Traditions of Greece and Rome*, 1–65, Princeton: Princeton University Press.

Porter, J.I. (2006c), *Classical Pasts: The Classical Traditions of Greece and Rome*, Princeton, NJ: Princeton University Press.

Porter, J.I. (2008a), 'Reception Studies: Future Prospects', in L. Hardwick and C. Stray (eds), *A Companion to Classical Receptions*, 469–81, Malden, Mass.: Wiley-Blackwell.

Porter, J.I. (2008b), 'Erich Auerbach and the Judaizing of Philology', *Critical Inquiry* 35: 115–47.

Porter, J.I., (2010), *The Origins of Aesthetic Thought in Ancient Greece: Matter, Sensation, and Experience*, Cambridge: Cambridge University Press.

Porter, J.I. (2011a), 'Making and Unmaking: The Achaean Wall and the Limits of Fictionality in Homeric Criticism', *Transactions of the American Philological Association* 141: 1–36.

Porter, J.I. (2011b), 'Sublime Monuments and Sublime Ruins in Ancient Aesthetics', *European Review of History: Revue Europeenne D'histoire* 18.5–6: 685–96.

Porter, J.I. (2013), 'Learning from Pater', *Classical Receptions Journal* 5: 218–25.

Porter, J.I. (2014), 'Nietzsche's Radical Philology' in A.K. Jensen and H. Heit (eds), *Nietzsche as Scholar of Antiquity*, 27–50, London and New York: Bloomsbury.

Porter, J.I. (2016), *The Sublime in Antiquity*, Cambridge: Cambridge University Press.

Potts, A. (1994), *Flesh and the Ideal: Winckelmann and the Origins of Art History*, New Haven: Yale University Press.

Pound, E. (1964), *The Cantos*, London: Faber & Faber.

Prete, S., ed. (1978), *Decimi Magni Ausonii Burdigalensis Opuscula*, Leipzig: Teubner.

Prins, Y. (1999), *Victorian Sappho*. Princeton, NJ.: Princeton University Press.

'Pronoun Envy' (1971), *Newsweek*, 78 (23), 6 December: 58.

Proust, M. (1965), *Choix de lettres*, ed. P. Kolb, Paris: Plon.

Purves, A. (2013a), 'Haptic Herodotus', in S. Butler & A. Purves (eds), *Synaesthesia and the Ancient Senses*, 27–42, Durham: Acumen.

Purves, A. (2013b), 'Thick Description: Auerbach and the Boar's Lair (Od. 18.388–475)', in M. Skempis and I. Ziogas (eds), *Topography, Geography, Landscape: Configurations of Space in Greek and Roman Epic*, 37–62, Berlin: de Gruyter.

Purves, A. (2015), 'Ajax and Other Objects: Homer's Vibrant Materialism', in *Ramus* 44.1–2: 75–94.

Purves, A. (forthcoming), 'Rough Reading: Touch and Poetic Form', in J. Connolly and N. Worman (eds), *The Oxford Handbook to Ancient Literary Criticism*, Oxford: Oxford University Press.

Puttenham, G. (1589), *The Arte of English Poesie*, London: Richard Field.

Pynchon, T. (1997), *Mason & Dixon,* New York: Henry Holt.

Quintilian (1921), *The Institutio Oratoria of Quintilian*. 4 vols, trans. H.E. Butler, London: Heinemann.

Rabaté, J.-M. (1996), *The Ghosts of Modernity*, Gainesville et al.: The University Press of Florida.

Radt, S., ed. (1985), *Tragicorum Graecorum Fragmenta*, vol. 3, Göttingen: Vandenhoeck und Ruprecht.

Ravetto, K. (2003), 'Heretical Marxism: Pasolini's *cinema inpopulare*', in R L. Rutsky and B.J. MacDonald (eds), *Strategies for Theory: from Marx to Madonna*, 225–48, Albany, NY: State University of New York Press.

Reed, J. (2004), *Boy Caesar,* London: Peter Owen.

Reynolds, L.D. and P. Marshall, eds (1983), *Texts and Transmission: A Survey of the Latin Classics*, Oxford: Clarendon Press.

Richardson, E. (2012), 'Nothing's Lost Forever', *Arion* 20.2: 19–48.

Richardson, E. (2013), *Classical Victorians*, Cambridge: Cambridge University Press.

Richter, S. (1992), *Laocoön's Body and the Aesthetics of Pain: Winckelmann, Lessing, Herder, Moritz, Goethe*, Detroit: Wayne State University Press.

Richter, S. (1996), 'Sculpture, Music, Text: Winckelmann, Herder and Gluck's *Iphigénie en Tauride*', *Goethe Yearbook* 8: 157–71.

Rilke, R.-M. (1987), *The Selected Poems of Rainer Maria Rilke*, ed. and trans. S. Mitchell, London: Pan.

Ritschl, F., ed. (1838), *Dionysii Halicarnassensis Prooemium Antiquitatum Romanarum*, Breslau: Aderholz.

Roberts, J. (1912), *Antiquity Unveiled: Ancient Voices from the Spirit Realms Disclose the Most Startling Revelations*, Philadelphia: Oriental Publishing Company.

Romaine, S. (1999), *Communicating Gender*, Mahwah, NJ: Erlbaum.

Roosevelt, T. (1951), *Letters. Vol. 2: 1898–1900*, Cambridge, Mass.: Harvard University Press.

Rowlands, M. (2010), *The New Science of the Mind: From Extended Mind to Embodied Phenomenology*, Massachusetts: MIT Press.

Rutherford, E. (2014), 'Impossible Love and Victorian Values: J. A. Symonds and the Intellectual History of Homosexuality', *Journal of the History of Ideas* 75.4: 605–27.

Ruthven, K.K. (1969), 'The Poet as Etymologist', *Critical Quarterly*, 11 (1): 9–37.

Sanders, E. (2014), *Envy and Jealousy in Classical Athens. A Socio-Psychological Approach*, Oxford: Oxford University Press.

Sarlo, B. (1993), *Jorge Luis Borges: A Writer on the Edge,* London and New York: Verso.

Saussy, H. (2011), 'Comparisons, World Literature, and the Common Denominator', in A. Behdad and D. Thomas (eds) (2011), *A Companion to Comparative Literature*, 60–4, Malden, Mass.: Wiley-Blackwell.

Schiller, F. (1998), *Essays*, New York: Continuum.

Schliemann, H. (1875), *Troy and its Remains: A Narrative of Researches and Discoveries Made on the Site of Ilium, and in the Trojan Plain*, trans. Dora L. Schmitz, ed. Philip Smith, London: John Murray.

Schliemann, H. (1880), *Ilios: The City and Country of the Trojans,* London: John Murray.

Schmitt, C. (2012), 'Tidal Conrad (Literally)', *Victorian Studies* 55 (1): 7–29.

Schmitt, C. (forthcoming), 'How to Read the Surface of the Sea.'

Schnapp, A. (1996), *The Discovery of the Past: The Origins of Archaeology*, London: British Museum Press.

Schork, R.J. (1998), *Greek and Hellenic Culture in Joyce*, Gainesville: The University Press of Florida.

Schrijvers, P.H. (2007), 'Seeing the Invisible: A Study of Lucretius' Use of Analogy in *De Rerum Natura*', in M. R. Gale (ed.), *Oxford Readings in Lucretius*, 255–88, Oxford: Oxford University Press.

Sedgwick, E.K. (2003), *Touching Feeling: Affect, Pedagogy, Performativity*, Durham, NC: Duke University Press.

Seidel, M. (1977), 'Ulysses', in M. Seidel and E. Mendelsohn (eds), *Homer to Brecht: The European Epic and Dramatic Traditions*, 123–39, New Haven and London: Yale University Press.

Seneca (2014), *Medea*, ed. and trans. A. Boyle, Oxford: Oxford University Press.

Serres, M. (1977), *La naissance de la physique*. Paris: Editions de Minuit.

Serres, M. and B. Latour (1991), *Conversations on Science, Culture, and Time: Michel Serres with Bruno Latour*, trans. R. Lapidus. Ann Arbor: University of Michigan Press.

Shea, A. (2012), 'Does "Decimate" Really Mean "Destroy One Tenth"?', *OxfordWords Blog*, http://blog.oxforddictionaries.com/2012/09/does-decimate-mean-destroy-one-tenth/, 10 September.

Sihler, A.L. (1995), *New Comparative Grammar of Greek and Latin*, New York: Oxford University Press.

Silk, M., I. Gildenhard and R. Barrow (2014), *The Classical Tradition: Art, Literature, Thought*, Malden, MA: Wiley-Blackwell.

Slaney, H. (forthcoming), 'In the body of the beholder: Herder's aesthetics and classical sculpture' in Alex Purves (ed.), *Touch and the Ancient Senses*, Durham: Acumen.

Slote, S. (2013), *Joyce's Nietzschean Ethics*, New York and Basingstoke: Palgrave Macmillan.

Smail, D.L. (2008), *On Deep History and the Brain*, Berkeley: University of California Press.

Smith, A. (2002), *The Theory of Moral Sentiments*, ed. Knud Haakonssen, Cambridge: Cambridge University Press.

Smith, M. (2004), 'Elusive Stones', in B. Acosta-Hughes, E. Kosmetatou and M. Baumbach, (eds), *Labored in Papyrus Leaves: Perspectives on an Epigram Collection Attributed to Posidippus (P.Mil.Vogl. VIII 309)*, 105–117, Washington, DC: Center for Hellenic Studies.

Snell, B. (1953), *The Discovery of the Mind: The Greek Origins of European Thought*, trans. T.G. Rosenmeyer, Harvard University Press.

Stahl, F.F.S. (1886), *De Ausonianis studiis poetarum Graecorum*, Kilia: C.F. Mohr.

Staley, G.A. (2010), *Seneca and the Idea of Tragedy*, Oxford: Oxford University Press.

Stanford, W.B. (1950), 'Homer's Use of Personal πολυ- Compounds', *Classical Philology* 45 (2): 108–10.

Staten, H. (2004), 'The Decomposing Form of Joyce's *Ulysses*', in D. Attridge (ed.), *James Joyce's* Ulysses: *A Casebook*, 173–98, New York: Oxford University Press.

Stendhal (1980), *De l'amour*, Paris: Gallimard.

Stevens, H.D. (2010), 'Normality and Queerness in Gay Fiction', in H.D. Stevens (ed.), *The Cambridge Companion to Gay and Lesbian Writing*, 81–96.

Stewart, A. (1997), *Close Readers: Humanism and Sodomy in Early Modern England*, Princeton: Princeton University Press.

Strawson, G. (2008), 'Against Narrativity', in *Real Materialism and Other Essays*, Oxford: Oxford University Press: 189–208.

Stray, C., ed. (2007), *Gilbert Murray Reassessed*, Oxford: Oxford University Press.

Stuttard, D., ed. (2014), *Looking at 'Medea': Essays and a Translation of Euripides' Tragedy*, London: Bloomsbury.

Susanetti, D. (2014), *Atene post-occidentale: Spettri antichi per la democrazia contemporanea*, Roma: Carocci.

Svenbro, J. (1976), *La parole et le marbre*, Lund: Studentlitteratur.

Symonds, J.A. (1872), *An Introduction to the Study of Dante*, London: Smith, Elder.

Symonds, J.A. (1882) *Animi Figura*, London: Smith, Elder.

Symonds, J.A. (1893), *In the Key of Blue and Other Prose Essays*, London: Elkin
 Mathews & John Lane.

Symonds, J.A. (1920), *Studies of the Greek Poets*, 3rd ed., London: A. & C. Black.

Symonds, J.A. (1967–1969), *The Letters of John Addington Symonds*, ed. H. M.
 Schueller and R.L. Peters, 3 vols, Detroit: Wayne State University Press.

Symonds, J.A. (1984), *The Memoirs of John Addington Symonds*, ed. P. Grosskurth,
 New York: Random House.

Symonds, J.A., trans. (1878), *The Sonnets of Michael Angelo Buonarroti and Tommaso
 Campanella*, London: Smith, Elder.

Taylor, H.O. (1919), *Prophets, Poets and Philosophers of the Ancient World*, New York:
 Macmillan.

Thompson, E. (2005), 'Sensorimotor Subjectivity and the Enactive Approach to
 Experience', *Phenomenology and the Cognitive Sciences* 4, 407–27.

Toop, D. (2010), *Sinister Resonance: The Mediumship of the Listener*, New York:
 Bloomsbury.

Torrance, I. (2007), 'Religion and Gender in Goethe's *Iphigenie auf Tauris*', *Helios*,
 3: 177–206.

Traub, V. (2007), 'The Present Future of Lesbian Historiography', in G.E. Haggerty and
 M. McGerry (eds), *A Companion to Lesbian, Gay, Bisexual, Transgender and Queer
 Studies*, 124–145, Oxford: Blackwell.

Traub, V. (2013), 'The New Unhistoricism in Queer Studies', *PMLA* 128.1, 21–39.

Trevelyan, H. (1941), *Goethe and the Greeks*, Cambridge: Cambridge University Press.

Tsagalis, C. (2004), *Epic Grief: Personal Lament in Homer's 'Iliad'*, Berlin: de Gruyter.

Tsitsibakou-Vasalos, E. (2007), *Ancient Poetic Etymology. The Pelopids: Fathers and
 Sons*, Stuttgart: Steiner.

Valdez, D. (2014), *German Philhellenism: The Pathos of the Historical Imagination
 from Winckelmann to Goethe*, New York: Palgrave Macmillian.

Valian, V. and J. Katz (1971), 'The Right to Say He', *Harvard Crimson*, 154 (66),
 24 November: 2.

Van Zyl Smit, B. (2010), 'Orestes and the Truth and Reconciliation Commission',
 Oxford Journal of Classical Receptions 2 (1): 114–35.

Vandenbroucke, R. (1985), *Truths the Hand Can Touch: The Theatre of Athol Fugard*,
 New York: Theatre Communications Group.

Vasunia, P. (2013), *The Classics and Colonial India*, Oxford: Oxford University Press.

Ventris, M. and J. Chadwick (1973), *Documents in Mycenaean Greek*, 2nd ed.,
 Cambridge: Cambridge University Press.

Volk, K. (2002), *The Poetics of Latin Didactic: Lucretius, Vergil, Ovid, Manilius*. Oxford: Oxford University Press.

Walcott, D. (1990), *Omeros*, New York: Farrar, Straus & Giroux.

Wales, K. (1996), *Personal Pronouns in Present-day English*, Cambridge: Cambridge University Press.

Wallace, R.E. (2008), *Zikh Rasna: A Manual of the Etruscan Language and Inscriptions*, Ann Arbor, MI: Beech Stave.

Watkins, C. (2011), *The American Heritage Dictionary of Indo-European Roots*, 3rd edn, Boston: Houghton Mifflin Harcourt.

Watmough, M.M.T. (1997), *Studies in the Etruscan Loanwords in Latin*, Florence: Olschki.

Weiss, M. (2009), *Outline of the Historical and Comparative Grammar of Latin*, Ann Arbor, MI: Beech Stave.

Weissberg, L. (1989), 'Language's Wound: Herder, Philoctetes, and the Origin of Speech', *Modern Language Notes* 104 (3): 548–79.

Wellbery, D.E. (1984), *Lessing's Laocoon: Semiotics and Aesthetics in the Age of Reason*, Cambridge: Cambridge University Press.

West, M.L., ed. (1998–2000), *Homeri Ilias*, Stuttgart and Leipzig: Teubner.

Wetmore, K.J. (2003), *Black Dionysus: Greek Tragedy and African American Theatre*, Jefferson, NC: McFarland Publishing.

Whitmarsh, T. (2013), 'Radical Cognition: Metalepsis in Classical Greek Drama', *Greece and Rome* 60: 4–16.

Wilamowitz, U. von (1908), *Greek Historical Writing and Apollo*, trans. G. Murray, Oxford: Clarendon Press.

Wilson, J. (2013), 'The Late Poetry', in E. Williamson (ed.), *The Cambridge Companion to Jorge Luis Borges*, 186–200, Cambridge: Cambridge University Press.

Winckelmann, J.J. (1756), *Gedanken über die Nachahmung der Griechischen Werke in der Malerey und Bildhauerkunst*, 2nd edn, Dresden and Leipzig: Walther.

Winckelmann, J.J. (1764), *Geschichte der Kunst des Alterthums*, Dresden: Walther.

Winckelmann, J.J. (1972), 'On the Painting and Sculpture of the Greeks', in *Winckelmann: Writings on Art*, ed. and trans. D. Irwin, London: Phaidon.

Winckelmann, J.J. (2006), *History of the Art of Antiquity*, trans. H.F. Mallgrave, Los Angeles: Getty Publications.

Winkler, J.J. (1989), *The Constraints of Desire: The Anthropology of Sex and Gender in Ancient Greece*, New York: Routledge.

Wiseman, T.P. (1992), *Talking to Virgil: A Miscellany*, Exeter: University of Exeter Press.

Witt, R.E. (1997), *Isis in the Ancient World*, 2nd edn, Baltimore: Johns Hopkins University Press.

Wolpers, T. (ed.) (2002), *Ergebnisse und Perspektiven der literaturwissenschaftlichen Motiv- und Themenforschung*, Göttingen: Vandenhoeck & Ruprecht.

Wood, C. (2011), 'Reception and the Classics', in W. Brockliss et al. (eds), *Reception and the Classics: An Interdisciplinary Approach to the Classical Tradition*, 163–73, Cambridge: Cambridge University Press.

Wood, J. (1999), *The Broken Estate: Essays on Literature and Belief*, New York: Random House.

Yourcenar, M. (1984), *The Dark Brain of Piranesi and Other Essays*, New York: Farrar, Straus & Giroux.

Index

abysses of time, 3–4, 15, 163, 223
Achilleid (Statius), 29
Achilles in Love (Fantuzzi), 26
Achilles: in Greek mythology 21, 22–5, 31, 36–40, 43–4, 77, 80, 258; modern reception of, 137
adultery, etymology of, 111
Aeneid (Virgil), 294
Aeschines, 27
Aeschylus, 28–9, 39, 41, 131, 152–4, 159, 231, 264. *See also Agamemnon, Choephori, Eumenides, Myrmidons, Oresteia*
aesthetic object, 76
aesthetics, 15, 76, 89, 94, 166; dramatic, 60
affordance, 91, 96, 102
Agamemnon, 24, 38, 52, 146, 148, 209, 256; modern reception of, 152–3, 155–6, 223
Agamemnon (Aeschylus), 41, 227
aischunē, 211
Alcibiades, 207
Aleph, The (Borges), 296–8
altus, 109–10
amour de l'impossible ('love of the impossible'), 41
anachronism, 27, 42–3, 181–2, 184, 187–8, 192–3, 263, 266, 269
Andreas Capellanus, 208
anger, 204, 208–18; erotic anger, 203; of Achilles, 15. *See also On Anger*
Antidosis (Isocrates), 165
Antigone (Sophocles), 154; modern adaptations of, 152
antiquarianism, 63, 94, 101, 164
antiquity: as great ruin, 71; as imaginary property, 87; as object of Classics, 12, 15; emergence of, 97–8; feel of, 71; innerness of, 88; notional homeland of, 51
apeiron ('boundless'), 24

Aphrodite: in Greek mythology, 80–1; in contemporary literature, 139
Apollo, 13; in contemporary literature, 129; statues of, 89, 128–9, 230
Apollo, Temple of (Delphi), 13
Appunti per un'Orestiade africana (Pasolini), 147–51
Arabian Nights, 294
archaeology, 4–6, 8, 172, 284; perfect, 12
Archer, Harry, 224
archetype, 7
Argonautica (Apollonius), 249–50
Ariadne auf Naxos (Benda), 54
Arianna a Naxos (Haydn), 53
Aristarchus, 24, 26, 28, 190
Aristophanes, 206–7, 211. *See also Frogs, Wealth*
Aristotle, 136, 205–6, 208–9, 212–14, 219, 224, 274. *See also Nichomachean Ethics, On Memory and Recollection, Peplos, Rhetoric*
Armide (Gluck), 53
Art of Love (Ovid), 207
Astbury, Brian, 152
astrophysics, 4
Auerbach, Eric, 27, 37, 167–70, 175–6, 275
Ausonius of Bordeaux, 167–71, 175–6. *See also Professores*

Barufaldi, Linda, 120
beauty, 13, 89–90, 138–9, 141, 213, 249, 285. *See also* sublime
Beccadelli, Antonio, 28–9, 39. *See also Hermaphroditus*
Beckford, William, 87–8, 98–102. *See also Dreams, Walking Thoughts, and Incidents*
Beethoven, Ludwig van, 22
Belvedere Apollo, 89, 230
Belvedere Torso, 89
Benjamin, Walter, 261